# The
# COMPLETE GUIDE to
# NORTH AMERICAN
# Fishing

First published in 2001, reissued in 2007

This edition published in 2015

Text and photos copyright © 2001, 2007, 2015
Ken Schultz, www.kenschultz.com
Design copyright © 2001, 2007, 2015 Carlton Books Limited

ISBN: 978-1-78097-627-3

Printed and bound in Dubai

PICTURE ACKNOWLEDGMENTS
The publishers would like to thank the following sources for their kind
permission to reproduce the pictures in this book:

All pictures by Ken Schultz other than those listed below:

Abu-Garcia: 94-95
Steve Bly/Ocean/Corbis: 3
Daiwa: 99TR, 120B
Fenwick: 126B
Hummingbird: 159B, 162
Lowrance: 159T, 160
Mustad: 142TR, 142BL
Okuma: 120T
Orvis: 110, 113
Penn Fishing Tackle: 107
Plano: 148T
Shimano: 100TL, 103TR, 108
Zebco Brands: 99BR, 114, 115TR

Fish Artwork by Duane Raver/USFWS 12, 25, 27TR, 32L, 32TL, 35TR,
38TL, 38L, 38BL, 42, 56L, 56BL, 68TL, 70TL, 73TR, 79, 88TL, 90TL,
92TL

The following illustrations were drawn by Dave Kiphuth, copyright Ken
Schultz: 172, 174, 176, 177B, 178BL, 181TR, 181BL, 182, 185, 187,
190T, 191T, 192TL, 193BL, 195, 199, 203, 206BL, 206BR, 211, 213T,
213B, 214T, 214B, 215T, 215B, 216, 218, 219R

Every effort has been made to acknowledge correctly and contact the
source and/or copyright holder of each picture, and Carlton Books Limited
apologises for any unintentional errors or omissions which will be
corrected in future editions of this book.

# *The*
# COMPLETE GUIDE *to*
# NORTH AMERICAN
# *Fishing*

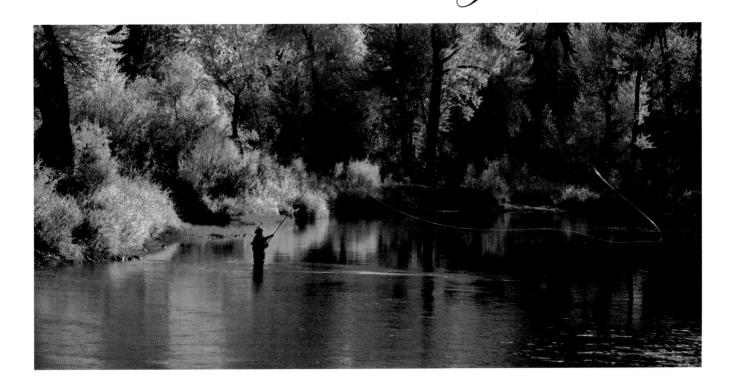

## KEN SCHULTZ

Fishing Editor – Fishing.About.com
Former Fishing Editor – *Field & Stream* and ESPNOutdoors.com

CARLTON
BOOKS

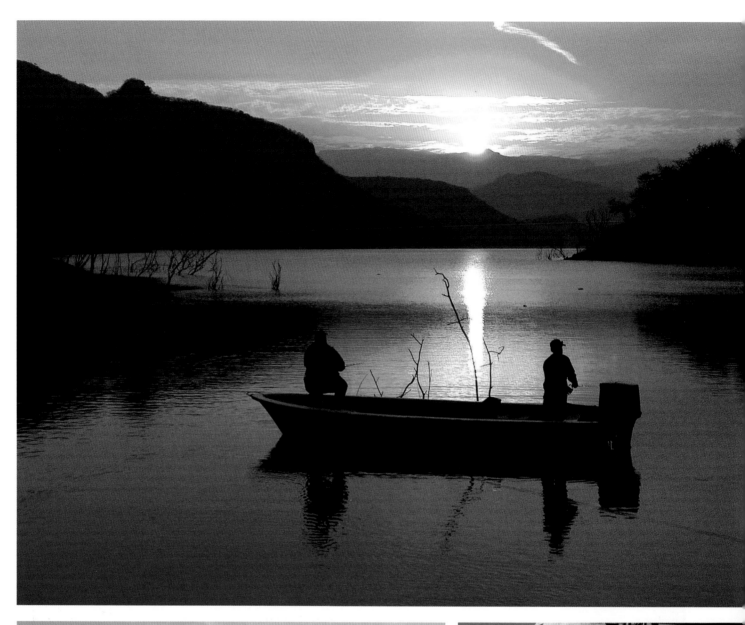

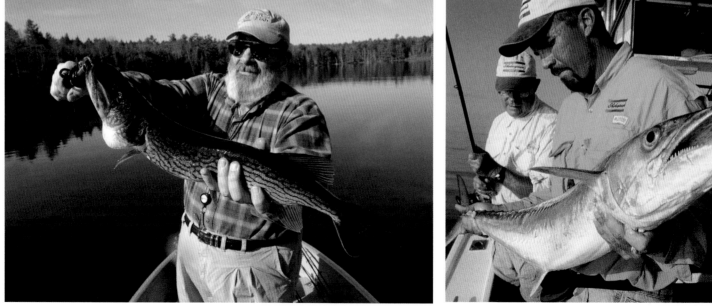

# CONTENTS

**Introduction**   6

## Fish   8

Albacore, Bonito and Little Tunny ........................ 10
American Shad ........................................................ 12
Arctic Charr .......................................................... 14
Arctic Grayling ...................................................... 16
Atlantic Salmon and Landlocked Salmon ............. 17
Barracuda .............................................................. 20
Billfish (Sailfish and Swordfish) ........................... 21
Bluefish ................................................................. 25
Bluegill .................................................................. 27
Bonefish ................................................................ 29
Brook Trout and Brown Trout ............................... 31
Carp ....................................................................... 35
Catfish ................................................................... 38
Chain Pickerel ....................................................... 42
Chinook Salmon and Coho Salmon ....................... 44
Crappie .................................................................. 46
Dolphin .................................................................. 48
Flounder and Halibut ............................................ 50
Jacks (Pompano, Amberjack and Yellowtail) ......... 52
Lake Trout ............................................................. 54
Largemouth and Smallmouth Bass ........................ 56
Mackerel ................................................................ 60
Muskellunge .......................................................... 62
Northern Pike ........................................................ 64
Permit .................................................................... 67

Rainbow Trout and Steelhead ............................... 68
Redfish ................................................................... 70
Rockfish ................................................................. 72
Seatrout and Weakfish ........................................... 73
Sharks .................................................................... 75
Snappers ................................................................ 77
Snook ..................................................................... 78
Striped Bass ........................................................... 79
Tarpon ................................................................... 82
Tuna (Bluefin, Blackfin, Bigeye and Yellowfin) ..... 84
Wahoo .................................................................... 87
Walleye .................................................................. 88
White Bass ............................................................. 90
Yellow Perch .......................................................... 92

## Tools   94

Fishing Reels ......................................................... 96
Fishing Rods ........................................................ 122
Line ...................................................................... 127
Lures .................................................................... 132
Natural Bait ......................................................... 140
Terminal Tackle ................................................... 142
Accessories .......................................................... 147

## Skills and Techniques   170

Casting ................................................................. 172
Retrieving ............................................................ 180
Jigging ................................................................. 185
Trolling ................................................................ 189
Drifting ................................................................ 193
Locating Fish ....................................................... 198
Hooksetting .......................................................... 202
Playing and landing Fish ..................................... 205
Releasing fish ....................................................... 209
Knots and knot tying ........................................... 213
Setting drag tension ............................................. 217
Hook sharpening .................................................. 219
Light-tackle fishing ............................................. 220

## Places   222

Canada ................................................................. 224
United States ........................................................ 233
Mexico ................................................................. 241

**Index**   250

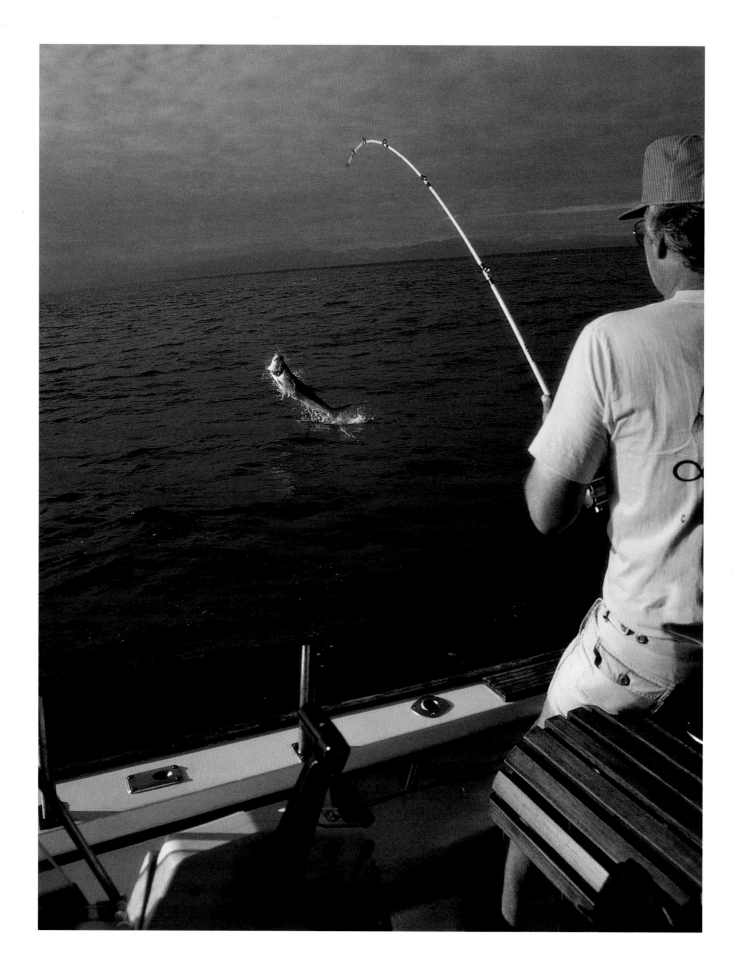

# Introduction

North American anglers are a pretty lucky bunch. Most of the continent has an abundance of water, no lack of access, a great diversity of highly desirable species in both freshwater and saltwater, and a host of ways to enjoy angling. It's no surprise, then, that on any given weekend, especially in spring and summer, millions of people are fishing in freshwater lakes, ponds, rivers, and streams, or in saltwater harbors, bays, flats, and canals, as well as inshore and offshore along the coasts.

For most anglers, fishing is a relaxing and peaceful way to enjoy nature, an activity in which you might catch something as fresh as you can get it for dinner, and also a sport that you can enjoy with family and friends. It's participatory; you move, you boat, you cast, you do things. You don't watch someone fish, like in an athletic contest. And when it all comes together, there's a magical strike and tug at the end of the line.

This book reviews all facets of North American sportfishing, with an emphasis on good basic information and handsome graphics. In reading it you may be struck by the number of species of importance to anglers, the wide ranges that many of them have, and how different so many are in terms of their habitats and the manner in which they are pursued.

Fishing is the original equal-opportunity sport, no matter what species you pursue. It doesn't require strength or abilities that can be attributed to a specific gender. Thus, the information here is useful to everyone, and the text focuses on the most important things to know about what you may fish for, what you will use, and how you will fish.

More than a manual of how to get into the sport, *The Complete Guide to North American Fishing* also highlights and celebrates the diverse elements of angling through ample, carefully selected photographs. The notion that all fishing is the same is certainly dispelled here in a pictorial sense. I hope that you'll refer to this book often, and keep it on display.

Ken Schultz
December 2014

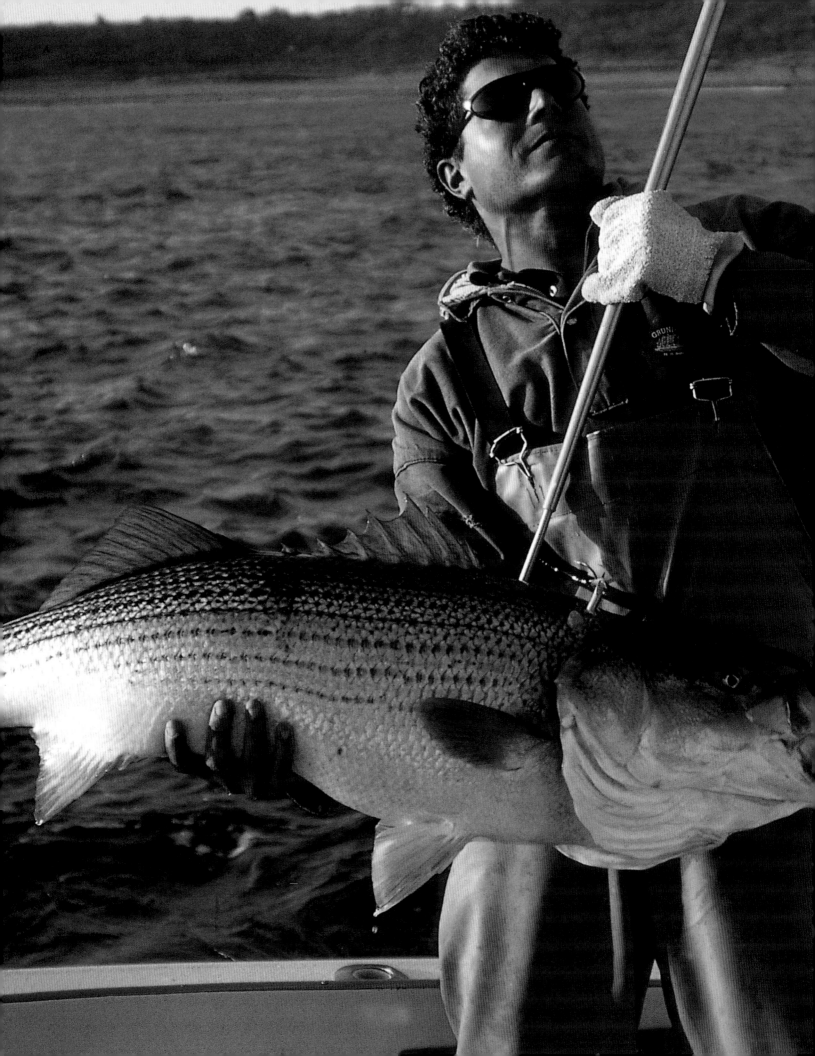

FISH

# ALBACORE, BONITO AND LITTLE TUNNY

**Known in North America as "chicken of the sea", because of its white meat and its popularity in canned form, albacore, a member of the tuna family, are an excellent light-tackle gamefish, and a valuable species commercially. Called true albacore in some places to avoid confusion with "false albacore" or little tunny, they are easily distinguished by pectoral fins which extend beyond the anal fin, and by their somewhat slimmer form.**

. . . . . . . . . . . . . . . . . . . . . . . . . . . . .

OFTEN ENCOUNTERED WHEN FISHING FOR OTHER SPECIES, ALBACORE AND BONITO CAN ATTRACT A CROWD.

Pelagic wanderers of tropical and temperate oceans, albacore are prominent along the Pacific coast, and are especially prevalent in southern California and Mexico, although El Niño currents may bring this fish close to Washington State and closer to the coast than usual. In the eastern U.S., albacore are important to canyon anglers in the Atlantic, as large schools often appear from late summer into early fall.

Although albacore can reach more than 90 pounds, they are common from ten to 25. They roam widely and travel fast. Depending on currents and water temperatures, albacore may be within a few miles of shore or far offshore, and like other tuna their diet consists of small fish, squid and crustaceans. They feed fairly close to the surface and in schools.

A lot of trolling with lures and natural bait is done to locate these fish. Once they have been found, anglers may continue trolling and try to stay with the school, or stop trolling and commence chumming and fishing with live or dead bait. Because of their size, hard strike and powerful runs, albacore are popular light-tackle fish, commonly pursued with 20- to 50-pound tackle. A variety of live and dead bait is used, especially anchovies on the west coast, although light-lining with live bait is most effective. Fly fishing is also possible, usually when a chum slick has been established and schools of albacore can be attracted within casting range.

False albacore is the name mostly used to describe a similar member of the tuna family, technically called the little tunny. It is also known in some places, though incorrectly, as "bonito." Of little value as a food fish, the little tunny tends to live closer to the shore than the albacore, is highly regarded as bait, and is a superb small gamefish. Indeed, they frequently fight so hard on light tackle that anglers find themselves boating dead or almost dead fish. Identification is fairly easy due to the several black spots present under the pectoral fin.

Little tunny are most abundant within 30 miles of shore during a late-summer to early-fall run along the mid-Atlantic and southern New England coasts, when they average five to 15 pounds (although they can grow to 35 pounds). They often chase bait into the surf and can be caught by surf casters retrieving small metal lures and jigs at high speed, and by flycasters pitching streamers. Many are also caught by trollers seeking school tuna and in chum lines intended for bluefish.

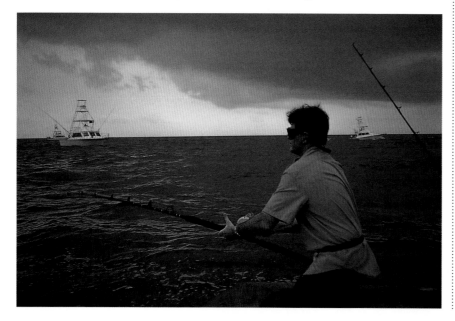

## AT-A-GLANCE

| | |
|---|---|
| **SCIENTIFIC NAME** | albacore: *Thunnus alalunga*; Atlantic bonito: *Sarda sarda*; Pacific bonito: *Sarda orientalis*; little tunny: *Euthynnus alletteratus* |
| **FAMILY** | tuna and mackerel |
| **TYPE** | saltwater |
| **SPAWNING** | Varies from late summer through spring |
| **PRIME FISHING** | Late summer and fall |
| **RANGE** (NORTH AMERICA) | albacore: Alaska to Mexico, Nova Scotia to Florida; Atlantic bonito: Nova Scotia to Florida; Pacific bonito: Alaska to Mexico; little tunny: Massachusetts to Florida |
| **PRIMARY HABITAT** | tropical, subtropical, and temperate coastal waters |
| **MAJOR PREY** | assorted small fish, squid, and shrimp |
| **LURES AND BAITS** | various live and dead natural baits, saltwater trolling lures, streamer flies |
| **PRIMARY TACKLE** | light big-game, light conventional, spinning, fly |

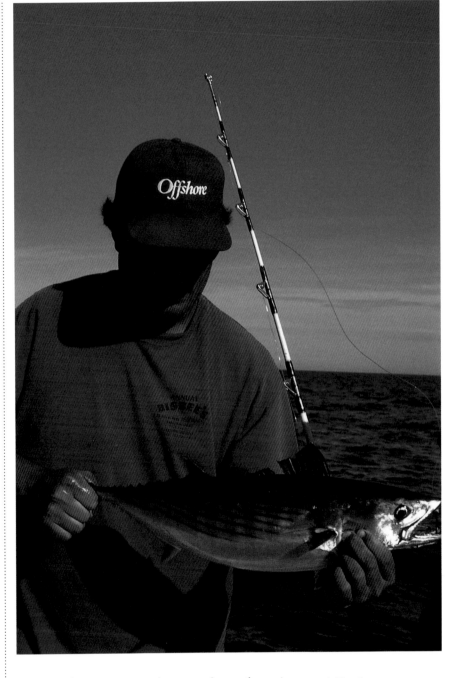

A NEW JERSEY ANGLER HOLDS AN ATLANTIC BONITO.

True bonito, which are also cousins of tuna, exist on both sides of the North American continent. Atlantic bonito range along the entire east coast in offshore environs, and are especially prominent from southern New England to New Jersey, although they are rare in the Caribbean and Gulf of Mexico. Pacific bonito range from Mexico to Alaska, but are especially prominent off California.

These species are similar in appearance. Bonitos, in general, have a cigar-like profile, with a rather pointed head and a slimmer or more compressed body than tuna. The back is blue or blue-green, fading to silvery on the lower sides and belly; a distinguishing feature is the dark lines that extend from the back to just below the lateral line.

Living in open waters, bonito feed primarily at or near the surface in schools, but they may also be found close to shore. The Atlantic bonito averages two to ten pounds, and feeds on small schooling fishes, squid, mackerel, menhaden, alewives, anchovies, silversides and shrimp. Pacific bonito are commonly found from three to eight pounds and prey on smaller pelagic fish as well as squid and shrimp. Anchovies and sardines appear to be their preferred food.

Bonito are excellent fighters, and their hearty appetites make them willing to strike many lures and baits. Sometimes, when a school is aroused, its members will take almost any bait or lure tossed their way. Bonito are often caught while trolling for larger quarry, and, when caught on the heavier tackle used for that sport, they are understandably overmatched. However, when caught on light tackle they are a robust battler, diving, surging, running, and generally doing their best to stretch the fishing line.

Most bonito are caught near the surface via a combination of trolling and live bait fishing. Schools are located by fast trolling with feather jigs and trolling plugs, and live bait or squid pieces are used to bait the fish once located. Bonito are neither put off by the wake of a boat nor by engine noise, so flatline length can be relatively short.

Sometimes bonito can be found near the shore and may be pursued by casters using assorted lures and flies, either from boats, the beach or a jetty. Metal jigs, long minnow plugs and streamer flies that imitate sand eels and spearing are used; ten- to 15-pound line on spinning or baitcasting tackle provides great enjoyment, as do nine- or ten-weight fly outfits with a weight-forward or sink-tip line.

# AMERICAN SHAD

**Not to be confused with the freshwater baitfish known as shad (which are actually the gizzard and threadfin species), the American shad is an anadromous coastal fish that is a seasonal favorite with the light-tackle crowd. Only available to anglers in spring and early summer, when it makes its annual spawning migration up freshwater rivers, the American shad displays a cartwheeling, broadside-to-the-current behavior when hooked, bringing a lot of enjoyment to lucky anglers. The arrival of the shad usually coincides with the first flower blossoms and is eagerly anticipated by both shore and boat anglers.**

. . . . . . . . . . . . . . . . . . . . . . . . . . . . . . .

KNOWN TO MANY as the "poor man's salmon," shad are caught in various rivers on the east coast, in the U.S. and Canada, and, due to transplanting, migrate up a number of U.S. rivers on the west coast. Their numbers, especially along the Atlantic, have fluctuated cyclically, and current population estimates are lower than they have been in quite a while. Dams, pollution and overharvest have impacted shad populations, both locally and regionally, over the past century. There is a commercial fishery for shad, whose roe is especially prized by gourmands. Its white,

A SHAD IS PLAYED ON THE ANNAPOLIS RIVER IN NOVA SCOTIA.

flaky flesh is full of bones but provides good eating if prepared properly.

The American shad is a member of the herring family, and is the most prominent coastal shad species. It is larger than, but closely related to, the hickory shad. Females are called roe fish or hens, and grow more quickly and generally larger than males, which are called bucks. American shad are common in the two- to five-pound class, with individuals up to seven or eight pounds not uncommon when the fish are abundant. They can grow to 11 pounds. The peak shad spawning migration occurs when the river temperature is in the 50s. Migration usually takes place in April in southern rivers and through July in the most northern waters, even beginning as early as mid-November in Florida. They often move through a river in stages or waves and are affected by water conditions. They are often not present in the same specific locales on a day-to-day basis, although they are primarily found in deep runs and pools. Adults attempt to return to the sea after spawning, and while many die right after spawning, others live to spawn again or several more times.

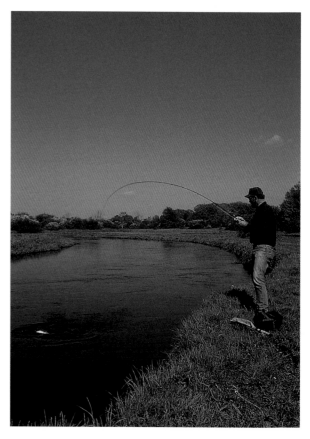

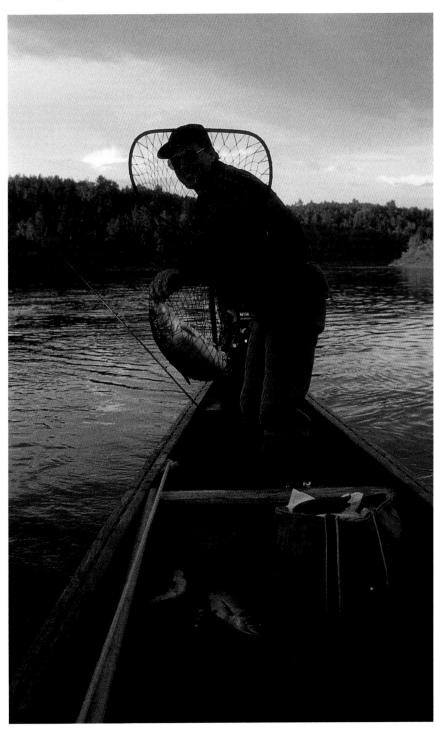

## AT-A-GLANCE

| | |
|---|---|
| **SCIENTIFIC NAME** | *Alosa sapidissima* |
| **FAMILY** | herring |
| **TYPE** | saltwater/freshwater |
| **SPAWNING** | spring through early summer |
| **PRIME FISHING** | spring through early summer |
| **RANGE** (NORTH AMERICA) | Labrador to Florida; southern Alaska to northern Mexico |
| **PRIMARY HABITAT** | migrates up coastal rivers to spawn |
| **MAJOR PREY** | Shad do not eat during spawning migration and are not caught otherwise |
| **LURES AND BAITS** | darts (jigs), small spoons, weighted flies |
| **PRIMARY TACKLE** | light spinning, fly |

Like other fish on spawning migrations, shad do not feed. They stop feeding during upstream spawning migration and resume during their relatively quick downstream post-spawning migration. Thus, imitating natural food isn't part of the angling pattern.

Lures include small jigs known as darts (also known as shad darts), small spoons and weighted streamer flies. Darts range in size from tiny to a half-ounce depending on water flow conditions and depth; smaller sizes may also be fished when the line is weighted with split shot. One-eighth- to one-quarter-ounce darts are most common. Popular colors include red and white (red head, white body), red and chartreuse, green and chartreuse, black and green, and red and yellow. Change colors frequently when you know there are shad in the pool you are fishing and they don't respond to your initial offering.

Spoons with No. 6 hooks are good if balanced correctly so they twirl fast. These are fished behind swiveling bead chain sinkers, or a downrigger if the water is deep. Both spoons and darts are fished about 50 to 75 feet behind an anchored boat, or at a similar distance when casting, using a quartering, cast-and-drift tactic, with emphasis on the end of the drift. It is common, incidentally, to get hung up and lose a lot of lures in the pursuit of shad.

For fly fishing, the norm is an eight-weight outfit with an eight- to nine-foot rod and sinking, fast sinking, or sink-tip fly lines depending on river depth and current flow conditions. A short leader is usually fine, and flies are commonly short-shanked streamers, sometimes brightly colored and often weighted with bead eyes. It is usually necessary to get the fly down to the bottom, so an across-swing-hang presentation is employed, with most fish taking as the fly makes its downcurrent turn or when it is stripped back in retrieval.

Concentrate angling efforts on dusk and the first three hours of daylight, the deeper portions of channels, and the head or tail of pools. When success tapers off in a given spot, moving slightly up, down or across the river might well result in more action.

Light spinning tackle is favored for shad, with a six- to seven-foot, light-action rod and spinning reel equipped with four- to eight-pound line. The reel should have a smooth drag, as large shad will take varied amounts of line during the fight.

A SUCCESSFUL SHAD ANGLER ON NEW BRUNSWICK'S MIRAMICHI RIVER.

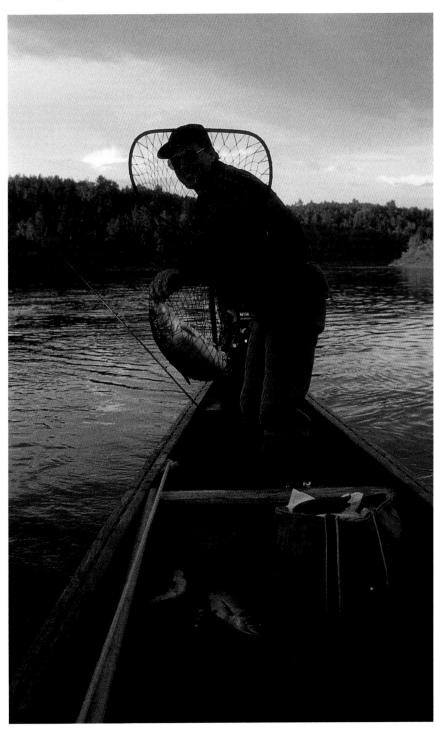

# ARCTIC CHARR

The Arctic charr is a member of one of the most distinguished-looking and prettiest families of fish—the charrs—that appear in freshwater. Many, including the Arctic charr, are particularly colorful in spawning mode and have distinctive body markings. Family relatives include brook trout and lake trout.

. . . . . . . . . . . . . . . . . . . . . . . . . . . .

## AT-A-GLANCE

| | |
|---|---|
| SCIENTIFIC NAME | *Salvelinus alpinus* |
| FAMILY | charr |
| TYPE | saltwater/freshwater |
| SPAWNING | late summer and early fall |
| PRIME FISHING | late summer and early fall |
| RANGE (NORTH AMERICA) | northern coast of Alaska, all of the northern coast of Canada easterly to Labrador |
| PRIMARY HABITAT | coastal rivers and connected lakes when migrating |
| MAJOR PREY | small fish, aquatic insects, and mollusks |
| LURES AND BAITS | spoons, spinners, flies |
| PRIMARY TACKLE | light to medium spinning, fly |

THIS SPECIES has the somewhat unusual distinction of existing naturally in anadromous (migrating annually to the sea) and non-anadromous (landlocked or living entirely in freshwater) versions. The former is generally larger than the latter, and of greater significance in both commercial fisheries and sportfishing.

Sea-run Arctic charr are strong battlers that make long runs and thrilling aerial jumps when hooked, and are prone to furious spinning and head-twisting gyrations. They are frequently caught in the pools of turbulent, swift rivers, and anglers should concentrate on the head of pools and where swift runs empty into open areas. Arctic charr are also school-

ing fish, and are likely to be present in small numbers.

The Arctic charr has light-colored spots on its body, with white on the leading edges of its lower fins. Overall body color is highly variable among sea-going and landlocked forms, and among individual stocks. Generally, the Arctic charr is silvery in non-spawning individuals, with deep green or blue shading on the back and upper sides, and a white belly. Spawning males exhibit brilliant

OPPOSITE PAGE: AN AUGUST-RUN ARCTIC CHARR FROM HADLEY BAY ON CAMBRIDGE ISLAND, NUNAVUT TERRITORY.

BELOW: CHARR FISHING ON THE COPPERMINE RIVER, NUNAVUT TERRITORY.

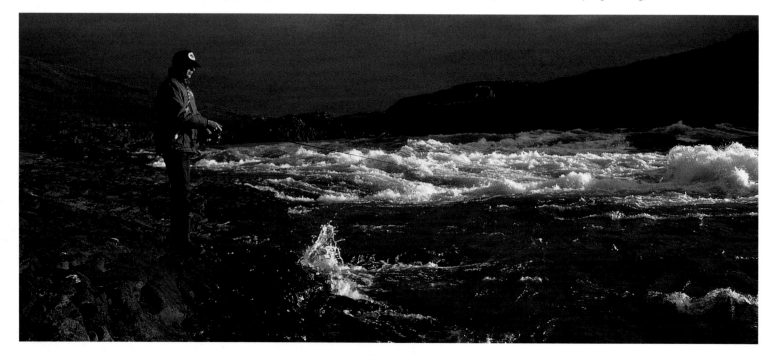

red or reddish-orange coloration on the sides, underparts, and lower fins. The flesh of sea-run charr, incidentally, is deep orange-red and highly prized.

While sea-run Arctic charr may grow to 33 pounds, they average about seven pounds, and fish over 12 pounds are generally considered to be large. Landlocked fish normally weigh a few pounds. In North America, the primary Arctic charr populations exist in the most northerly regions of Canada and in Alaska.

Sea-run charr live in their birth river for at least four years and then migrate to the sea for the first time in spring. They return anywhere between mid-August and late September, with the larger fish returning first, as soon as mid-July in some cases. Unlike other salmonids, all Arctic charr leave the sea and overwinter in rivers and lakes, although not all are spawners; some go back and forth several times before they first spawn. Landlocked charr reach maturity when they are smaller and younger, but have a lifestyle similar to their anadromous brethren.

Most of the better fishing for North American sea-run charr occurs far north and mainly in mid- to late summer. Some areas have just a six-week season before the weather becomes cold and sometimes snowy. The end of this period, however, is usually when the larger and most colorful spawning fish are available, although this varies with location.

Charr are sometimes clustered so thickly that a river seems to be full of them; at other times they can be scarce. Fishing is sometimes fast, with continuous action, but these are spooky fish—when a school is alarmed, it moves off and the spot has to be rested for a while.

In rivers, charr often hold at the head of a pool. A particularly good location is where the current drops over a gravel bar and dumps into a deep pool. In swift, high water it is necessary to use heavy-bodied spoons, often with some red or orange color, which sink below the surface turbulence. Weighted spinners and some plugs may also do the job, and heavily dressed flies on fast-sinking lines are necessary for fly anglers. Fly fishing is better when the water is lower; many different wet flies and streamers can be used, with some bright color for appeal, and dry flies may catch fish in appropriate circumstances (i.e. when there is a mosquito hatch).

In lakes, concentrate on inlets, where the river dumps into a lake. Early in the season, charr can be observed and caught as they wander along the edges of ice floes that are breaking up; a spoon, jig or streamer fly works here.

Light to medium spinning tackle with six- to ten-pound line is the norm for Arctic charr. Fly anglers need a reel with ample backing, and usually fast-sinking or sink-tip lines on seven- to nine-weight outfits.

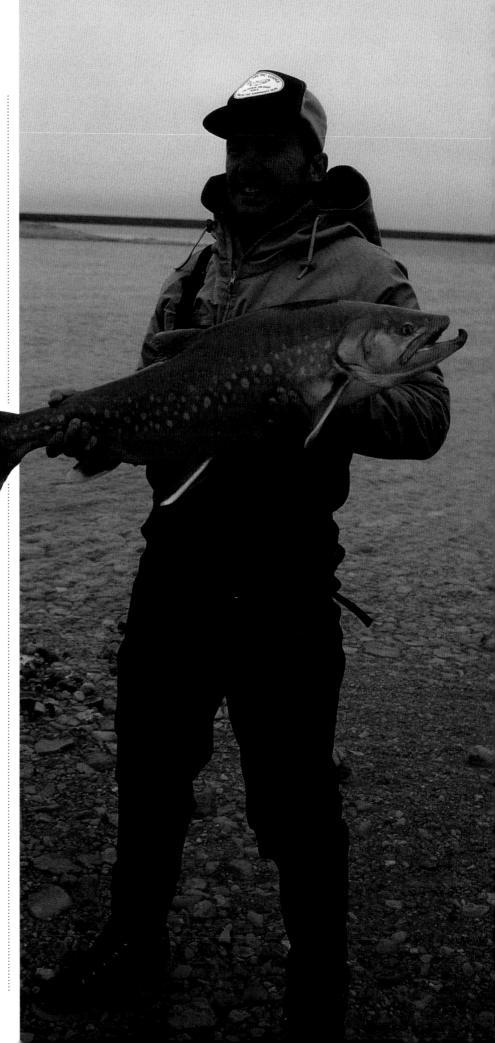

# ARCTIC GRAYLING

In North America, Arctic grayling are primarily found in remote and difficult-to-access northern coldwater areas, and are therefore little-known to most anglers. They are seldom the primary quarry for anglers traveling to the far reaches of Alaska and Canada, but they are a desirable, secondary attraction and a spunky, eager, acrobatic and pretty light-tackle catch.

. . . . . . . . . . . . . . . . . . . . . . . . . . . . . . . . . .

## AT-A-GLANCE

| | |
|---|---|
| SCIENTIFIC NAME | *Thymallus arcticus* |
| FAMILY | Trout and whitefish |
| TYPE | Freshwater |
| SPAWNING | Spring |
| PRIME FISHING | Summer, early fall |
| RANGE (NORTH AMERICA) | Arctic drainages from Hudson Bay westerly to Alaska; central Alberta and British Columbia; upper Missouri River drainage in Montana |
| PRIMARY HABITAT | Large and small rivers, connected lakes |
| MAJOR PREY | Aquatic insects |
| LURES AND BAITS | Small jigs, spinners, flies |
| PRIMARY TACKLE | Light spinning, fly |

RELATED TO TROUT and whitefish, Arctic grayling have a distinctive-looking, sail-like dorsal fin, which is purple to black and speckled with rows of often-bluish spots. Generally grayish-silver overall, grayling usually have shades or highlights of gold and/or lavender, as well as many dark spots which may be shaped like Xs or Vs.

Grayling may grow to a maximum of six pounds, but over three pounds is very big and most average just under one pound. They prefer clear, cold, well-oxygenated water in large river systems and lakes, but are most common in rivers, especially in eddies and the head of runs and pools.

A TYPICAL GRAYLING IN AN ATYPICAL SETTING: HUNT FALLS, SASKATCHEWAN.

In lakes they are found at river mouths and along rocky shorelines. Usually found in groups, they commonly seek refuge among small rocks on the stream bed or lake bottom and primarily eat small fish, insects and fish eggs. They can often be seen dimpling the water and feeding on surface insects, usually mosquitoes.

Grayling have small mouths, and many fish shake free of the hook. Though scrappy, feisty fish that jump and fight to the end, they must be handled gently, as they die quickly when held out of the water or if manhandled. They squirm and wriggle all the time, making it difficult to unhook them in the water and to grasp them. Barbless hooks are especially useful for unhooking these fish.

The best way to catch Arctic grayling is by dry fly fishing with five- to seven-weight lines. When not rising freely to insects, grayling may better be pursued with a wet fly or nymph. A floating fly line is used most of the time, and a sink-tip line on occasion. Grayling can be leader-shy, and they pursue flies and often strike at the end of a drift. Fly size ranges from No. 12 through 18, and the general rule is skimpy and either black or brown. Exact representations are not usually critical.

Light or ultralight spinning tackle is also excellent, using two- through six-pound test line. Small spinners and spoons are often used, but the best artificial is a small dark jig. Black or brown marabou or soft-plastic-bodied jigs in $\frac{1}{16}$- to $\frac{1}{8}$-ounce sizes produce very well, in flowing and still water.

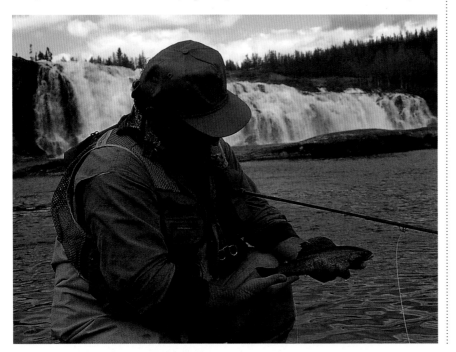

# ATLANTIC SALMON AND LANDLOCKED SALMON

A prominent fish since Roman days, the Atlantic salmon has long been held in high esteem for its flesh as well as its sporting attributes. Known for its acrobatics and streaming runs when caught, the Atlantic salmon is the only salmon originating naturally in the Atlantic Ocean.

A LANDLOCKED ATLANTIC SALMON CAUGHT WHILE TROLLING AT CAYUGA LAKE, NEW YORK.

IN RECENT DECADES, overfishing, pollution, dams and other factors have seriously curtailed the world's population of Atlantic salmon, which, like all anadromous fish, spend much of their life in the ocean and return to natal rivers to spawn. There are no longer any fishable populations of sea-run Atlantics in the U.S. Canadian sea-run Atlantic salmon numbers are well off their historic highs as well, although modest numbers ascend some coastal rivers in Quebec and New Brunswick. The pursuit of sea-run Atlantic salmon in North America is primarily done on private water at fairly high cost.

In the U.S. and Canada there are natural and stocked populations of the landlocked variety. These are known in some quarters as "ouananiche," but are mainly simply referred to as "landlocked salmon," even though there areother species of salmon that are also technically landlocked. They have identical characteristics to sea-run Atlantics, though they generally grow to smaller sizes.

Atlantic salmon returning from the ocean generally have a long, slim, silvery body and a nearly square tail fin. They darken the longer they are in freshwater. Young

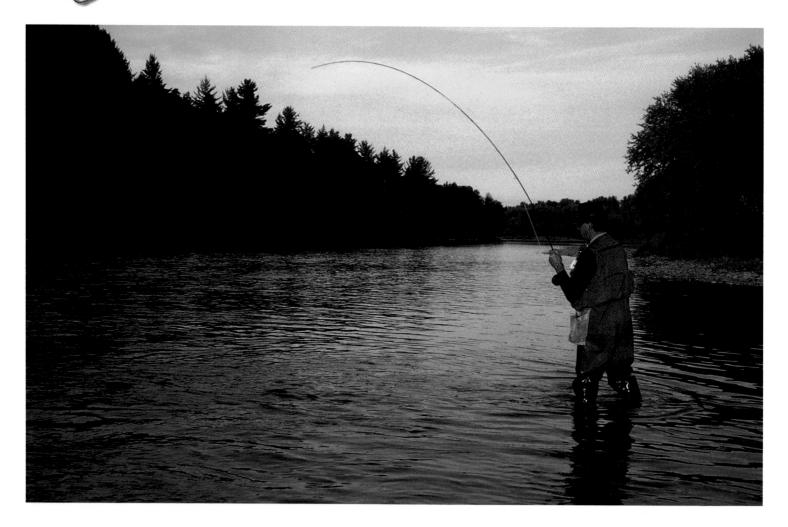

salmon that return to spawn prematurely are called "grilse," and have a slightly forked tail. At spawning time the males have elongated hooked jaws. Landlocked Atlantics look the same, although spawning fish may be darker.

Sea-run fish may live for eight years and grow to 80 pounds, although no such sizes have been recorded in decades. Most specimens today are under 20 pounds, even in the better waters, although the occasional larger fish is caught. In North America, anglers may fish for a week and only have a few small salmon, often grilse, to show for their effort. Landlocked salmon are capable of growing from 30 to 40 pounds, principally in the Great Lakes where they have abundant forage, although the average size is about five pounds.

Salmon are only caught by anglers when they ascend freshwater rivers to spawn. In coastal rivers they are primarily found in deep runs and pools, seldom in fast water or riffles. Although some landlocked salmon exist in rivers all year, the great majority spend most of their lives in the open water of lakes, and ascend tributaries to spawn; in rivers they inhabit deep runs and pools, and in lakes they stay in cooler, deeper levels where baitfish (primarily smelt and alewives) are abundant.

Unlike Pacific salmon, adult Atlantics do not all die after spawning; some migrate back to the sea and live to spawn another time. Like most anadromous species, spawning Atlantic and landlocked salmon do not feed.

Atlantic and landlocked salmon hug the bottom in rivers, resting in pools and deep-water sections. They are not usually caught in the fast-water reaches, although they can be located at the head and tail of pools, and in slick-water runs.

Angling for sea-run Atlantic salmon in North America is, by regulation, restricted to fly fishing. On some waters there are also restrictions on the hooks which can be used, with weighted hooks or flies declared illegal to minimize accidental, or deliberate, foul hooking of fish.

The vast majority of anglers wade and cast, although some guided anglers may cast from boats. It is common to start fishing above the head of a pool or run, and methodically work through the entire stretch, casting down and across and letting your fly swing at the end of each cast. Most fish are caught when the fly makes its swing or when it hangs momentarily in the current at the end of the swing. Many sea-run fish are caught by anglers who cast to a specific fish that has been seen, rather than

## AT-A-GLANCE

| | |
|---|---|
| **SCIENTIFIC NAME** | *Salmo salar* |
| **FAMILY** | trout |
| **TYPE** | sea-run Atlantics: saltwater/freshwater; landlocks: freshwater |
| **SPAWNING** | late spring through early fall |
| **PRIME FISHING** | sea-run Atlantics: summer and early fall; landlocks: spring |
| **RANGE** (NORTH AMERICA) | sea-run Atlantics: northern Maine to Ungava Bay, Quebec; landlocks: New York and New England states; the Great Lakes; the Maritime Provinces and Quebec |
| **PRIMARY HABITAT** | sea-run Atlantics: coastal rivers during spawning migration; landlocks: interior lakes and rivers |
| **MAJOR PREY** | sea-run Atlantics do not eat during spawning migration; landlocks consume smelt, alewives, and aquatic insects |
| **LURES AND BAITS** | flies for both species; spoons, spinners, and plugs for landlocks |
| **PRIMARY TACKLE** | fly tackle for sea-run Atlantics; fly and spinning for landlocks |

casting blindly for unobserved fish, as is usually done in coho and chinook angling.

Wet flies in various colorful patterns and sizes are popular for Atlantic salmon fishing, with the larger flies generally reserved for fast, high rivers. Dry flies work at times, too, which is an anomaly considering the nonfeeding disposition of these fish; the dries used, however, are large flies and usually tied out of tightly packed deer hair.

Atlantics may take on the first, fiftieth or one-hundredth cast, acting out of reflex or annoyance, and they may be put down easily or be relatively undisturbed by the angler's presence and activities. Unlike other salmon in rivers, Atlantics and landlocks are prone to jump high and often, in addition to making long, demanding runs.

Long rods and reels with plenty of backing are required. Standard fly tackle consists of an eight- or nine-weight rod equipped with a floating fly line and a reel with 200 yards of 20- or 30-pound test backing. Leader length should match rod length, or be slightly shorter. A sinking fly line or sink-tip fly line is not used. A nine-foot rod with nine-weight line is standard in North America, and useful considering the bulk of some of the flies that are cast. Rods to 12 and 13 feet, such as the two-handed Spey versions popular in Europe, have gone to a few users in recent years.

On many Atlantic salmon rivers, 70- to 100-foot casts are the norm, although that is not always necessary. What is usually necessary, however, is to make a good

presentation by getting a good drift of the fly, mending the line where necessary, and at times even riffling it across the surface gently. Early morning, evening and overcast conditions are often preferred.

Landlocked salmon in rivers are caught in a similar manner to sea-run fish, while those in lakes are preferably caught by trolling, in the period directly following ice-out, when the water is in the mid-40s. Landlocks are caught from the surface to 20 feet deep at this time, and can be found near shore over relatively shallow bottom or in open areas over deep water. As the surface temperature increases, the fish move deeper, staying generally in 52- to 57-degree water and roaming after such forage as smelt.

Surface trollers use streamer flies, spoons and small plugs, sometimes fishing with a fly rod, a light spinning outfit or conventional tackle and lead core line. Downrigger and sideplaner fishing are effective, too, using spoons and plugs. A relatively fast trolling speed is employed, with lines set from 75 to 200 feet behind the boat on flatlines and 40 to 80 feet back on deep downriggers.

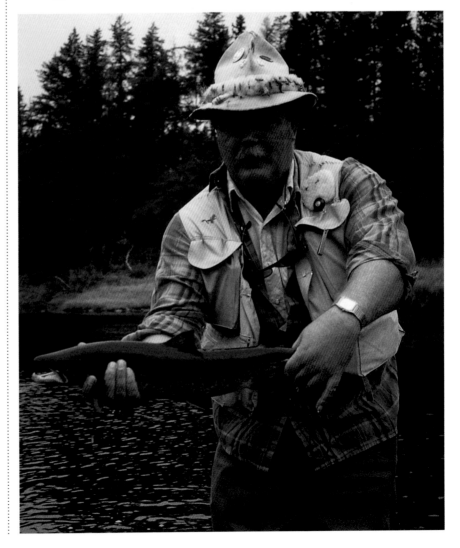

A SEA-RUN GRILSE FROM NEW BRUNSWICK'S CAINS RIVER.

# BARRACUDA

**Although it is not a media darling and gets little attention from most quarters, the barracuda is a fine gamefish and a fierce battler, especially in larger sizes. Barracuda often strike savagely and frequently jump out of the water when hooked.**

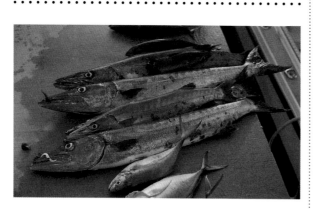

SEVERAL GOOD-SIZED BARRACUDA FROM WALKER'S CAY IN THE BAHAMAS AWAIT THE FILLET KNIFE.

SOMETIMES IT IS AN EASY FISH TO CATCH; in fact, it can be a nuisance when you are after other species. Yet at times it is a fish that will not be around when you're deliberately looking for it. Barracuda can also be dangerous due to aggressiveness and a mouthful of sharp teeth, which requires careful handling, and they may be problematic to eat, since some barracuda are poisonous and cause a crippling ailment called ciguatera. Unfortunately, there is no safe or reliable way of recognizing toxic individuals, although it would be especially wise to avoid fish from reef locations.

Barracuda are a fish of tropical waters. North America has two major species, the great barracuda, which occurs in the Atlantic (especially in Florida), and the Pacific barracuda, which occurs in the Pacific (especially in southern California and Mexico). The former are common between five and 20 pounds, while the latter rarely exceed ten pounds.

Barracuda inhabit bays, inlets, lagoons and the shallows of mangrove islands, and are found around reefs, wrecks, piers, sandy or grassy flats, and coastal rivers where saltwater and freshwater mingle. They generally prefer shallow areas, yet many a blue-water troller has ventured a little too close inshore and been rewarded with a barracuda while seeking other game. Large barracuda are often found in or near deep water and by themselves, while smaller barracuda may school.

The main food of barracuda is other fish, generally whatever is most available in their habitat. Needlefish, small jacks, mullet, anchovies, smelt and squid are prominent. Feeding mainly by sight, barracuda are attracted to flash and movement and are by nature a curious fish. They will follow a lure for quite a distance, yet scoot off as the lure nears a boat. For this reason, it is good when casting to make fairly distant casts beyond a barracuda to give it a chance to follow and strike the lure without being alarmed. The best barracuda lures are flashy, erratically worked surface plugs, shallow-running minnow plugs, spoons, surgical tube lures and large streamer flies. A quick retrieve is best for all offerings. Barracuda often follow a lure that is worked at a slow or moderate speed, but refuse to strike it, or will ignore a lure that stops altogether; an increase in speed can be the means of triggering a strike.

Sight fishing for barracuda is fun and practical. Casters ply the shallows and flats looking for barracuda, most of which lie motionless waiting to pounce on prey. Despite their size, they can still be difficult to spot.

Tackle for barracuda includes light- to medium-action spinning and baitcasting gear, as well as fly fishing gear. There is also a lot of trolling done for these fish, usually with heavier conventional or levelwind gear and while pursuing other species. Plugs, spoons, trolling feathers and rigged bait are used.

## AT-A-GLANCE

| | |
|---|---|
| SCIENTIFIC NAME | *Sphyraena barracuda* |
| FAMILY | barracuda |
| TYPE | saltwater |
| SPAWNING | late spring through summer |
| PRIME FISHING | year-round |
| RANGE (NORTH AMERICA) | North Carolina to Florida; southern California to Mexico |
| PRIMARY HABITAT | inshore flats, bays, and islands; offshore wrecks and reefs |
| MAJOR PREY | assorted fish |
| LURES AND BAITS | plugs, spoons, flies, rigged trolling baits, live hooked bait |
| PRIMARY TACKLE | spinning, baitcasting, fly |

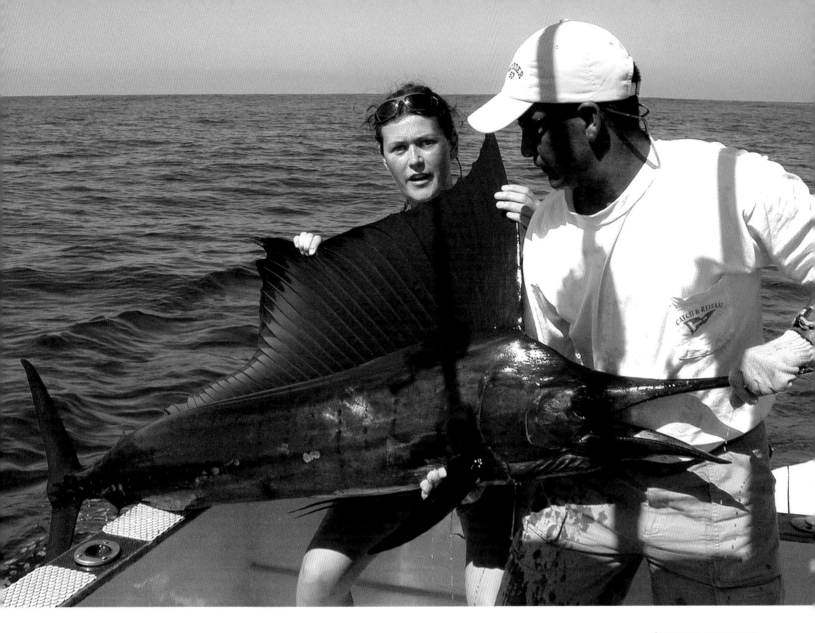

# BILLFISH (SAILFISH AND SWORDFISH)

Billfish are pelagic saltwater sportfish characterized by a long spearlike or swordlike upper jaw. This bill may be used to stun prey when feeding, but not necessarily to spear it. These species are migratory, inhabit tropical and temperate waters, swim at great speeds, and have complex air (or swim) bladders that allow them to compensate rapidly for changes in depth, meaning that they can move without difficulty from deep water to the surface. In North America, billfish include sailfish, blue marlin, striped marlin, white marlin and swordfish.

## Sailfish

The sailfish is probably the most glamorous billfish. Swift in the water and acrobatic out of it, it is distinguished by its large, flapping, namesake high dorsal fin, which is slate blue with many black spots, contrasted by a brown-blue body.

Apart from the high dorsal fin, sailfish are similar in shape and size to white marlin and small blue marlin. They can be found off all North American coasts, although Pacific fish tend to be much larger in size. Sailfish from 20 to 60 pounds are common in the Atlantic, and from 50 to 100 pounds in the Pacific. They may grow to over ten feet in length.

Sailfish often form schools or small groups, and can be found in loose aggregations over a wide area. Occasionally lone fish are observed cruising near the surface. They feed on squid, octopus, mackerel, tuna, jacks, herring, ballyhoo, needlefish, flyingfish, mullet and other small species, and feed on the surface or at mid-depths.

Fishing methods for this species are similar to those for other billfish, although lighter tackle is more appropriate. Methods include trolling with strip baits, whole mullet or ballyhoo, plastic offshore trolling lures, and trolling feathers or spoons, as well as fishing with live jacks, mullet and other small natural baits.

Sailfish are among the most exciting light-tackle, big-game fish and can be enjoyed on light conventional gear as well as spinning, baitcasting and fly outfits. The spectacular jumping of the sailfish makes it a superb light-tackle quarry, as this leaping, combined with its generally small size, prevent it from having long-term stamina. Spinning and baitcasting rods with 12- through 30-pound line are standard, and fly gear is very effective if you use bait-and-switch tactics. Smaller specimens found in the Atlantic are especially good fun and relatively easy for even inexperienced anglers to enjoy.

## Marlin (Blue, Striped, and White)

Given their size, relative abundance and glamor as hard-fighting battlers, the various marlin species are at or near the top of the saltwater gamefish ladder. In North America, blue, striped and white marlin are available, all in tropical and warm, temperate ocean waters.

The blue marlin is the largest of the three, with an ability to exceed 1,000 pounds, although it is generally caught between 150 and 400 pounds. In North America, they are seasonally caught from the upper mid-Atlantic south through the Caribbean and in the Gulf of Mexico, and are also a major catch in Hawaii. Their size and powerful fighting strength, plus the fact that they are more widespread in range than the other marlin species, make blue marlin the marquee billfish. Most are released after capture in North America, although as migrants to other areas they are susceptible to commercial catch, especially by longliners, which have caused populations to decline.

A SAILFISH STRUGGLES BEFORE CAPTURE.

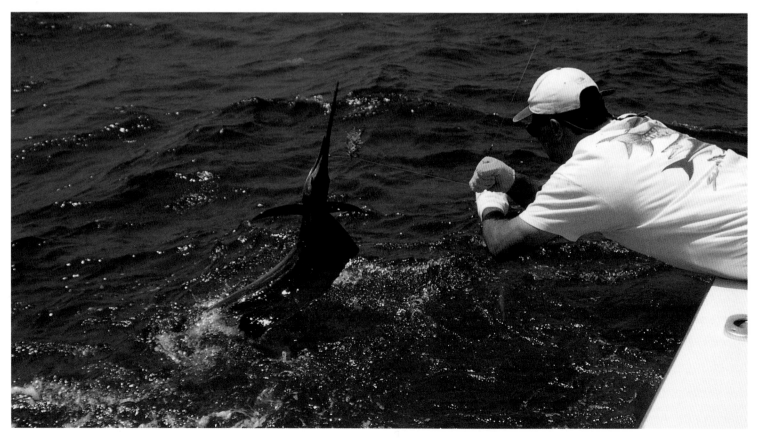

## AT-A-GLANCE

| | |
|---|---|
| SCIENTIFIC NAME | sailfish: *Istiophorus platypterus*; blue marlin: *makaira nigricans*; striped marlin: *Kajikia audax*; white marlin: *Kajikia albidus*; swordfish: *Xiphias gladius* |
| FAMILY | sailfish, blue marlin, striped marlin, and white marlin: billfish; swordfish: swordfish |
| TYPE | saltwater |
| SPAWNING | varies |
| PRIME FISHING | varies, though generally summer through fall |
| RANGE (NORTH AMERICA) | sailfish: Massachusetts to Florida, Gulf of Mexico, Pacific coast of Mexico; blue marlin: New York to Florida, Gulf of Mexico, southern Pacific coast of Mexico; striped marlin: southern California to Mexico; white marlin: Massachusetts to Florida, Gulf of Mexico; swordfish: Nova Scotia to Florida, southern California to Mexico |
| PRIMARY HABITAT | tropical and temperate offshore waters |
| MAJOR PREY | assorted pelagic fish and squid |
| LURES AND BAITS | offshore trolling lures and rigged baits; live bait |
| PRIMARY TACKLE | lever drag big-game tackle and conventional tackle for larger specimens; heavy spinning and fly tackle for smaller billfish |

Cobalt blue in color, the usually solitary blue marlin is found in the warm blue water of offshore environs, usually over considerable depths and where there are such underwater structures as canyons, dropoffs, ridges, seamounts and currents that attract copious supplies of baitfish. They feed on almost anything they can catch, with squid and pelagic fish, including assorted tuna, mackerel and dolphin, most common.

The striped marlin in North America is found only in the Pacific Ocean, primarily ranging from southern California south through Mexico, with special prominence along the Baja peninsula and off Cabo San Lucas. Smaller than blue marlin, the striped marlin is well known for its fighting ability; when hooked, it is more likely to be airborne than in the water, and may make a dozen or more tailwalking leaps. In some waters it can be caught fairly close to shore.

This steely blue billfish has iridescent blue spots on its fins and pale blue or lavender vertical stripes on the sides. In North America it has been caught to over 300 pounds, and is common from under 100 to about 200 pounds.

Mostly solitary, striped marlin may form schools during the spawning season, and can be fairly abundant in places that have plenty of forage. They feed on pilchards,

anchovies, mackerel, sauries, flyingfish and squid. The spear of the striped marlin is sometimes used both as a weapon for defense and as an aid in capturing food, in the latter case slashing prey sideways rather than impaling it.

White marlin are the smallest marlin, but an active leaper and great fish to catch on light tackle. An Atlantic Ocean species, the white is the most frequently encountered marlin along the eastern U.S., where it is almost exclusively released (often tagged) after capture. Maryland, North Carolina and Florida have the most reliable fishing for this species in North America.

A lighter-colored marlin with occasional vertical bars, the white may grow to well over 100 pounds, but is most common in North America in the 60-pound class. Like other marlin it is pelagic and migratory, usually found in deep blue tropical and warm temperate waters, and is usually solitary or found in small groups, the latter due to the presence of ample food. White marlin are opportunistic feeders, foraging on whatever pelagic food is most available, especially sardines, herring and squid.

Fishing for marlin primarily means offshore trolling. Blue marlin are caught by trolling large, whole baits, such as bonito, dolphin, mullet, mackerel, bonefish, ballyhoo, flyingfish and squid, as well as various types of artificial lures and sometimes strip baits. Most anglers catch striped marlin by trolling eight- to 12-inch skirted offshore lures. White marlin are mainly caught by trolling with small, whole or strip baits, whole rigged small- and medium-sized ballyhoo, small spoons and feathers and sometimes live bait.

Blind strikes are generally the rule for marlin, but you can occasionally tempt a marlin on the surface to strike if lures are trolled past it, or if live bait is cast to it. Concentrate on temperature breaks and converging currents where there is a lot of bait and clean blue water.

Outrigger lines and flatlines are used – as are teasers, trolled at fast speeds. Tackle for white marlin is often in the 20- or 30-pound conventional range, while spinning or

A BOAT LEAVES KAPA'A ON THE ISLAND OF KAUAI, HAWAII, AT SUNRISE FOR A DAY OF MARLIN FISHING.

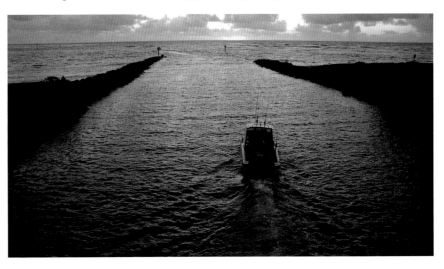

levelwind outfits may be kept handy with a rigged bait to use when a fish is visually spotted within casting distance of the boat. Whites also make good candidates for fly fishing, especially if they are numerous in an area and can be teased into casting range. Heavier tackle is used for blues, with 50- and 80-pound lever drag tackle most common, and 130-pound-class tackle where big fish are likely. Striped marlin fall in between in terms of tackle, with 20- to 50-pound tackle most common, although small stripers can be caught on a fly rod.

## Swordfish

Long one of the ocean's most coveted big game species, the swordfish is not encountered by anglers in North American waters in the numbers that it used to be, due in large part to commercial over-exploitation through longlining, and because the fish are found far offshore and not often caught by the same water-covering sportfishing methods

A SMALL BLUE MARLIN IS ABOUT TO BE TAGGED BEFORE RELEASE.

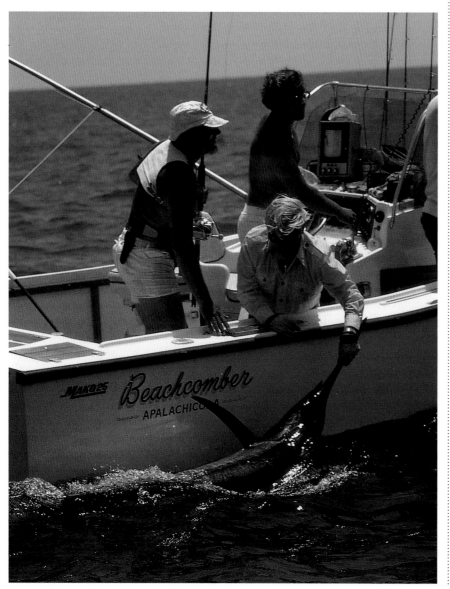

used for other billfish. Those few swordfish caught by anglers are comparatively small; while swordfish may in the past have grown to over 1,000 pounds, specimens over 400 pounds today are uncommon, and anglers are more likely to see them in the 100- to 200-pound class.

This darkish-bodied fish is distinguished by a pointed, long, flat snout that is swordlike in shape and measures at least one-third the length of the body. Their "bill" is significantly longer and wider than that of any other billfish, and also causes this species to be known as broadbill swordfish.

Swordfish inhabit tropical, temperate and occasionally cold waters, migrating between cooler waters in the summer to warmer waters in the winter for spawning. They are more prominent along the Atlantic coast of the U.S., and the Pacific coast off Mexico, typically offshore in waters that have a depth of between 600 and 2,000 feet deep. They swim alone or in very loose aggregations, and frequently bask at the surface, airing their first dorsal fin.

Swordfish feed daily, primarily at night; they may rise to surface and near-surface waters in search of smaller fish, or prey upon abundant forage at depths to 1,200 feet or more. Squid is the primary food, although menhaden, mackerel, bluefish, silver hake, butterfish, herring, dolphin, and others are part of their diet.

Anglers normally fish for swordfish by trolling and drift fishing, particularly at night when they are closer to the surface feeding. Depths vary from 60 to 80 feet below the surface to many hundreds of feet. Often, live or cut baits are staggered at various levels, and light sticks are employed at least 6 feet above the baits to call attention to them, with balloons attached via rubber bands to the line to help indicate pickups.

Occasionally, daytime anglers will see a swordfish basking on the surface, with their dorsal and tail fins protruding from the water. These fish are usually alarmed by an approaching boat, so a natural bait must be presented carefully and repeatedly before the swordfish will take it. Once a swordfish has been spotted, the speed of the boat should not be changed appreciably and the trolled bait should be eased quietly ahead of the fish. Casting live bait to surface-finning swords is also practiced, and there can be success drift fishing during the day, using squid and cut baits fished at extreme depths.

Tackle is 30- to 50-pound big-game outfits with lever drag reels for smaller fish, and 180-pound gear for fishing at great depths and where larger specimens may be encountered. Line capacity is a factor, since swordfish may be hooked exceptionally deep and run a long distance. In their fight they may also rush the surface at any time and leap out of the water, then continue with blistering runs.

# BLUEFISH

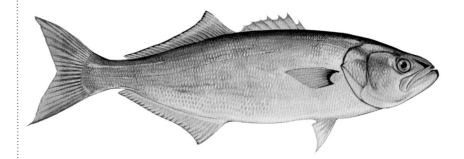

A native of the Atlantic coast in North America, the bluefish is one of the most impressive of all saltwater species because of the aggressive way it attacks food, and because of its tenacious and determined fight. A species that may jump out of the water when hooked, bluefish are tough to handle because of their sharp and ever-chopping teeth, and they may be caught in quantity at times, as they travel in schools of like-sized members.

. . . . . . . . . . . . . . . . . . . . . . . . . . . . . . .

ALTHOUGH BLUEFISH may grow to over 40 pounds, a large blue is one over 15 pounds, and most are under five pounds. In some places, anglers catch a large number of snapper blues, which weigh under a pound but are superb to eat.

Bluefish have been cyclical in abundance in the past, and sporadic in location as well, sometimes being more abundant in the northern or southern parts of their range. Along the Atlantic coast, bluefish migrate northward in the spring and southward in the fall, and are generally

caught in inshore waters as they migrate up and down the coast.

Boaters catch them in fairly close proximity to the shore, and surf anglers catch them along the beaches and off jetties. Smaller blues are often found in bays and estuaries. Many times, especially in the fall, schools of blues are observed attacking baitfish, particularly small menhaden (known as peanut bunker). Menhaden are a major food item, and bluefish also prey on mackerel and herring.

Bluefish are easily detected when they are plundering schools of baitfish because there will be birds working the slick that is created. In such instances, casting, jigging and trolling in the perimeter vicinity are standard tactics. At other times, blues are a little harder to locate, usually being found deep, around tide rips, and in places where the water is unruly, particularly inshore on a moving tide. Bluefish usually feed on whatever food is most available, but they can be selective and, in addition to small fish, will also scrounge the bottom for sand worms and eels.

A host of angling techniques and terminal items will produce bluefish, in large part due to their aggressiveness. This is true for the boat as well as shore angler. Trolling may be the most-employed boating technique, using diving plugs, thick-bodied spoons and surgical tubes; a fast speed is preferred. Drifting and jigging is popular where bluefish are known to be located, using metal jigging spoons and bucktails, sometimes tipped with a piece of meat. Live bait works better than dead, but some anglers chum for blues and successfully drift hooked pieces of cut bait amid the chum. Casters use a variety of plugs, as well as streamer flies when the fish are thick.

Shore, surf and pier anglers can still fish with bait in current, or cast surface or diving plugs and squid-imitation spoons. There should always be movement to the offering, as still lures or bait will go untouched. Streamer flies will

## AT-A-GLANCE

| | |
|---|---|
| **SCIENTIFIC NAME** | *Pomatomus saltatrix* |
| **FAMILY** | bluefish |
| **TYPE** | saltwater |
| **SPAWNING** | spring |
| **PRIME FISHING** | summer through fall |
| **RANGE** (NORTH AMERICA) | Nova Scotia to Florida |
| **PRIMARY HABITAT** | temperate coastal waters, inshore bays and estuaries |
| **MAJOR PREY** | various fish, especially menhaden |
| **LURES AND BAITS** | spoons, jigs, plugs, flies, cut bait, live bait |
| **PRIMARY TACKLE** | light conventional, medium baitcasting and spinning, fly |

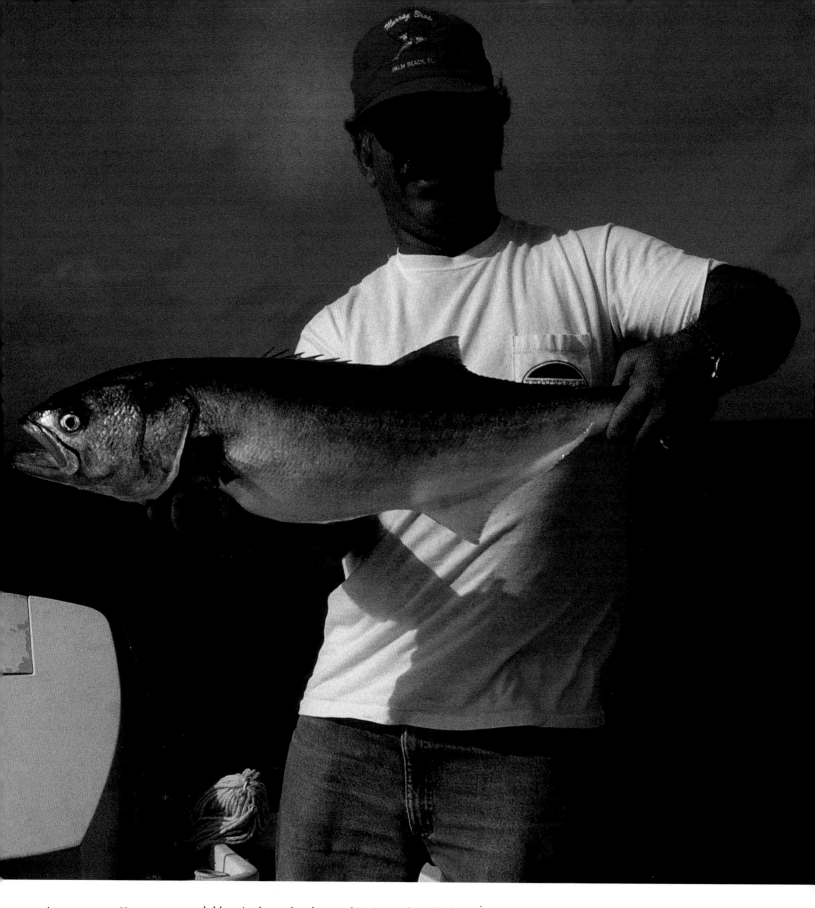

catch blues in the surf and around jetties, and small plugs will also catch them in the surf when they are chasing small menhaden.

Some anglers, incidentally, "sniff out" bluefish by smell, searching for a fresh-cucumber odor where blues have been plundering bait. Tackle varies widely, from heavy boat rods for trolling and deep jigging to light spinning tackle and fly rods. Light tackle is best when the fish are numerous and not exceptionally large. Because of a bluefish's strong fight, the drag on a reel should be of good quality. In a boat, use a gaff to land fish that are to be kept. Bluefish have extremely sharp teeth, so take great care when handling them.

# BLUEGILL

Popularly known as "bream" or "brim," bluegills are widely distributed and prominent members of the sunfish family, and native to North America. Many young anglers have cut their fishing teeth on bluegills, and their perky fight on light tackle, plus good-eating flesh, make them a favorite catch—especially in small lakes and ponds. Bluegills that grow to eight or nine inches long have helped give rise to the term "panfish," meaning species that, when cleaned, are just right for pan frying.

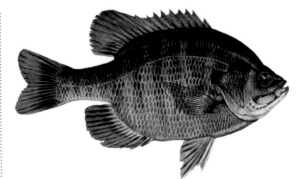

LEFT: THIS BIG BLUEGILL, FROM A SMALL FLORIDA LAKE, STRUCK A FAIRLY LARGE CRANKBAIT.

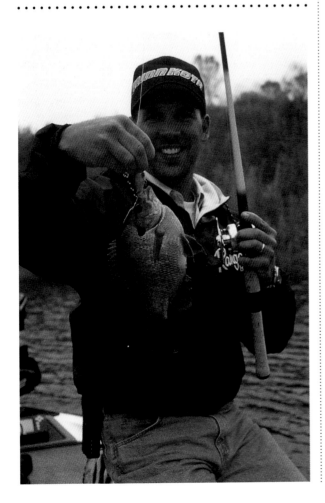

BEING PROLIFIC FISH, bluegill—as well as their redbreasted sunfish, pumpkinseed and shellcracker cousins—may become too numerous for some environs, which results in overcrowding and a stunted population. An overabundance of sunfish can be bad for some other fish populations because of competition for food and a tendency to prey on the young of their own and other species.

Although their roundish body is typical of all sunfish, bluegills vary in color more than many other freshwater species, which sometimes prompts misidentification. They may be dark blue or bluish-purple in some places, with an olive cast in others, and more pale and distinctly marked in still others. Their gill cover has a wide dark flap, and breeding males have an orange breast and belly.

The largest bluegills can tip the scales at nearly five pounds, although this is extremely rare. One-pound

## AT-A-GLANCE

| | |
|---|---|
| SCIENTIFIC NAME | *Lepomis macrochirus* |
| FAMILY | sunfish |
| TYPE | freshwater |
| SPAWNING | spring |
| PRIME FISHING | spring and early summer |
| RANGE (NORTH AMERICA) | entire U.S. east of the Mississippi River, portions of eastern-southern Canada, Texas to New Mexico, northeastern Mexico |
| PRIMARY HABITAT | lakes and ponds |
| MAJOR PREY | aquatic insects, small minnows, larvae |
| LURES AND BAITS | small jigs, spinners, and plugs; flies; earthworms and crickets |
| PRIMARY TACKLE | light and ultralight spinning and spincasting, fly |

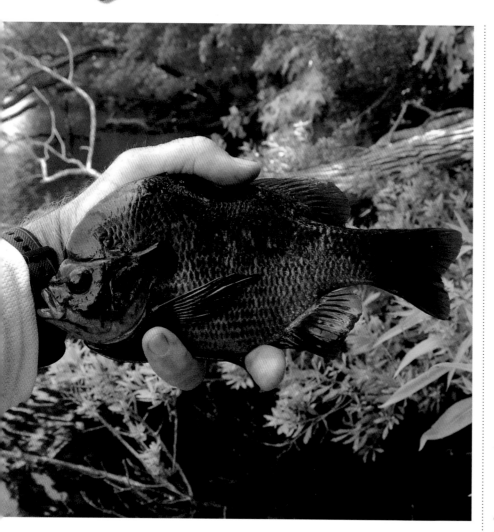

bluegills are considered large in nearly all waters, and fish that weigh about half a pound and are six to eight inches long are more the norm. Hybrid bream, particularly a farm-raised fish known as a "Georgia Giant," have been grown to five pounds and are popularly used for stocking small ponds.

Although bluegills are ideal for small ponds, they also do well in large and small lakes, sluggish streams and rivers, swamps and the pools of creeks. Like largemouth bass, they are somewhat of a shallow-water and cover-preferring fish, liking quiet waters, but they also inhabit water as deep as 30 feet in the middle of summer when the upper layers are extremely warm. Their primary food is insects, small minnows, fish eggs, crayfish, snails and worms; small mouths generally prevent them from taking larger food items, and explain why few are caught by anglers fishing for largemouth bass, even when these species are in the same locations.

Bluegills are most commonly pursued by anglers in spring and early summer when spawning in shallow water, which occurs when water temperatures are around 70 degrees. Bluegills make shallow, round nests in water up to

six feet deep over sandy or muddy bottoms; the nests are often easily observed along shorelines.

Since bluegills are something of a schooling fish, where you find one you usually find others. They can be aggressive at times and finicky at others, which means that you may need to be able to switch from live bait to lures or flies when you are specifically seeking these fish. If bluegills are feeding heavily, you may see them dimpling constantly as they attack a larvae hatch, mosquitoes or the eggs of nesting bass or crappies.

With the exception of springtime, it is necessary to move around from one cover type to another to locate a school. Search for deeper logs, bushes and brush, plus grassy flats, channels, lily pads and humps. In fall and early winter, scour shallow and deep dropoff areas and note that bluegills may be from mid-water down to the bottom. In any given lake, the habits of bluegills are fairly dependable from year to year.

The foremost natural bait for bluegills is a live cricket. Bring at least eight or ten dozen if the place you are fishing has good numbers of bluegills. You will not catch a fish on every cricket, of course, because a lot will fall off the hook or be nibbled off it by bluegill. Fish these on a No. 8 long-shanked Aberdeen hook by impaling the cricket through the shoulder area and letting it wiggle loosely on the bend. Use a delicately balanced float (not a super-buoyant bobber) to indicate a pickup, and set the hook quickly.

Small angleworms and pieces of nightcrawler are also effective natural baits. Use a No. 8 long-shanked hook with these, the least amount of split shot possible (or none), and a small balsa float.

Tiny marabou-, chenille- and soft-bodied jigs are good lures for bluegills. These are sometimes most effective when fished under a light float so the jig remains in one place and at one depth, although with slight movement, for a longer period than it would if maneuvered on a steady cast-and-retrieve. Small spinners, tiny spinnerbaits and small jig-and-spinner combinations are also effective at times, and occasionally the smallest plastic or wooden plugs.

A No. 10-hooked green, sponge-rubber spider with white legs is good on a fly rod, cane pole or casting rig when fished under a float. Small poppers, as well as wet and dry flies and nymphs (these on No. 12 and 14 hooks), are also good for fly fishing when bluegills are shallow or actively feeding.

Light spinning or spincasting outfits and four- to eight-pound line are ideal for bluegills, and long cane poles without reels are also used to dabble bait into selected pockets. Fly fishing tackle mostly includes a floating line, although a sink-tip line may be useful on occasion; outfits range from five weight to eight weight, the latter as much for bass fishing duty.

# BONEFISH

**Though comparatively few North Americans have actually caught a bonefish, most are familiar with them thanks to the great press and television exposure they get. Their reputation as a premier saltwater gamefish precedes them, because of their scorching runs when hooked and their overall cautious nature.**

. . . . . . . . . . . . . . . . . . . . . . . . . . . .

A FISH OF TROPICAL WATER, the bonefish is indeed a wary creature, usually stalked on shallow flats where it is very much in tune with its environment. Here one moment, gone the next, is the situation for this poorly named fish, which is often referred to as a phantom or silver ghost by its admirers.

Like the tarpon, bonefish have little culinary attraction and therefore not much commercial value. Most are caught and released by anglers. Generally restricted in North America to the Florida Keys and some portions of Mexico, their populations are relatively good.

Bonefish may grow to 19 pounds, but a fish of eight pounds is large, and over ten a notable accomplishment. Fish from two to four pounds are common. Large specimens are generally loners or travel in small groups of from five to ten individuals; smaller fish frequently occur in schools that number from half a dozen to several dozen.

The main habitat of bonefish is the shallow areas of intertidal waters, including around mud and sand flats as well as mangrove lagoons. They may also live in waters up to 30 feet deep and can live in oxygen-poor water because they have the ability to inhale air into a lung-like bladder.

Bright silver in color, the bonefish is a bottom-foraging species which is served well by a suckerlike mouth and snout-shaped nose. Crabs, shrimp, clams, shellfish, sea worms, sea urchins and small fish are their normal diet. They are most likely to feed on a rising tide, often doing so near mangroves. They root in the sand with their snout for food and are often first detected while feeding with their body tilted in a head-down, tail-up manner, with all or part of the tail fin protruding through the surface. These are referred to as tailing fish. Bonefish also sometimes stir up the bottom when rooting, and this cloudy mudding can be a telltale sign to an observant angler.

Anglers primarily locate and catch bonefish on shallow tidal flats and shoals, which they scour for small clams, crabs, worms and shrimp. These locations range from less than a foot up to several feet deep, a situation in which any fish feels vulnerable. Since the

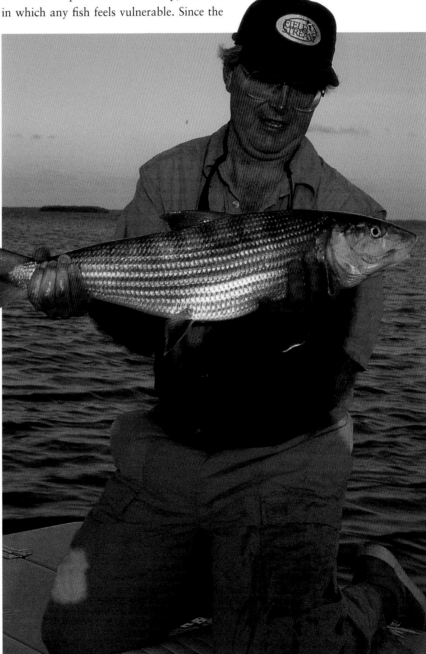

A FAIRLY LARGE BONEFISH FROM ISLAMORADA, FLORIDA.

noise of an outboard motor, and probably even an electric motor, would alarm a bonefish, most boaters prefer to pole silently along, staking the boat and fishing from the boat, or by foot when their quarry is spotted. Waders carefully approach feeding fish to get into casting range without alarming them.

The best time for spotting shallow fish is from the end of an ebb tide through the beginning of a flood tide. A slack flood tide can produce results for anglers who fish waist-deep water by casting blindly with small jigs. Bonefish seldom feed on shallow flats when the water temperature falls much below 70 degrees, preferring deeper water.

Unless their tails are poking through the surface, bonefish can be very difficult to see, even in the shallowest water. Polarized sunglasses aid through-the-water vision, while calm water and bright sun can also help visibility. Seeing the fish is important to the presentation of a jig, fly, shrimp or crab, as it is necessary to place it six to ten feet ahead of a feeding or cruising individual, and preferably upcurrent. If the offering lands on top of the fish or a school, the fish will dart away.

When a bonefish is hooked there is an instant explosion in the water. The fish immediately streaks across the flats toward the security of deep water, perhaps taking 80 to 100 yards of line off the reel. This requires a properly set reel drag and raising the rod tip up high so the line avoids mangrove roots, grass and other flat objects that could cut the line or leader.

Bonefishing is almost exclusively done with flycasting or light spinning tackle. A six- to seven-foot spinning rod and six-pound nylon monofilament line are just right, as is a nine-foot fly rod, eight-weight floating line, and fly reel with adequate line capacity and adjustable drag.

Small streamer flies or weighted shrimp and crab imitations in light brown and yellow work well. Jigs are the primary lures, preferably in pink, white and yellow colors. Shrimp, clam and conch meat are popular natural baits, with shrimp the best. Just the smell of fresh shrimp is an inducement, so break off the tail and two of the four fans and thread it on the hook. Chumming is effective, incidentally, and some bonefish anglers anchor or stake their boat and chum with crushed shrimp.

## AT-A-GLANCE

| | |
|---|---|
| **SCIENTIFIC NAME** | *Albula vulpes* |
| **FAMILY** | bonefish |
| **TYPE** | saltwater |
| **SPAWNING** | late winter to spring |
| **PRIME FISHING** | year-round |
| **RANGE** (NORTH AMERICA) | southern Florida, Yucatan Peninsula |
| **PRIMARY HABITAT** | shallow flats, mangrove islands |
| **MAJOR PREY** | shrimp, crabs |
| **LURES AND BAITS** | small jigs, flies, live and cut shrimp, crabs |
| **PRIMARY TACKLE** | light spinning, fly |

AS THE SUN SETS, AN ANGLER SURVEYS THE SHALLOW FLATS FOR A LAST CHANCE AT BONEFISH.

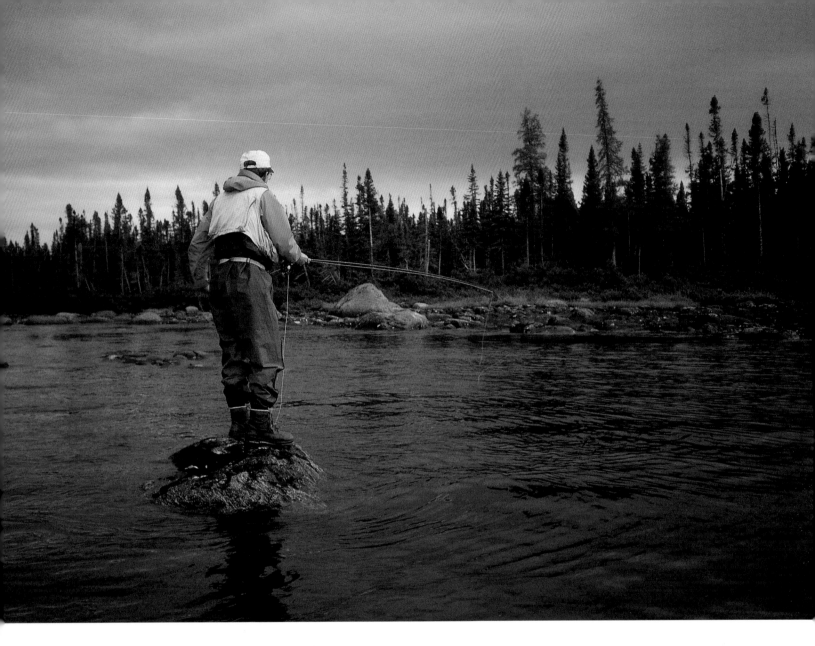

# BROOK TROUT AND BROWN TROUT

These two species are both known as trout, and are often considered in the same breath by stream anglers, but they are only distantly related. The brook trout, which is native to North America and commonly called a speckled trout, is actually a member of the charr family and related to its larger brethren, lake trout and Arctic charr. The brown trout is a true trout, yet a fish whose closest relative is the Atlantic salmon.

. . . . . . . . . . . . . . . . . . . . . . . . . . . . . . . . . . . . . . . . . . . . . . . . . . . . . . . . . . . . . . . .

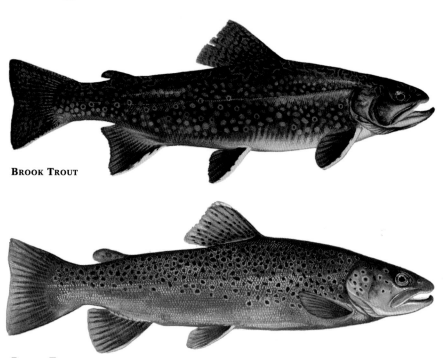

**BROOK TROUT**

**BROWN TROUT**

THE BROOK TROUT has long been a favorite catch of stream and pond anglers, especially in the northern part of its range. Though seldom found in large sizes, it is an aggressive fish, and a beautiful one. The brown trout is often a challenge to anglers, a strong fighter occasionally prone to jumping, and a fish that can be caught using varied tackle and techniques.

In general, brookies come more easily to the hook than brown trout, with whom they cross range and share some common waters. Today, large brook trout are fairly uncommon, except in some Canadian lake and river systems where they have access to big-water forage. A brookie over 12 inches in most waters is a sizable fish, and one over two pounds is uncommon. Nevertheless, brook trout are capable of reaching larger sizes, and fish over six pounds do exist in some Canadian waters.

Brook trout are striking enough in appearance that there is seldom any confusion with other fish, especially if you are looking at a native specimen. Like other charr it has a white border on the outer edge of all but the tail fin; it also has unique, wormlike, wavy vermiculations on the back and head. These appear on the dorsal, adipose and caudal fins like a series of tiger stripes. Colored body dots also appear on the flanks.

Brown trout are more widely spread than brook trout, having a warmer temperature tolerance and being not only adaptable to, but abundant in, more environments. Through most of their range, brown trout are primarily thought of as residents of flowing water. However, they also live in lakes, where they may grow to enormous sizes, and are found in sea-run forms, which

are anadromous and generically called sea trout.

Browns are capable of growing to 40 pounds in North America, which may occur in large rivers and in lakes with ample forage. Most brown trout in lakes are two to four pounds, and in streams from nine to 14 inches long.

This species gets its name from the olive green, brown or golden-brown hue of their bodies, which is typical of river-dwelling specimens. They have dark spots, sometimes encircled by a pale halo, that are plentiful on the back and sides. Sea-run browns have a more silvery coloration and their spotting is less visible. Residents of large lake systems have a silvery coloration as well, dark spots without halos, and no colored spots.

Brook trout are a coldwater species that inhabit a wide range of rivers and streams, ponds and lakes, and even brackish water. They are seldom found in sluggish streams, or streams with plenty of backwater and pockets of little or no movement. Brown trout prefer cool, clear rivers and lakes with temperatures of 54 to 65 degrees. They can survive in warmer waters than most other trout, but in streams they do best where the summer temperature is less than 68 degrees. In streams and rivers they are wary and elusive fish that look for cover, hiding in undercut banks, in stream debris, surface turbulence, rocks and deep pools.

In lakes, brown trout seek out levels of preferred temperature, being deep during summer months and shallower in spring and fall when the water is cooler. After iceout, they are in shallow and nearshore areas,

## AT-A-GLANCE

| | |
|---|---|
| **SCIENTIFIC NAME** | brook trout: *Salvelinus fontinalis;* brown trout: *Salmon trutta* |
| **FAMILY** | brook trout: charr; brown trout: trout |
| **TYPE** | freshwater |
| **SPAWNING** | Fall |
| **PRIME FISHING** | spring in lakes; late spring and summer in rivers |
| **RANGE** (NORTH AMERICA) | brook trout: from northern Ontario east to Newfoundland and south to northern Georgia, and in the upper Midwest; brown trout: southern region of Canada, most of the U.S. except the most southerly states and Alaska |
| **PRIMARY HABITAT** | brook trout: ponds, rivers, streams; brown trout: lakes, rivers, streams |
| **MAJOR PREY** | aquatic insects and small fish in rivers; fish, especially alewives and smelt, in lakes |
| **LURES AND BAITS** | flies, spinners, spoons, plugs, earthworms |
| **PRIMARY TACKLE** | spinning and fly, some baitcasting in lakes for large brown trout |

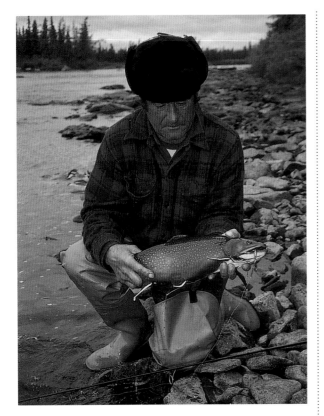

often around warmer tributaries, but move deeper as the surface level warms. Sea-run brown trout spend two to three years in freshwater, then migrate downstream to spend one or two growing seasons in coastal waters near river mouths and estuaries. Most return to their home streams to spawn.

Brook and brown trout both spawn in the fall, migrating up or into tributaries. Both are also somewhat omnivorous. All types of aquatic insects and small fish are a principal part of their respective diets. In small streams their diet may be largely insects; but in larger flows, or where there is plenty of baitfish, it will also be assorted small fish. In large lakes, the primary diet for brown trout is other fish, especially abundant pelagic schooling species, such as alewives; small fish are a primary food for sea trout. Perhaps as a result of wide food interests, fishing methods are diverse for both species, and particularly so for brown trout. Fishing for brook and brown trout in all forms of flowing water is an activity that requires proper presentation, a knowledge of the habits of the species, and an ability to analyze the water and determine what places are likely to hold fish, in order to be consistently successful.

Brown trout tend to lie in slower and warmer waters than brookies, yet they will both inhabit pools and slicks in rapid-flowing waters. They are often found in pockets behind rocks, in the slick water downstream from an eddy or pool, in dark, swift water just above a falls or rapids drop, beneath a falls and in spring holes.

Many, if not most, river trout are caught by fly fishing. Fly anglers usually use a light outfit (seven- or eight-foot rod for four- to seven-weight line) in order to fish small streams, using perhaps an outfit on the upper end of this range for larger or more open waters and/or places where big fish might be found. Leader length should be about seven feet for small waters, slightly longer elsewhere (equal to the length of rod is often a normal measurement), tapering to a 2X or 3X tippet.

Flies must be selected according to the type of minnow or aquatic insect prevalent at the time. There is an enormous assortment of dry and wet flies, nymphs and streamers to use on trout, depending on the circumstances.

Spring and summer insect hatches particularly attract river trout. In the spring these hatches may occur during the day, but later in the season they may be most evident around sundown and last long into the night. Small fish are often preyed upon in a long, shallow gravel flat above a deep pool.

Spinning tackle users also have a lot of success with river trout, using small spinners, small spoons, occasionally a light jig, and sometimes minnow-imitation plugs, as well as worms and salmon eggs where bait fishing is legal, and large spoons and spinners in big, swift-flowing waters. Spinning equipment should be light or ultralight, with lines ranging from four- to eight-pound strength. In some smaller streams it is possible to use two-pound line and a five-foot ultralight rod.

LEFT: WILD BROOK TROUT IN THE FAR NORTH ARE COLORFUL AND DISTINGUISHED.

FISHING FOR BROWN TROUT ON NEW YORK'S BEAVERKILL RIVER.

Angling for trout in lakes, reservoirs and ponds is a completely different sport. Trout here are not readily accessible, they wander a lot in search of food, and are not always confined to readily identifiable terrain.

Trout may be found at any level after iceout or in late winter and early spring, but are often found within the upper 20 feet or less. Thermal discharges, tributaries, rocky shorelines and the like contribute to warmer-water locales which attract trout.

Brown trout, which are more numerous in lakes than brookies, seek preferred temperature zones in lakes as they get warmer. An ideal situation in large lakes is to find a place where temperature, forage and shore structure coincide. If you are looking for schools of baitfish, and monitoring preferred water temperature, try to find both of these where the thermocline intersects the bottom. This would be a prime place to start looking for brown trout in the summer on large lakes. Trout may be more concentrated, incidentally, along a sharply sloped shoreline than a moderately sloped one.

To have regular success means covering a lot of water. When trout are shallow and near the surface they can be caught by trolling, casting from shore or in a float tube, or drifting with bait. Although casting is the most fun, trolling is often more popular, because it allows you to cover a lot of ground and look for active, aggressive fish, particularly trout that perhaps have not been spooked or otherwise bothered by other anglers and boaters. Drift fishing with a boat is usually a live-bait proposition, but it is slow and often less productive than lure trolling.

If you cast from shore, you may simply be limited to one spot, such as a pier or breakwall, and must cast repeatedly in the hope of attracting a moving, incoming fish to strike your lure. This can pay off in tributary areas in spring, when warm river water attracts a significant number of fish, or when fish are attracted here prior to upstream spawning migration. In most lakes, however, it is better to be mobile, concentrating shore-casting efforts near prominent points, inlets, steep banks, rock- and boulder-studded shores, shorelines with sharp dropoffs to deep water, and warm bay and cove areas. Try casting spoons and crankbaits, or sinking minnow-style plugs from the shore.

There is seldom any reason to use very heavy tackle for trout in lakes. Spinning and baitcasting tackle is used for trolling, and spinning and fly equipment for casting. Rods are usually long, in the seven- to nine-foot range, for browns and slightly shorter for brook trout, and line strengths from four- to ten-pounds are usually adequate.

BROWN TROUT SUCH AS THIS
GREAT LAKES' SPECIMEN ARE
SILVERY AND FAT.

# CARP

Although carp are a primary target of anglers in other parts of the world, particularly in Europe, they have second-class status as sportfish in North America. Whether this is deserved or not depends upon one's point of view. Plenty of desirable freshwater sportfish and an abundance of publicly accessible waterways to fish, combined with a perceived difficulty in catching this plant-eating species and a disdain for it because it can be destructive to some habitats, means that most anglers make little or no effort to catch carp.

A SMALL CARP FROM LAKE OAHE, SOUTH DAKOTA.

A S A RESULT, MANY ANGLERS do not realize how tough carp can be to land. When caught, they make a streaking run, and can take line off a reel in a hurry. In fact, big fish cannot be horsed in without really stout tackle.

Carp were introduced to North America more than a century ago, and they prospered so well that they are now among the most abundant fish in terms of weight, or biomass, especially in the U.S. Additionally, large individual specimens exist in many bodies of water.

Carp receive minor attention in North American outdoor media. Since only a relatively small number of people fish for them, and most in fairly unsophisticated ways, angling methods lag behind those in Europe, where these fish have been caught and re-caught and where it is necessary to use a refined approach to garner success.

Throughout the world there are many species of carp, which are actually long-living and large-growing members of the extensive minnow family of fish. North America has relatively few carp species of interest to anglers. The most significant of these is the common carp. The white Amur, or grass carp, is also fairly common; sterile grass carp reared in hatcheries have been widely stocked, primarily in small lakes and ponds, as a means of helping to control aquatic plant growth.

A large-scaled fish, carp generally range from gold to olive to brown in color, with a yellowish coloring on the lower sides and belly and a reddish tint to the lower fins. They have a deep body, short head and forked tail, and use their size to great advantage when hooked, as they are tenacious, strong battlers.

In North America, there are many opportunities for catching 15- to 25-pound carp. The average is closer to five pounds, however, and a ten-pounder is generally considered large. Bigger fish exist in many places, in part due to the relative lack of fishing pressure.

These fish have a toothless, almost suckerlike mouth, which is clearly adapted to bottom foraging. They feed on tiny plants and animals obtained by rooting along the lake or river bottom, often, but not exclusively, in the mud. Carp draw food in with their suckerlike mouths and spit out or excrete bottom sediments.

Carp have a highly developed sense of taste due to specialized taste buds in the skin of their snout, mouth, lips and throat. They detect most of their food, especially in murky waters, by smelling, and then they sample it with their barbels or lips. Sometimes curious, they will pick up a possible food item and taste it before ingesting. But they are also cautious and wary enough to avoid suspect items.

Carp are most noticeable to anglers in the spring or early summer when they spawn in shallow muddy areas. When spawning, they wallow in the mud and roil the water, and may cause stifling clouds of silt to occur. In the process, they produce a high number of eggs and young,

## AT-A-GLANCE

| | |
|---|---|
| SCIENTIFIC NAME | Common carp, *Cyprinus carpio* |
| FAMILY | minnow |
| TYPE | freshwater |
| SPAWNING | spring |
| PRIME FISHING | spring through fall |
| RANGE (NORTH AMERICA) | throughout most of the U.S. and southern Canada |
| PRIMARY HABITAT | lakes, ponds, rivers |
| MAJOR PREY | aquatic plants, algae, aquatic insects, snails, mollusks |
| LURES AND BAITS | natural and processed baits |
| PRIMARY TACKLE | spinning, spincasting |

which helps bring forth large populations in some waters, especially big lakes, reservoirs and rivers.

Although in Europe a great deal of chumming (called feeding) is done for carp, this is lightly practiced in North America, if at all. It is illegal in some places, and viewed with disdain in others, although this is often the result of ignorance.

Getting carp to take an angler's bait is often a challenge. They are not chasers or stalk-and-attack hunters, and are unlikely to strike most lures (although it does happen occasionally). Where they are abundant and lightly fished, carp may strike a slow-moving jig and either a weighted fly or a dry fly. In North America, carp are primarily caught on dough balls, corn, worms, processed baits and commercially prepared baits, usually without chumming, although more anglers now use some chum. Chum may be corn or groundbait, which is made from crushed bread crumbs or stale bread, the latter being soaked, mixed into a paste and stiffened with bran or corn meal. It is made into balls and tossed into the water, clouding and flavoring it.

Although there is some sight fishing for – and stalking of – carp, the majority of carp fishing is done by stillfishing with bait, primarily from the shore but also from a boat. Most shore anglers rest their fishing rods in a holder or otherwise prop it up and pay close attention to the rod tip, the line, a float if it is used, and to any strike-indicating device.

Carp are primarily found in shallow water in lakes and reservoirs. They find bait better on a sand or gravel flat than in thick weeds, although they like weeds as well, if not for the plants then for the snails and other food items found under or among them. In back waters, work narrow, open areas between deep-water locales. Carp funnel through these while feeding. They also like shady spots, such as under overhanging trees and bushes.

THOUGH NORMALLY CAUTIOUS FISH, THESE CARP AT A MARINA IN LAKE MEAD, NEVADA, MILL AROUND FOR FEEDING.

In rivers, look for carp at the head of pools, in eddies and slow-moving slicks, beneath undercut banks and near banks beneath snags. They also hold along bottom structures where there is some current relief. In big rivers they can be found en masse below dam structures, where eddying currents rotate against lock-and-dam walls or gate ends.

Bait is usually fished in water depths of ten feet or less, commonly from three to six feet deep, and with a variety of bait rigs. For less-wary carp in places where they are abundant, you might be able to use split shot a short distance from the bait, fishing on the bottom and setting the hook as soon as you feel a pickup. However, carp are usually very cautious, and you often need to fish in a way that allows the fish to pick up the bait without sensing the presence of either bait or line. Bottom or near-bottom rigs should use a sliding sinker in order to let the fish pick up the bait and perhaps move with it, ideal in theory but not always possible in practice.

Carp tackle varies widely from the occasional angler to the devotee. Ten-pound line is adequate, but if you want great sport and do not mind losing a fish or two, four- to six-pound line on an ultralight outfit will do nicely,

especially if you are fishing unobstructed open water. Where big carp exist, especially in snag-infested areas, you need a good-quality abrasion-resistant line, perhaps from ten- to 20-pound strength, and a reel with a smooth-working drag. Thin-diameter lines are very useful for carp fishing because the finer lines are less detectable, yet they still have the strength of conventional-diameter line.

Spinning, spincasting, baitcasting and flycasting tackle are all used, but spinning is best for making all types of presentations, and reels with a baitfishing or quick line-release feature are preferred by some anglers. Long rods with long handles are used by shore anglers, who need length when fishing close to shore for finicky fish; rods here range from seven to 13 feet. Using an 11- to 13-foot-long rod helps keep a close bait in precise position and minimizes line interference from the rod tip to the float or terminal rig. When fishing a long distance away, however, a long rod does not offer a significant holding advantage, although it does enhance distant bait placement and is more forgiving on light line strengths. A good carp rod will be soft enough in the tip to allow for lobbing baits, yet sensitive enough to detect delicate pickups.

CARP TYPICALLY INHABIT TURBID WATER AND PUT A GOOD BEND IN THE ROD.

# CATFISH

As a group, catfish are remarkably abundant in North America, and are popular with anglers despite lacking in glamor and overall status. While they do not have the characteristics of more widely admired species—which jump when hooked, rise to the surface for food and look pretty—catfish have adapted well to their many environments and are readily available to a wide number of anglers.

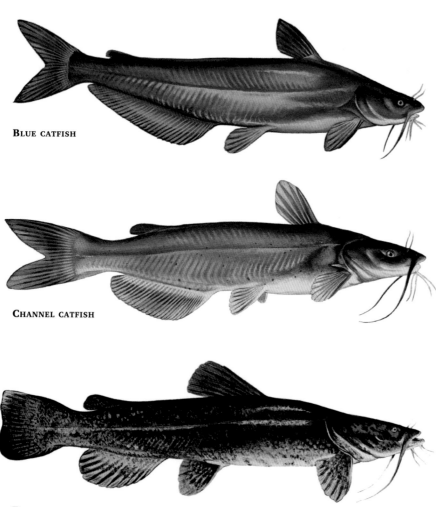

**BLUE CATFISH**

**CHANNEL CATFISH**

**FLATHEAD CATFISH**

BECAUSE MOST CATFISH SPECIES rank highly as table fare, they are collectively one of the most popular angling targets in North America. It helps that they are also fairly willing fish that are generally not too difficult to catch in smaller sizes, and that they do not require much sophistication in technique, tackle or presentation methods.

There is little finesse in angling for any of the catfish species. They live in deep holes, often in turbid water, and their diet is unsophisticated, as they use their eight sensory barbels to locate food. Most of the catfish caught are under two pounds, but on the right tackle they have spunk, and the bigger specimens can be a challenge to land, even if they usually do not provide a lot of drama. Larger fish are bulldog-like battlers, and those species that can grow over 20 pounds provide individuals with tackle-busting qualities.

These fish are among the freshwater species that are almost always kept for consumption. Liberal bag limits exist in many places, since catfish are generally abundant. Angling can be simple or complicated, relaxed or intense, but anyone can enjoy this activity, without special casting skills or highly sophisticated methods, and generally from almost any type of craft as well as from shore.

## Prominent species

In North America, catfish predominantly live in sluggish streams or in the quiet waters of lakes and ponds. They spawn in spring and early summer, and are bottom-feeders, taking both live and dead foods. They are typically active at night, although some are more active in the day than others, and on dark, overcast days or in roiled, murky water. Although there are numerous catfish species in North America, there are seven in particular of most relevance to anglers. Three of these are bullheads, which are smaller-growing species that are generally more northern in range. These are brown bullhead, black bullhead and yellow bullhead. All three have nearly identical habits and are indistinguishable in flavor.

Bullheads are widely spread, and especially prominent east of the Rocky Mountains, having been transplanted deliberately or accidentally to waters well beyond their original range. Like other catfish, brown, black and yellow bullheads can survive in water that is very low in oxygen. Where conditions are favorable, bullheads may multiply beyond food capacity, resulting in an overpopulation of stunted catfish with oversized heads and shrunken bodies. The other species that are

## AT-A-GLANCE

| | |
|---|---|
| **SCIENTIFIC NAME** | blue catfish: *Ictalurus furcatus*; channel catfish: *Ictalurus punctatus*; flathead catfish: *Pylodictus olivaris*; white catfish: *Ameiurus catus* |
| **FAMILY** | catfish |
| **TYPE** | freshwater |
| **SPAWNING** | spring and early summer |
| **PRIME FISHING** | summer |
| **RANGE** (NORTH AMERICA) | blue catfish: west of the Missouri River drainage and northern Mexico; channel catfish: most of the continental U.S., southern Canada, and northeastern Mexico; flathead catfish: primarily west of the Missouri River drainage in the U.S.; white catfish: primarily Atlantic and Gulf coastal states from New York to Florida and west to Texas, plus California and Oregon |
| **PRIMARY HABITAT** | large and small lakes, rivers |
| **MAJOR PREY** | assorted fish, especially gizzard and threadfin shad |
| **LURES AND BAITS** | live and dead (cut) natural baits, processed baits |
| **PRIMARY TACKLE** | medium and heavy baitcasting and spinning |

much-larger-growing flathead catfish has a broad, flat head, and the lower jaw projects beyond the upper. It can grow to over 100 pounds, although the average size caught by anglers weighs less than five pounds. Twenty-pounders are not uncommon.

None of these species is finicky about their food, although they do have finicky moments. They are eclectic in foraging, however, and both smell and taste are important components of catfish feeding and fishing. Most catfish have taste glands located over much of their body, although these glands are concentrated in their long, sensory whiskers. Stinkbaits are popularly used for angling, and these

A LARGE FLATHEAD CATFISH FROM LAKE MARION, SOUTH CAROLINA.

of great recreational significance —and in some cases also commercially significant—are channel catfish, blue catfish, white catfish, and flathead catfish.

The blue catfish, which may grow to over 150 pounds, is the largest of these, although one over 25 pounds is considered large. It is slate blue above and white below, and ranges throughout the large streams of the Mississippi River system, but is most abundant by far in the deep, warm waters of the south. Small blue catfish are often confused with channel catfish. Both have forked tails, but channel catfish are more likely to have dark spots; they can be positively distinguished by anal fin ray count.

The maximum weight of channel catfish is close to 60 pounds, though the average is less than five pounds. Young channel catfish have black spots over a bluish body, and fins that are margined with black; the black becomes subdued or is absent in older fish. Channel cats prefer clear, flowing waters, but they also do well in lakes and ponds. They fight well when caught and are commonly stocked in ponds to provide fishing fun as well as food. The channel catfish is also the species most commonly used in catfish farming enterprises.

The white catfish lives primarily in streams feeding into the Atlantic, ranging southward from New England to Florida. It reaches a known maximum size of about 22 pounds, although the average is less than three pounds. The

SMALL CATFISH ARE A STA-
PLE IN MANY PONDS, LIKE
THIS ONE IN GEORGIA.

poles for small specimens to heavy-duty levelwind reels and stout saltwater boat rods for big bruisers. For the majority of catfishing activities, anglers overmatch their tackle to the standard size of fish expected. Sometimes this is because a lot of catfishing requires bait-on-the-bottom presentations, using a heavy enough weight to keep the offering in place, and sometimes it is because of the possibility of hooking big and strong catfish in snag-laden habitat.

Stillfishing and drift fishing are the general methods of catfishing, while casting is generally ineffective and trolling practically useless. On occasion, and in places where some species, especially channel cats, are abundant, some cast-and-retrieve fishing—especially using diving plugs or jigs tipped with bait—has merit. However, the tactile nature of catfish, and their general behavior, lends itself primarily to more passive presentation methods.

Anglers disagree greatly on which bait best attracts various species of catfish. On each sector of major waterways, there is someone who makes a home-brewed concoction that native catfish anglers swear by. Generally these contain cheese, anise oil, sour mash, ground corn, crushed shad, and sometimes a bit of rotten chicken liver. Most of these homemade baits work, but fresh bait is usually more productive.

Generally, items used to attract and catch the various catfish fall into these categories: cut bait, which is pieces of dead fish; live bait; prepared bait, which includes dips, pastes and various concoctions labeled stinkbaits; and miscellaneous bait, which includes animal meat, cheese, blood and sundry offerings (especially frozen chicken liver, which is popular for channel catfish and fished on a single hook).

Cut bait can include parts of various species of fish, often, but not exclusively, those that are present and abundant in the catfish's normal environment. Sometimes a whole dead fish is used for bait, but chunks and pieces of dead bait are used more often and are fished until they lose their freshness. Herring, gizzard shad, threadfin shad, mullet, sucker, chub, carp, shiners, smelt and panfish, where legal, are used as cut bait, as well as dead shrimp and clams. Cut bait is seldom used for bullheads, although small chunks might be tried in places where there are large individuals.

Live bait is primarily fish and worms, but also includes catalpa worms, leeches, crayfish, shrimp, hellgrammites, grasshoppers, crickets and even frogs. Treble hooks are popular, but singles also do a good job of hooking fish.

Stinkbaits are mainly dips, or moist preparations that have the consistency of paste or dough and are molded and formed into shape on a hook. Some dips have a creamy consistency and include smelly foods mixed with various liquids and fillers; a hooked sponge is thoroughly immersed in the dip, or a short soft-plastic ringed worm can be used

include soured clams, ripened chicken entrails, coagulated blood, and various cheese and doughball mixtures, all are allowed to cure until they acquire a potent odor. A good catfish bait will attract some species from a long distance.

Channel, blue, white and flathead catfish all have a finely developed sense of smell, and bullheads have a slightly less-well-developed sense of smell. They are often first attracted by food odor, though they may feel and taste food with their chin barbels before consuming it. As a result, catfish are aware of objects that produce odor, particularly prey fish, other predators and other catfish. The distance at which they can detect odors is debatable, and this ability is likely to be more important where there is current.

## Angling

Large catfish are generally the product of big waters, primarily the biggest river systems and huge lakes or reservoirs, especially those in warm locations with abundant forage fish populations. That notwithstanding, a lot of fishing takes place in smaller waters, particularly ponds, especially for bullheads and stocked white and channel catfish. Fishing for catfish after dark is often very productive and the low-light hours of dusk and daybreak are also particularly good times.

Fishing with rod and reel can run the gamut from cane

as a dip holder. Paste-style stinkbaits are like dips that have been mixed with more filler and bonding agents so they can be formed into balls; pastes are fished with single or treble hooks buried in them. Stinkbaits that are too loose to hold by themselves on a hook, but too firm to be a dip, can be fished in a net sack.

Bullheads and small catfish tend to mouth and nibble bait, while larger fish may take it more readily. Blue and flathead catfish take bait more forcefully than channel and white catfish, sometimes really nailing it. Fishing on or close to the bottom with some form of bait is the most reliable way to hook catfish.

Try current cuts in rivers, as well as stream mouths, gravel and rock bottoms, deep-cut river banks, shallow riffle areas with a hard bottom, river channels, wing dams, the area below hydro dams, and pools below riffles. Deep holes or pools present especially good opportunities. Catfish are generally not found in the runs below a pool, and some pools taper so gradually into a run that it is hard to tell where the run actually starts. Cover in a pool, especially boulders near the head of the pool, makes it a likely place for catfish. Start at the end of a riffle and the top end of the pool and fish the head of the pool first, especially if there is cover there. Then move down through the pool to the tail end, fishing any cover or snags that exist.

There is often good catfishing in the tailrace water below a dam, and in the river (or rivers) that feed a reservoir. Some very large fish can be caught here. Realize that current flow may vary with seasons and with demand for water, and levels and flow can change as water is stored or released.

In big impoundments, concentrate on old river beds and channels and where curves, bends and deep holes exist, as well as where two channels converge. Ledges, or any place where the lake bottom drops off to deep water out in the main lake, also produce catfish, as do humps that drop fairly abruptly to deep water. The area near the dam, and the riprap and boulders along the face, can also concentrate fish. The mouths of tributaries, including small feeder creeks, and the mouths of coves, backwater ponds, sloughs and other areas that provide a funneling point for travel, are also places to focus on in lakes. Steep, rocky, timbered banks, especially in coves, and the back of coves, sloughs and backwater ponds where there are stumps and timber along a sharply sloped bank, merit fishing effort.

Bullheads and small catfish are most likely to be found in soft-bottom backwaters and ponds with ample submerged vegetation. In ponds or small lakes where there is a weedline, you are likely to find bullheads along the deeper edge of the weeds, but in many places there is no such delineation and most weeds are thick and submerged in varying depths of water. In this case, look for them in the deeper portions, fishing your bait right above thick bottom-hugging weeds or

on the bottom amidst sparser weeds. An inlet is a good place to concentrate efforts, as is the deep water near a dam if there is one, and also any place that might funnel fish.

Light spinning and spincasting tackle is very appropriate for most catfishing activities, especially bullheads and white catfish. For fish up to a couple of pounds, light-action outfits, short rods, and two- through eight-pound lines are more than adequate. To be a little more well-rounded, and better able to deal with mid-size and some larger fish, light- and medium-action spinning or baitcasting gear, with eight- through 14-pound line, and rods of five-and-a-half- to seven-foot length, are suitable.

When fishing for big catfish, a sturdy, light-duty conventional reel or medium- to heavy-duty baitcasting reel, spooled with a minimum of 17-pound line, is necessary. This should be coupled with a medium- to heavy-action rod; a shorter rod, in the six- to seven-foot range, will suffice if there is little need for casting and you are using heavy line, but for regular casting and for cushioning light line, try a seven- to nine-footer. Line strengths used by big-cat anglers are often between 25 and 40 pounds, and some spool this onto heavy-duty levelwind reels with ample capacity. Such gear is necessary because of the obstructions that exist in many catfish waters.

YOU MUST HANDLE CATFISH, LIKE THIS CHANNEL CAT, CAREFULLY TO AVOID BEING PUNCTURED BY SHARP FINS.

# CHAIN PICKEREL

**Chain pickerel are an aggressive, available fish, fairly easy to catch and respectable battlerson appropriate tackle. They are popularly caught through the ice in winter, and frequently caught in open water, sometimes by people who are fishing for other species rather than pickerel.**

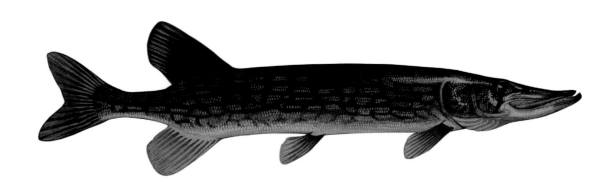

LONG AND LEAN, and with distinctive, chain-like markings, the chain pickerel is a smaller, but equally fearsome-looking version of its northern pike and muskellunge cousins. It is sometimes confused by name with walleyes, particularly in southern Canada where walleyes are called "pickerel," but the walleye is a member of the perch family and is unlike the true pickerel in nearly every respect other than having a similar number of teeth.

Although chain pickerel can grow to over nine pounds, a fish over four pounds is considered large, and most are in the long-and-thin, one-pound class. They inhabit shallow, vegetated waters of lakes, swamps, streams, ponds, bogs, tidal and nontidal rivers, backwaters, and quiet pools of creeks and small to medium rivers, as well as the bays and coves of larger lakes and reservoirs.

The primary hangout of chain pickerel is lily pads and various types of weeds, and they sometimes lay near such objects as stumps, docks and fallen trees. These environs are quite similar to those of largemouth bass. Chain pickerel are solitary fish, and prefer water temperatures from 75 to 80 degrees. Spawning takes place from late winter to early spring just after iceout in 46- to 51-degree water, usually in March through May.

A healthy appetite contributes to the aggressiveness of chain pickerel and to their ability to be caught on various lures. They feed primarily on other fish, as well as the occasional insect, crayfish, frog or mouse. Their fish diet is primarily small minnows and fry, but they are fond of mid-size fish like yellow perch and other pickerel in four-to six-inch lengths. They will often attack larger fish, too, and it is not uncommon to catch a large pickerel that is still trying to digest another pickerel half its own length. Mainly sight feeders, they lie motionless in patches of vegetation, waiting to snatch small fish, but may be lured from a distance to something that appears vulnerable.

## AT-A-GLANCE

| | |
|---|---|
| **SCIENTIFIC NAME** | *Esox niger* |
| **FAMILY** | pike |
| **TYPE** | freshwater |
| **SPAWNING** | late winter and early spring |
| **PRIME FISHING** | spring and summer |
| **RANGE** (NORTH AMERICA) | mid-Atlantic states north to Nova Scotia; Georgia, Florida, Louisiana |
| **PRIMARY HABITAT** | lakes and ponds |
| **MAJOR PREY** | assorted fish |
| **LURES AND BAITS** | spinnerbaits, plugs, spoons, flies |
| **PRIMARY TACKLE** | light spinning and spincasting, baitcasting, fly |

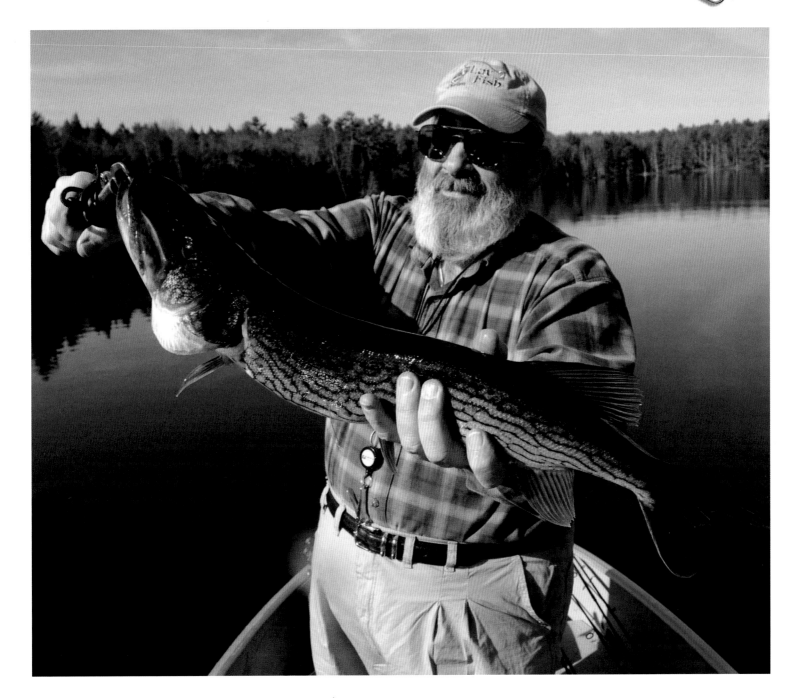

Pickerel are primarily attracted to movement and flash. Nearly any lure with a spinning blade or sparkle-like appearance will catch at least one pickerel in its lifetime. Standard spinners and small spoons are traditionally effective lures, but they are prone to hanging up in thick cover. Spinnerbaits, weedless in-line spinners, and weedless spoons are a better option. Worms and jigs also work, but the result is often a line severed by the fish's teeth. Fly fishing is also worthwhile for pickerel, with streamers being especially ravished. Tandem-bladed spinnerbaits with a white or chartreuse skirt are probably the single most popular pickerel lure, fished with a trailer hook and equipped with various-color blades. A variety of colors works in other

lures, but silver and shad are among the favorites.

Live minnows or shiners up to six inches long are top natural baits in the winter. Pickerel often strike to stun or cripple their prey so they can re-attack and consume it head first. Thus, they usually take bait sideways in their mouth and run off with it a bit, maneuver it around, then swallow it head first.

Considering the size of the average catch, the best gear for pickerel is a spinning outfit with four- or six-pound line. On light tackle or fly rods, pickerel run, jump and cavort in a pleasing manner. Only the larger pickerel put up a really good fight on medium to heavy tackle, as often used for largemouth bass.

CHAIN-LIKE MARKINGS AND AN AGGRESSIVE DISPOSITION CHARACTERIZE CHAIN PICKEREL, LIKE THIS LARGE SPECIMEN FROM A NEW YORK LAKE.

# CHINOOK SALMON AND COHO SALMON

**Chinook and coho salmon are the two most prominent members of the Pacific salmon family, and have long been important for food and recreation. The chinook is the largest of all salmonids and is a strong and tenacious battler commonly known as king salmon or spring salmon. Though smaller, the coho is often a spectacular, acrobatic fighter and is also known as silver salmon.**

. . . . . . . . . . . . . . . . . . . . . . . . . . . . . . . . . . . . .

A BRIGHT CHINOOK SALMON, STILL WITH SEA LICE, IS RELEASED OFF LANGARA, BRITISH COLUMBIA.

BOTH ARE ANADROMOUS FISH, living in the Pacific and returning to their natal rivers to spawn, after which they die. These fish can adapt to an entirely freshwater existence, and have done so with tremendous success in the Great Lakes, where they have become one of the greatest fisheries transplant/management/revitalization stories of all time.

The sea-run Pacific stocks of both species have deteriorated through large portions of their range due to dams, habitat alteration, pollution and excessive commercial fishing. Some populations in the Pacific northwest are threatened or endangered.

Most sportfishing for sea-run chinook and coho salmon occurs in rivers and streams when these species are on their spawning migration. A fair amount occurs in saltwater, almost all in bays, estuaries and inshore waters near the coast, targeting fish that are migrating to, or gathered nearby to run up, their natal tributaries. The chinook and coho salmon of the Great Lakes are pursued extensively in the open water of the lakes, where they feed heavily, and in tributaries in late summer and early fall when spawning.

These salmon change from a pure silvery color in the ocean (or large lake) to a darker, and sometimes reddish, color when spawning. Their bodies undergo a great physical transformation as well, particularly the head, and they do not eat once they have started this spawning-run transformation.

Chinooks can grow to 126 pounds, although those over 30 pounds are large but not uncommon among sea-run populations. In the Great Lakes they are commonly caught from 15 to 30 pounds in size, and can grow to nearly 50 pounds. Cohos can grow to 33 pounds and are common from four to ten pounds in both sea-run and Great Lakes populations.

The period of migration into spawning rivers and streams varies widely among Pacific coast populations. Alaskan streams, for example, normally receive a single run of chinook salmon from May through July. Fish here, and elsewhere in the Pacific northwest, may make extremely long migrations. Streams throughout the Great Lakes primarily receive chinook from late August into October, although there are some spring runs. These fish wander considerable distances, and their location varies.

Both chinook and coho salmon have relatively short lives, yet they grow quickly thanks to aggressive foraging. Sea-run fish feed on herring, pilchard, sandlance, squid

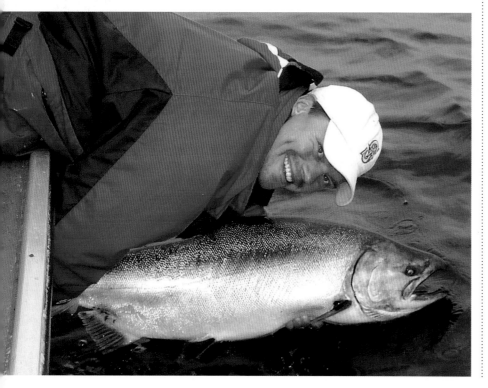

## AT-A-GLANCE

| | |
|---|---|
| **SCIENTIFIC NAME** | chinook salmon: *Oncorhynchus tshawytscha*; coho salmon: *Oncorhynchus kisutch* |
| **FAMILY** | salmon |
| **TYPE** | native to saltwater, also found in freshwater |
| **SPAWNING** | late summer and early fall |
| **PRIME FISHING** | summer, early fall |
| **RANGE** (NORTH AMERICA) | northern California to Alaska, Great Lakes |
| **PRIMARY HABITAT** | coastal inlets and rivers in the Pacific; open water and tributaries in the Great Lakes |
| **MAJOR PREY** | herring in saltwater; alewives and smelt in freshwater |
| **LURES AND BAITS** | spoons, spinners, plugs, flies, cut dead bait, especially herring |
| **PRIMARY TACKLE** | spinning, baitcasting, fly |

and crustaceans. Great Lakes fish primarily feed on alewives and smelt.

Many tactics exist for catching chinook and coho salmon. Overall, far more angling occurs in freshwater, either in rivers when the spawning run occurs or in the open water of the Great Lakes, than in saltwater.

The latter primarily occurs in nearshore, tidewater and estuary locations, with anglers using spinners and cut herring, trolling with flies (mostly for coho), mooching, jigging and live bait fishing. This takes place when the fish gather in the vicinity of coastal rivers prior to ascending them. Salmon normally stay well below the surface, and a heavy weight or downrigger is necessary to keep trolled bait at the desired depth. Depths range from 40 to 250 feet or more, depending on location, temperature, currents and other factors.

Channels, passes and straits that funnel current are popular sites, particularly along current seams and where a back eddy exists. In northern areas, steep rocky shores near mainland or islands, which are well washed by current and tidal movement, are prime spots, and often with a cut herring for bait, fished very close to the bottom. Fishing at low light is often more productive than during bright mid-day light. Some surface trolling for coho salmon is possible, using light tackle, when they are congregated on or near shoals where food is abundant. This is done with streamer flies, trolled fairly fast over bull kelp beds, with the fly skipping over the water.

Coho and chinook in the Great Lakes are widely pursued throughout the season in open water. They are inshore early in the season and ultimately seek out a water temperature of between 48 and 55 degrees; this occurs at the thermocline, which is usually deeper as summer progresses, although its depth changes due to shifting winds. Coho tend to be found closer to shore than chinooks. Both species gather in schools as they seek out desirable water conditions and forage.

Great Lakes salmon wander a lot and are found at varied levels in open water, particularly beyond 30 feet and as much as 70 to 120 feet deep in the summer. Thus, it is necessary to search and fish deeply for them most of the time. This is done in open water where there are few, or no, shoals or islands. A variety of trolling techniques is primarily used, with downrigger fishing most popular. Some drift fishing and a limited amount of jigging is also done.

Salmon in rivers do not actually feed, so imitating a natural food source in appearance or action is unnecessary. Getting the attention of a fish that will aggressively, and reflexively, swipe at your offering is the whole game. A precise presentation, therefore, particularly in regard to getting the bait or lure down to the bottom and directly ahead of the fish, is of foremost importance.

Long rods, medium-heavy lines and small offerings are the elements in coho and chinook fishing in small to medium flows. Salmon eggs, spinners, spoons, flies and wobbling plugs are all used.

Salmon hug the bottom, resting in pools and deep-water sections. They are also found in the tail of a run before swifter water, and in holes and runs along deep-water banks. They are not usually caught in the fast-water reaches. Offerings must be cast slightly upstream and quartered, drifting with the current to the end of the swing. Whatever is used, it must bounce or swim along the bottom, and the right-size sinker is critically important. Too little and the offering never reaches the bottom and is totally ineffective; too much and it drags in the current, acting unnaturally or hanging up repeatedly.

In rivers, tackle ranges from 14- to 30-pound test line, the latter used in narrow rivers and where heavy weights and big fish are encountered. Levelwind reels are preferred, and long (eight- to nine-foot) rods are employed. Fly rods suitable for nine- and ten-weight lines with plenty of reel backing are necessary. In open-water trolling, eight- to nine-foot downrigger rods get most play, with levelwind reels most popular and line strength ranging from 12 to 20 pounds, although lighter line can be used.

CAUGHT BY TROLLING ON THE BRITISH COLUMBIA COAST, THIS COHO SALMON STILL HAS SEA LICE ON ITS FINS.

# CRAPPIE

**There are two species of crappie in North America, and most people cannot tell one from the other, not to mention the myriad names that can be applied to both. No matter, because crappie are beloved by many people as a fun fish to catch and a sweet species to pan- or deep-fry.**

IN THE SPRING, CRAPPIE ARE OFTEN CAUGHT AROUND BRUSH AND TIMBER LIKE THIS SPECIMEN FROM TRUMAN LAKE IN MISSOURI.

THOSE SPECIES are black crappie and white crappie, which are members of the sunfish family, including largemouth and smallmouth bass, and somewhat of a body and color cross between a largemouth bass and a bluegill. Like bluegill, they can be plentiful in some waters, and liberal catch limits may be desired to help thin their numbers out.

Both species are generally a silvery-olive color with dark spots, and both are deep-bodied with fairly large mouths. Technically, the foolproof way to distinguish between the two is by counting the dorsal fin spines; the black crappie usually has seven or eight while the white crappie has six.

Crappie are pretty aggressive eaters, and they grow to better sizes than many other so-called "panfish." Although the maximum size is about five pounds, and most are caught in the three-quarter-pound class, there are many places where fish from one to two pounds can be found. Insects, young shad, minnows and small sunfish are dietary staples. Small minnows are prominent food, and gizzard or threadfin shad are major forage in many reservoirs. Crappies also consume the fry of many species of gamefish. Inhabiting backwaters, sloughs, creeks, streams, lakes and ponds, crappie prefer cooler, deeper, clearer waters with aquatic vegetation. They usually exist in schools of similar-size specimens, so when you come across one fish remember that others are likely to be around. They are especially active in the evening and early morning, and remain active through the winter.

Spring is a very popular crappie fishing time in many places, because these fish move shallow to build nests and spawn. Spawning takes place in early spring and summer in 62- to 68-degree water, and occurs over gravel areas or other soft material, with fish nesting in colonies. A lot of fishing at this time takes place around some form of wood or brush.

During their spawning period, crappies are reasonably predictable and easy for anglers to catch. After spawning, they move to deeper water and gather in schools. They congregate tightly in sunken weedbeds, dropoffs, offshore brushpiles, river channel drops, shoreline riprap, flooded timber and sunken cribbing. Many crappies are caught in ten to 15 feet of water among tree limbs in standing timber. During the heat of the day, they are situated on the cool, shaded side of such structures. Other shaded areas that may attract these fish include bridges, piers,

docks and the bases of old tree stumps. Massive schools of crappies may form at different levels of the lake, and are usually situated horizontally.

Crappies may move into deeper water in the fall to gather around underwater structures such as old channels, rocky ledges or weedbeds. Though they will move around a bit, they generally remain in deep water until spring. Crappies also offer a prime opportunity for winter fishing, and many northern ice anglers make these fish their number-one pursuit.

In timberless lakes, and especially large reservoirs, anglers plant brushpiles to attract and hold crappies. In waters where it is legal to do this, anglers may plant many brushpiles, often in places known only to them and sometimes in front of their own docks or boathouses. They visit them often. Some trolling is done for crappies, but most anglers drift or anchor, and either jig or stillfish with minnows. A greater number of crappie are caught using live minnows than any other natural bait; other good baits are grasshoppers, crickets and worms.

A small, fine-wire jig is the favored artificial crappie catcher. Standard colors are white and yellow, followed by silver, green, chartreuse and multi-colored tinsel models. One-eighth of an ounce is the most common size, but depth, wind and other factors may warrant going a little heavier or lighter. Another good lure is a small, single-bladed spinnerbait with a plastic grub or curl-tail body, as is a small jig tipped with a tiny minnow that is hooked from the top of the head through the mouth. Crappie have tender mouths and strike lightly; regularly successful anglers develop a fine jigging motion and subtle feel. Occasionally crappies strike a large minnow or lure, mostly in waters where these fish are abundant;

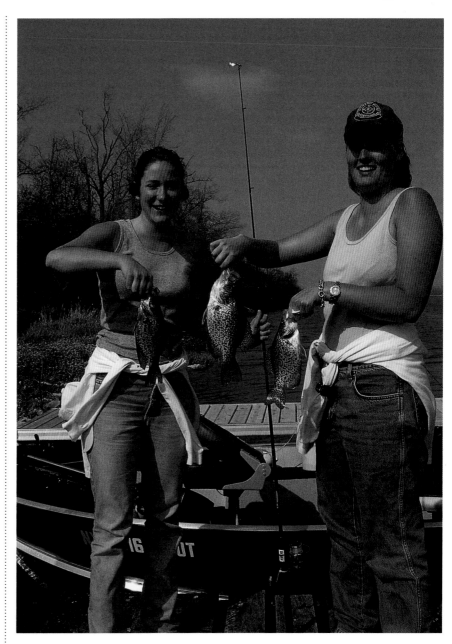

## AT-A-GLANCE

| | |
|---|---|
| **SCIENTIFIC NAME** | black crappie: *Pomoxis nigromaculatus*; white crappie: *Pomoxis annularus* |
| **FAMILY** | sunfish |
| **TYPE** | freshwater |
| **SPAWNING** | spring |
| **PRIME FISHING** | spring |
| **RANGE** (NORTH AMERICA) | Most of the U.S. and southern Canada |
| **PRIMARY HABITAT** | lakes, ponds, streams, creeks |
| **MAJOR PREY** | small fish, aquatic insects |
| **LURES AND BAITS** | small jigs, small spinners and spinnerbaits, minnows, crickets |
| **PRIMARY TACKLE** | light spinning and spincasting |

one-and-a-half- to two-and-a-half inch-long offerings are best for jigs, spinnerbaits and plugs.

Many anglers work lures too quickly for crappies, even though they think they're retrieving pretty slowly. When jigging, you have to put some effort into maneuvering your boat properly over crappie structures and fishing carefully.

Ultralight spinning or spincasting reels equipped with four- or six-pound test line, and five- to five-and-a-half-foot-long rods, are the norm for crappie fishing. Fly rods, telescoping fiberglass rods and cane poles are used as well. Cane poles or telescoping glass rods play a large, traditional role in crappie fishing. Eight- to 12-foot poles work well for boat anglers, but bank anglers prefer 16- to 20-footers. The line is seldom longer than the length of the pole, and live bait is dabbled in place after place.

THESE ANGLERS FOUND A SPOT THAT YIELDED A NUMBER OF NICE-SIZE CRAPPIE, WHICH IS TYPICAL FOR THIS SPECIES.

# DOLPHIN

**In nearly every respect—especially edibility, coloration and fighting ability—the dolphin is a premier gamefish. If only it inhabited the nearshore waters of a greaterportion of the U.S., it would be the hands-down-favorite saltwater target. Nevertheless, this offshore resident, which is one of the most acrobatic of fish and delightfully aggressive to catch on all types of fishing tackle, is highly esteemed and fervently sought, and is especially desired on light tackle.**

.........................................

A DOLPHIN LEAPS
CLOSE TO THE BOAT.

MANY PEOPLE KNOW the dolphin by its Hawaiian name, mahimahi, or by its Spanish name, dorado—both of which are extensively used in restaurant menus. Non-anglers sometimes refer to this species as dolphinfish, to avoid confusion with the mammalian porpoise, which is commonly called a "dolphin."

Dolphin have an appearance that distinguishes them from other saltwater species. Their body is slender and tapered, and a rich iridescent blue-green on top and bluish gold on the flanks. Those colors change rapidly, muting to yellow-green as the fish is held out of the water. Bull dolphin, which are large males, have a high vertical forehead, while females have a more rounded head.

A short-lived fish of tropical waters, dolphin average from five to 15 pounds and may grow to over 80. A fish over 30 is large, however, yet dolphin to 50 pounds are caught in some parts of North America each season. Most dolphin live four years on average, and must have significant growth to grow to such a large size in such a short time. This means that they feed aggressively, which is one of the attributes that makes them so appealing to anglers, since aggressive feeding means a willingness to take many sportfished lures and baits.

In fact, dolphin, which swim extremely fast, feed in pairs, small packs and schools, extensively consuming whatever forage fish are most abundant. They are visually oriented and primarily forage in daylight. Flying fish and squid are prominent in their diet, while small fish and crustaceans around floating sargassum weed are common food for smaller dolphin (those up to eight pounds or so, which are termed "chicken" or "peanut" dolphin).

As a warmwater pelagic species, dolphin inhabit the open ocean. They are usually found close to the surface over deep water, and are often concentrated around floating objects, especially buoys, driftwood and seaweed lines or clusters. Young dolphin are commonly found in warm, nearshore waters in sargassum beds or other flotsam.

Dolphin are almost always encountered by anglers on or just under the surface, and are probably the most surface-oriented of all saltwater gamefish. When offshore anglers run into packs of dolphin they are often able to elicit strikes from several fish in quick order. Fish from eight to 20 pounds or so are especially likely to gather in schools, while larger dolphin (called "slammers" by some), are more likely to be found in small packs, usually with one or two bulls and a few cows. These larger

## AT-A-GLANCE

| | |
|---|---|
| SCIENTIFIC NAME | *Coryphaena hippurus* |
| FAMILY | dolphin |
| TYPE | saltwater |
| SPAWNING | spring and early summer |
| PRIME FISHING | spring |
| RANGE (NORTH AMERICA) | Massachusetts to Florida, Gulf of Mexico, Oregon to Mexico |
| PRIMARY HABITAT | tropical offshore water |
| MAJOR PREY | assorted small fish, flyingfish, squid |
| LURES AND BAITS | offshore trolling lures and rigged baits, live bait, flies |
| PRIMARY TACKLE | light big game and conventional, medium to heavy baitcasting and spinning, fly |

not weigh more than 20 pounds. The strike, when casting or trolling, is usually savage. A reel with 20-pound line is good when mid- to large-size fish are possible.

Eight- to ten-weight flycasting outfits are likewise excellent tools. When dolphin are milling near a drifting boat, it is not necessary to make a very long cast, so even lightly experienced fly anglers can get a flashy streamer out to them. The reel should have a good, adjustable drag.

BRILLIANT COLORS TYPIFY THE DOLPHIN; THIS BULL WAS CAUGHT OFF THE FLORIDA KEYS.

dolphin are more likely to be ocean roamers, which makes them both hard to target deliberately and more likely to be an incidental catch.

Most dolphin are located by trolling at a quick speed, usually while fishing for marlin and sailfish. Rigged trolling baits (flying fish, squid, mullet and balao) on large hooks are usually used, as are offshore trolling plugs and feathers. Heavy conventional big-game tackle is the norm, since it is necessary for billfish; big dolphin fight well even on this tackle, but their fight can be enjoyed much better if they are caught on light big-game outfits, or spinning or flycasting equipment.

Many anglers keep spinning and flycasting tackle handy in case they come across a school of dolphin while trolling. Then they stop and cast surface or diving plugs, bucktail jigs, spoons, streamer flies and possibly live bait. In other cases, boaters cruise offshore looking for floating debris, observing schools, birds and other indicators. When the boat is in casting range of observed fish (which can be seen from a high tower), the captain instructs the mate and anglers as to its position, some unhooked live bait is thrown to tease the fish close to the boat (other chum and sand chum balls are also employed), and then hooked bait, lures or flies are cast to the school of dolphin as individuals come close and weave in and out. It is not uncommon for two, three or four anglers to be hooked up at the same time, in an epic melee of jumping fish, crossed lines and scrambling anglers.

Because dolphin pull hard, leap often and sometimes tailwalk across the surface, seldom digging for the greatest depths, they can be caught on light tackle and played from a drifting boat. A seven-foot spinning rod and six- to 12-pound line is ideal for smaller fish, as most dolphin do

# FLOUNDER AND HALIBUT

SUMMER FLOUNDER,
ALSO KNOWN AS FLUKE,
LIKE THESE FROM THE
EASTERN SHORE OF
VIRGINIA, ARE AN
IMMENSELY POPULAR FISH.

**Flounder and halibut are general terms for various flatfish species in North America. Although the different flounder and flatfish species, as well as other related flatfish, have different habitats and grow to different sizes, they are prominent in both recreational and commercial fishing. Well regarded as table fare, flatfish have firm, white, delicate flesh that can be prepared in various ways.**

A LL OF THESE FISH are bottom dwellers, characterized by flat, platter-like bodies and by having both eyes on one side of their head. One side of their highly compressed (or "flat") body appears translucent or milky white, while the other is a mottled assembly of muddy browns, reds, whites and greens. These fish can change the color and intensity of their skin coloration to camouflage their presence. Many bury in bottom sediment and lie in wait for unsuspecting prey.

In North America, flounder and halibut are found along almost every coastline. Prominent Pacific coast species are the giant Pacific halibut, California halibut, several species of sanddab, and the starry flounder. Prominent Atlantic and Gulf Coast species are winter, summer, southern, windowpane and Gulf flounders, plus the endangered Atlantic halibut.

Some of these fish live along the continental shelf and slope, while others come into shoal and inshore waters, even being found in bays and estuaries and tolerant of brackish water. For example, in the northern Gulf of Mexico, the southern flounder inhabits shallower water than the Gulf flounder, which rarely enters reduced-salinity water, while the southern flounder often occurs in water of low salinity or even in freshwater.

Flounder and halibut have a wide range in maximum size. Both Atlantic halibut and Pacific halibut have been reported to reach 700 pounds, although the largest caught by anglers is respectively 255 pounds and 459 pounds. Some species of flounder can grow to over 20 pounds, but most flounder caught are small, and many are under two pounds.

Flounder and halibut do not get rave reviews for their fighting ability, although this is offset by their food virtue. The vast majority are taken while drifting and stillfishing with some form of natural bait, although a few are occasionally caught on lures. Since they are not fish that travel in schools, they are usually found over a wide area, which is conducive to drifting with the tide and/or wind. Flounder are available all year round in some places, and many are caught in shallow, protected areas that are accessible to small boats.

Summer flounder, which are also called "fluke" and are prominent in the Atlantic, are primarily caught on minnows, shrimp and squid, using a two-bait bottom rig with one fished on or near the bottom while the second is held about a foot off the bottom. Use enough weight to keep the bait on the bottom, even when there is a strong tidal flow. An artificial lure (like a small jig) can be used in combination with bait; attach it to the upper leader so that it stays off the bottom and can move realistically in the current. Try drifting over places with abundant food, like rough or irregular bottoms, in or near inlets, and around pilings, wrecks and jetties. Occasionally jig the line upward to give the bait movement.

California halibut, which are very popular in the Pacific, are most commonly caught in 60 to 120 feet of water along the coast and in bays and estuaries. They primarily feed on anchovies and other small fish, often well off the bottom and during the day, and secondarily on squid, crustaceans and mollusks. Somewhat aggressive, California halibut are mostly taken by drift fishing with bait (especially live anchovies) on sandy flats. However, trolling with lures and bait, fishing in shallow water, and fishing on deep structures are also productive techniques to try.

Pacific halibut are a fish of the deeper and cooler Pacific. They are found at depths from 75 to many hundreds of feet deep, especially on cobble, gravel and sand bottoms near the edges of underwater plateaus and breaklines. They eat crab, squid, octopus, cod, pollack, sablefish, herring and sand lance. Nearly all fishing for Pacific halibut is done on or close to the bottom with heavy tackle and such baits as herring, squid, octopus, belly strips from halibut or salmon, and whole bottomfish; these are rigged on a wire spreader or a sliding-sinker rig, with sinker size ranging from four ounces to four pounds. Metal, slab-type jigs and leadhead jigs are also used.

Big tackle and heavy lines (80-pound or more) are used for the biggest Pacific halibut, and lighter gear if smaller fish are prevalent. Fifteen- to 20-pound line is the norm for California halibut fishing. Lighter gear is used for the different flounder, with spinning, baitcasting and conventional gear all fished, depending on the amount of weight in question.

A PACIFIC HALIBUT FROM PRINCE OF WALES ISLAND, BRITISH COLUMBIA.

## AT-A-GLANCE

| | |
|---|---|
| SCIENTIFIC NAME | assorted depending on numerous species: Pacific halibut, California halibut, Atlantic halibut, several species of sanddab, plus starry, winter, summer, southern, windowpane, and Gulf flounder |
| FAMILY | flounder |
| TYPE | saltwater |
| SPAWNING | varies from fall through spring |
| PRIME FISHING | summer |
| RANGE (NORTH AMERICA) | entire Atlantic, Gulf, and Pacific coasts, depending on species |
| PRIMARY HABITAT | inshore coastal waters, bays, and estuaries |
| MAJOR PREY | small fish, shrimp, crabs |
| LURES AND BAITS | jigs, live and cut baits |
| PRIMARY TACKLE | light conventional, medium baitcasting and spinning |

# JACKS
## (POMPANO, AMBERJACK AND YELLOWTAIL)

**A host of North American saltwater species are members of the jack family, which also includes various pompanos. They range greatly in size, inhabit temperate and tropical waters, and are strong, fast swimmers that act like bulldogs when caught. Some species are also good eating and are highly sought commercially.**

. . . . . . . . . . . . . . . . . . . . . . . . . . . . . . . . . . . . .

PROMINENT MEMBERS of this family in North America include permit, which are discussed elsewhere; amberjack, yellowtail, and Florida pompano, which are noted in more detail here; and almaco jack, bar jack, jack crevalle, horse-eye jack, yellow jack, palometa, roosterfish, blue runner and rainbow runner.

A light-tackle favorite, the Florida pompano is a fine sportfish and makes great eating. It has a deep, flattened body and a short blunt snout that enables it to feed on mollusks, crustaceans and small fish. Similar to a permit, though smaller, it seldom grows larger than six pounds, and is most prominent from Chesapeake Bay to Florida and west to Texas.

Florida pompano are found along sandy beaches, oyster bars, grassbeds, inlets, and often in the turbid water of brackish bays and estuaries, usually in large schools and staying in warm waters of 82 to 89 degrees. They are caught by anglers fishing from bridges, jetties, piers, the surf and small boats; most people fish on the bottom with natural baits (sand fleas, shrimp, clams and small crabs), although some cast or troll small lures, especially jigs with a short bucktail body. Late summer and early fall are best. The amberjack is the largest member of the jack family and a stubborn battler. Most amberjack weigh under 20 pounds, but they are commonly caught to 40 pounds and may exceed 150. Some amberjack are migratory while others are year-round residents. In North America they are most abundant off the coasts of Florida and in nearby Caribbean waters, and also in Hawaii. Large fish are generally solitary, and smaller ones often form small groups. They are found mostly in offshore waters and at considerable depths, as well as around offshore reefs, wrecks, buoys and oil rigs, where they feed on fish, crabs and squid.

While amberjack can be caught anywhere in the water column down to depths of several hundred feet, they are mostly associated with near-bottom structures in the 60- to 240-foot range. Fishing with cut or live bait is very popular, sometimes in conjunction with chumming, as is vertical jigging with bucktails, jigs with soft plastic bodies, or metal jigging spoons. Lures are sometimes adorned with meat. It is hard to turn a big amberjack immediately and get it coming away from the cover. This is why heavy tackle is employed in places where big specimens are found. A strong rod and fairly heavy line are often needed, and some anglers who hook an amberjack while deep fishing for snappers and groupers, find that they are overmatched when an amberjack comes along. Many amberjack anglers like standup tackle with 30- to 50-pound-class outfits; a two-speed reel is very helpful for gaining on these bruisers.

## AT-A-GLANCE

| | |
|---|---|
| SCIENTIFIC NAME | Florida pompano: *Trachinotus carolinus*; greater amberjack: *Seriola dumerili*; yellowtail: *Seriola lalandi* |
| FAMILY | jacks |
| TYPE | saltwater |
| SPAWNING | spring and summer |
| PRIME FISHING | year-round |
| RANGE (NORTH AMERICA) | Florida pompano: Massachusetts to Florida and west to Texas; amberjack: Florida and the Gulf of Mexico; yellowtail: California to Mexico |
| PRIMARY HABITAT | pompano: coastal inshore waters, bays, estuaries; amberjack: reefs, wrecks, buoys; yellowtail: reefs, rocky inshore waters, wrecks |
| MAJOR PREY | pompano: mollusks, crustaceans; amberjack and yellowtail: fish, crabs, squid |
| LURES AND BAITS | pompano: jigs, shrimp, clams, crabs; amberjack: jigs, jigging spoons, live and cut bait; yellowtail: jigs, trolling lures, plugs, flies, assorted live and cut bait |
| PRIMARY TACKLE | pompano: light to medium spinning; amberjack and yellowtail: medium to heavy conventional |

Like amberjack, yellowtail are fast swimming, hard striking, strong-pulling fish that give anglers a great struggle, especially in large sizes; they are a great favorite with shore, boat and light-tackle, big-game anglers. In North America, the California yellowtail is most prominent in the Pacific from Mexico to southern California.

These are primarily schooling fish found around offshore reefs and rocky shores, as well as in deep water around wharves and jetties and manmade structures such as sunken vessels or artificial reefs. Occasionally they will venture along ocean beaches and into larger estuaries.

They mainly feed on small fish, squid and crustaceans.

Fishing for yellowtails is diverse and includes trolling, jigging, casting lures, rock and surf fishing, and fishing with bait. Tackle ranges from conventional saltwater outfits in various classes down through roller-tipped boat rods of various configurations, as well as light and medium gear. Lures can be large surface poppers, offshore trolling lures, plastic squid, metal spoons, metal jigs, skirted lures, feathered lures, artificial flies, dead fish, casting plugs, etc. Baits include pilchards, squid, strips of mullet, tuna and bonito, plus live fish.

LARGE AMBERJACK LIKE THIS FLORIDA SPECIMEN TAKE A LOT OF WORK TO LAND.

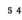

# LAKE TROUT

**Lake trout are one of the largest-growing species of gamefish in North America, but one that is little known to a large number of anglers, especially in the U.S., because of its predominantly northern range and preference for cold, deep waters. Others know it in somewhat skewed terms, having used excessively heavy tackle to dredge smaller fish up from great depths, and therefore think of it as not much fun to catch.**

NORTHERN CANADA LAKE TROUT, SUCH AS THIS ONE FROM NUELTIN LAKE, MANITOBA, ARE DARK, DISTINCTIVELY MARKED, AND STRONG BATTLERS.

H OWEVER, LAKERS from north-country waters, which reside in lakes that seldom warm up enough to establish a thermocline, are strong-pulling, head-shaking runners that give a fine account of themselves in all sizes, and are readily taken on all types of fishing tackle by versatile and accomplished anglers. Thus, the habitat and means of fishing have a lot to do with how you view this fish.

It is a surprise to many people to learn that the lake trout is not actually a member of the "trout" clan, but a charr, and as such is a relative of other charr family members like brook trout and Arctic charr. Nevertheless, it is greatly different in size, habitat and behavior. Lake trout, incidentally, have been crossed with brook trout to produce a hybrid that is known as a splake; the splake's tail is less deeply forked than the lake trout, and its body markings resemble the brook trout.

In appearance the lake trout's body is grayish to brownish, with white or nearly white spots which extend onto the dorsal, adipose and caudal fins. White leading edges exist on all the lower fins. Lighter specimens are often the deep-dwelling fish of light-colored southerly lakes with alewife and smelt forage bases; darker specimens, including some with reddish and orange tones, come from less fertile tannin-colored shallow northern lakes.

Lake trout are one of the longer-lived freshwater species, with some northern specimens having been aged to 60 years. They have been caught up to 72 pounds, and a fish of 102 pounds was netted in 1961, making this species second only to chinook salmon among salmonid species in overall possible size. A 20-pounder, however, is considered large (even "trophy") in all parts of its range, and the average catch is between four and ten pounds.

Lakers primarily inhabit the cool regions of large, deep lakes, and their diet is principally fish, including other lake trout, whitefish, grayling, sticklebacks, suckers, sculpins,

ciscoes, smelt and alewives. They usually stay deep and often near the bottom at cool levels; in some places, including the Great Lakes, this level may exceed 100 feet. In far northern waters they may not be very deep even in midsummer, staying from ten to 40 feet deep because of cool upper-level temperatures. They often orient to structure, cluster at tributaries, and wander in search of food, and although they are not school species like some of their forage, they are usually found in groups, often of like-sized individuals. Spawning occurs in late summer or early fall over clean, rocky lake bottoms, especially shoals and reefs. Some early cold-water lake trout fishing is done by casting from shore with spoons, spinners, plugs and flies, especially along rocky shorelines and around tributaries. Most fishing, however, is done from a boat, occasionally by casting and jigging, but primarily by trolling. In the winter, ice anglers use jigs, live bait and dead cut bait.

In most large waters, lakers are predominantly caught by trolling slowly at relatively deep levels, below the thermocline and often near bottom, with flashy spoons and diving plugs. Anglers focus on structure (primarily shoals or reefs) from late spring through early fall, especially along dropoffs, around reefs and rocky structures, and along steep rock walls.

Shallower rocky islands and reefs are prime foraging grounds for lake trout, which move into such spots to feed, then retreat to deep water. Early and late in the year are good times to find lake trout in the upper 20 feet of a lake or reservoir, if the water temperature is favorable.

Lake trout have a curious nature and sometimes follow a lure a considerable distance, sometimes nudging the lure and sometimes just staying right behind it for a long while.

## AT-A-GLANCE

| | |
|---|---|
| SCIENTIFIC NAME | *Salvelinus namaycush* |
| FAMILY | charr |
| TYPE | freshwater |
| SPAWNING SEASON | late summer, early fall |
| PRIME FISHING | spring and fall |
| RANGE (NORTH AMERICA) | all of Canada and Alaska, plus the northernmost U.S. including the Great Lakes |
| PRIMARY HABITAT | deep lakes |
| MAJOR PREY | assorted fish, including alewives, smelt, ciscoes, and suckers |
| LURES AND BAITS | spoons, plugs, jigs, flies, cut bait |
| PRIMARY TACKLE | medium to heavy baitcasting and spinning, fly |

THIS SMALL LAKE TROUT FROM LAKE ONTARIO, NEW YORK, WAS ATTRACTED TO A TROLLING RIG.

When holding a rod, jerking or pumping the rod tip periodically, as well as dropping it back a few feet or speeding it up momentarily, are tactics that provoke these fish into striking. When rods are set in holders, changes in boat speed and turns, and manipulative boat operation momentarily affect the swimming pattern of a lure, and these are often factors that cause a lake trout to strike. It is not the faster or slower speed of the lure that draws strikes so much as a change in behavior. Lakers basically like a slow presentation.

Jigging with light jigs can provide exciting small lake trout action in north-country rivers, and for schools of small fish that prowl the shorelines of lakes in the evening. Large jigs are occasionally more effective than trolling spoons or plugs in places where lake trout are abundant. The best jigging spots are reefs and river mouths; at the latter, focus on the side of heavy current where a major tributary dumps into a large lake.

Lake trout can also be caught by casting and retrieving small spinners and spoons, streamer flies, and plugs primarily in northern locales. In flies, try streamers when fishing in current and in the shallows, and possibly dry flies when small lakers are observed cruising shorelines for mosquitoes in the far north.

Tackle runs the gamut from conventional deep-trolling hardware to fly, spinning and baitcasting equipment. Baitcasting and conventional tackle for trolling are generally preferred. Lakers give the best account of themselves on light line, which, because they inhabit open water, is very feasible provided you do not need heavy weight to get down to them.

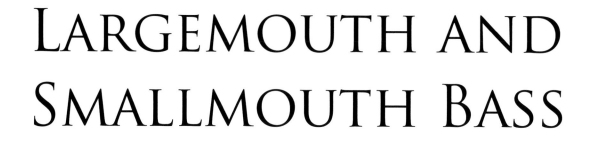

# LARGEMOUTH AND SMALLMOUTH BASS

Together, largemouth and smallmouth bass, most commonly referred to simply as "bass" by many anglers, are the most popular freshwater species in North America. Largemouths are more widely spread than any other major freshwater gamefish and, because of their fairly aggressive nature, are very susceptible to varied lures, baits and tactics. Though less widely spread and smaller growing than largemouths, smallmouth bass are greatly admired for their fighting ability, and are a superb light-tackle gamefish.

LARGEMOUTHS ARE FOUND in reservoirs, lakes, ponds and large, slow rivers with quiet backwaters. They adapt especially well to fertile waters; are fond of cover and objects; do not roam much; ambush a lot of their prey; and reside among or near logs, stumps, lily pads, brush, weed and grass beds, bushes, docks, fence rows, standing timber, bridge pilings, rocky shores, boulders, points, weedline edges, stone walls, creekbeds, roadbeds, ledge-like dropoffs, humps, shoals and islands.

Smallmouths also inhabit lakes, ponds, reservoirs, rivers and streams, although they prefer slightly cooler water than their cousins. They are located around rocky points; craggy, cliff-like shores; rocky islands and reefs; and rip-rap banks, preferring small rocks but also being found around boulders, gravel and some obstructions.

Although experienced anglers have no trouble distinguishing between these species, less frequent anglers may confuse the two if they fish in areas where both species overlap (some waters contain both). Since

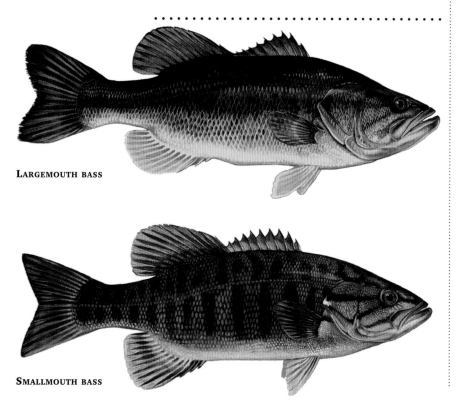

**LARGEMOUTH BASS**

**SMALLMOUTH BASS**

## AT-A-GLANCE

| | |
|---|---|
| **SCIENTIFIC NAME** | largemouth bass: *Micropterus salmoides*; smallmouth bass: *Micropterus dolomieu* |
| **FAMILY** | sunfish |
| **TYPE** | freshwater |
| **SPAWNING** | spring |
| **PRIME FISHING** | spring through fall |
| **RANGE** (NORTH AMERICA) | largemouth bass: southern Canada, northern Mexico, all U.S. states, except Alaska; smallmouth bass: southern Canada and most of the U.S., except Florida and Alaska |
| **PRIMARY HABITAT** | largemouth bass: lakes, ponds, large river systems; smallmouth bass: lakes, ponds, rivers, streams |
| **MAJOR PREY** | assorted fish, crayfish |
| **LURES AND BAITS** | plugs, spinnerbaits, jigs, spinners, weedless and jigging spoons, soft worms, flies, live crayfish |
| **PRIMARY TACKLE** | baitcasting, spinning, spincasting, fly |

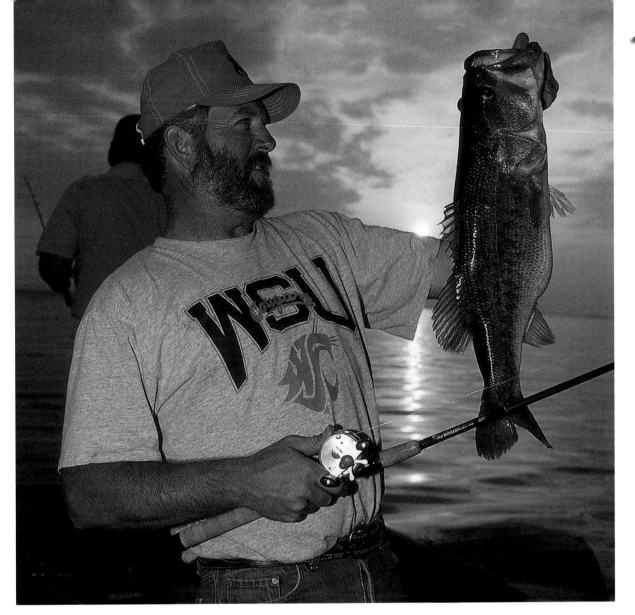

BIG LARGEMOUTH ARE
THE HOLY GRAIL FOR
BASS ANGLERS; THIS
ONE CAME FROM LAKE
GUERRERO, MEXICO.

coloration in these and other fish can vary greatly according to their environment, color is not a foolproof means of differentiation, although smallmouths almost invariably are more brown and largemouths more green on the back and upper sides. Largemouths have a broad stripe of diamond-shaped blotches along the midline of the body, which are absent in the smallmouth and a good differentiating point. In largemouths, the tip of the upper jaw extends past the eye, while in smallmouths the tip of the upper jaw does not extend past the eye.

Food preferences are wide ranging for largemouths; they consume other fish, especially shiners, shad, minnows, small bluegills and the like, plus crayfish and assorted other live food, especially if it is vulnerable and easily captured. Their menu is so diverse that it lends itself to the use of a wide range of lure types, sizes, colors and actions. Crayfish are prominent in the diet of smallmouths in many places, although they also consume small panfish, yellow perch and assorted fingerling-size minnows in lakes. In rivers, they also consume minnows, hellgrammites and leeches, plus nymph larvae and other aquatic insects.

A healthy appetite and preference for warm water

enables largemouth bass to grow to respectable size. The all-time record is a 22-pound four-ounce fish, and numerous bass from 15 to 22 pounds have been caught in the warmer lakes of California, Florida, Mexico and Texas over the years. However, a largemouth over five pounds is considered fairly big in its northern range, where growing seasons are shorter, and over eight pounds is considered big in more southerly waters. Ten pounds is a magic, unofficial "trophy" mark for most anglers, although one that is virtually unachievable in northerly areas. Smallmouths do not grow nearly as large as their brethren; a five-pounder is a terrific fish anywhere, and smallmouths over three pounds are a fine catch and usually a handful if caught on modest tackle.

In many places, the most ardent bass anglers release all of the bass they catch, which generally bodes well for the future. However, really big bass are susceptible to stress- and handling-related mortality, so great care should be taken with them. Fishing pressure for bass is very intense in some places, which makes catching good numbers, or fish of size, more difficult.

Fishing for largemouth and smallmouth bass is different in some ways and similar in others. Both species

**RIGHT:** AT CALIFORNIA'S
TEJON LAKE, AN ANGLER
RELEASES THE BASS HE
CAUGHT FROM THE
NEARBY REEDS.

**BELOW:** A NICE FLORIDA
LARGEMOUTH BASS CAUGHT
IN THE SPRING ALONG A
GRASSY BANK.

are adept at locating prey in turbid water and at night, and are mainly sight feeders in water that permits good vision. When foraging where visibility is limited, they primarily use a highly developed lateral line for detecting vibrations and locating prey. As a result, bass are oriented to both hearing and seeing, and many types of lures, including some that really have no acute resemblance to natural food, are capable of catching fish.

Because bass are primarily cover- and object-oriented fish, they are often poorly suited to trolling, but well suited to casting, which is the overwhelming preference of anglers. Casting with assorted types of lures is the predominant choice, although in some situations bass anglers use such live baits as shiners, crayfish and salamanders.

Although bass can be caught throughout the year, the activity and interest of most anglers picks up in the spring, which is when bass spawn and are usually shallow and close to shore, particularly in lakes. Small lakes and ponds are best early in the season because they warm up first. On large bodies of water, better places to fish early in the season include coves, shallow flats, feeder creeks and tributary areas, which are generally warmer than the rest of the lake. Spinnerbaits and crankbaits are the primary spring lures for largemouths in lakes. In flowing water, smallmouth anglers rely on flies (streamers, nymphs and dries), small jigs, small crankbaits and light jigs.

In many places, bass are not as accessible in the summer because the shallow water warms up significantly. So the fish move to deeper water or hold deeper in thick cover that is difficult for the average angler, especially the casual one, to fish. Submerged humps, long points and old reed beds are good places in large lakes and impoundments, as are areas with heavy cover (both weeds and timber for largemouths only) and a reasonable amount of depth. Surface lures are good early and late in the day or on dark days, and soft-bodied worms are a perennial favorite along with large silicone-bodied jigs, especially for largemouths. Weedless spoons and weedless plastic baits are also worthwhile in heavy cover for largemouths. In places that are heavily fished or heavily used by boaters, and/or where the daytime temperature is great, it pays to go fishing at night. Many of the same lures that work for largemouths also work for smallmouths, although the latter generally prefer more diminutive sizes. Hair-bodied, soft plastic, and rubber-legged jigs are good for smallmouths in the summer, and occasionally in the spring and fall, with particular emphasis on fishing these by rocky banks and sharply sloping shorelines.

Bass generally move shallower in the fall as the water temperature drops from summer highs. Favorable conditions last much longer the further south one goes,

A TRIBUTARY TO QUEBEC'S LAC BEAUCHENE PRODUCED THIS SMALLMOUTH BASS.
A TRIBUTARY TO QUEBEC'S
LAC BEAUCHENE PRODUCED
THIS SMALLMOUTH BASS.

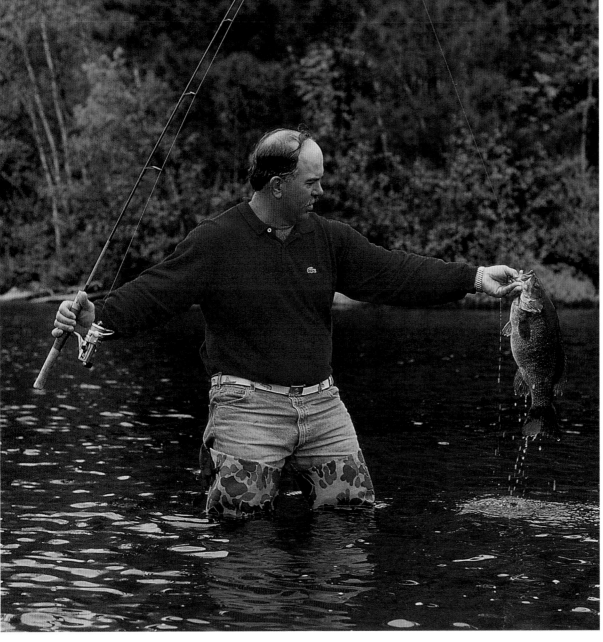

since climate changes are generally more gradual. Ponds and small lakes are initially good, although they cool off rapidly after a succession of cold nights. Shallow and near-shore environs become worthy of greater attention in the fall, but anglers should not be averse to working deeper water if shallow prospecting fails to bring dividends. Spinnerbaits, crankbaits, jigs and surface lures have merit at this time.

With so much bass fishing taking place from boats, especially those equipped with an electric motor, it is important to position a boat properly to make accurate casts and proper presentations. Precise presentations are especially important when fishing for largemouth bass, and accurate casting is sometimes a necessity.

No one type of tackle is necessarily best for bass fishing.

Baitcasting and spinning tackle are widely preferred by avid anglers, but flycasting and spincasting tackle are certainly appropriate for some situations.

The allure of baitcasting tackle for the most avid largemouth bass anglers is good casting control, cranking power for working large, hard-pulling lures, and power for fishing in heavy cover as well as landing big bass. Ten- or 12-pound test line is standard with this tackle for the majority of largemouth bass fishing, although lighter and heavier line is used where situations are appropriate. In spinning gear, light- and medium-duty tackle are common for both largemouth and smallmouth, with six- to ten-pound used for largemouths and six- and eight-pound for smallmouths, though sometimes lighter and heavier strengths are used.

# MACKEREL

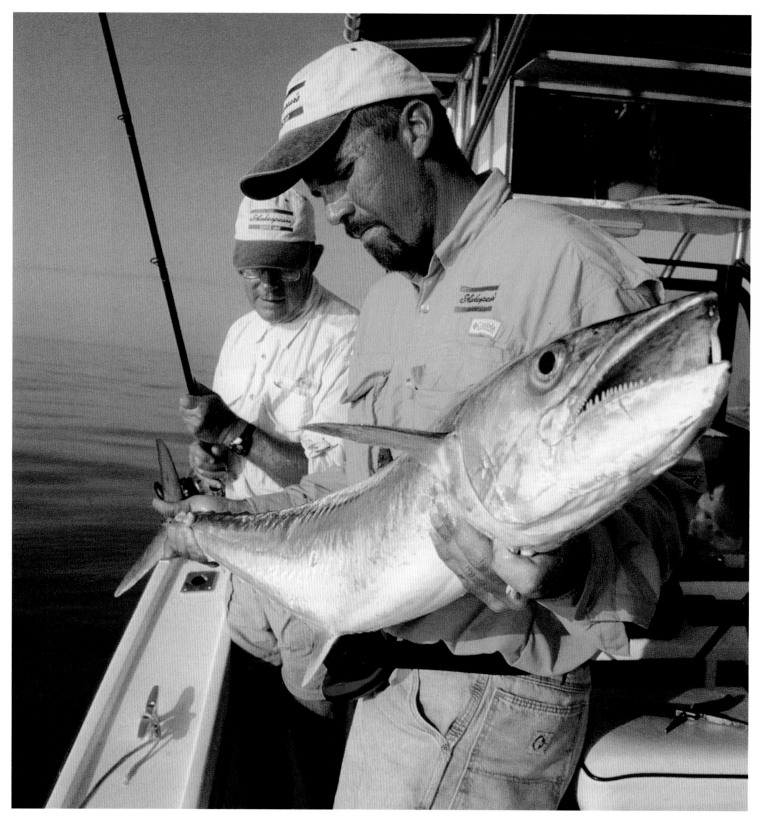

A relative of tuna, mackerel are open-sea schooling fish with streamlined bodies and crescent-shaped tails. They are much smaller than tuna overall, but just as swift. A prominent North American species is the Atlantic mackerel, which is a smallish fish commonly weighing about a pound, and a favorite food item. It is alternately plentiful and scarce in the North Atlantic Ocean, and a pelagic species that prefers cool, well-oxygenated, open ocean waters where it feeds on fish eggs and various small fish.

. . . . . . . . . . . . . . . . . . . . . . . . . . . . . .

## AT-A-GLANCE

| | |
|---|---|
| **SCIENTIFIC NAME** | Atlantic mackerel: *Scomber scombrus*; Spanish mackerel: *Scomberomorus maculatus*; king mackerel: *Scomberomorus cavalla* |
| **FAMILY** | tuna and mackerel |
| **TYPE** | saltwater |
| **SPAWNING** | spring through summer |
| **PRIME FISHING** | summer |
| **RANGE** (NORTH AMERICA) | Atlantic mackerel: Labrador to North Carolina; Spanish and king mackerel: Massachusetts to Florida, the Gulf of Mexico to the Yucatan Peninsula |
| **PRIMARY HABITAT** | Atlantic mackerel: coastal inshore waters and bays; Spanish mackerel: varied from inshore to offshore; king mackerel: temperate open water, reefs, wrecks, and inlets |
| **MAJOR PREY** | assorted small fish, squid, shrimp |
| **LURES AND BAITS** | Atlantic mackerel: jigs, tube lures, flies; Spanish mackerel: spoons, jigs, live minnows, shrimp; king mackerel: spoons, jigs, plugs, trolling lures, assorted live bait and strip bait |
| **PRIMARY TACKLE** | Atlantic and Spanish mackerel: light conventional, baitcasting, spinning; king mackerel: heavy baitcasting and spinning, light to medium conventional |

MOST FISHING for this species takes place in near-shore environs or in large bays. A favorite rig consists of several small tube lures attached at one-foot intervals to a main leader and weighted with a heavy (three- or four-ounce) diamond jig. Since mackerel are a mid-water fish, its important to have the baits at the right level. Most people find this level by dropping their rig to the bottom, then slowly working it back up in increments, pausing and jigging as they do this. Once fish are caught they return their rig to the same level. When the fish are not too deep, jigs and flies are also effective, and sometimes chum is used to attract and hold the fish near the boat. Also popular are Spanish mackerel, both as a gamefish and food fish, as well as bait for big-game fishing. This species averages two to three pounds but can grow to 13. Occurring inshore, nearshore and offshore, Spanish mackerel prefer open water but are sometimes found over deep grass beds and reefs, as well as in shallow-water estuaries. They form large, fast-moving schools that migrate great distances along the shore, staying in waters above 68 degrees, and feeding on other fish, squid and shrimp.

Because Spanish mackerel migrate close to land, they are caught from small craft inshore, as well as from larger boats, and by anglers on piers, bridges and jetties. Casting, live bait fishing, jigging and drift fishing are all effective, and a variety of lures, including metal squids, spoons, diamond jigs, bucktail jigs and feather are used. When fish are plentiful, small jigs may be rigged in multiples. Minnows and live shrimp are the best natural baits. Light six- to ten-pound spinning tackle provides excellent sport.

Prized for its fight, size, and flesh, the king mackerel is the largest mackerel in the western Atlantic, capable of reaching 90 pounds. Individuals to 20 pounds are not uncommon, although the average is under ten.

Also known as kingfish, king mackerel are primarily an open-water, migratory species, preferring warm waters seldom below 68 degrees. They often occur around wrecks, buoys, coral reefs, ocean piers, inlets and other areas where food is abundant, usually consisting of other fish as well as shrimp and squid.

Fishing methods include trolling or drifting either deep or on the surface using strip baits, lures or small whole baits, as well as casting lures and live baits. Balao, mullet, jacks, herring, pinfish, menhaden (pogies), blue runners, ladyfish, croakers and Spanish mackerel are among the baits used, with the largest baits preferred for bigger mackerel. Spoons, feathers, jigs and plugs prove effective under various conditions, as do such combinations as feathers and strip bait and skirted strip bait. Chumming works well to attract and hold these fish.

Many larger fish are caught by trolling with multiple (two or three) bait rigs, rigs of mullet on feathers, spoons, live fish pulled slowly in the boat's wake, and a large plain spoon following a diving planer. Downriggers are used in conjunction with live baits, and live fish may also be run near the surface on kites. Deeper fishing can produce larger individuals.

# MUSKELLUNGE

The muskellunge probably has the least number of anglers fishing for it, but the greatest mystique. A premier gamefish by virtue of its size, strength, predatory habits, and peculiar disposition, this strictly North American fish has a fairly limited range and is one of the more difficult species to catch on a consistent basis. Muskellunge have suffered from overharvest in the past, but due to the conservation efforts of a devoted core of anglers, who release nearly every specimen they catch, populations in some waters are doing very well.

A 37-INCH MUSKIE, CAUGHT EARLY ON A FALL DAY ON THE OTTAWA RIVER, ONTARIO.

THE MUSKELLUNGE is related to the northern pike and the chain pickerel, and similar in appearance by virtue of having a long, narrow body, a broad, tapered head and a mouthful of sharp teeth. Although colors and body markings may vary, especially among fish in different regions of the continent, muskellunge generally have dark, vertical bars that look like vermiculations or spots over a brownish or green background. A related, but distinctly marked, relative is the tiger muskellunge, which is a sterile hybrid that results from the interbreeding of true muskellunge and northern pike. Tiger muskies occur naturally in the wild, but many in North America are the result of hatchery stockings.

One of the largest strictly freshwater fish in North America, the muskellunge has been reported to over 80 pounds, but no muskie over 70 pounds has been verified. The average muskie is in the seven- to 15-pound class, and while specimens over 20 pounds are not rare, those over 30 pounds are infrequent and over 40 rare. An increase in catch-and-release fishing has helped to produce larger fish.

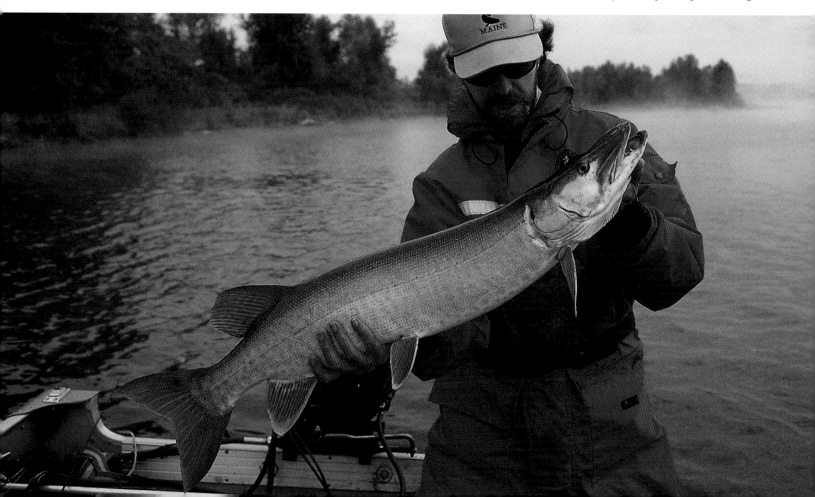

Primarily found in the Great Lakes, Hudson Bay and Mississippi River drainages, muskies inhabit medium-to-large rivers and lakes of all sizes, preferring cool waters and residing in both deep and shallow areas. They are especially prone to locate in shallow, heavily vegetated waters less than 40 feet deep, but may be found in deep water where there is no vegetation, but ample feeding opportunity.

Muskies tend to stay in one general area, often holding in or near thick weedbeds waiting for prey. They sometimes roam from deeper to shallow environs to feed, preferring larger, rather than smaller, fish. Among the top foods are yellow perch, suckers, golden shiners and walleyes, with smallmouth bass and many other fish on their menu. Successful muskie fishing requires discipline, dedication, patience and a lot of hours on the water. Often the reward is a follow—seeing a fish cruise in to eyeball your lure—rather than a hookup or landing.

Since muskies are attracted to the edges of vegetation, the underwater area where weeds end and deep water begins (called a breakline), and irregular contour features, are prime places to fish. A long, underwater slope near deep water, especially if it breaks sharply to 20 or 25 feet, is also a top location. Even better if there is heavy vegetation nearby or rock piles on the breaklines. Also good are areas that attract baitfish, such as shoals, submerged islands and bars. In rivers, pay attention to how the current washes around structure or cover. A good place is a point or shoal that is washed by a strong current. Another is one where two flows converge (like where a tributary enters the main river). Do not ignore back eddies, slicks and current edges either.

Most muskies are caught less than 30 feet deep, often from 15 to 25 feet. Sometimes they are much shallower. Most casters lure fish in from five to 15 feet deep, while trollers usually catch them from eight to 30.

A MUSKIE DOES BATTLE NEAR THE BOAT.

Casting and trolling are both effective, though many avid anglers disdain trolling (it may be illegal in some places, too), even though you can cover a lot of water. Trolled lures are fished on fairly short lines, and some muskies are caught right in the prop wash.

One downside to trolling is that because muskies will pursue a cast-and-retrieved lure right to the boat, occasionally striking at boatside, trollers do not see fish that might follow their lures. This following tendency shows an angler where a fish is located, and good muskie anglers remember all of the places where they have caught and seen fish on their favorite waters, so they visit these places regularly.

Popular lures include large jigs, jerkbaits, surface plugs, bucktail spinners and some diving plugs. For casting, the preference runs to bucktails and jerkbaits, the former mainly used in shallow- to mid-depth casting, over the top of submerged cover, and along the edges of shallow submerged cover. Black is the top producer. Large, shallow-running, minnow-style plugs account for a lot of muskies, too, especially around the edges of weeds and sometimes over the top of deeply submerged vegetation.

Diving plugs can be both cast and trolled, although casting is tough on the arms and wrists if you do it long. Popular colors include perch, walleye, bass and muskie patterns, plus black, black-and-white, chartreuse, silver-and-black, and yellow.

Heavy tackle is the norm for most serious muskie anglers. A stiff, and relatively short, rod is standard, with at least 25- to 40-pound line, though some use thin-diameter microfilament lines from 50- to 80-pound strength. It is hard to set the hook into a large muskie, so multiple hooksetting and a low-stretch line can be advantageous. A wire leader is also used, usually from 12 to 24 inches long, because of a muskie's formidable dentures.

## AT-A-GLANCE

| | |
|---|---|
| SCIENTIFIC NAME | *Esox masquinongy* |
| FAMILY | pike |
| TYPE | freshwater |
| SPAWNING | late winter, early spring |
| PRIME FISHING | fall |
| RANGE (NORTH AMERICA) | southern Canada from Quebec to Manitoba; northern U.S. from Vermont to Iowa and south through the Appalachians |
| PRIMARY HABITAT | lakes, rivers |
| MAJOR PREY | assorted fish |
| LURES AND BAITS | plugs, spinners, spinnerbaits, jigs |
| PRIMARY TACKLE | baitcasting |

# NORTHERN PIKE

PIKE LIKE FLASHY, COLORFUL LURES, AND ARE OFTEN VERY AGGRESSIVE.

**Why the northern pike is not simply named pike is something of a mystery, since there is no "southern" pike species. Often called simply "northern," the pike is a coolwater fish of the northern latitudes of the U.S. and much of Canada, and one of the most aggressive freshwater gamefish. It grows fairly large, fights well, and can be caught with many different types of tackle, lures and natural baits.**

BOLD-EYED and shaped like a long missile with a mouthful of teeth, the northern pike has an elongated body and a broad, flat head. Its slightly yellow-green flanks bear lighter-colored, kidney-shaped horizontal spots or streaks, and its overall colors can be lighter or darker depending on the environment. Young specimens are sometimes confused with a smaller relative, the chain pickerel, which has chain-like markings, and large specimens may be mistaken for muskellunge.

Most pike are in the three- to six-pound class, but chances to catch fish up to 15 pounds are good, and fish over 15 and up to 25 pounds are definite possibilities in many Canadian and Alaskan waters. Although stories of fish over 30 pounds surface occasionally, pike of this size are very rare in North America, where a 46-pound two-ounce New York fish caught in 1940 remains the record. Pike are especially abundant in Canada and Alaska, and fairly abundant in Midwestern states, Great Lakes drainages, and parts of the Rockies. They are found outside these areas as well, and have been widely transplanted. Pike prosper in diverse habitats, although they do not adapt well in waters where the temperature stays very warm for a long period. They have a special fondness for living in among aquatic plants, where they are well adapted to hiding and ambushing prey. The weedy portions of lakes, ponds and rivers are common pike hangouts, although better locations may have to do with the abundance of weeds and the depth of the water, as well as other matters. In lakes with little or no vegetation, or where factors mitigate against living among weeds (such as warm shallow waters), pike will also exist in deeper, open habitat. In many cases, and especially in midsummer, smaller specimens are likely to be shallow, while larger individuals inhabit cooler depths.

Other fish make up the major portion of the diet of a pike, which learns from an early age to use cover as a means of ambushing unwary prey. Walleye and yellow perch are common food items, as are whitefish and suckers and other pike. Pike are capable of eating fish that are nearly one-third of their own body length. Exceptional

## AT-A-GLANCE

| | |
|---|---|
| **SCIENTIFIC NAME** | *Esox lucius* |
| **FAMILY** | pike |
| **TYPE** | freshwater |
| **SPAWNING** | late winter, early spring |
| **PRIME FISHING** | late spring, early summer |
| **RANGE** (NORTH AMERICA) | most of Canada from Labrador to Yukon Territory, Alaska, northern U.S. from New England to Montana |
| **PRIMARY HABITAT** | lakes, rivers |
| **MAJOR PREY** | assorted fish |
| **LURES AND BAITS** | plugs, weedless spoons, spinners, spinnerbaits, jigs, streamer flies |
| **PRIMARY TACKLE** | baitcasting, spinning, fly |

sight feeders, pike are attracted to movement and color, and in more northerly waters they are known to be more active on bright days rather than dark, overcast days.

In lakes, many pike anglers concentrate exclusively on weeds, especially fishing in weedy bays, around weedy river inlets of lakes, weedy shoreline points, reefs with coontail weeds, marshy shorelines, lily pads, and reedy pockets along sandy and rocky shorelines. Shallow weeds are good early in the season, but later, larger fish are more likely to be around cabbage weeds in six to 15 feet of water. The outer edge of this is likely to attract big pike, as are pockets or indentations.

In rivers, pike are attracted to places that afford easy ambush. Thus, good places include where small rivers and streams merge with the main flow, in the small eddy beneath a beaver hut, downstream from islands, in shallow backwaters, under docks, on shorelines just below riprap or wing dams, on the inside of large eddies, and where brush and slow water meet.

With color, flash and motion often important to catching pike, popular lures run a wide gamut. Favorites include the traditional red-and-white spoon; a fluorescent orange-bladed spinnerbait or bucktail spinner; an orange-and-yellow-backed minnow imitation plug; a yellow, Five-O-Diamonds pattern spoon; a black bucktail with a single fluorescent spinner; and shallow- and deep-diving plugs in gaudy and metallic colors. However, when pike are not especially aggressive, or even lethargic, they are not prone to such lures, but favor large hair- or rubber-bodied jigs, large streamer flies, soft-plastic jerkbaits, and weightless plastic worms.

Steel leaders can be very helpful in pike fishing, since large pike may take lures deep or get some of the line in its mouth, and since many lure-hooked pike get free when they cut leader-less line. Six- to nine-inch wire leaders do not hamper casting but afford some protection, with titanium leaders being especially useful because they last so long and do not kink.

Casting weedless lures directly into a mass of shoreline vegetation and retrieving outward is a fairly standard pike fishing tactic, and one that many anglers employ, though it is also one that suffers in heavily fished waters. Thus, pike anglers need to be diverse.

One way to do this is to try rattling, bulbous-type shallow-running plugs in lieu of the more traditional minnow-imitating versions. Some large minnow-shaped

A DISTINCTIVELY MARKED TROPHY CLASS NORTHERN PIKE FROM SCOTT LAKE, SASKATCHEWAN.

plugs, incidentally, as used in trolling for stripers and muskies, are effective pike catchers. Another option is a medium- or deep-diving crankbait that possesses rattles, working it in a stop-go fashion over and through the weeds. Consider barbless hooks when using multi-hooked lures for pike, not only because it makes unhooking and removal from a net easier, but because it lessens the chance of you being seriously hooked by a rambunctious pike. Some plugs can easily be switched to single barbless hooks.

Try spinnerbaits early in the season, in the weeds, around timber and stumps, and across rocky points. Try soft-plastic and hair-bodied jigs along the deep edge of weedbeds in midsummer, and for sight fishing early in the season when pike are in the shallows but not aggressive. Try streamer flies when pike are shallow and can be stalked

and sight-fished. Live and dead bait are occasionally used by some anglers, especially through the ice in winter, and when stillfished on the bottom in spring after iceout.

Baitcasting and spinning tackle are by far the preference for most pike anglers, although fly tackle is obviously also used. Baitcasting is most preferable where large lures or bait are used or the opportunity exists to catch large fish. Being stiffer, baitcasting rods have an advantage over other types of tackle in hook-setting, which can be a problem with really large pike. Line capacity is not a big factor in reels. Rods should be five-and-a-half to seven feet, with a stiff butt and mid section and a rather fast tip. Most pike anglers prefer heavy line, with 12- to 17-pound test favored, but many opt for six- to ten-pound line where the cover is not thick.

# PERMIT

A member of the jack family, the permit is one of the most coveted saltwater gamefish, most often pursued by sight fishing with spinning or fly tackle on tidal flats, where it is hard to approach without spooking. This silver-bodied fish with dark fins and a dark back is most common in Florida, the Bahamasand the Caribbean. Often caught up to 25 pounds, it can grow to over 50 pounds.

. . . . . . . . . . . . . . . . . . . . . . . . . . . . . . . . .

PERMIT INHABIT shallow warm waters in depths of up to 100 feet, and young fish prefer clearer and shallower waters than adults. They are found in channels or holes over sandy flats and around reefs, and sometimes over mud bottoms. Younger, smaller permit are primarily schooling fish that travel in groups of ten or more, though they are occasionally found in greater numbers and become solitary with age. They are also occasionally attracted to areas where the bottom is stirred up, and primarily eat mollusks when feeding on sandy bottoms, where they root in the sand; on reefs they eat crabs, shrimp and sea urchins. Some angling is done by bait fishing or jigging in intermediate-depth water over reefs and wrecks. However, permit venture onto sandy flats on a rising tide to scour the bottom for food, and are often seen cruising or tailing while feeding on the bottom. This is where most fishing is done, as permit are sighted, stalked and cast to with a jig, fly or live crab or shrimp. Here they are renowned for being difficult to approach, difficult to entice to strike, difficult to set the hook in and difficult to land.

It is usually critical to make a precise presentation to shallow permit, although this is made easier and less critical if you encounter a school. Relatively few permit are hooked, however, and fewer still landed, in comparison to the number of fish seen. When rooting on the bottom for food, permit have a small viewing window, which explains why it is necessary to get your offering where they can see it, and then to move it just enough to interest them. Bait, lure or fly should be cast a few feet in front of the fish so that it will be presented just to its side. Keep the rod tip high and work your offering on the surface toward

## AT-A-GLANCE

| | |
|---|---|
| **SCIENTIFIC NAME** | *Trachinotus falcatus* |
| **FAMILY** | jacks and pompano |
| **TYPE** | saltwater |
| **SPAWNING** | spring and summer |
| **PRIME FISHING** | year-round |
| **RANGE** (NORTH AMERICA) | Massachusetts to Mexico, primarily Florida |
| **PRIMARY HABITAT** | shallow near-shore waters, flats, reefs |
| **MAJOR PREY** | crabs, shrimp |
| **LURES AND BAITS** | small jigs, flies, live crabs and shrimp |
| **PRIMARY TACKLE** | baitcasting, spinning, fly |

the permit, then let it swim or fall down to the fish.

Most permit are caught on live crabs and some on live shrimp. Small jigs produce a fair number of fish. Weighted flies are the most challenging offering, due to the difficulty of getting into casting position and being able to counter wind and other factors.

When hooked, permit streak over the flats and head toward deep water on a long, sustained run. They might seek obstacles to cut the line on or to try to dislodge the hook, so you must keep the rod high and be using a reel with ample line capacity and an excellent drag. Permit have superior stamina and will fight for a long time (40 minutes or longer for a 20-pound fish is likely). They are often caught on light- to medium-action seven-foot spinning rods and eight-pound line. Flycasters use a nine- or ten-weight fly rod and floating line with sink tip.

CAUGHT ON A CRAB AT MARATHON, FLORIDA, THIS LARGE PERMIT IS ABOUT TO BE RELEASED.

# RAINBOW TROUT
# AND STEELHEAD

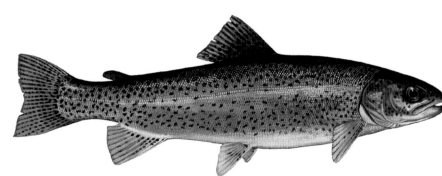

The rainbow trout is one of the most important species of fish for commerce and recreation. It is widely cultivated for food, and has been stocked on six continents, being found in streams, rivers and lakes. Anglers especially favor the rainbow's beautiful coloration and acrobatic tendencies when hooked. Its tolerance for moderate-temperature water has made it known to a wider range of anglers than any other fish called "trout" (it is actually in the Pacific salmon family), and it exists in both freshwater-resident and anadromous, or sea-run, forms.

A NADROMOUS RAINBOWS are known as steelhead or steelhead trout, and are equally spectacular as leaping, cartwheeling fighters. These fish migrate to sea as juveniles and return to freshwater as adults to spawn. There are no major physical differences between a steelhead and rainbow trout, although the nature of their differing lifestyles results in subtle differences in shape and general appearance and a greater difference in color.

ABOVE RIGHT: RELEASING A NATIVE RAINBOW TROUT ON THE BLACKWATER RIVER, BRITISH COLUMBIA.

Rainbows are characterized by a reddish-pink band along each side about the midline and a generally profuse amount of small black spots over the body. These spots appear on the back above the lateral line, as well as on the upper fins and tail; in some fish, the black spots may extend well below the lateral line and even cover the entire lower side. Stream dwellers and spawners usually show the darkest and most vivid colors and markings. River or stream residents normally display the most intense pink-stripe coloration and heaviest spotting, followed by rainbows from lake and lake-stream systems. By contrast, the steelhead is silvery and may not have a pink stripe along the middle of its sides.

## AT-A-GLANCE

| | |
|---|---|
| **SCIENTIFIC NAME** | *Oncorhynchus mykiss* |
| **FAMILY** | salmon |
| **TYPE** | freshwater/saltwater |
| **SPAWNING** | spring and summer |
| **PRIME FISHING** | rainbow trout: summer; steelhead: varies |
| **RANGE** (NORTH AMERICA) | rainbow trout: Alaska, western and southern Canada, most of the U.S., except for the far southern and southeastern states; steelhead: northern California to Alaska, the Great Lakes |
| **PRIMARY HABITAT** | rivers, streams, lakes, ponds |
| **MAJOR PREY** | rainbow trout: aquatic insects, small fish; steelhead do not eat during their spawning migration but otherwise consume small fish |
| **LURES AND BAITS** | rainbow trout: flies, spinners; steelhead: spoons, spinners, plugs, flies |
| **PRIMARY TACKLE** | rainbow trout: spinning, fly; steelhead: spinning, baitcasting, fly |

Rainbows in small waters generally don't grow very large, and are common from two to four pounds. Those in large inland lakes may weigh from seven to ten pounds and can grow to over 30 pounds. Steelhead grow much larger on average, and may exceed 40 pounds, although the norm is five to 12 pounds.

The preferred habitat of rainbow trout is moderately flowing streams with abundant cover and deep pools, yet they do well in large rivers and lakes. They prefer water temperatures of 55–64 degrees, but can tolerate up to 70 degrees. They spawn in spring.

Steelhead have similar interests in rivers, and wander the depths of large lakes, much like salmon, searching for food. Most steelhead appear in rivers from August into the winter. Some rivers have spring-run steelhead, which end their ocean or big-lake journeys in mid-April, May and June; bright, shiny spring-run fish may be mixed with well-marked resident rainbows that have spent the entire winter waiting for the spring spawning period. Still other populations return to their home stream in July and are known as summer steelhead. Spring and summer runs are much less common than fall runs. Insects, crustaceans, snails, leeches and small fish are the main food for rainbow trout. Steelhead in large lakes primarily consume such pelagic baitfish as alewives and smelt. When making spawning runs in rivers and streams, they do not feed.

Spawning-run steelhead in rivers and streams are eagerly pursued through winter and spring by anglers using flies, spinners, spoons, diving plugs and natural baits, especially salmon or trout eggs and crayfish tails; they like fast, deep, running water, often gathering in holes, in whitewater areas, and behind rocks and log jams. Angling techniques, in general, are similar to those used for chinook salmon in rivers, with emphasis on getting down to, and drifting along, the bottom. There is a significant fishery for lake-dwelling steelhead in the Great Lakes, which are caught in a manner similar to salmon and brown trout, primarily by trolling. Both deep and shallow trolling methods are employed according to season and water temperatures. Angling methods for rainbow trout differ depending on whether the fish are found in rivers or lakes, and are similar to fishing for other trout species, with weighted spinners, wobbling spoons, assorted streamer flies, egg-imitation flies and worms fished near the bottom especially preferred in river and stream habitats. More about this is covered in the section on brook trout and brown trout (see pages 31–34). In rivers that also contain salmon runs, rainbow fishing success is typically greatest in the spring and fall before and after the large salmon runs.

A STEELHEAD LIKE THIS WASHINGTON STATE SPECIMEN WOULD MAKE ANYONE HAPPY.

# REDFISH

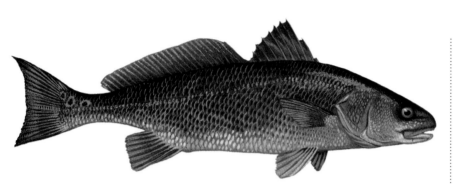

**The redfish is the most prominent member of the large family of drums and croakers. Technically it is a red drum, and also commonly known as channel bass, although it is not a bass of any kind. It is the second largest member of this family, behind black drum, and is so widely distributed from the mid-Atlantic to Florida and across the entire Gulf of Mexico that it is one of the top coastal sportfish in the U.S.**

LIKE OTHER DRUM, the redfish is capable of making a drumlike noise by rapping a muscle against its swim bladder, which acts as a resonator and amplifier for the sound. This noise is believed to be associated with locating and attracting mates, and can sometimes be heard from a good distance, occasionally by people above the water. Like striped bass, redfish were intensely harvested by commercial fishermen for market purposes until fishing restrictions or outright bans were enacted to stem the collapse of populations. Bans on netting resulted in a dramatic comeback of Gulf of Mexico stocks, and caused exceptional growth in light tackle inshore fishing in that region.

A coppery-bronze color with a subterminal mouth and blunt nose, the redfish is distinguished by having one (usually) or several black dots at the base of its tail. It is more elongated in body than a black drum, and lacks its cousin's chin barbels. Redfish can grow to over 90 pounds, and are common in the mid-Atlantic over 30 pounds, although such large individuals are rare in the Gulf of Mexico, where reds under 15 pounds are the norm and the average is less than five pounds.

Smaller redfish generally inhabit brackish water and saltwater on sand, mud and grass bottoms of inlets, shallow bays, tidal passes, bayous and estuaries. They are also found in shallow waters near piers and jetties and on grassy

SMALL REDFISH, LIKE THIS ONE FROM THE COOPER RIVER IN SOUTH CAROLINA, ARE OFTEN FOUND IN MARSHY AREAS FEEDING ON CRABS.

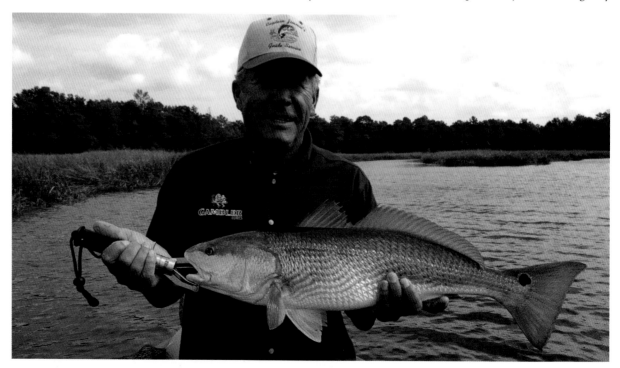

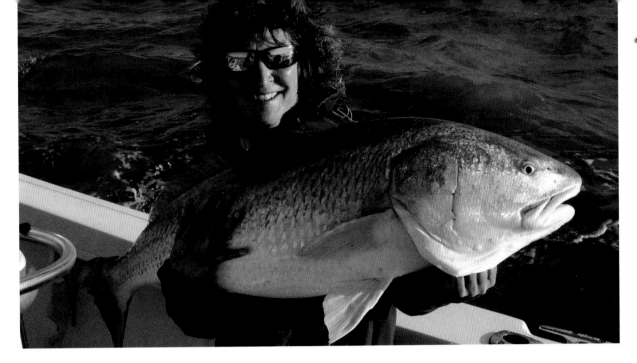

A LARGE RED DRUM CAUGHT IN CHESAPEAKE BAY ON A BOTTOM-SOAKED BAIT.

flats, and can tolerate freshwater, where some have been known to dwell permanently. Larger redfish prefer deeper waters of lower estuaries and tidal passes, and are also caught along beaches in classic surf-fishing situations. Bigger fish may move offshore.

Redfish use their downturned mouth, plus their senses of sight and touch, to locate forage on the bottom through vacuuming or biting the bottom. They feed on crabs, shrimp, sand dollars, menhaden, mullet, pinfish, sea robin, lizardfish, spot, Atlantic croaker and flounder. In shallow water, redfish are often observed browsing head-down with their tails slightly out of the water, a behavior called "tailing."

Redfish can be very easy to catch at times, and spooky and difficult at others. They can be caught with a variety of methods, lures and baits, in clear as well as turbid waters, and along beaches, at inlets, on grass flats, in marshes, in deep channels and around shoals.

## AT-A-GLANCE

| | |
|---|---|
| **SCIENTIFIC NAME** | *Sciaenops ocellatus* |
| **FAMILY** | drum |
| **TYPE** | saltwater |
| **SPAWNING** | fall |
| **PRIME FISHING** | summer, fall |
| **RANGE** (NORTH AMERICA) | Maryland to Florida, Gulf of Mexico to northern Mexico |
| **PRIMARY HABITAT** | inlets, bays, and estuaries |
| **MAJOR PREY** | crabs, shrimp, small fish |
| **LURES AND BAITS** | jigs, plugs, spoons, flies, live crabs and shrimp |
| **PRIMARY TACKLE** | baitcasting, spinning, fly |

Sight casting is the most favored fishing method. Anglers spot nearshore roving schools along beaches, or stalk tailers that are feeding in shallow water. Such stalking is especially conducive to fly fishing, using streamer flies and crab or bunker imitations. Eight- to ten-weight fly rods are fine for quiet backcountry conditions, but ten- to 12-weight outfits are necessary for the bigger fish in surf and beach conditions. However, casting with small plugs and with soft plastic baits is equally favored for sight fishing.

Anglers in boats try to get a high vantage point and cruise along beaches and inlets looking for dark masses of fish just under the surface in water that varies from a few feet to 20 feet deep. Sunny conditions are generally necessary for this, and clear water makes for the best visibility. Casting blindly to unseen fish can also be productive. Working marsh edges on an outgoing tide is likely to produce generally smaller redfish, but is excellent for light tackle users and small boat anglers.

Smaller redfish are commonly taken on leadhead jigs fished with soft trailers. When the water is off-colored or turbid, rattling plugs, single-blade (gold) spinnerbaits with a soft-bodied lure, and popping or walking surface plugs can be effective. Smaller fish in estuaries and flats are suitable for many of the same lures that catch largemouth bass in freshwater, as well as medium to light spinning and baitcasting outfits. Ten- to 15-pound lines are generally adequate. Live baits such as crab, shrimp, mummichogs, and finger mullet are effective.

The bigger redfish of the Atlantic surf generally require sturdier tackle, biggler lures, and heavier line. Cut mullet or menhaden, and crab (hard, soft, and shredders) are the preferred baits. Redfish frequently mouth bait before running off with it, so you need to react accordingly. When caught, redfish are not flashy fighters, but they are strong and stubborn. Larger specimens are very powerful.

# ROCKFISH

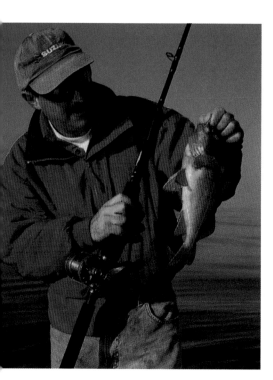

THIS VERMILION ROCKFISH WAS TAKEN IN DEEP WATER NEAR MARINA DEL REY, CALIFORNIA.

**In North America, rockfish are a prominent and important part of Pacific sport fishing from Alaska to Mexico, with numerous species occurring in different parts of this range. Most are good to eat and are also important to the commercial fishing industry, which catches them in otter trawls. Many stocks are overexploited, however—a situation compounded by continued harvest, the site-specific (non-migratory) nature of these fish, and the fact that many fish, having been caught from deep water, suffer a burst air bladder, and are unable to be released.**

. . . . . . . . . . . . . . . . . . . . . . . . . . . . .

MOST ROCKFISH are caught by anglers in deep water, using bottom-fishing tactics or mid-water drifting. Though commendable as food, rockfish are not known for their great battles, although the larger specimens of some species will provide good sport. Among the more commonly encountered species are the black, blue, copper, quillback, vermilion, and yelloweye rockfish, and the bocaccio.

Most rockfish caught by anglers are in the 20- to 24-inch range, although some may attain 40 inches in overall size. Rockfish have bony plates or spines on their head and body, a large mouth, and pelvic fins attached forward near the pectoral fins. The spines are venomous and can cause pain and infection. Some species are brightly colored, and since all appear somewhat perch-like or bass-like, they are often incorrectly called sea bass.

Rockfish are slow-growing and extremely long-lived. Some live in the shallower nearshore waters of the continental shelf, while others inhabit deeper waters on the edge of the continental shelf. They feed on a variety of food items, with mature fish preferring sand lance, herring and small rockfish, as well as crustaceans.

Rockfish are found around rocky bottoms, and often at depths exceeding 200 feet. Ledge-like dropoffs, deep rock valleys and craggy peaks are especially good, as they contain holes and crevices for hiding. Heavy weights or jigs are needed to get to the bottom in such depths; thus, eight to 16 ounces are used depending on the circumstances. Metal lures and jigs are often fished with a plastic grub or piece of squid attached; these are bounced off the rocks but can also be fished up through the water column, as some species are not tight to the bottom. Squid is the preferred bait, because it is firm enough to stay on the hook while being chewed upon.

Lighter lures and multi-bait rigs are used in water under 100 feet, although this is usually where smaller rockfish are found. Herring, shrimp, worms, squid, small live fish and strips or pieces of fish are used for bait. Some rockfish are caught near the surface and are susceptible to casting with lures and perhaps flies, although this usually occurs when the water is clear and calm. The usual bottom rig here has three to six hooks above a heavy sinker. Low-stretch lines are helpful when deep fishing for rockfish.

## AT-A-GLANCE

| | |
|---|---|
| SCIENTIFIC NAME | assorted depending on numerous species. |
| FAMILY | rockfish |
| TYPE | saltwater |
| SPAWNING | late winter, early spring |
| PRIME FISHING | summer |
| RANGE (NORTH AMERICA) | Alaska to Mexico |
| PRIMARY HABITAT | coastal deep water, primarily over hard bottoms |
| MAJOR PREY | assorted fish |
| LURES AND BAITS | heavy jigs, cut and strip baits, squid |
| PRIMARY TACKLE | medium to heavy conventional |

# SEATROUT AND WEAKFISH

**Members of the same family as drum and croaker, seatrout and weakfish are popular saltwater species caught inshore along beaches and in bays and estuaries, making them available to a host of shore, surf and boat anglers. Similar in some respects, they are excellent table fare and have been commercially overfished, resulting in declined numbers, although seatrout have benefited from the cessation of gillnetting.**

. . . . . . . . . . . . . . . . . . . . . . . . . . . . .

A LTHOUGH THERE ARE SEVERAL SPECIES of seatrout, the most prominent is the spotted seatrout, which is commonly known as a speck, speckled trout or simply trout. These occur along the Atlantic and Gulf of Mexico coasts, but are most abundant from Georgia through Florida and across through Texas.

Spotted seatrout are dark gray or green on the back, with sky-blue tinges shading to silvery and white below, and round black spots on the back, tail and dorsal fins. They can weigh up to 17 pounds, but are common from one to three pounds, with fish over seven pounds considered large. Seatrout inhabit the sandy and grassy bottoms of shallow bays, estuaries, bayous, canals and beaches, and can also be found around oil rigs usually within ten miles of shore. They are considered schooling fish but are not migratory, and rarely move over 30 miles, although they do head into deeper waters or deep holes to avoid cold temperatures. Shrimp and small fish are their primary food, but they also eat mullet, menhaden and silversides.

Spotted seatrout are caught on a variety of offerings because they feed throughout the water column. Anchoring and casting lures or stillfishing with bait, drifting under the occasional control of an electric motor or pushpole and casting, and trolling slowly through holes and channels, are all practiced in appropriate places and conditions.

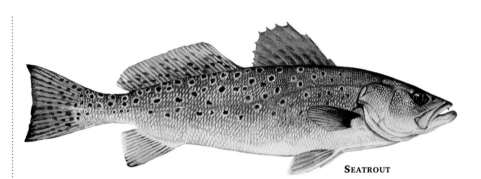

**SEATROUT**

Shrimp and minnows are the most common live bait, but cut mullet, softshell crabs, worms and squid are among other effective natural baits. Popular lures include soft worms, bucktail jigs, grubs and jigs with assorted soft tails, surface and shallow-swimming plugs, spoons and streamer flies. Jigs with soft tails, either curly, grub-shaped or shrimp-shaped,

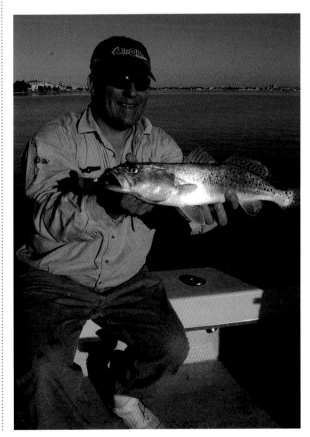

A NICE SPOTTED SEATROUT CAUGHT ON A SOFT-BODIED JIG IN TAMPA BAY, FLORIDA.

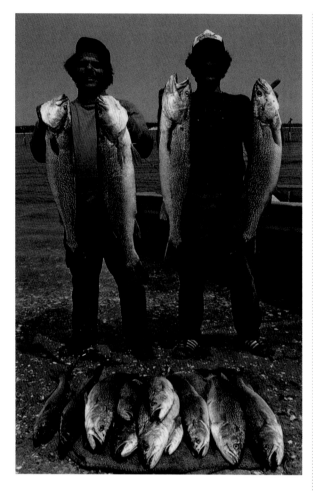

LARGE WEAKFISH FROM
LONG ISLAND, NEW YORK.

and lavender on the sides with a golden tinge; numerous small black spots speckle the top, sometimes forming wavy diagonal lines. Unlike the spotted seatrout, its spots do not extend onto the tail or the second dorsal fin, and are not as widely spaced. Weakfish occur on the east coast from Florida to Massachusetts, being most abundant from North Carolina to Florida in the winter and from Delaware to New York in the summer. They commonly range from one to four pounds, but can weigh as much as 19.

Like seatrout, weakfish inhabit sandy and sometimes grassy bottoms in shallow waters along shores and in large bays and estuaries, including salt marsh creeks and river mouths, although they do not enter freshwater. They eat crabs, shrimp, menhaden, silversides, killifish and butterfish, and forage at different levels as necessary.

Drifting or stillfishing with bait is very popular. Shrimp, squid, shedder or peeler crabs, worms, eels, mullet and other small fish are used, plus pieces of mackerel or bunker. Chumming is also effective. Many lure users fish with metal jigs, grubs, or bucktail jigs garnished with a plastic worm body, whether drifting in a boat or anchored. Bucktails, usually garnished with a soft action tail or a strip of squid or other bait, are highly favored lures, as are leadhead jigs with soft bodies. Casting with plugs or streamer flies is usually done when the fish are fairly shallow and in bays and estuary environs. Concentrate around oyster bars, bridges and inlet jetties, and focus on structure and edges. Light- to medium-spinning or baitcasting tackle is usually just right; six- to 12-pound line is commonly used by small-boat anglers, often on standard freshwater tackle. Slightly heavier gear may be employed for trolling and also for surf fishing.

are especially favored, and these are usually worked slowly via casting. Light tackle is very appropriate for these fish, with many anglers using light baitcasting or light to medium-light spinning tackle, and a lesser number employing flycasting gear. In the Gulf, sight fishing for trout (and redfish) is extremely popular, and shallow-water craft are used for negotiating abundant grass flats where fish are visually located and then cast to with bait, lures or flies. In other areas, fishing by wading or casting from boats is common, usually for unseen fish located in such feeding or resting places as grass and shellfish beds or in deep holes or channels, where blind casting or even trolling may be effective.

Occasionally seatrout feed on, or close to, the surface; then, surface plugs and fly rod poppers work. Generally, these fish are active below the surface and are caught on shallow-swimming plugs that imitate small baitfish, or on bottom-walking jigs. Many anglers use a popper and natural shrimp, working the surface popper to attract the attention of a trout to the shrimp.

Weakfish, which are sometimes called northern seatrout and gray trout, are named for their tender mouth, not for their fighting ability, as this species strikes hard and makes one or two strong runs after being hooked. It appears dark olive or greenish to greenish-blue on its back, and blue, green, purple

## AT-A-GLANCE

| | |
|---|---|
| SCIENTIFIC NAME | spotted seatrout: *Cynoscion nebulosus*; weakfish: *Cynoscion regalis* |
| FAMILY | drums and croakers |
| TYPE | saltwater |
| SPAWNING | spring through summer |
| PRIME FISHING | summer, fall |
| RANGE (NORTH AMERICA) | spotted seatrout: Alabama through Florida and west to northern Mexico; weakfish: Massachusetts to Florida |
| PRIMARY HABITAT | near shore in bays and estuaries |
| MAJOR PREY | spotted seatrout: shrimp, small fish; weakfish: shrimp, small fish, crabs |
| LURES AND BAITS | jigs, plugs, flies, live shrimp and minnows, cut bait |
| PRIMARY TACKLE | spinning, baitcasting, fly |

# SHARKS

Some 370 species of shark exist worldwide, although only a relative few are either encountered by anglers or are of interest to them for sportfishing purposes. Nevertheless, angling for sharks has increased markedly since these relics of the past became good movie subjects, and intense pressure from many sources has impacted their numbers.

· · · · · · · · · · · · · · · · · · · · · · · · · · · · · · · · ·

S HARKS MUST SWIM otherwise they sink, because their bodies are slightly denser than water. Thus, they must move forward, a physical requirement that requires a lot of energy, which in turn means a constant need to eat. Naturally, this bodes well for angling.

The hunt for food is greatly aided by the superior senses of sharks, which constantly sample the water for odors and sounds. Sharks can smell blood at the one-part-per-million level or less and are drawn to bleeding prey. Low-frequency vibrations, such as the sounds made by something splashing in the water, attract sharks, and their hearing is further enhanced by the lateral line, which extends along the head and sides of the body and is sensitive to vibrations, currents and pressure changes. Additionally, the visual system of sharks is well developed and used both in high and low light levels. Shark eyes include a special structure called the *tapetum lucidum* that increases their sensitivity in low light levels.

As if all of this was not impressive enough, sharks have electroreceptors in their snout and lower jaw that can detect tiny electrical fields created by their prey's muscular movement. This sensory system may also help the shark navigate. The bottom line is that sharks are very efficient predators, a fact that anglers should take into consideration when pursuing them.

In North America, some of the shark species that anglers catch or pursue with some regularity include blacktip, blue, brown, dusky, bonnethead, lemon, leopard, mako, porbeagle, sandbar, sharpnose, tiger and thresher shark. Some are encountered on shallow flats, some in inshore environs, and some offshore. The mako is the premier shark, not only because it is such great eating, but

## AT-A-GLANCE

| | |
|---|---|
| **SCIENTIFIC NAME** | assorted depending on numerous species |
| **FAMILY** | shark |
| **TYPE** | saltwater |
| **SPAWNING** | varies |
| **PRIME FISHING** | summer |
| **RANGE** (NORTH AMERICA) | varies with species; different sharks are found on all North American coasts |
| **PRIMARY HABITAT** | varies with species from inshore to offshore |
| **MAJOR PREY** | assorted fish |
| **LURES AND BAITS** | assorted live, dead, and cut natural baits |
| **PRIMARY TACKLE** | medium to heavy conventional and big game |

because it fights hard, has good endurance and is a fast, active swimmer that jumps spectacularly. It also grows quite large; in fact, female makos weigh over 600 pounds before becoming mature, and they can grow to over 1,000 pounds. Most sharks are released by anglers today, with many being tagged for conservation efforts.

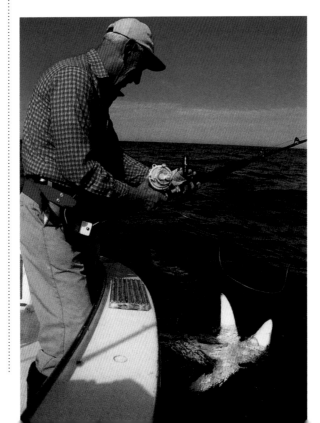

THIS BLUE SHARK, ABOUT TO BE LANDED AND RELEASED OFF MONTAUK, NEW YORK, APPEARS TO BE EYEBALLING ITS CAPTOR.

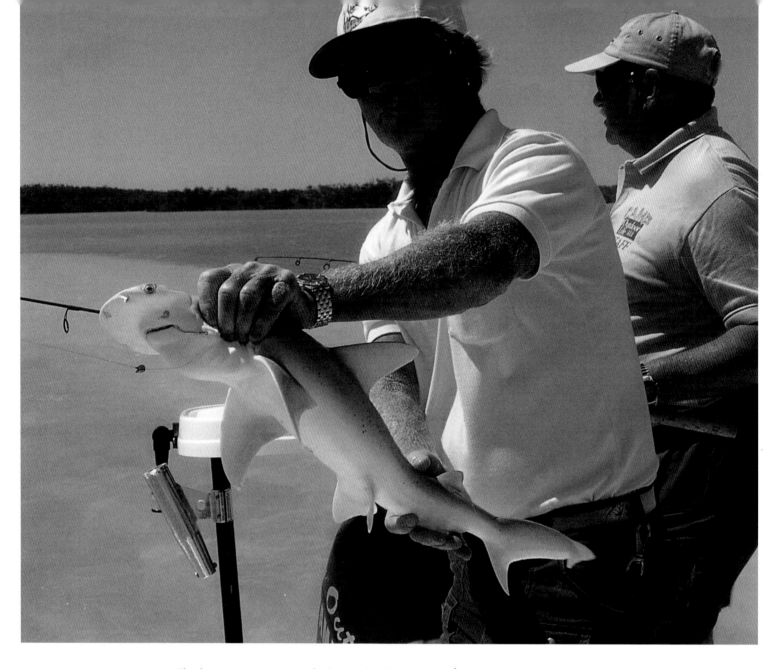

Sharks are opportunistic feeders and will often eat whatever is available. Most sharks in North America are caught in open water where even large specimens can be handled on relatively light tackle if the angler handles the tackle well and is patient. Twenty- and 30-pound-class outfits are excellent for most sharks caught offshore; for makos, 50- and 80-pound tackle may be used. With modern stand-up tackle, belts and harnesses, there is no need to sit in a chair to fight even the largest sharks.

Light tackle is most appropriate for smaller sharks, such as blue sharks, for example, especially if they can be chummed to the boat and eyeballed to select spinning, baitcasting or flycasting tackle. Some sharks that roam the flats, like blacktips and lemons, can be caught by casting lures and flies to them.

Most shark fishing is done away from the flats in the ocean, where sharks are scattered widely and not tied to a particular area. Usually, sharks have to be attracted to the angler. That means chumming to create a steady slick and stream of food. Oily fish, like bluefish, mackerel and menhaden, make good shark chum. Sharks can detect this from great distances and this permits long boat drifts.

Hooked baits are set from just under the surface down to about half the water depth. Floats or balloons hold baits at the desired depths, and sinkers are normally required to hold bait down. Almost any kind of hooked bait will work at times, with the same fish used for chum being ideal. Natural baits can be fished whole or as fillets. To enhance unharmed release of your catch, use just one hook in the bait and set the hook fairly quickly after a shark picks it up. Some species of shark, like mako and thresher, can be caught by trolling. However, it is best to add a baitfish to a heavy trolling lure, then slow-troll it below the surface. Do not troll the lure without bait on it.

It is necessary to use wire leaders when shark fishing, incidentally. Fifteen feet of No. 12 to 15 single-strand wire is a good choice for large sharks; this length will allow a big shark to spin on the leader without its teeth reaching the main line. This wire will kink if a shark spins, but it is preferable to braided wire, which large sharks might chew through.

# SNAPPERS

There are more than 100 species of snappers around the world, and half a dozen of them are of interest to anglers in tropical or subtropical waters of North America. Many snapper species are important commercial fish and high-quality food, and reef-inhabiting species are popular with anglers. Most are schooling fish and generally bottom dwellers. Species vary in attainable size and habitat preference from shallow near-shore and inshore waters to deeper shelf environs.

. . . . . . . . . . . . . . . . . . . . . . . . . . . . . . .

## AT-A-GLANCE

| | |
|---|---|
| **SCIENTIFIC NAME** | gray snapper: *Lutjanus griseus*; red snapper: *Lutjanus campechanus*; yellowtail snapper: *Ocyrus chrysurus* |
| **FAMILY** | snapper |
| **TYPE** | saltwater |
| **SPAWNING** | summer |
| **PRIME FISHING** | spring and summer |
| **RANGE** (NORTH AMERICA) | gray and yellowtail snapper: Massachusetts to Mexico; red snapper: Massachusetts to Florida, Gulf of Mexico |
| **PRIMARY HABITAT** | gray snapper: offshore reefs and wrecks; red snapper: deep rocky bottoms; yellowtail snapper: coral reefs |
| **MAJOR PREY** | small fish, shrimp, crabs, worms |
| **LURES AND BAITS** | jigs, squid, cut bait |
| **PRIMARY TACKLE** | gray and red snapper: medium to heavy conventional; yellowtail snapper: light and medium spinning, baitcasting |

ONE OF THE MORE SIGNIFICANT of the snappers in North America, particularly in Florida, is the gray snapper, also known as the mangrove snapper. A variable gray color, and favoring coral or rocky reefs, rock outcroppings and shipwrecks, the mangrove snapper averages about a pound, but some ranging from eight to ten pounds have been caught in some locations.

Also significant is the red snapper, which is widely recognized because of its pinkish color; it is one of the most valuable commercial fish and has been severely overfished. The red snapper is usually found from 12 to 24 inches long, but may grow much larger; it is mainly found in the Gulf of Mexico and along the southern Atlantic coast over a rocky bottom at depths of 60 to 400 feet.

These snappers are opportunistic bottom feeders that eat other fish, shrimp, crabs and worms. Both are caught with bottom fishing methods at the right depth over irregular terrain. Anglers fish for mangrove snapper offshore from head boats and smaller private boats using sturdy rods, heavy monofilament line, and two-hook bottom rigs baited with squid and cut fish. These fish are also caught in mangrove- and seagrass-dominated estuaries using shrimp, clams, bloodworms and sometimes small jigs.

Red snappers are caught over reefs, wrecks and oil rigs, usually fishing with stout tackle and lines in the 50-pound class. Multiple- and single-hook bait rigs are used. Squid heads with long tentacles, whole medium-size fish, and fresh bloody strips of little tunny or greater amberjack catch big red snapper, which prefer a still or very slowly moving bait.

Another popular species, which is especially colorful and which makes superb eating, is the yellowtail snapper. An olive or bluish-gray fish with yellow stripes and a forked yellow tail, the yellowtail snapper is frequently caught up to three pounds, and is abundant in southern Florida and the Bahamas, usually occurring in coral reefs in loose schools.

A scrappy fish that puts a good bend in a light- to medium-action spinning rod, it is caught inshore by using cut fish and squid on the bottom from bridges and piers, and offshore by fishing over reefs from small private boats and party boats. Yellowtails are often attracted to chum, and can be caught higher in the water column when they come into an established chum slick, although they often do not take bait as aggressively as some other snappers, and many are not hooked due to their small mouth or the use of too large a hook.

A YELLOWTAIL SNAPPER FROM KEY WEST, FLORIDA.

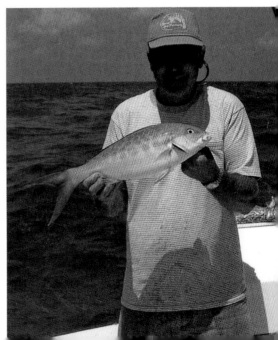

# SNOOK

**There are about a dozen species of snook worldwide, with the common snook most prevalent in Florida and the black snook present in portions of Mexico. A relative of the larger-growing barramundi of Australia and Nile perch of Africa, snook are highly prized for their flesh as well as sporting virtue.**

. . . . . . . . . . . . . . . . . . . . . . . . . . . . . . . .

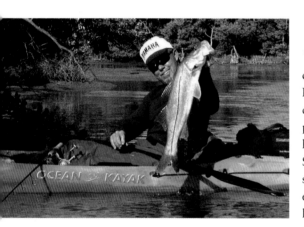

THIS SNOOK WAS CAUGHT IN THE BACKWATERS OF FLORIDA'S EVERGLADES.

SNOOK WERE A FAVORED commercial species in Florida until they were designated a gamefish by law. Decades ago there was a severe decline in the Florida snook population because of overfishing, loss of habitat and pollution. Since being given protected status in Florida in 1982, which established a legal size, a bag limit and a closed season during the summer spawning period, numbers have increased to good levels.

Known for their hard fight and aggressive strike, snook jump, run, dive deep, pull very hard, and are generally tough to land. Many snook are lost by anglers, in part because these fish have a penchant for heavy cover; when hooked, they often try to reach cover and cut the line.

Prone to ambushing prey as currents sweep food into their vicinity, snook feed on both freshwater and saltwater fish, shrimp, crabs and larger crustaceans. Snook can grow to over 50 pounds, but are only occasionally caught over 20 and are commonly four to eight pounds.

Although not anadromous, snook are able to tolerate freshwater and low-salinity saltwater. They primarily inhabit warm, shallow coastal waters, preferring fast-moving tides and the shelter of estuaries, lagoons, mangrove areas and brackish streams, as well as freshwater canals and rivers. Snook are not tolerant of water temperatures below 60 degrees. Their winter abode is protected, stable-temperature areas such as those under bridges, in ship channels, warm-water outflows near power plants, and the upper reaches of estuaries.

Snook are primarily caught by casting with lures or flies and by fishing with live bait. Small mullet are good, and livelined by anglers who stillfish or drift.

Casters primarily work shallow near-shore areas, often casting into thick mangrove stands and up under the bank. Accurate casting is often very important, as you need to pitch a plug or fly into an opening or back under the brush rather than land it on the edge of the cover.

Small spoons, poppers and flies are cast, but the favorite snook lure is a walking plug that can be worked rapidly on the surface, or a darting shallow-running plug that can be worked in jerky, erratic motions just under the surface.

A moving tide, usually the high ebb, produces well for snook. Some sight fishing is done by anglers drifting and looking for cruising fish on cover-laden flats or shores, but most angling is blind prospecting in likely places. Fly fishing is most prudent when fish can be seen, but is also done in known snook-holding cover where fish are not visible. Popping bugs and streamer flies are the terminal items.

Snook may be found singly or in groups, with larger fish generally loners. Some angling is done in deep holes with jigs or by trolling, often in the winter when cold water makes snook sluggish. Some night fishing, primarily around bridges and piers, is also done in the summer.

Although a stiff-tipped rod is needed for properly working snook plugs, the tackle may be similar to that used in largemouth bass fishing. Baitcasting gear is better for accuracy and fish control, with 12- through 17-pound line the norm.

## AT-A-GLANCE

| | |
|---|---|
| SCIENTIFIC NAME | common snook: *Centropomus undecimalis* |
| FAMILY | snook |
| TYPE | saltwater |
| SPAWNING | late spring, early summer |
| PRIME FISHING | summer, fall |
| RANGE (NORTH AMERICA) | primarily Florida |
| PRIMARY HABITAT | near shore waters in estuaries and lagoons, mangrove flats |
| MAJOR PREY | assorted fish, shrimp, crabs |
| LURES AND BAITS | plugs, jigs, flies, live mullet |
| PRIMARY TACKLE | baitcasting |

# STRIPED BASS

The striped bass is one of North America's most distinguished and remarkable gamefish. It has been abundant and important since colonial days; it has experienced wide population fluctuations, including in recent times; it has been a staple for recreational and commercial fishing; it has adapted to a strictly freshwater existence, which has enabled it to expand its range greatly from the Atlantic coast to the Pacific and to be available in both sea-run and landlocked forms; and it has been successfully crossbred with other species.

. . . . . . . . . . . . . . . . . . . . . . . . . . . . .

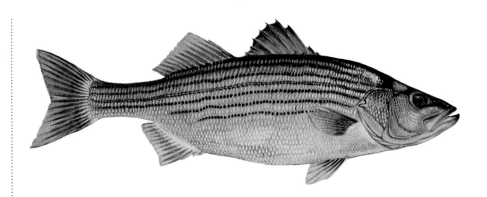

ALSO KNOWN AS ROCKFISH, the sea-run striper is originally a fish of the mid-Atlantic coast, with major stocks originating in Chesapeake Bay, Delaware Bay and the Hudson River. As recently as the 1980s, this coastal population was in dire straits due to commercial overharvest and pollution. However, strict control measures, coupled with some improvements in water quality, have allowed these fish to rebound to exceptional numbers, providing a sportfishery that has energized many thousands of anglers.

Both sea-run and landlocked stripers, which are characterized by seven or eight horizontal stripes along their body, are scientifically the same fish, although the landlocked form have adapted to a strictly freshwater existence. This is possible because the striper is anadromous; each spring, sea-run stripers migrate up coastal bays and rivers to spawn, returning afterward to the ocean. In freshwater, these fish exhibit the same behavior, using a large lake like the ocean. Spawning runs usually take place when the water temperature is in the mid- to upper 50s.

In freshwater, the striped bass has been crossed with a related and strictly freshwater species, the white bass, to create a hybrid fish. That fish is usually called a hybrid striper, but is also known in some places as whiterock bass

or sunshine bass. Striped bass differ from hybrids in the regularity of their stripes, the hybrid usually has interrupted stripes by the fact that they cannot grow as large.

Sea-run striped bass average five to ten pounds, though they will often reach weights in the 30- to 50-pound range and can grow to about 80 pounds. In freshwater they can attain nearly the same overall weight, with the average being slightly smaller, although this depends on the particular lake. Hybrids are typically found in the five-pound class, but can grow to just over 20 pounds.

## AT-A-GLANCE

| | |
|---|---|
| **SCIENTIFIC NAME** | *Morone saxatilis* |
| **FAMILY** | temperate bass |
| **TYPE** | saltwater and freshwater |
| **SPAWNING** | spring |
| **PRIME FISHING** | saltwater: late summer, fall; freshwater: year-round |
| **RANGE (NORTH AMERICA)** | saltwater: Nova Scotia to Florida, Gulf of Mexico coast to Louisiana; northern California to Washington; freshwater: widely introduced as pure and hybrid strains in reservoirs from New York to Florida and west to California, with the exception of the upper Midwest, Plains, and Rocky Mountain states |
| **PRIMARY HABITAT** | saltwater: near shore coastal waters, bays, estuaries, rivers; freshwater: lakes and rivers |
| **MAJOR PREY** | saltwater: assorted fish, especially menhaden, worms, eels; freshwater: primarily gizzard and threadfin shad |
| **LURES AND BAITS** | plugs, jigs, jigging spoons, flies, live eels, cut bait |
| **PRIMARY TACKLE** | light conventional, baitcasting, spinning, fly |

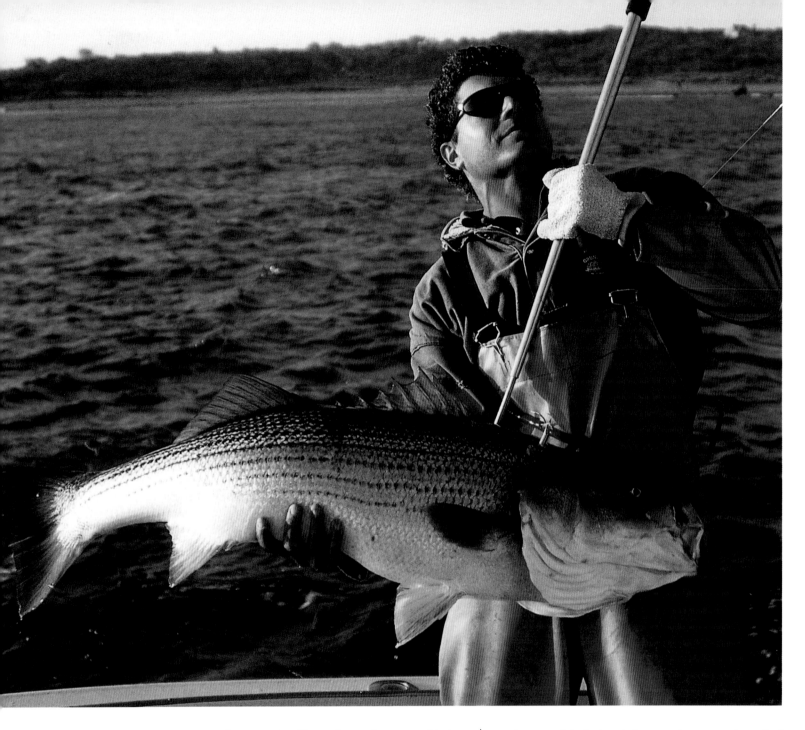

THIS LARGE STRIPED BASS STRUCK A TUBE LURE TROLLED NEAR MONTAUK, NEW YORK.

In saltwater, striped bass migrate along coastal inshore environs and tidal tributaries. They are often found around piers, jetties, surf troughs, rips, flats and rocks. During spawning runs they can also be found in channels of medium to large rivers. In freshwater, they are commonly found in open-water environs, or in the tailrace below dams. They are seldom found near shore or docks or piers, except when chasing baitfish.

Stripers have a large mouth and an appetite to match. Sea-run fish feed heavily on herring, menhaden, flounder, alewives, silversides, eels and smelt, as well as worms, squid and crabs. Freshwater striped bass prefer shad, herring and minnows.

Feeding times vary, although stripers are more often nocturnal feeders. Many anglers have greater success in low-light conditions and after dark. Unlike some anadromous fish during their spawning run, stripers feed while migrating to their spawning grounds, although they reportedly cease feeding shortly before spawning.

Although stripers are voracious, they are also selective, usually feeding exclusively on one food item at a time. One of the keys to catching striped bass is to understand what they are eating at a given time, or to try all their favorite foods until you find what they will take. In saltwater, that usually boils down to three or four favorite items, and even less in freshwater.

Striped bass in saltwater are caught by all the different ways of fishing known to anglers. They can be taken by trolling live baits, rigged baits, spoons, plugs, tube lures and just plain hardware. They can be taken by casting with either spinning, baitcasting, or conventional equipment and using plugs, spoons, live bait, rigged bait or cut bait.

They can be taken from an anchored boat using casting equipment or conventional equipment to fish on or near the bottom or at different levels in the water column, with or without chum. They can be taken from boats drifting with the tide or pushed by the wind and bouncing bucktailed jigs off the bottom, dragging live eels or bunker near the bottom, or even using chunks of cut bait. Striped bass can also be caught on fly tackle, using streamers or artificial replicas of real baitfish, in every environment in which they swim.

In saltwater, stripers are found in open beaches, in rips where tidal streams flow into bays or open water, off rock jetties or concrete walls, under docks, piers and bridges, or around pilings where bait naturally congregate. They are also caught in the fall when plundering large schools of moving baitfish, which is a watch-run-and-cast-quickly affair. Many anglers fish from the beach or from jetties, using long rods and plugs, jigs, soft plastics and bottom bait. Since these fish often move with the bait or tide, it is usually more effective to fish from a boat.

Drifting live eels from a moving boat is one of the deadliest methods, as is deep jigging with a heavy leadhead jig and an eel. Fishing with bunker (menhaden) or mackerel is also popular. Some trollers use an umbrella rig that holds four to six small tube lures, although it requires stout tackle to handle this. Others troll with large single tubes, usually on wire line, which have a propensity for catching fairly large-size fish. Still others troll with plugs and large jigs. Fly fishing for striped bass in saltwater,

incidentally, has increased, with both shore and boat anglers having success on shallow- to intermediate-depth fish with large streamer flies.

Tide plays a role in all striper fishing methods and locations. Many anglers who consistently catch bass will fish from the last hour of the flood through the first two or three hours of the ebb. To most coastal striper anglers, the two best periods to catch striped bass are in late spring and very early summer, and in mid- to late fall.

Stripers are predominantly nomads in freshwater, and locating these fish is sometimes a more formidable task than catching them. They are vigorous predators, however, just as in saltwater, and their habitats are usually blessed with abundant forage populations, primarily gizzard and threadfin shad. They, too, are good targets for various angling techniques, including using live bait, jigging, casting and trolling.

Casting is done to schools of fish feeding on large pods of bait near the surface (which is observed by watching for bird activity), and to fish in the tailrace waters below a dam. Live bait is stillfished while the boat is at anchor or slowly adrift, using enough weight to keep the bait at the proper depth and right below the spot where you have positioned it. Cut chunks or strips of bait are sometimes effective, but fresh, lively bait is usually preferred. Jigging is primarily done when stripers are holding in deep water in a defined area, using half- to two-ounce bucktail jigs and jigging spoons. Trolling may be practiced the most, either flatlining or downrigging, using a range of sizes and colors of plugs.

Long rods, in the eight-and-a-half- and nine-foot category, are popular for casting, trolling and bait fishing, especially if large fish are to be encountered. Baitcasting reels with large line capacity, a solid drag and a freespool clicker are most popular, using 17- or 20-pound line, though lighter line and other light tackle, including fly rods, are used in appropriate circumstances.

A CHUNKY HYBRID STRIPED BASS FROM A GEORGIA POND.

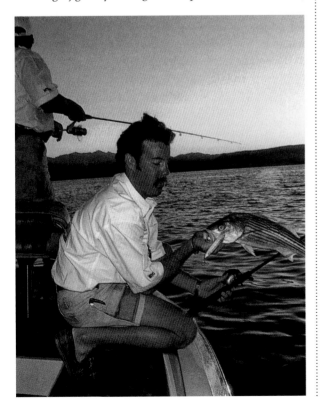

LEFT: THIS LAKE MEAD, NEVADA, STRIPER TOOK A SURFACE PLUG AT SUNRISE.

# TARPON

A fish of warm, tropical waters, the tarpon is one of the gamefish most associated with saltwater angling, thanks to its profound acrobatics, large size and tough demeanor. In North America, it is primarily found in Florida and the Gulf of Mexico. It is fairly abundant, thanks to the fact that it has no significant commercial value in North America, and is largely caught and released by anglers. Many people target this species when it appears on shallow flats, and all anglers appreciate the drama that ensues when a tarpon is hooked and its large silvery form rockets many feet out of the water.

A TARPON DANCES ON THE SURFACE AT DUSK.

## AT-A-GLANCE

| | |
|---|---|
| SCIENTIFIC NAME | *Megalops atlanticus* |
| FAMILY | tarpon |
| TYPE | saltwater |
| SPAWNING | late spring and summer |
| PRIME FISHING | spring |
| RANGE (NORTH AMERICA) | Virginia to Florida, Gulf of Mexico west and south to Mexico |
| PRIMARY HABITAT | near-shore coastal waters, bays, estuaries, inlets, flats |
| MAJOR PREY | assorted fish, crabs |
| LURES AND BAITS | plugs, spoons, jigs, flies; live mullet, crabs, shrimp, pinfish, and other baits |
| PRIMARY TACKLE | light conventional, medium to heavy baitcasting and spinning, fly |

NICKNAMED THE "SILVER KING" because of its brilliant-silver sides and belly, the tarpon has a compressed form with large, platelike scales, a huge mouth, and a distinctive upturned lower jaw. Although it is capable of growing to well over 200 pounds, a tarpon over 100 pounds is quite large, and most caught in North America are in the 40- to 60-pound class, although a fair number of fish from 60 to 120 pounds are landed annually. Tarpon have the remarkable ability to breathe both underwater and out of the water. When dissolved oxygen levels in the water are adequate, tarpon breathe through their gills, like most fish. When oxygen levels are depleted, however, they can also breathe by gulping air, which is then passed along to their highly-specialized swimbladder. The swimbladder functions as an accessory lung and even resembles that organ, with its spongy, highly-vascular tissue. The swim bladder can also be filled with air as needed to help the fish maintain its desired depth in the water. Scientists believe the tarpon's ability to breathe air is a nifty adaptation that allows it to survive in the stagnant, oxygen-poor pools and ditches it frequents.

North American tarpon are most abundant in estuaries and coastal waters, but they also occur in rivers and offshore marine waters, and occasionally on coral reefs. It is typical for tarpon to exist in schools, which number from several individuals to a dozen or more. They are opportunistic feeders as well, primarily foraging on a variety of fish, shrimp and crabs.

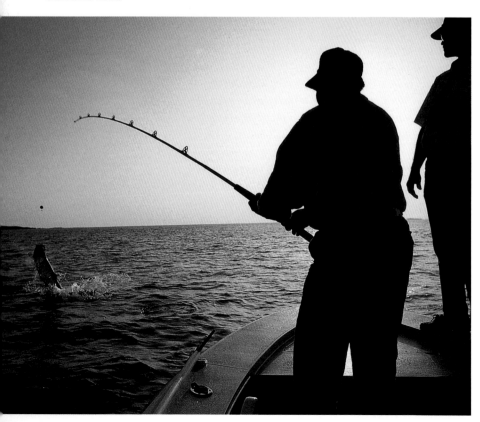

Anglers seek tarpon in rivers, bays, lagoons, shallow flats, passes between islands and mangrove-lined banks. Small tarpon up to 20 pounds are usually located in estuaries and river mouths, in freshwater rivers, and in sloughs and canals; these provide great fun on light tackle.

Fishing methods for most tarpon include drifting or stillfishing with live mullet, pinfish, crabs, shrimp or other natural bait, or casting with spoons, plugs or other artificial lures and flies. The best fishing can be at night when tarpon are feeding. Casting is most favored by many anglers, although it may not be appropriate when the fish are deep or unaggressive. Casters usually sight-fish, staking out a shallow-draft boat near a channel or hole or moving along shallow grassy flats, usually by poling. They wait for tarpon to come within casting range, or try to spot cruising fish and then move to intercept them.

A variety of plugs is used, with shallow runners fished in a whiplike or jerky, pull-pause retrieve being most effective. Surface plugs are also fished, and flycasters mainly employ large streamers and crab or shrimp imitations. Lures and flies are cast just ahead of a passing fish. Often there is only one chance at a cruising fish or school, so poor placement of the offering can spook the fish.

Although tarpon sometimes strike readily, even turning and moving a short distance to take a lure or fly, it is usually necessary to have your offering right in front of the fish in its path of travel. Finicky fish may ignore even a perfect presentation.

When using live bait, anglers drift or anchor and stillfish with bait presented under a float. Mullet, pinfish, crabs and shrimp are used, usually in deep areas or in channels. Some jigging is also done in deep-water holes and passes; slow-trolling, using big spoons, plugs and feathers, is attempted along the edges of flats near deep water.

Sharp hooks are an absolute necessity for tarpon, which have a tough, bony mouth. It is usually best to set the hook firmly several times. Many tarpon are nevertheless lost during one of their many jumps. They also have a tough gill plate that can cut the fishing line readily, so strong leaders are routinely used.

Standard tackle is a seven-foot baitcasting rod and a reel filled with at least 200 yards of 12- to 20-pound line, the heavier strengths being more commonly used, especially where large fish are possible. Flycasters use a nine- to ten-foot rod with plenty of backbone for ten to 12 weight line, and a fly reel that has plenty of strong backing line.

The tarpon's powerful leaps, sometimes up to ten feet out of the water, and bone-jarring bursts of speed, test the skill of anglers. The nature of their high and often-frequent jumps is such that many anglers are happy simply to get a few jumps out of a tarpon before it shakes the hook.

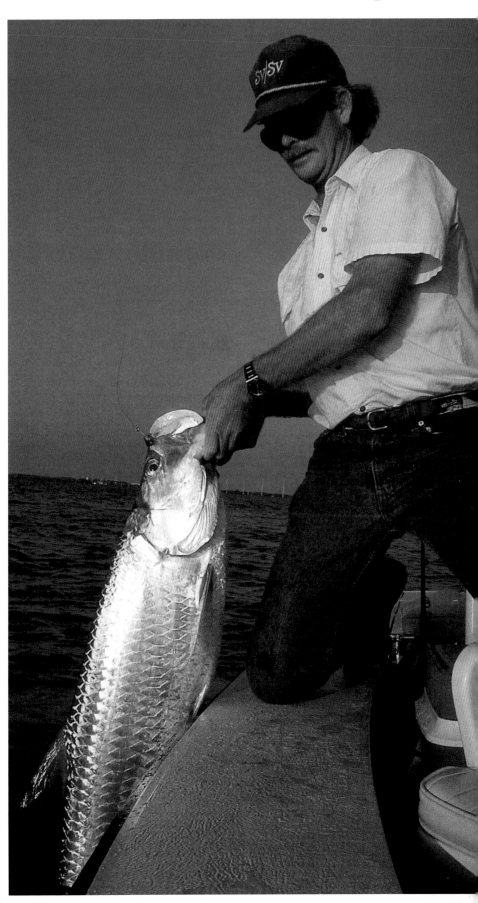

A SMALL TARPON CAUGHT ON LIVE BAIT IN THE FLORIDA KEYS.

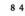

# TUNA
## (BLUEFIN, BLACKFIN, BIGEYE AND YELLOWFIN)

**Collectively tuna may be the most valuable fish in the world, particularly in light of the commercial demand worldwide for the various species. Most tuna are also great gamefish, although in North America, because of the migratory habits of tuna and the distances from the coasts that they are found, only a small number of anglers annually actually catch them.**

. . . . . . . . . . . . . . . . . . . . . . . . . . . . . . . . . . . . . .

RELATED TO MACKEREL AND BONITO, tuna are pelagic, schooling fish found throughout the open waters of temperate and tropical oceans. In North America, the tuna that most anglers are familiar with are the larger species—bluefin, bigeye and yellowfin—plus blackfin tuna, albacore, skipjack tuna and little tunny. While abundant at times and in certain places, these fish are heavily exploited, especially by commercial fishing; some are rated by fisheries scientists as overexploited, and some populations—especially bluefin tuna—have declined significantly. All tuna are strong fish, and the largest ones are the strongest of all fish caught by anglers. With streamlined bodies that feature a pointed head and tapered tail, they are

A 90-POUND YELLOWFIN
TUNA FROM NEW JERSEY.

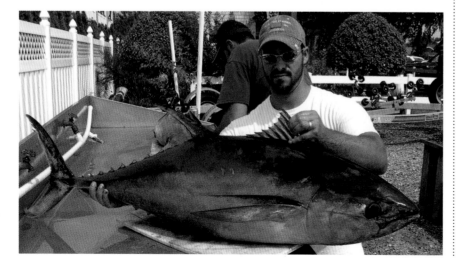

## AT-A-GLANCE

| | |
|---|---|
| **SCIENTIFIC NAME** | bigeye tuna: *Thunnus obesus*; blackfin tuna: *Thunnus atlanticus*; bluefin tuna: *Thunnus thynnus*; yellowfin tuna: *Thunnus albacares* |
| **FAMILY** | tuna and mackerel |
| **TYPE** | saltwater |
| **SPAWNING** | varies, primarily spring through summer |
| **PRIME FISHING** | late summer |
| **RANGE** (NORTH AMERICA) | varies with species, primarily Massachusetts to Florida, Gulf of Mexico, and both coasts of Mexico |
| **PRIMARY HABITAT** | deep offshore waters |
| **MAJOR PREY** | assorted pelagic fish |
| **LURES AND BAITS** | offshore trolling lures, rigged natural bait, strip bait, live and cut bait |
| **PRIMARY TACKLE** | light to heavy lever drag big game for most tuna; heavy spinning and light conventional for blackfin and school bluefin |

fast swimmers, with some schools capable of cruising at 30 miles per hour.

Tuna have a unique physiology in that they are generally cold-blooded and able to maintain a body temperature up to 18 degrees above that of the surrounding water. This ability greatly increases the power and response of muscle mass, allowing species like the bluefin to fight longer than other species and enabling them to adapt to warm Gulf Stream waters and to frigid North Atlantic waters.

Tuna must consume great amounts of food to maintain their constant-swimming lifestyle and fuel their rapid growth. Thus, tuna are likely to be encountered in areas where massive quantities of schooling baitfish are located and feeding can be accomplished with a minimum expenditure of energy.

The largest and most-coveted member of the tuna family is the bluefin. It is commercially coveted for its dark red flesh, and is of great recreational interest, although only to the relative few with the means and equipment to venture to appropriate offshore environs. This species, as well as its cousin the southern bluefin tuna (a fish of

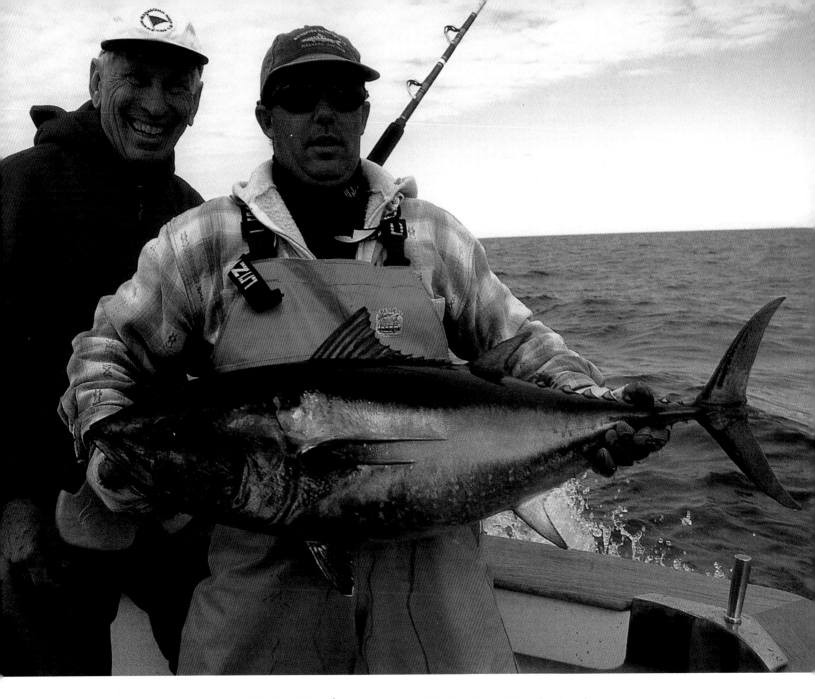

the southern hemisphere), is severely overfished and has declined in numbers worldwide.

The bluefin, which appears dark blue on its back and upper sides with gray or green iridescence, can grow to over ten feet in length, and weigh up to 1,500 pounds. It is common from 16 to 79 inches and from 200 to 400 pounds, with individuals over 1,000 pounds rare. For classification and recording purposes, the National Marine Fisheries Service has defined the different sizes of bluefin as: small school bluefins, under 27 inches curved fork length; school bluefins, from 27 to 47 inches (about 14 to 66 pounds); large school bluefins, from 47 to 59 inches (about 66 to 135 pounds); and small medium tuna, from 59 to 73 inches (about 135 to 235 pounds). All bluefin of these sizes in the U.S. are reserved for angling and cannot be sold. What can be caught commercially and sold are large medium bluefins, which range from 73 to 81 inches (about 235 to 310 pounds), and giant bluefins,

which are over 81 inches. Sportfishing for these latter two classes requires the use of very heavy tackle.

Found in schools of similar-size individuals, bluefins migrate extensively and feed on squid, eels, mackerel, flyingfish, herring, whiting and mullet. Giant bluefins tend to stay with schools of herring, mackerel and squid during summer visits to cool northern areas, while school bluefins may hang around shoals of sand launce (sand eels), anchovies and other smaller baitfish. In North America, bluefins are most prevalent to anglers seasonally offshore in the Atlantic from the Canadian Maritimes to North Carolina and in the Bahamas. School bluefin are available in the Pacific off Mexico as well.

Angling for tuna is fairly similar through most of their range, since they are seldom encountered anywhere but in open water. Trolling with rigged baits and lures, and fishing bait from a drifting or anchored boat, are the major activities. A minor amount of casting is done,

and that usually when fish are attracted close to a boat via chumming.

Yellowfins are the most common warm-water tuna and are distinguished by their yellowish fins and long second dorsal and anal fins. Also called Allison tuna, particularly in Bermuda, they are heavily pursued by purse seiners and longliners, but are reasonably abundant and sometimes wander relatively close to shore.

Most yellowfins that are caught by anglers weigh under 100 pounds, but they are common up to 200 pounds and can grow to 400 pounds or more. The largest yellowfins in North America have been encountered by San Diego-based, long-range party boats fishing in the Revillagigedo Islands off the coast of Baja California. Specimens over 200 pounds are common there during many winter trips, and some in the 300- to 400-pound class are boated. Yellowfins are also encountered in the Atlantic Ocean, and are caught in the Gulf Stream from Montauk, New York, to Florida.

Yellowfins are a good target for trollers and also for bait anglers. Trolling with small fish, squid, strip baits and artificial lures, as well as chumming and live bait fishing, are primary methods. Offshore anglers do especially well with this species by chumming with chunk baits at night.

Bigeye tuna look similar to yellowfins but are noted for their large namesake eye, which evidently facilitates feeding in low light deep below the surface. Schools of bigeye generally run deep during the day, whereas schools of bluefin, yellowfin and some other tunas are occasionally known to swim at the surface, especially in warm water. They normally occur from 16 to 67 inches in size, but may attain 75 inches. Bigeyes are often caught in the 100- to 200-pound class in U.S. waters, but can grow to over 400 pounds.

Bigeyes make extensive migrations and commonly frequent the depths, particularly during the day. Unlike other tuna, they are rarely seen chasing bait at the surface. Their primary food is squid, crustaceans, mullet, sardines, small mackerel and other deep-water species. Strong fighters, they are caught on baits primarily set at depths of 100 feet or more during the night, and are irregularly caught by trolling. Heavy tackle, such as 80-pound outfits, are commonly used for these powerful fish.

Blackfin tuna are much smaller than these other species. They may grow to 40 inches and 45 pounds, but are most common at about 28 inches and in the ten- to 30-pound range. In North America, blackfin are common in the Atlantic from North Carolina south, and in the Gulf of Mexico. They are Florida's most abundant tuna, where their peak spawning period occurs in May.

Blackfin often feed near the surface, and frequently form large mixed schools with skipjack tuna. Their diet includes various small fish, plus squid and crustaceans. They are fine light-tackle fish, especially when chummed to the boat with live baits. Some charter captains specialize in this, using a cast net to garner hundreds of pilchards, then using them as hooked and unhooked bait. Blackfin can also be taken by casting small lures, flies, or natural baits, and by trolling with ballyhoo, mullet and other small fish, as well as strip baits, spoons, feathers, jigs or plugs.

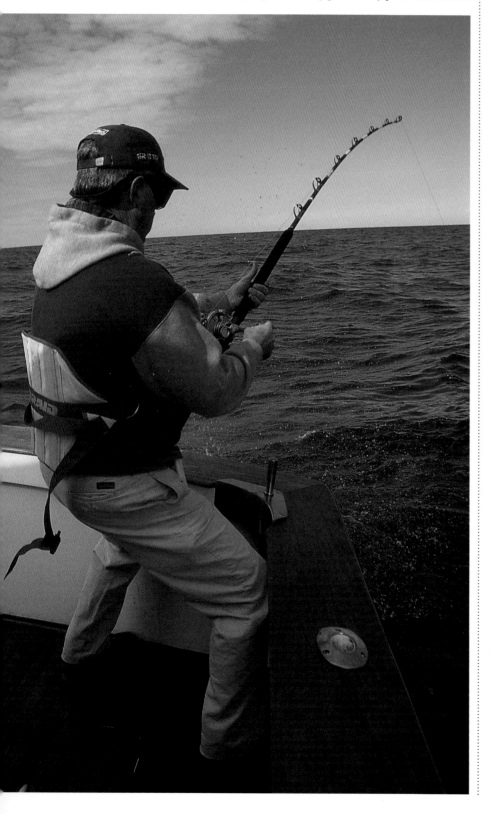

MOST TUNA ANGLERS USE SHORT RODS AND STAND TO FIGHT THE FISH.

# WAHOO

**Said to be one of the fastest fish in the sea, wahoo can sizzle line off a reel, a trait that endears it to anglers, although many in North America have not made this fish's acquaintance. A fish of tropical waters, it is caught on this continent in the Caribbean and off Baja California, as well as in Bermuda.**

· · · · · · · · · · · · · · · · · · · · · · · · · · · · · · · · · · ·

A CLOSE RELATIVE OF the king mackerel, wahoo are long and slender with a sharply pointed head, widely forked tail, and a brilliant or dark blue color along its back with many vertical bands. Though many are caught up to 30 pounds, they can grow to more than five times that, as the world record is a 184-pound Cabo San Lucas, Mexico, fish.

An oceanic species, wahoo are pelagic and seasonally migratory, frequently solitary or forming small, loose groupings of two to seven fish rather than compact schools. They are known to associate with banks, pinnacles and flotsam, and are occasionally found around wrecks and deeper reefs where smaller fish are abundant. They feed on porcupinefish, flyingfish, herring, pilchards, scad, lanternfish, small mackerel and tuna, and squid.

Trolling is the primary means of catching wahoo, many of which are caught incidental to other fishing activities, and early in the day. They are located near humps, ledges, seamounts and other places that cause current to well up, as well as along current edges and around floating objects and sargassum.

Trollers work at high speeds (six to ten knots or more) with near-surface lures, and also troll deeper for larger fish via planers, downriggers and wire line. Offerings include whole, rigged Spanish mackerel, mullet, ballyhoo and squid, plus strip baits, diving plugs, heavy bullet-head trolling lures and other offshore trolling lures. Live bait fishing and kite fishing are less practiced but sometimes productive, and on occasion there are opportunities for casting with plugs, spoons, metal jigs and flies.

Dark lure colors, especially green, mackerel patterns, purple and black bodies, and dark-combo bodies, are effective on these fish. Deep-running plugs must track straight at high speeds, which limits the possibilities.

## AT-A-GLANCE

| | |
|---|---|
| **SCIENTIFIC NAME** | *Acanthocybium solandri* |
| **FAMILY** | mackerel and tuna |
| **TYPE** | saltwater |
| **SPAWNING** | spring through summer |
| **PRIME FISHING** | summer |
| **RANGE** (NORTH AMERICA) | Pacific and Atlantic coasts of Mexico; North Carolina to Florida |
| **PRIMARY HABITAT** | continental slope offshore waters |
| **MAJOR PREY** | flyingfish, assorted pelagic fish |
| **LURES AND BAITS** | offshore trolling lures, plugs, spoons, rigged natural baits, live bait |
| **PRIMARY TACKLE** | light to medium big game and conventional |

Heavy-duty wire leaders are a necessity owing to the toothy mouths of these fish.

The first scorching run of a wahoo may peel off at least 100 yards of line in seconds, and the heat generated by the friction has been known to burn out the drag on some reels. Keep your hands off the spool. Occasionally this fish jumps on the strike and often shakes its head violently when hooked in an effort to free itself. Be careful when handling these fish, as you may put fingers in jeopardy.

CAUGHT TROLLING OFFSHORE IN MEXICO, THIS WAHOO WILL MAKE GOOD EATING.

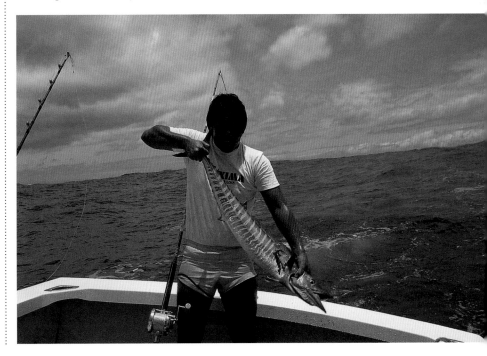

# WALLEYE

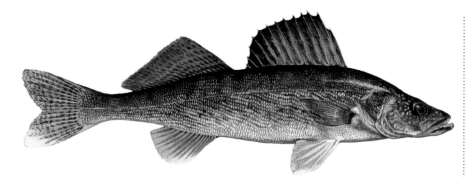

**The walleye is one of the most popular freshwater fish in North America, and also one of the most desirable for consumption. Although not spunky on rod and reel, it is a challenging species to catch in many places, because it is often not an aggressive feeder.**

. . . . . . . . . . . . . . . . . . . . . . . . . . . . . . . . . . . . . .

WALLEYES ARE ESPECIALLY PROMINENT in the Midwest, the Great Lakes, the southern and eastern Canadian provinces, and major river systems. They are readily identified by their large, glassy, opaque-like eyes and a white-tipped lower lobe on the tail fin. Recognized as a coolwater species (and called pickerel in many parts of Canada), they are a member of the perch clan; their smaller cousin, sauger, and the hybrid from these two fish, the saugeye, are less widely distributed, but similar in behavior.

Like perch, walleyes are a schooling fish, so you can expect that when you catch one, more are nearby. They also have somewhat light-sensitive eyes that make them most active in low-light and dark situations in many environments, although they do feed during daylight hours.

Walleyes relate to baitfish presence and to structure. Their prey, which is usually different species of minnows and small fish, varies with the body of water, often being whatever small fish are most prevalent. In some places, that may be yellow perch, in others, it may be alewives.

The types of structure that they favor include rock reefs, sandbars, gravel bars, points, weeds, rocky or riprap causeways or shorelines, and creek channels. Walleyes are particularly known for congregating in or along the

RIGHT: TROLLING PLUGS LIKE THIS CATCH MANY WALLEYES.

edges of vegetation. Weeds favored by walleyes, for the most part, are submerged, sometimes slightly visible on or near the surface, especially in shallow water, and often deeper and out of sight. Thick clumps of weeds are preferable to scattered weeds, because the former offer more cover. Shorter weeds in moderately deep water are often preferred by walleyes than taller weeds in the same depth. Knowledgeable walleye anglers always look for the weedline and its depth. An excellent situation to find, though not one as readily fished, is where the weeds are thick and the edge is close to a sharp bottom dropoff. Working the edges of the weeds is particularly effective.

In some places, particularly large lakes, walleyes are also found in deep water, suspended or on the bottom where there are open, basin-like flats. Some walleyes, especially big ones and those that are likely to be feeding, do not hold to the traditional forms of structure that anglers have worked determinedly for so many years, but are in places that have been relatively neglected. They are there to take advantage of the migratory schools of baitfish that are prevalent in those waters, mainly smelt and alewives. So the walleyes relate to the presence of those fish and they may be in a few feet of water or in 20 or 30 feet, over a bottom that is much deeper.

Fishing presentations for walleyes run a gamut, but have largely centered on jigging, still-fishing or drifting with live bait, trolling with bait rigs, casting crankbaits, and trolling with plugs. Jigs are mostly used with bait (leeches, minnows and worms) although hair- and grub-bodied jigs are used as well. Fixed and slip bobbers are used for live bait fishing, although sometimes a jig and worm is fished below a bobber. Trolling rigs include weight-forward or June-bug-style spinners, as well as spinner-and-worm/leech harnesses, and walking or bottom-bouncing sinkers. Many walleye

anglers backtroll to keep the boat in proper position. Jigs and rigs are used and almost always fished very slowly.

Borrowing a page from salmon and trout anglers, walleye anglers on big waters have recently gone to forward trolling more often. These anglers are primarily using shallow to deep-diving plugs (and sometimes spoons), trolling them on flatlines, in-line planers, large sideplaner boards, and even downriggers. Fishing is done at precise depths for suspended and mobile walleyes, and locating the fish, getting to the precise depth, and having good lure action are of paramount importance.

Walleyes spawn in early spring or late winter, usually when the water temperature is in the 42- to 50-degree range. They do this in rivers or other tributaries if they exist in a lake, and in shallow bays. Fishing, where legal, is relatively easy then, but becomes more difficult after spawning when the fish migrate out of rivers and bays into main lake structures and disperse. Through summer, various forms of structure, as well as deep water, are worked. In the fall, walleyes become more concentrated again and are especially found on main lake points that are close to deep water. In large lakes they will migrate toward the upper end where a river comes in, or to a dam end. This is a good time to get bigger fish, incidentally.

In rivers, walleye fishing is a bit different in several respects. They spawn through the same temperature range, and they migrate after spawning, although they may not go very far in smaller systems. In both spring and fall they may be located off the mouths of tributaries: in spring, they are drawn by spawning needs; in fall, by baitfish. They do not suspend, however, and are almost always caught by making bottom-oriented presentations.

In large river systems, many walleyes are caught close to dams in winter and spring. At other times, work the deep water off wing dams, island channel cuts, deep-water bridge abutments, and center channel edges. Look for walleyes to locate along a river channel that has considerable depth as well, especially in midsummer.

Riprap is an especially favored walleye haunt in rivers, especially in the evening and if there is deep water nearby. Other prominent locales include cuts, where currents meet each other; eddies and slicks; along and behind islands; large rocks; and the head and tail of pools. River walleyes feed on assorted forage, including crayfish, hellgrammites and minnows. They are caught by jigging, casting and trolling with spoons, spinners and plugs, and fishing with live bait.

Jigs are the most effective river walleye lure, probably because they are worked close to the bottom and represent minnows or crayfish. Small and shallow rivers generally require $1/8$- to $5/8$-ounce jigs; in fast water you should increase weight. Fish jigs with the current; there is actually

no need to jig them, and a slow rolling action is best. In spring and fall, use white, yellow, chartreuse and silver colors and in summer use brown, black, green or orange-and-brown.

Live bait is also very effective. A live bait rig, $1/4$- to one-ounce weight, rigged with 20 inches of dropback leader and a No. 2 short-shanked hook, is used. Minnows, nightcrawlers, leeches, salamanders, waterdogs and crayfish are used for bait, plus assorted minnows. Sinker style can be split shot, egg, Lindy, Baitwalker or other bottom-bouncing type.

Tackle needs for walleyes in lakes and rivers are not very complicated. Spinning rods from five-and-a-half to seven feet long in medium action, and reels filled with eight- to 12-pound line, are standard. For trolling, especially when planer boards are used, longer rods and stouter gear may be necessary. Baitcasting tackle can be used, but is usually not necessary, and fly tackle is seldom appropriate.

FISHING AT DUSK FOR WALLEYE AT KESAGAMI LAKE, ONTARIO.

## AT-A-GLANCE

| | |
|---|---|
| **SCIENTIFIC NAME** | *Stizostedion vitreum vitreum* |
| **FAMILY** | perch |
| **TYPE** | freshwater |
| **SPAWNING** | spring |
| **PRIME FISHING** | spring through fall |
| **RANGE** (NORTH AMERICA) | most of northern and central U.S. and western states except California; southern Canada |
| **PRIMARY HABITAT** | lakes and rivers |
| **MAJOR PREY** | assorted fish, especially perch and minnows, and aquatic insects |
| **LURES AND BAITS** | jigs, plugs, spinners, earthworms, minnows, and leeches |
| **PRIMARY TACKLE** | spinning and baitcasting |

# WHITE BASS

**Often lumped into the category of "panfish" because of their generally small size, white bass are highly prized by many anglers, especially those who fish in reservoirs and river systems where this species is abundant. A spunky, hard-fighting fish, and one that is prolific and excellent eating, white bass are usually found in schools; when located, they often provide fast action, which makes them especially good for family fishing and enjoyment by young anglers. Because they are often abundant, harvest limits may be liberal, and anglers often keep a good number for the table.**

. . . . . . . . . . . . . . . . . . . . . . . . . . . . . .

WITH A SILVERY COLOR and dark flank stripes, the white bass looks a bit like a small striped bass, to which it is related as a member of the temperate bass family. When a white bass is crossed with a striped bass, in fact, the result is known as a hybrid striper (called sunshine bass in some places).

Most whites run from half-a-pound to one pound in size; a two-pounder is a fairly large specimen, although some occasionally run to three and four pounds. Size usually varies with geographic location—the larger fish generally being found in more southerly areas where there is abundant shad forage and a longer growing season. Spawning occurs in the spring, in rivers and in tributaries to impoundments, and large numbers of fish may be available to anglers at that time.

Shad, silversides, smelt, alewives, crustaceans, perch, sunfish, insects and crayfish are the primary forage for white bass, which generally inhabit cool deep waters, although they come to the surface to feed on schools of small shad or other minnows. When this schooling behavior occurs, which is normally early or late in the day, there is often a commotion observable to anglers.

Lures that mimic the shape and size of the predominant forage are advisable, particularly small crankbaits, bucktail

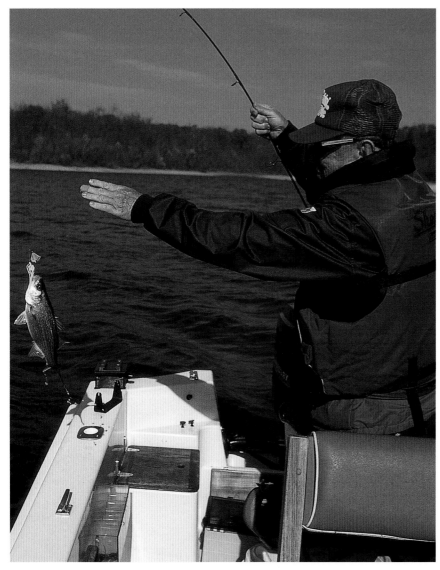

AN ANGLER FISHES FOR WHITE BASS FROM STOCKTON LAKE, MISSOURI.

place to place to stay with actively moving schools is part of the phenomenon. Wind-blown gravelly lake points and adjacent shorelines are also good for non-schooling whites in the fall; they often have schools of baitfish, which in turn attract white bass.

In large lakes and reservoirs, white bass anglers should pick out a dozen or so places where these fish have been caught in the past and return to each one when looking for this species. Try along riprap shorelines, rocky points, reefs off islands, old river channels, sand bars, sudden dropoffs and stony flats with constant depths between ten and 16 feet. In rivers, look to areas where streams enter, where bridge pilings disrupt current flow, above wingdams, downstream from lock-and-dam structures, and on rocky points. With the exception of the spawning period, white bass are constantly on the move. They often seem to prefer deep, open water, but venture near the surface when vigorously pursuing baitfish. Schools may tear into minnows or shad one minute, disappear, then reappear either a short or long distance away tearing into baitfish again. They may not reappear at all, or they may resurface out of sight.

Marabou jigs in yellow, chartreuse and white are popular for casting and fishing on or near the bottom, and small diving plugs catch suspended fish. Small live minnows are also used, often with a popping cork ahead of them to make a surface commotion; the cork draws attention to the jittery minnow several feet below, which in turn begets a strike. For surface fishing, try a small propellered floating plug, and a ⅛-ounce white or chartreuse buzzbait with a plastic blade.

Spinning or spincasting rods equipped with four- to eight-pound line are perfect for catching white bass, which give a good tussle on this light equipment. A fly rod can also be used when the fish are congregated and feeding.

or marabou jigs, silver jigging spoons, spinners, sinking lures and tailspinners. Some small stickbaits and buzzbaits are also effective. Casting is by far the most popular way to catch white bass, but some are caught by trolling; in northerly waters, where anglers troll plugs off planer boards (primarily for walleyes), they accidentally catch a slew of white bass. Nevertheless, jigging, casting and live bait account for most success.

White bass spawning runs are prominent in the spring on many large lakes and river systems. This behavior occurs when the water temperature in the spawning tributaries exceeds 55 degrees. Because of the white bass's schooling nature, it is common to catch them in numbers in one given location. When actively feeding, white bass can be caught readily, but they can also be temperamental and hard to entice.

Some of the best action, and the most fun, occurs in late summer and into fall when schools of white bass feed near the surface on shad. These schools hold a lot of white bass, which literally tear into the baitfish. Many boats follow these schools and enjoy fast "jump fishing," casting into the schools and also catching fish that swarm around hooked brethren. Watching for bird activity and running from

## AT-A-GLANCE

| | |
|---|---|
| SCIENTIFIC NAME | *Morone chrysops* |
| FAMILY | temperate bass |
| TYPE | freshwater |
| SPAWNING | spring |
| PRIME FISHING | summer through fall |
| RANGE (NORTH AMERICA) | widely distributed in lakes and river systems in the U.S., especially in the central and southeastern regions |
| PRIMARY HABITAT | lakes, ponds, rivers |
| MAJOR PREY | assorted small fish |
| LURES AND BAITS | jigs, spoons, spinners, plugs |
| PRIMARY TACKLE | light spinning, spincasting, baitcasting |

# YELLOW PERCH

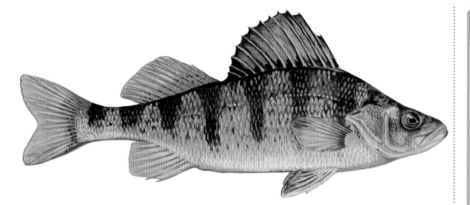

Perch are widely available in North America, they are fairly easily caught, and they are an important forage species in small sizes for large predatory gamefish. All of this makes them VIP fish, even though they do not get as much press as fellow panfish species like crappie and bluegill. Predominantly a northern coolwater species, the yellow perch is prized for its edibility. Residing in clean, cool habitats accounts for its firm white flesh, which has a flavor equal to that of walleye, its cousin.

. . . . . . . . . . . . . . . . . . . . . . . . . . . . . . . . . . . . . .

JUMBO PRE-SPAWN PERCH
CAN BE CAUGHT SHALLOW
AND CLOSE TO SHORE IN LATE
WINTER OR EARLY SPRING.

## AT-A-GLANCE

| | |
|---|---|
| SCIENTIFIC NAME | *Perca flavescens* |
| FAMILY | perch |
| TYPE | freshwater |
| SPAWNING | early spring |
| PRIME FISHING | winter through spring |
| RANGE (NORTH AMERICA) | coast to coast in the northern U.S. and southern Canada |
| PRIMARY HABITAT | coolwater lakes |
| MAJOR PREY | aquatic insects, small fish, crustaceans |
| LURES AND BAITS | small jigs and spinners, earthworms, minnows |
| PRIMARY TACKLE | light spinning and spincasting |

THOUGH GENERALLY SMALL and not an endurance battler when caught, perch are popular in large and small lakes alike throughout the year, especially in winter when taken through the ice, and during spring when they are spawning. They prefer cool water, and travel in schools, so the opportunity exists to catch a good number when you have located a school. Fairly liberal bag limits usually exist to help thin down their numbers. Yellow perch are unmistakable in appearance, having a golden-yellow body that is tinged with orange-like fins, and six to eight dark broad vertical bars that extend from the back to below the lateral line. Some individuals, especially larger fish, appear humpbacked due to the deepest part of the body beginning at the first dorsal fin, then tapering slightly to the beginning of the second dorsal fin.

In most places, a perch of one pound and ten inches in length is large, although sometimes perch upwards of one pounds are encountered. Larger fish are extremely rare. The average is about half-a-pound or slightly more and about six to seven inches long. Yellow perch have the distinction of being the oldest "all-tackle" world record fish in the history books, due to an incredible 1865 specimen that weighed four pounds three ounces.

Yellow perch are mostly lake and pond inhabitants, although they are occasionally found in streams and rivers. Clear, weedy lakes that have muck, sand or gravel bottoms are especially favored. They inhabit the open areas of most lakes, and prefer temperatures around the mid-60s. Smaller

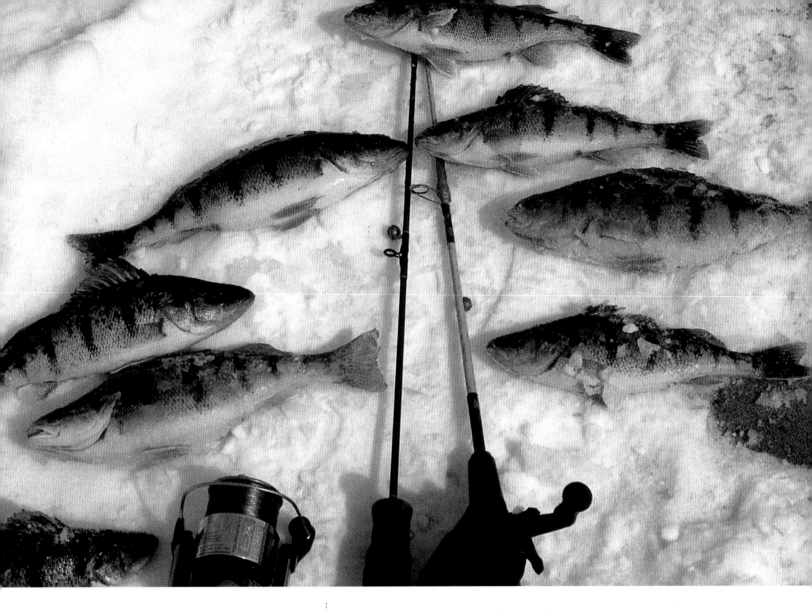

lakes and ponds usually produce smaller fish; however, perch can grow large in very fertile lakes with moderate angling pressure.

Spawning occurs in early spring in the shallow areas of lakes or up in tributary streams when the water temperature is between 45 and 50 degrees. Perch are prolific and known to overpopulate many lakes, especially those where they have been introduced and have out-produced and out-competed the resident fish (especially true of trout).

Perch have a wide-ranging diet; they primarily forage on young crayfish, snails, aquatic insects, fish eggs and small fish, including young of their own species. For the most part they feed in the shallows at dawn and dusk and are not especially active at night, but this is not necessarily true in all waters, and many anglers have success through the midday hours.

Perch can be good sport in cold water and on light spinning or spincasting gear. They will school deep in places where surface temperatures get warm, although they do move shallower to feed. They are often located in weedbeds in shallow lakes, and usually you have to fish on or close to the bottom here. Fishing deep, vertically with jigs or bait, is also important in larger bodies of water.

Live worms, live minnows, small minnow-imitating plugs, jigs, spoons and spinners are the primary perch attractants. Small jigs with hair- or curl-tail grub bodies are especially popular, in white, yellow, shad and gray or silver, especially if imbedded with flakes. Seldom are yellow perch caught on larger lures that are meant for other gamefish, and rarely do they come to the surface or travel far in pursuit of a lure. It is usually important to work slowly and deep with smaller lures.

Live natural bait is very effective on perch, but they are also adept at nibbling and stealing it. Floats are frequently employed with live bait; nightcrawler rigs, sporting a No. 2 hook and No. 2 spinner, are also effective. Chumming has its devotees as well, including those who use mealworms and more fragrant ground concoctions. In winter, minnows, worms, waxworm larvae, small jigging spoons and small jigs are the top producers through the ice.

Light spinning or spincasting outfits, equipped with two- through eight-pound test line, are more than adequate for perch. Fly fishing, though less popular, is also effective, particularly when yellow perch are in shallow water in the spring.

BIG YELLOW PERCH CAUGHT WHILE ICE FISHING.

TOOLS

# FISHING REELS

## Baitcasting

Baitcasting tackle is very popular in North America, and although it is primarily used in freshwater fishing, it is still suitable for a range of light saltwater applications. It is characterized by a reel with a spool that revolves when both retrieving and dispensing line, and by a levelwind guide that lays retrieved line evenly on the reel spool. The style and method of reel operation are similar to that of conventional tackle, which generally lacks a levelwind mechanism, although both baitcasting rod and reel are light- to medium-light, multipurpose fishing equipment, whereas conventional tackle is heftier.

TOP-OF-THE-ROD MOUNTING, A REVOLVING SPOOL, AND STRONG GEARS MAKE THE BAITCASTING REEL A GOOD CHOICE FOR MANY FISHING APPLICATIONS.

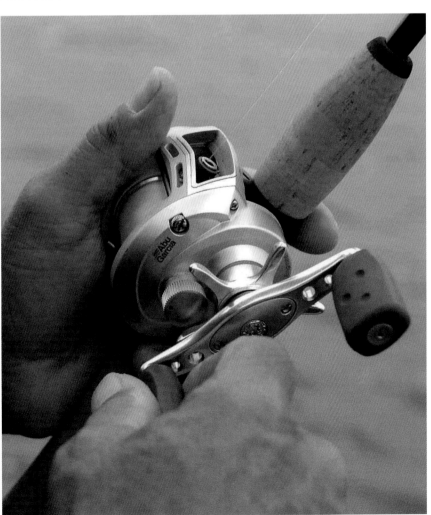

Despite what its name suggests, baitcasting tackle is not exclusively, or even primarily, relegated to use with natural bait; it is most prominent for use in casting lures, but sometimes in fishing with bait and in trolling. Baitcasting tackle can provide very accurate lure placement for casters, and is compatible with diverse fishing methods.

Many baitcasting reels have a number of features, some of them specialized for particular fishing activities, since most are used for cast-and-retrieve angling and are commonly employed with heavier lures and weights than spinning or spincasting reels. Larger models are not comfortable for continuous casting, however. Some baitcasting reels are used with very light lines and lures, and some heavy-duty, large-capacity models are used in very demanding situations.

The most important features are the gears and the cast-control function, which significantly affect casting and retrieving. The main problem with a baitcasting reel is the ability of the user to control the movement of the spool when casting to prevent a backlash. However, when this technique is mastered, it is possible to be extremely accurate when casting with this equipment. Gears are of special concern when it comes to line recovery and cranking power. Incidentally, every baitcasting reel has an adjustable drag mechanism, which is activated by turning a star wheel on the drive gear. This is located on the sideplate under the handle. The drag tension is set to the desirable level at the beginning of each day's fishing, and is relaxed at the end of the day.

### CASTING FEATURES

With all baitcasting reels, controlling the flow of line off the spool is important to proper use. A baitcasting reel is placed in freespool by depressing the line release clutch. On most reels, the clutch is situated on the front of the reel to permit quick, one-handed operation. This may be a contoured bar (called a thumb bar) over the spool that bridges the sidewalls, or a switch that is recessed into the sidewall and permits the thumb to slide onto the spool. On older reels, the clutch is a button that is located away from the spool.

When you put the reel in freespool, you must apply thumb pressure to the spool to prevent line from paying

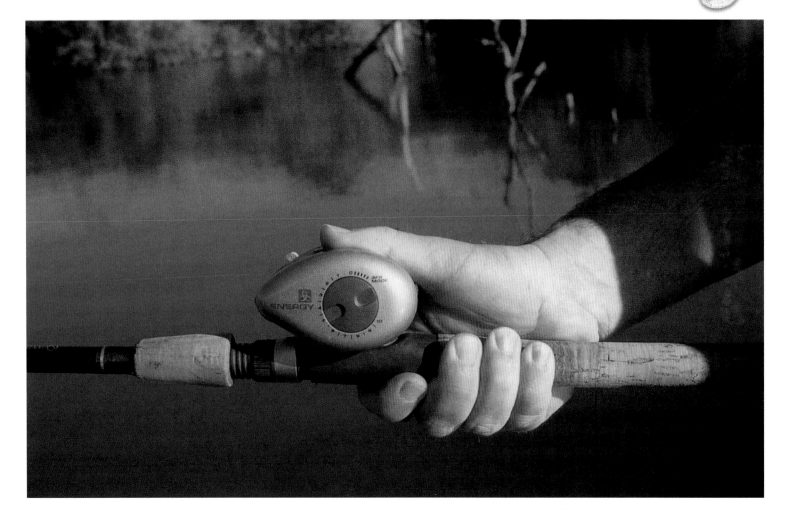

out prematurely. Place your thumb on the spool so that the spool cannot turn; this is done when the reel has a thumb bar or recessed switch, because the thumb of the casting hand immediately contacts the spool as it depresses this clutch. In reels with a clutch button, you need to use two hands, keeping the thumb of the non-casting hand on the spool while you press the button with your other hand.

There are three means of controlling the spool when line is flowing off the reel: mechanical, magnetic and manual. Manual spool braking is done by applying thumb pressure to the moving spool. This is learned through trial and error and is perfected with experience; it requires the application of different degrees of thumb pressure for the weights on the line, distances being cast, and types of rods and reels being used. Although you can learn to use a baitcasting reel without applying thumb pressure, you cannot fish without some manual control all the time. This applies to all reels.

Mechanical spool braking is done by applying pressure to the moving spool with centrifugal brakes (also called weights). Reels with centrifugal brakes have blocks that have to be engaged to effect spool braking. These blocks exist on one side of the reel, usually the left. They are

accessed on some reels by removing the entire sideplate or on others by unlocking a quick-release bayonet cover. Some newer reels feature an external adjustment via a sideplate dial, which is by far the easiest method of adjusting centrifugal pressure.

Centrifugal brakes are used in conjunction with the spool tension knob. This device is a knurled knob, or bearing cap, on the sideplate where the handle is located, and is adjusted by hand. Tightening the knob puts tension on the spindle of the spool, but it is not purely a spool-braking device, as it is primarily intended to control excessive end play, or sideways movement, of the spool.

Spool tension must be adjusted according to the weight of the object being cast; if you switch frequently to lures of different weights, you should reset the tension. To set tension when the reel is on the rod with line attached to a lure, hold the rod out and dangle a lure from the tip, place your thumb on the spool, and put the reel into freespool. Decrease thumb pressure and allow the lure to fall. Adjust the spool tension knob so the lure slowly descends to the ground when thumb pressure is relaxed. The spool should stop revolving at the instant the lure hits the ground. For continued, long-distance casting, decrease spool tension

THE MAGNETIC SPOOL CONTROL MECHANISM OF A RIGHT-RETRIEVE BAITCASTING REEL.

and put the centrifugal brake blocks in the off position.

Magnetic spool braking is a completely different system, and common on the majority of reels. This system employs a magnetic field to place variable degrees of force on the spool. A series of small, disk-like magnets is located in the interior of the sideplate opposite the handle. When an exterior magnetic control knob is turned, it changes the distance of the magnets from the metal spool; when the magnets are closer more force is applied, and when they are further away less force is applied. Lower settings enable longer casts; higher settings help prevent backlash under adverse conditions, such as when casting into the wind.

While these systems are touted as "eliminating backlash," they are not foolproof, and if magnetic spool-braking reels are not used correctly, they will still backlash. However, they are excellent for those who are learning to cast with this equipment when the proper settings are selected. Beginners should use a higher

tension setting when they start; this will cut down on the distance achieved at first, but it is better to do this than to be frustrated by backlashes. With a little practice, you can ease off on the tension and keep learning until you become comfortable with less tension. Some of the newest magnetic spool-control systems are very sophisticated, and have the ability to alter magnetic force according to the speed of the spool during the cast.

To set a magnetic spool reel up for casting, begin by adjusting the spool tension knob as previously detailed, starting with the magnetic control at the lowest setting. Once the mechanical tension knob is adjusted, turn the magnetic setting from zero to an appropriate level, make a few medium-intensity casts, and adjust the magnetic control up or down as necessary before you start serious casting. Slight thumb pressure on the spool is advisable when starting with low magnetic control, but you can apply less pressure than you would if using only mechanical braking. Complete beginners should set the magnets at maximum level until they are proficient at releasing the lure and applying thumb pressure.

Many baitcasting reels have a selectable switch that automatically engages the pinion. This is called a flipping feature. With this switch on, the reel is out of gear only when the thumb is kept on the freespool bar. When you release thumb pressure, the reel is instantly in gear. The advantage is that you do not have to turn the handle to put the reel in gear. Since the reel is already in gear when a fish takes or when the line tightens, no time is wasted setting the hook.

## RETRIEVING FEATURES

Most baitcasting reels are right-hand retrieve models and are not convertible. Although right- and left-handed anglers have been using this system for many decades, it favors the minority of people who are left-handed. There are a few reels with left-handed retrieve, but these are not nearly as accepted in the marketplace as right-retrieve reels.

It is theoretically beneficial for people who are right-handed to reel with their left hand and for lefties to reel with their right hand, so that the dominant hand is the one that holds the rod and is used to play the fish or direct the retrieve. This is especially significant when frequent casting is involved. Since the dominant hand is used to cast the rod, there is no need to take further action after casting to start using the reel; the other hand is immediately placed on the reel handle grip and it turns the handle. This lack of time delay is important in some fishing situations.

Most anglers both cast with their right hand and retrieve with their right hand, meaning that they have to switch the rod and reel from right to left hand at some point. Most good casters become adept at making this transfer while the lure is in flight, taking their right thumb off the spool just as the lure touches the water, and then quickly grabbing the reel handle and cranking before the lure has a chance to get deep. This takes fine timing.

If you are new to baitcasting and are right-handed, consider getting a left-retrieve reel, since you do not have old habits to break. If you are already accustomed to casting a spinning outfit with your right hand and reeling with the left, this is the same principle. Many new right-handed baitcasters have found it worthwhile to start out with a left-retrieve reel and continue with it (left-handed anglers can simply use the many standard right-retrieve reels).

BELOW: ROUND DAIWA MILLIONAIRE BAITCASTING REEL WITH PALM SIDEPLATE REMOVED.

LEFT: MANY ANGLERS WHO CAST A LOT WITH BAITCASTING TACKLE HOLD THE REEL IN THE PALM OF THEIR HAND WHILE RETRIEVING.

THIS QUANTUM SMOKE PT INSHORE REEL IS BEEFED UP FOR SALTWATER USE

In regard to gears, baitcasting reels generally have stronger and more efficient gears than those in a stationary or fixed-spool reel, because the gear set operates on a parallel axis. The drive gear is linked to the reel handle and the pinion gear connects to the spool. This system provides the multiplying gear ratio for ample line retrieval rates with a small spool, and still delivers substantial cranking power. It also allows for the use of heavy lines.

When using baitcasting reels, some methods of fishing cause high-stress cranking. This requires a rigid gear support system, so that under great duress there is no flex to affect the inner workings of the reel. The use of heavy line, and cranking large fish in extreme conditions, can put tremendous stress on all components, and both the material and construction of the frame and shaft supports are what keep the gears aligned properly and able to last for a long time.

Gear ratios are generally categorized as high (fast) or low (slow), but this is relative to the type of reel and application. Furthermore, the size of the spool may be such that a low-gear-ratio reel actually recovers more line per full turn of the handle than a high-ratio reel with a smaller spool. This is known as line recovery, and can be an important factor to judge when evaluating a reel.

Low gear ratios are about 3.8:1, although few such ultra-slow reels are used for cast-and-retrieve fishing, and high gear ratio today now extends to about 8.1:1,

THE SHIMANO CALCUTTA TE DC IS A PREMIUM BAITCASTING REEL WITH DIGITALLY CONTROLLED SPOOL BRAKING TO HELP ACHIEVE LONG BACKLASH-FREE CASTS.

ASSORTED SIZES OF LEVER-DRAG BIG-GAME REELS.

which is exceedingly fast. Most reels fall in or about the 5.5:1, 6.3:1, and 7.3:1 designations, with the latter considered fast. With baitcasting reels, a high gear ratio is preferable for cast-and-retrieve fishing with lures that do not pull hard, but a low gear ratio is preferable for hard-pulling lures. What is gained in retrieve speed is lost in cranking power.

Finally, most better baitcasting reels now have continuous anti-reverse, a feature that restricts backward movement of the handle. This feature is especially relevant to cast-and-retrieve applications and to some styles of bait fishing, primarily because it is relative to how the reel operates when the forward-turning motion is stopped. Ideally, a reel used for casting should engage instantly and firmly. A continuous anti-reverse feature keeps the handle and drive gear from moving even the slightest bit backward.

# Big game (lever drag)

Used exclusively in saltwater fishing, big game reels are extremely durable "heavy-duty" revolving-spool products. They are similar to conventional reels in many respects, but substantially different in that they feature a lever drag. Big game reels (which are also called lever drag reels), and appropriate rods, are mainly associated with offshore blue water trolling or bait fishing for billfish, tuna and sharks; however, smaller models are used for some reef and inshore fishing, and some may also be used for limited casting activities. Able to endure extreme pressures, big game reels help subdue tough fish quicker than would be possible with other equipment, largely due to the gears and the type of drag.

The lever drag on big game reels is a great improvement over the star drags that exist in baitcasting and conventional reels, which are also revolving spool products. The latter reels can only be preset to one drag tension setting, which cannot be reliably changed to precise levels during use. Thus, drag tension is not readily adjustable to known levels. Turning the star wheel adjusts the drag tension, which is usually set to a predetermined level before fishing. If that wheel is deliberately or accidentally turned later, especially while playing a fish, drag tension is changed and may be too little or too great for the circumstances. Once the tension is changed, it cannot be re-calibrated with absolute certainty while playing a fish.

Also, it may be desirable to increase or decrease drag tension deliberately while playing a very large and powerful fish, but doing so means making an adjustment to a "guesstimated" level of tension, and being unable to return to a known preset tension level if necessary later on. Most anglers cannot make accurate on-the-fly adjustments to the

preset tension of a star drag reel, which is a problem when fishing for the toughest species, when using light lines, and in circumstances where a lot of line is taken from the reel.

The drag on big game reels can be fine-tuned, and they feature a device to limit drag-setting range. In these reels, the drag adjustment mechanism is separate from the reel handle and does not turn with the handle as the star wheel on a conventional reel does. This, plus the fact that the position of the drag lever is constantly visible, means less chance of inadvertently changing drag tension, and always being certain of the level of tension applied. Big game reels also have several tension settings that permit preset tension at one level for setting the hook and at another level for applying maximum pressure on a stubborn fish.

The lever of a big game reel applies various amounts of drag tension on the spool; the greater the tension, the more force it takes to pull line from the spool. Completely releasing tension allows the spool to turn most freely (freespool). In use, the reel sits on top of the rod and faces toward the angler; the thumb of the rod-holding hand is placed on the spool to keep the line in check, and the free hand is used to move the drag lever backward to minimum tension, which places the reel in freespool. When thumb pressure is relaxed, line flows off the spool and out through the rod guides, carried by the weight of the object at the terminal end of the line. Big game reels feature a click ratchet, also called a warning click, that is used to warn that line is being taken off the reel, and this may be employed when a reel is not held or left unattended. To retrieve line, the drag lever is moved forward to apply some degree of tension on the spool, and the spool is turned by rotating the handle, which winds line onto the reel.

A 50-POUND BIG GAME OUTFIT SITS IN A ROD HOLDER, A COMMON PLACE FOR IT WHILE TROLLING.

The adjustable drag mechanism is activated by moving a lever that is located on the same sideplate as the handle. Unlike other reels, this equipment has dual drag settings, usually referred to as strike and full, which are preset to the desired level at the beginning of each day's fishing and relaxed when the day is concluded.

Whereas other revolving spool reels have multiple friction washers and multiple metal washers, big game reels have either single-plate or multi-plate clutches. Many have just one friction washer, so there is low inertia startup, but the size and material of that washer is critical. The drag in any reel should ideally operate smoothly, without hesitation. In other words, it will start immediately when needed and maintain a constant rate of tension as line flows continuously off, as well as keeping the same level of tension during the time it takes to play and land a strong fish. The less variation there is in the performance of the drag the better.

This friction washer is called upon to slip freely and also to create a high amount of pressure. Thus, you are looking for two opposite attributes. Most modern big game reels have a woven carbon fiber friction washer, referred to by some as graphite, which does an excellent job of addressing these demands.

Some large big game reels have a preset drag lock that is tamper-proof and meant to keep the preset drag adjustment from being accidentally altered. Pressing a button overrides the lock; this is mainly an advantage to charter captains who do not want anglers to turn the drag adjustment button accidentally and lose a prized fish.

No big game reels possess a level line-winding mechanism. You must manually direct the placement of line on the spool to produce an even line lay. This can be a problem for some anglers, since these reels (which sit on top of the rod) are heavy and awkward to hold for some people. Unevenly wound line bunches and may prevent either retrieval or dispensing—as well as contributing to binding of line wraps.

Like other revolving spool reels, the spool of a big game reel revolves as line pays out, and also when line is retrieved by turning the handle. When the reel is placed in freespool and line is dispensed from the reel, a backlash can occur if the revolving spool turns faster than the line is carried off that spool. Applying light pressure to the spool prevents this.

Unfortunately for left-handed anglers, big game reels are manufactured in only a right-handed cranking version and cannot be converted by the angler as a spinning reel can—although some may be converted to (or even originated in) left retrieve by custom shop operators. This is because applications with big game reels are very demanding, the outfits are generally heavy, and the majority of people are right-handed, meaning that it is normal to want to use the dominant hand for the hard cranking work that is often an element of big game reel use. Since these reels are used for landing big fish, it is common to attach them to a harness, which relieves the rod-holding arm. If a person is right-handed, all of the heavy-duty cranking of the reel is done with the stronger hand, which in theory is better for anyone who is right-handed, although not as desirable for a lefty.

In the past, most reels with lever drag were single speed, having one fixed gear ratio. Today, most have dual-speed operation, which means that they can alternately operate at two gear ratios, one of which is high and the other low. Shifting from one gear to the other is simple and accomplished in a fast-touch manner, generally by pressing a button.

The gear ratio in single-speed big game reels varies. Older models were as low as 1.2:1, but some can be found now as high as 6.3:1, which is an enormous difference. In two-speed reels, the low gear ratio may be as low as 2.3:1, but is typically over 3:1, while the high-speed gear ratio will be between 5:1 and 6.3:1.

Two-speed operation allows you to shift from high ratio—which would be used for most purposes—to low ratio for the extra cranking power necessary for demanding situations. Low is used for power, and high is used for speed. If you must clear lines quickly, for example, it is best to do this in high gear; there is little resistance, and you can crank away quickly. Being able to shift instantly from high to low speed provides

SHIMANO'S TIAGRA 130 IS A TWO-SPEED LEVER DRAG REEL MEANT FOR THE LARGEST GAMEFISH.

AMPLE LINE CAPACITY AND QUICKLY ACCESSED TWO-SPEED GEAR CONTROL DISTINGUISHES THE PENN INTERNATIONAL SERIES OF LEVER DRAG REELS.

OPPOSITE PAGE: A BIG GAME REEL IS CLAMPED TO A ROD, WHICH IS PLACED IN A ROD BELT TO AID PLAYING BIG FISH.

benefits for various situations, including out-muscling a big fish that has sounded directly below you, or pulling a large fish away from its craggy bottom hole.

In principle, less line is recovered per turn of the handle in low gear, so theoretically you spend more time when using it. However, when using low gear it is easier to get a strong fish's head, turn it, and be in control. If you were using a high gear ratio to battle a stubborn fish, it might actually take more time, since it will be harder to turn the handle, and thus you will actually have to work harder with the fish.

The greater power of the low-speed mode, when used in combination with high speed (gaining line quickly, for example, when a fish runs toward you), can reduce fighting time overall, which is clearly helpful for releasing fish in good health. It also diminishes angler fatigue, which can otherwise lead to mistakes and prolonged battles.

High and low are relative terms when discussing gear ratio, and categorization is relative to the size and diameter of the reel. A 2.2:1 gear ratio might actually be a "high" gear ratio on a large-line-capacity big game reel (like a 130-pound-class model), and would provide a great deal of line recovery compared with a smaller diameter reel that had a numerically greater gear ratio. This generally low numerical gear ratio also provides a lot of cranking power. Reels that can easily handle a heavy load are said to have a lot of cranking power. A longer handle, which many big game reels possess, also helps with this.

Big game reels are classified by the strength of line that they are designed for and the capacity they hold. Unlike conventional reels, which use an "O" (or ought) designation from decades ago, big game reels conform to well-established line classifications from 12- through 130-pound strengths, with corresponding capacity and drag system capability. These classifications are usually specified as being IGFA class, which means that they conform to established parameters of line breaking strength for world record consideration.

The largest big game reels, the 80- and 130-pound class versions, are used for the biggest game, such as monster billfish and tuna. The 30- and 50-pound reels have been more popular for wide-ranging offshore applications, but greater interest in light-tackle and stand-up fishing has increased the popularity of 12-, 16- and 20-pound reels. Line capacity is great for all of these products.

This varies a lot, however, by type of reel (a wider-spool model will hold more) and by type and diameter of line used. Capacity is considerably greater for braided microfilament line, which is thinner than comparable-strength nylon monofilament line. One 50-pound standard-width two-speed big game reel currently in production, for example, holds 220 yards of 50-pound nylon monofilament or 630 yards of braided line. Furthermore, some anglers load these reels with a backing (or backshot) of mono and a topshot of braid to get the amount and type they want on the reel, resulting in a spooled length somewhere in between these two numbers.

# Conventional

Like baitcasting reels, conventional reels are characterized by a spool that revolves while retrieving and dispensing line. The term "conventional" is a bit deceptive, signifying

only that this is the oldest type of reel, with the line moving perpendicular to the spool axis. Conventional tackle is generally medium- and heavy-duty fishing equipment, having the ability to deal with the strongest fish and with situations requiring a lot of line. Very few conventional reels have a levelwind line guide, and they are larger and sturdier than baitcasting reels. Most conventional reels are fairly heavy as a result of sturdy components necessary for the frame, spool and gears, which is what makes these reels capable of handling tough fishing.

This equipment is very popular and widely used in saltwater fishing because of the differences in conditions, techniques and size of fish when compared with freshwater. Appropriate versions can be used in saltwater applications ranging from inshore flounder fishing to offshore trolling, including deep grouper and cod fishing, plus casting to tarpon and wahoo; in freshwater, this gear may be used in trolling for Great Lakes salmon and bottom fishing for big catfish and sturgeon. Many conventional rod and reel combinations are best suited to specific tasks, which is why this gear is described as boat, bay, surf, trolling, bottom fishing and ocean tackle.

Most conventional reels are used to troll lures or bait, and to fish at various depths with sinking lures or with bait, both of which call for paying line off the reel rather than casting. Some conventional reels are used to cast lures and natural bait. The vast majority of conventional reels are designed for right-handed retrieve and are not convertible. The left/right-retrieve situation with these products is akin to that for baitcasting reels.

In operation, a conventional reel has a lever that activates or deactivates the gears, in essence taking the reel into or out of freespool. With the reel on top of the rod handle and facing toward the angler, place the thumb of your rod-holding hand on the spool to keep the line in check, and move the gear lever backward with your free hand. This disengages the gears and puts the reel in freespool. When the gears are disengaged and line is dispensed from the reel, a spool overrun can occur if the revolving spool turns faster than the line is carried off that spool. Applying light pressure to the spool is necessary to prevent this. When thumb pressure is relaxed, line flows off the spool and out through the rod guides, carried by the weight of the object at the terminal end of the line. Conventional reels feature a click ratchet that is used to signal that line is being taken off the reel; it may be employed when a reel is left unattended. To retrieve line, the gears are engaged by moving the lever forward, and the spool is turned by rotating the handle, which winds line onto the reel. When line is wound onto the spool, you generally must level the line manually for even line distribution. Unevenly wound line bunches up, which may prevent retrieval and dispensing, and may cause binding in the spool. Leveling is done by using your thumb to direct the line across the spool as it is retrieved; some lighter-duty conventional reels have a levelwind mechanism that automatically distributes the line back and forth across the spool. Having to level line on a spool manually is the biggest drawback to using a conventional reel.

Line capacity, gears, and drag are the most critical components of conventional reels. As with lever drag reels, line capacity varies depending on spool diameter and type of line. Nylon monofilament capacity ranges from about 275 yards in smaller models to over 1,000 yards in the largest models, but is more than twice that amount for braided microfilament lines. Some anglers combine both line types on the reel, with monofilament as backing and braid as the top line.

Unlike baitcasting products, conventional reels are basically classified by the strength of line they are designed for and the capacity they hold. Some have long been characterized by an "O" (or ought) designation that was created many years ago, and which has been gradually fading in common parlance. However, some conventional reels for saltwater use have been labeled from 1/0 to 14/0 sizes, the latter meant for 130-pound test line. The most popular sizes have been the 2/0, 4/0 and 6/0 models, which are meant for 20-, 30- and 50-pound line, respectively. Many contemporary reels are designated by manufacturers according to a product series name, accompanied by some combination of model numbers and letters; these may or may not have an obvious connection to the intended line strength or line capacity.

Conventional reels nearly always have efficient heavy-duty gears. The drive gear is linked to the reel handle and the pinion gear connects to the spool. Most better conventional reels have a stainless-steel pinion gear and a bronze main gear. In a few reels both are stainless steel. Some conventional reels—especially those with a higher gear ratio—have helical gears, which allow at least partial engagement of several gear teeth at all times, spreading the load and potential wear. This is mainly an issue where the gear teeth are small, as is found on higher-ratio models, and there is less surface with which to make contact. Obviously the high-stress cranking that

THE SENATOR SERIES OF PENN REELS IS TYPICAL OF MEDIUM-DUTY CONVENTIONAL PRODUCTS WITH A STAR DRAG.

OPPOSITE PAGE: SALTWATER PARTY BOAT ANGLERS USE CONVENTIONAL REELS FOR BOTTOM FISHING.

is experienced with conventional reels requires a rigid support system, so that under great stress there is no flex to affect the inner workings of the reel.

As with other reels, gear ratios in conventional reels are generally categorized as high (fast) or low (slow); however, the size of the spool may be such that a low-gear-ratio reel actually recovers more line per full turn of the handle than a high-ratio reel with a smaller spool. Some current models of conventional reels, and many older ones, have low gear ratios, in the 2.0:1 to 3.0:1 class. The evolution of conventional reels has brought about a broader range of gear ratios, however, with models up to and exceeding 6.0:1, and currently as high as 6.4:1. A high gear ratio is preferred for cast-and-retrieve fishing; a low gear ratio is preferred for deep bottom fishing. What is gained in retrieve speed is lost in cranking power, which is the ability to handle a heavy load. The lowest-gear-ratio reels have the greatest cranking power and the highest-gear-ratio reels have the least cranking power.

Also important, however, is the amount of line recovered per turn of the handle, which is called line recovery. That is a better measurement of retrieval ability than gear ratio, and is determined by spool diameter. When the level of line on a spool is low, as it might be when a strong fish takes a lot of line, less line is recovered per turn of the handle than when all of the line is on the spool. Similarly, the amount of line recovered per turn of the handle of a fully spooled reel that has a small spool would be less than the amount of line recovered per turn of the handle of a fully spooled reel that has a large spool.

Regarding drag, conventional reels all have an adjustable drag mechanism, activated by turning a star wheel on the drive gear.

A LIGHTWEIGHT GRAPHITE BODY DISTINGUISHES THE SHIMANO TLD STAR CONVENTIONAL REEL.

Drag tension should be set to the desired level at the beginning of each day's fishing and relaxed when fishing is concluded.

On most conventional reels, this drag system is usually a multi-element system with washers that are keyed together. Washers are alternately stainless steel and some type of friction material. The material of friction washers is critical to drag performance, with the ideal being smooth, non-hesitating drag operation, with the drag starting immediately when needed, maintaining constant tension as line flows continuously off the reel, and keeping the same level of tension as it is periodically called upon during the time it takes to play and land a strong fish. Performance is affected by the range of adjustment designed in the reel, and by the number and material of the friction washers that you may need for really large fish.

Most conventional reels today use woven carbon-fiber friction washers, which show no appreciable wear after extensive or rugged use, and have excellent range. This material is also especially good when applying maximum tension to the drag washers, or deliberately locking down the drag tension as far as it will go. Some friction washers (including asbestos and Teflon) cannot be locked down enough when fighting big fish, and because of this drag still slips even when the drag star is turned as tightly as possible. In most conventional reels, and especially better-quality models, carbon-fiber friction washers are used with stainless-steel washers, the number of which generally varies from seven to 13 elements, the greater number being on bigger reels. A greater number of friction washers increases the total drag surface area.

Most conventional reels have good to excellent drag performance. These reels do have a drag-related drawback, however, with respect to striking and fighting large, powerful fish (also true for baitcasting reels). This is the fact that drag tension is not easily or readily adjustable to known levels.

Turning the star wheel adjusts the drag tension, which is usually set to a predetermined level before fishing. If that wheel is deliberately or accidentally turned later, especially while playing a fish, drag tension is changed and may be too little or too great for the circumstances. Once the tension is changed, it cannot be re-calibrated with absolute certainty while playing a fish. It may also be desirable to increase or decrease drag tension deliberately while playing a fish (usually a very large and powerful one for the tackle), but doing so means making an adjustment to an uncertain level of tension, and being unable to return to the original preset level if necessary later on, as well as possibly exceeding the limits of the tackle. This drawback is primarily related to big game fishing, which is why lever-drag big game reels evolved.

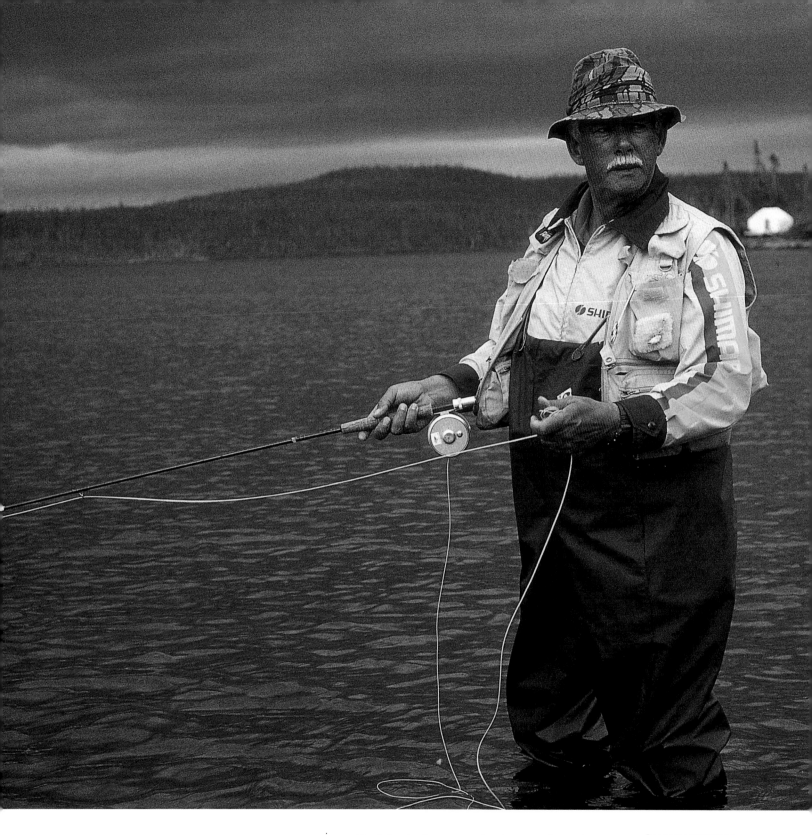

# Fly

Unlike all other reels, fly reels do not play a role in dispensing line; this is because line is stripped off the spool of fly reels to help deliver a weightless fly to the fish. Unlike all other reels except spinning, fly reels are always situated under the rod and below the handle grip, a placement that counterbalances the weight of the rod, feels natural, and reduces arm fatigue.

Used in freshwater and saltwater, fly reels range from light small-profile models matched with the lightest line weights in freshwater to large-profile saltwater heavyweights with a lot of line capacity and drags that help pressure the strongest fish. Size is important in terms of capacity to handle large fish, and for matching up with the rod and line being used. Lighter lines used for smaller fish do not need large reels, but heavier lines, which have a larger diameter and which are likely to be used for stronger and bigger fish, obviously require a large reel.

IN MOST FRESHWATER FISHING, THE FLY REEL IS SMALL AND MAINLY A MECHANISM FOR STORING LINE.

LARGE ARBOR FLY-REEL
(LEFT) AND TRADITIONAL
SMALL-ARBOR FLY
REEL; BOTH HAVE AN
ADJUSTABLE DRAG.

A fly reel has no casting or line-dispensing function. It holds line, which is pulled out by hand to become available for the actual casting exercise; it retrieves line for storage, but not for the act of manipulating a fly; and it provides a variable degree of drag to pressure a strong fish when it pulls line from the reel.

Manufacturers and anglers often refer to fly reels as trout reels, salmon reels or saltwater reels, which is representative of line capacity and features than actual use. Fly reels are best identified as being single-action, multiplying action or automatic; these categorizations are all related to line recovery.

A single-action model features a spool inside a frame with the handle built on the spool. Each turn of the handle causes one turn of the spool, so there is a 1:1 ratio in line retrieval. This is also referred to as direct drive, and is the category in which about 90 percent of fly reels fit; most of these are fairly lightweight models. For many fish sought with flycasting tackle, single-action reels have plenty of line and backing capacity. The single-action reel has few

moving parts and minimal features, so it is simple and reliable. Many anglers carry an extra spool with these reels, so they can change line quickly if conditions warrant.

A multiplying-action fly reel is similar in design to a single-action reel, except that its gearing causes one revolution of the handle to turn the spool more than one time, which is how spinning, spincasting and baitcasting reels operate. The spool of a multiplying-action fly reel with a 2:1 ratio revolves two full times for each full revolution of the handle. Multiplying-action fly reels are more expensive than comparable single-action reels, and are used where rapid recovery of fairly long lengths of line is important to keep up with a fast-moving fish; some steelhead, salmon, and big-game saltwater anglers favor a multiplying-action fly reel.

An automatic fly reel winds in line automatically when a trigger is depressed, which releases tension in a pre-wound spring. That tension is built up when line is stripped off the reel. Automatic fly reels are fairly heavy, have limited line capacity and do not have an extra spool option. They

are not used in saltwater, and are mainly preferred for close-quarters freshwater fishing where quick pickup of loose line is desirable. Used mainly for panfish and small trout, an automatic fly reel is also a viable flycasting tackle option for someone who only has the use of one hand or has limited use of both hands.

The key elements of a fly reel are smooth operation and durability, and, in the case of reels used for strong fish, good drag performance.

All fly reels have a foot that is attached to the frame or housing and which holds the reel in the rod handle. Most better frames are made from highly "anodized" machined aluminum. Some frames may be of open or full design, and vented or solid. A full frame provides structural strength for reels made of less expensive materials, and requires that line from the spool be directed through the frame before it can be run through the rod guides. Open frames make line changing and rigging easier, and in better reels that are machined from strong materials they do not sacrifice strength. A vented frame is perforated with holes of varying sizes and shapes, and is preferred for stylistic as well as practical reasons; spools may be vented as well.

These holes also reduce weight slightly, although few people can tell the difference of an ounce or two in loaded reels. Fly reel spools are generally deep and narrow. Newer designs incorporate a large arbor for greater line retrieval per turn of the handle without sacrificing capacity. Large arbor spools recover significantly more line than conventional arbor spools and cause less fly line memory (coiling). Many spools also have an exposed or overlapping rim flange, known as a palming rim; this allows you to apply judicious tension on the spool with your fingertips or palm when a fish is taking line, or, more importantly, when pumping a large fish during a battle.

One-piece machined spools are found on better reels, and top models also have a counterbalanced design and turn easily on ball bearings. Balancing prevents spool wobbling, which occurs on unbalanced reels when a strong fish takes line and makes the spool spin at a furious pace, since the handle is on one side of the spool and there is nothing on the other.

Most fly reels have a simple drag system that is accessed by depressing a spring-loaded switch on the face of the spool to remove the spool. Underneath there is a simple

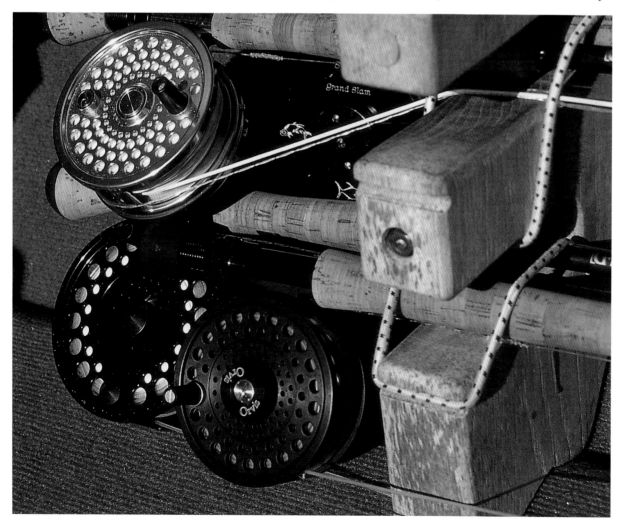

SALTWATER FLY REELS WITH LARGE LINE CAPACITY.

A LIGHT FLY REEL AND ROD IS THE TYPICAL OUTFIT FOR SMALL STREAM FISHING; ANGLER HOLDS A BROOK TROUT.

brake or click drag that has one or two pawls engaging a gear. The simplest reels should have a drag that allows for enough adjustment so that when line is pulled off the reel quickly it does not cause a line overrun and tangling. These pawls cause an audible clicking sound that differs from when line is being dispensed to when it is being retrieved.

A lot of fly reels have a compression drag system that utilizes one or more washers (also called discs) to press against the spool. Turning an external drag adjustment knob puts tension on a friction washer, which applies pressure to the spool to slow it down. There may or may not be a metal drag washer in the system, which presses upon the friction washer. Cork is the primary material used for the friction washer, although a few big game models use a carbon-fiber washer. Some fly reel drags have metal and friction washers in an adjustable, caliper-type

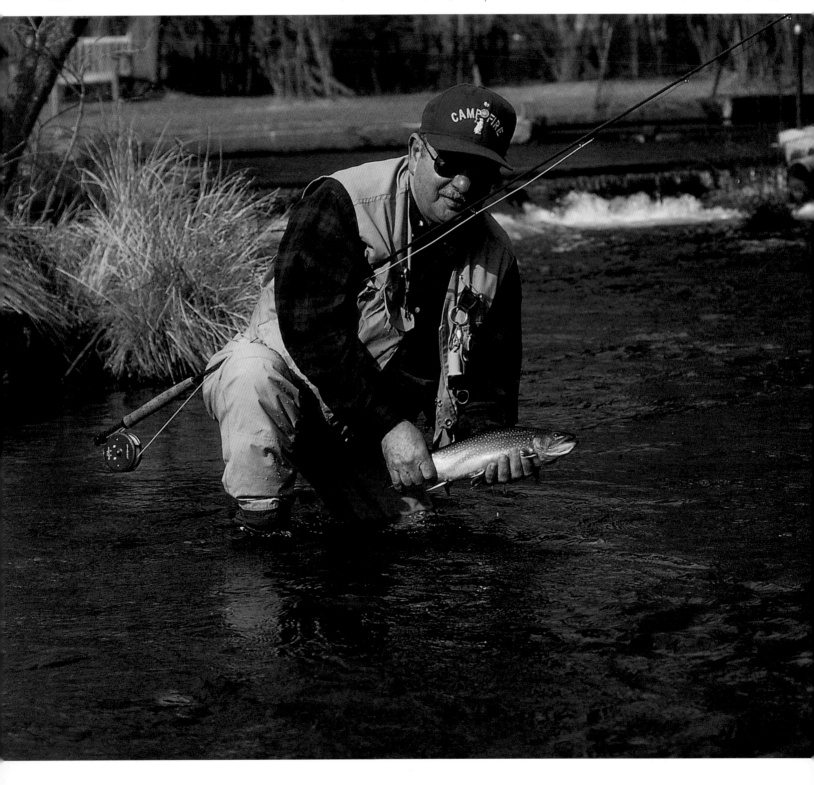

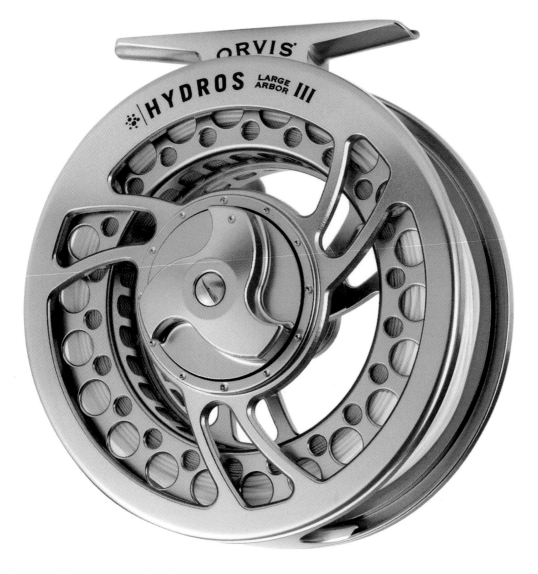

system that uses friction washers like dual braking pads to apply pressure to the spool. Some reels use O-rings in a caliper-like system instead of disc-like friction washers. In all cases, the rings or washers that are made of friction material compress with pressure, and in hard use a lot of heat builds up within the drag system. As with all other types of reel, the better drags are those that operate smoothly over a wide range of adjustments with good braking systems.

Some fly reels have an anti-reverse feature; when line is pulled from the reel, the spool turns but the handle does not. Another feature of some reels is readily convertibile right- or left-hand retrieve. Fly reels by tradition are commonly set to retrieve right-handed, and many older reels were only designed for this operation (similar to conventional and baitcasting reels). But this seems more suited to left-handed anglers, as they can hold the rod in their dominant hand and retrieve with their weaker hand. Thus, some right-handed anglers prefer left-hand cranking and right-handed rod holding, and convertibility (with some internal re-configuring) is important to them,

especially if they will tangle with large fish that require a lot of pumping and reeling.

Although many fly reels are suitable for the average range of fishing conditions that anglers encounter, some stand out from others under stress, abuse, frequent use and demanding situations. That is when the value of better-quality items becomes apparent. One indication of better quality is a finely machined and finished frame and spool. An anodized finish, or other corrosion-resistant finish, is common to the better reels and any that are to be used in saltwater, and top reels are made of aluminum and stainless steel. Other quality matters include a smooth drag system and easy drag startup, a good range of drag adjustment and a strong and smooth handle knob.

These all add up to durability and top performance for demanding fishing. However, many fly reels are used in routine fishing for generally small- or medium-size fish, and do not require the best drag features or the top materials. Most fly reels are used in freshwater, and many times the angler does not get into the backing on the reel.

WITH STACKED CARBON DRAG WASHERS THAT HAVE A LOT OF SURFACE AREA, THE ORVIS HYDROS EXEMPLIFIES A LARGE-ARBOR REEL INTENDED FOR SUBDUING STRONG FISH.

# Spincasting

The spincasting reel is the youngest of all types of reel, having been invented in 1947, with the first production models introduced by Zebco two years later. It is the easiest of all fishing reels to learn to use, and is suited to a variety of light- to medium-duty angling applications. It is durable, adequate for the majority of freshwater angling activities, and relatively inexpensive. The fact that most spincasting reels come pre-spooled with line eliminates the most basic rigging problem.

Some people erroneously believe that spincasting tackle is meant only for panfish and catfish angling, or for fishing with bait and a float. Usage really depends on a person's abilities and preferences, and on the grade of equipment. That said, very few spincasting reels are used in saltwater because most spincasting reel components are enclosed, which makes cleaning the reel with freshwater a challenging task, and because of low line capacity and reduced cranking power.

Spincasting reels have a stationary spool covered by a front cover with a hole or opening through which line passes. Line is wound on the spool under the cover or hood, and a button is used to release the line. This is very

different from other reels, and is a design that inherently lacks cranking power.

These reels range from ultralight models that weigh a few ounces and are used with four-pound line, to heavy freshwater and light saltwater models that weigh between 15 and 17 ounces and are used with 20- to 25-pound line. They work best when the terminal gear (lure or hook plus sinker) weighs between ¼- and ¾-ounce.

The spincasting reel usually has a pushbutton that controls the release of line, a stationary spool that line is wound around by a spinner head with a line pickup pin, and a round, or cone-shaped, cover with an opening for line to pass through. It also has an adjustable drag that is controlled mostly by a thumb wheel or star wheel, and either a single- or dual-grip handle. Convertible retrieve is not generally an element of spincasting reels because of the dominance of on-center gears, which by their nature prohibit convertability. Therefore, the majority of spincasting reels are set up for right-handed cranking. However, some models have off-center gears and can have convertible right or left retrieves. These are always the higher-end products, and include models that sport line-release triggers and sit under the rod handle.

A primary constraint to spincasting reels is relatively low line capacity. They hold less than 150 yards of

25-pound line; most, in fact, hold far less line of much lighter strength, and their limits in this regard explain, in part, why spincasting reels are typically prespooled by the manufacturer. By contrast, most baitcasting and spinning reels have much greater line capacities.

The spool of a spincasting reel, which is enclosed by the front cover, makes the reel easier to use, but also creates a misperception that the line cannot easily be feathered on the cast to control accuracy. Furthermore, because the line on the spool is not in constant view of the angler, several line-related functional problems can unknowingly develop. Too much line, too little line, tangled line, frayed line or twisted line are difficult to detect with spincasting reels. The gearing system on spincasting reels is similar to the gearing system on spinning reels. Both transfer crank-handle rotational forces through a 90-degree bend to the reel's mechanism that wraps line on the spool. This is accomplished through a gear system capable of converting motion between two 90-degree shafts. In comparison, revolving spool reels transfer motion from the crank handle directly to the spool through two parallel shafts. Of the different categories of fishing equipment, spincasting reels display the most inherent limitations in gearing efficiency, and many anglers feel that it is more difficult to retrieve identical weights with a spincasting reel than with a spinning or baitcasting reel. In essence, this is what accounts for limited cranking power.

Incidentally, many spincasting reels have a low gear ratio, ranging from 2.5:1 to about 4:1. Some of the models intended for use with artificial lures have a higher gear ratio. However, spool diameters are typically larger.

Generally, a large-diameter spool is good for distance casting, but spincasting reels have more areas that come in contact with the line during casting than spinning or baitcasting reels. These contact areas impart friction to the line, thus reducing potential casting distance. Line flows freely off the end of a spinning reel, only hitting the front flange of the spool before reaching the first line guide (stripper guide) on the rod. In

WITH MULTIPLE BALL-BEARINGS, CONTINUOUS ANTI-REVERSE, AND A HEAVY-DUTY DRIVE TRAIN, THIS ZEBCO MODEL TYPIFIES A SPINCASTING REEL MEANT FOR MORE STRENUOUS FISHING APPLICATIONS.

EASY TO USE, SPINCASTING TACKLE IS OFTEN THE FIRST EQUIPMENT THAT YOUNG ANGLERS TRY.

contrast, line on a spincasting reel comes in contact with similar components, plus the inside surface of the front cover and the edges of the protective front cover line guide as it exits the reel. This friction reduces casting distance and cranking power. Thus, casting distance is generally greater on spinning reels than spincasting reels. However, spincasting and spinning reels both inherently have the capability to cast further distances than baitcasting reels—thanks to a stationary spool rather than the revolving spool on baitcasting reels.

Some anglers think that spincasting tackle is not very good for making accurate casts, but this is often a function of poor casting technique, mismatched tackle, or both. Some exhibition casters are remarkably accurate with conventional spincasting tackle, more so than they would be with other equipment, simply because they have mastered all of the elements of the spincasting game and have properly matched gear. And some of the best European match tournament anglers use specialized spincasting reels because of the ease with which the reel can be controlled. The typical angler, however, uses spincasting tackle primarily in situations where accuracy and distance are not critical, and where the species of fish sought are usually small, which tends to reinforce the perception that accuracy is not an attribute of this equipment.

As with any type of tackle, accuracy is really a function of practice and using the right technique. The spincasting reel has the capability of being quite accurate; if you use your forefinger to contact the line as it exits the front cover, you are in almost constant contact with it. Because the line is making a loop as it exits the front cover, in theory the angler may not be in as constant contact with the line as

THIS GIRL IS USING A SPINCASTING REEL WITH A LINE RELEASE TRIGGER; THE REEL MOUNTS UNDER THE ROD; HER COMPANION IS FISHING WITH A TYPICAL SPINCASTING OUTFIT.

he/she would be when using a baitcasting reel. In addition, hand position on most spincasting reels is the same as it is on baitcasting reels, making it an easier transition from using spincasting tackle to baitcasting tackle.

The drag mechanism on better spincasting reels has improved markedly in recent years. The lowest-priced spincasting reels do not have sophisticated drags, but most other models have reasonably good drags and a few are excellent in this respect.

There are several different types of drag systems used in spincasting reels. The simplest is one that uses a drag wheel and features a spring arm that puts pressure on the edge of the spool. It is reasonably effective for modest fishing applications.

The most common system has a threaded shaft that rotates by means of the drag wheel (or occasionally drag star), which puts pressure on a clutch plate located between the spool and the body of the reel. This system has the ability to produce extremely smooth drags at low tension settings.

Both of these rely on the spinner head remaining stationary and the spool rotating so that it releases line from the spool. An advantage of this is that the line exits the spool in a fixed location. Because line is not traveling around the spool, as it would do if the spinner head rotated, a loop—such as the one generated in the casting mode—is not produced. The absence of this loop contributes to reduced drag variation, which means smooth drag performance. A disadvantage of a stationary spinner head and rotating spool is that if the reel handle is rotated while the drag is slipping, the line becomes twisted, which can cause tangling problems if not remedied. For this reason, many spincasting reels have a spool clicker built into the reel. When the spool turns backward to release line, a clicking sound indicates that the drag is functioning. This is an audible reminder not to rotate the handle until the drag stops slipping. Unfortunately, many people inadvertently put twist in their line by continuing to reel when the line is slipping via the drag. This is the most common fault of inexperienced anglers.

A unique type of drag system found in spincasting reels functions with a slipping gear instead of a slipping spool. It has the advantage of producing less twist in the line, regardless of the level of expertise of the angler. In this system, the spinner head rotates backward, unwrapping line from the spool, much like back-reeling. This is accomplished by a floating drive gear and is controlled with a drag star. A disadvantage to this system, however, is uneven drag performance. As the spinner head unwraps line from the spool, a loop is formed. This loop results in drag variations, which are much higher than those found in other spincasting reel drag systems.

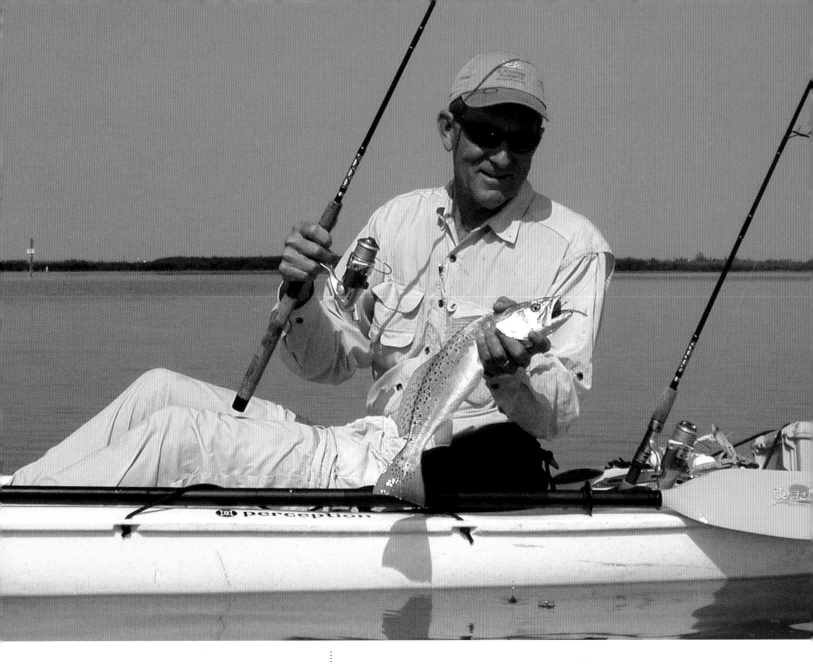

# Spinning

It is fair to say that the importation of spinning reels to North America after the Second World War greatly helped stimulate sportfishing interest. These products were called fixed-spool reels at first, and, together with the near-simultaneous emergence of fiberglass rods and nylon monofilament line, they made angling easier for thousands of people who had previously not been very involved with this activity.

Despite their name, spinning reels have a spool that does not spin or revolve, but is fixed in place. Because the spool does not move during a cast, there is no chance of a backlash forming, as happens when a moving spool turns faster than the line is carried off that spool. During the retrieve, line is wound or spun around the spool, giving rise to the name of this equipment. When spincasting reels (which also have a stationary spool) evolved, spinning reels were called open-faced reels, because they did not

have a cover over the spool like spincasting reels did.

No matter what the terminology, spinning reels are very popular and widely used. They are fairly easy to cast with, relatively backlash-free, and well suited for fishing with light or small terminal tackle, especially in casting.

Spinning tackle has a greater following in freshwater fishing than in saltwater fishing because of differences in conditions, techniques and size of fish, yet technical advances have resulted in a wide range of equipment that is suitable for applications ranging from ultralight panfishing to offshore fishing for sailfish and white marlin. Reels range from small-profile ultralight models designed for use with two-pound test line to large-profile saltwater heavyweights for use with up to 30-pound line. Appropriate models can be used in casting, trolling and fishing with bait, making this truly versatile equipment.

One of the factors that contributes greatly to the popularity of spinning tackle is that the reels are mounted underneath the rod handle, a position that is only shared by fly reels. This feels comfortable and balanced to many

A KAYAK FISHERMAN NEAR ST. PETERSBURG, FLORIDA, LANDS A SEATROUT CAUGHT ON A MEDIUM-LIGHT FRONT-DRAG SPINNING REEL.

A MIXTURE OF LIGHT TO
MEDIUM-HEAVY DUTY
SPINNING REELS.

people, especially inexperienced anglers, and it reduces arm fatigue from constant casting. The fact that spinning reels are convertible to either right- or left-hand retrieve assures that the rod is held in the dominant hand, which is often not the case for those using other tackle.

While the basic principle of a spinning reel operation has remained the same over time, major evolutions have occurred in the drag and casting features, and especially in twist reduction; as with other reels, gears are a critical component of performance.

The gears of a stationary spool reel are generally less efficient than those of a revolving spool reel because they are offset (the drive gear shaft is at a right angle to the pinion gear shaft) rather than being directly in-line. While this has some cranking power drawbacks, it is because the crankshaft of spinning reels runs through the whole reel that allows for convertible right- or left-retrieve, which is not possible with existing revolving spool reels.

A wide range of gear ratios exists in spinning reels. Many are in the high (6:1 to 7:1) category. Many spinning-reel users prefer a high ratio, but fail to take into account the actual line recovery of the reel, which is the amount of line recovered per turn of the handle. That is determined by spool diameter. If two reels have the same gear ratio but one has a larger spool diameter, that one will recover significantly more line per turn of the handle. Furthermore, a lower gear ratio usually means more cranking power. The size of the spool is an element of casting, especially with regard to the width relative to the depth of the spool. Many spinning reels now have relatively large width-to-depth ratio spools. In a very narrow spool, line will pull from deeper in the spool and make a sharper angle as it comes off. On a wider spool, more of the line remains closer to the top of the spool flanges. When casting, the line does not make as

dramatic an angle as it passes over the spool flange as it does on a narrower spool. This is the premise behind so-called long-cast or long-stroke reels. Overall spool diameter also has an influence on casting distance.

A newer type of spinning reel spool design, found on only one brand of reel to date, features a "wave"-style flange rather than a continuous rolled edge, as had been the norm since the production of the very first spinning reel. The toothlike or gearlike configuration of this newer-style spool edge helps eliminate line fouling or bird's nests resulting from large coils of line coming off the body of the spool, thereby improving overall casting performance as well as helping to achieve greater distance.

Spinning reels have always suffered from a tendency to produce line twist. Twisted line hampers casting and general fishing effectiveness, and may result in damaged line, so it is a problem to be avoided and corrected. Reducing or eliminating twist is an ongoing focus for spinning reel manufacturers.

Although improper use of fishing equipment is the major cause of line twist (especially reeling at the same time as outgoing line is causing the drag to slip), the normal operation of a spinning reel may promote line twisting. Twist can occur if the line turns over on itself while moving from the bail to the spool.

Most line rollers turn as the line comes in. The size and shape of the line roller are factors that affect twisting. Many better reels today have a larger diameter, sharp roller slopes, and grooves to help prevent twist. These keep the line in one spot on the roller and prevent it from moving around, as well as eliminating slack line movement. These components by themselves do not prevent twist, but they do help to keep the line in such a position that it does not spin over.

OPPOSITE PAGE:
ANGLER IS PLEASED WITH
HER LARGEMOUTH BASS,
CAUGHT ON LIGHT
SPINNING TACKLE.

RIGHT: THIS INTERNAL VIEW OF AN OKUMA CORONADO REEL ILLUSTRATES THE OFFSET GEARS OF A SPINNING REEL. THESE ARE STAINLESS STEEL GEARS.

The drag mechanism on spinning reels used to be fair to poor, but it has improved markedly since this gear has been used for more challenging fishing. Low-end spinning reels have unsophisticated drags, most medium- and higher-quality models have reasonably good drags, and many of the higher-priced ones have very good drag systems.

Spinning reels have predominantly front- or rear-mounted drag systems. Many experienced anglers prefer front drag because of smoother performance. Both systems feature one or more discs or washers that direct adjustable tension on the spool shaft by turning an adjustment knob.

On a front-mounted drag the adjustment knob is at the very top of the spool. On some of these reels, there is a pop-off button in the middle of the knob, which is pressed to free the spool from the shaft, allowing the drag adjustment to be unaltered when the spool is removed.

On a rear-mounted drag the adjustment knob is at the bottom of the reel. The spool on this reel is simply removed by pressing a pop-off button at the top of the spool, regardless of the drag tension setting. Such easy spool removal is an advantage to rear-mounted drag

reels, although spool removal is not a frequent necessity for many anglers.

Rear-drag reels are somewhat easier to adjust during the act of fishing because they keep hands away from the line. Adjusting drag tension on a front-mounted drag while playing a fish means that your hand may get in the way of the line. On a reel with top-mounted drag, the line extending from the bail roller, which is usually under a lot of tension, is often in the way when a quick adjustment is necessary. This is generally viewed as a disadvantage to top-mounted drags, although for many anglers it is seldom necessary to increase or decrease drag tension during the act of fighting a fish, and in fact it should not be adjusted if it has been set properly.

In the mid-1990s, a spinning reel drag system with a center drag was introduced. The drag control was located on the middle of the reel on top of the lower housing of the spool. This placement theoretically means that the drag control mechanism is easy to adjust when line pays off the reel. Of greater significance, however, is that it provides a large friction washer surface area. Although this reel was praised by some, it did not sell well, and the manufacturer discontinued it. But the principle has promise and a center drag may reappear in a future product.

With any of these systems, drag smoothness, or the ability to perform without erratic motion over a wide range of adjustment, is especially critical. This is controlled by the materials, the way in which they are assembled and the size of the washers.

The design and placement of front- and center-mounted drags allows for the use of larger washers, which is one reason why they perform well. A rear drag can be every bit as smooth, but has difficulty maintaining that smoothness at higher line-tension settings unless it uses the same size drag washers as the front and center drags. When large washers are used in a rear drag reel the body starts getting bigger, which is less aesthetically attractive to some people. Since the trend in most reels has been to a smaller overall size, rear drags have had correspondingly-sized washers. Front and center drags, however, allow for small overall body size but larger washers, which means that they perform better than rear drags if the drag material allows.

The primary material in modern high-end spinning reels, most of which have very smooth drags, is Teflon, or a proprietary synthetic composite that is a mix of fiberglass, graphite and Teflon; in spinning reels, these materials do a reasonable job of satisfying two opposite demands: starting up quickly and smoothly; and maintaining even

THE SELF-CENTERING FUNCTION OF THIS DAIWA EMBLEM Z-SURF REEL ENABLES EASY LINE PICKUP FOR CASTING.

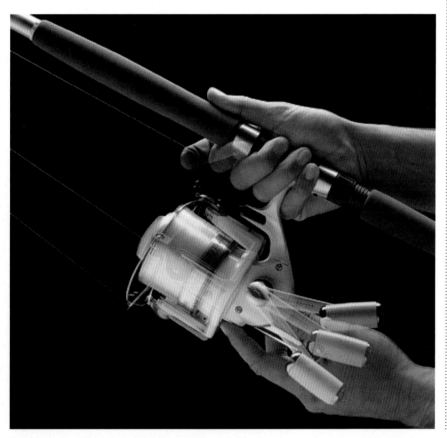

performance. Since heat dissipation is one of the most important elements of a properly functioning drag, metal washers (which dissipate heat well) are used in conjunction with friction washers made from other materials, which provide the smooth slip surface.

In most mid-priced spinning reels, the drag system is generally of fairly good quality, while in most high-priced models it is good to excellent. Since the majority of spinning reels are used for light and medium-light applications in freshwater, the drags are actually overbuilt for the majority of users.

With the exception of fishing for steelhead, salmon, stripers and big trout, freshwater anglers generally do not require exceptional drag performance. Saltwater anglers often need, and really test, the performance of a spinning reel drag. Thus, drag performance and drag components are mainly significant to people who will catch fish that will put some pressure on a reel. Sometimes, of course, you never know when a fish will come along that will do just that.

A few spinning reels have combined drag systems in which there are both front and rear drags, the front drag being the primary one for fish fighting and the rear drag being a means of releasing tension on the line while the bail is closed. The rear drag is small and has a very light setting, so that if a fish takes live bait, for example, it can move off under minimal resistance. When ready, the angler engages the main system and uses it to play the fish. Generally there is a lever to engage or disengage the main drag; in some systems, the main gear is engaged automatically when the handle is turned. This is primarily an advantage when fishing with bait.

A final point about modern spinning reels is that most better models feature a continuous, or infinite, anti-reverse ability, which is very helpful. This feature ensures that the reel engages instantly and firmly because the drive gear does not move even the slightest bit backward. This helps to avoid slack line and prevents errant loops from forming on the spool. It aids solid hooksets.

MOST OF THE SPINNING REELS USED IN FRESHWATER FISHING ARE LIGHT OR MEDIUM-LIGHT MODELS.

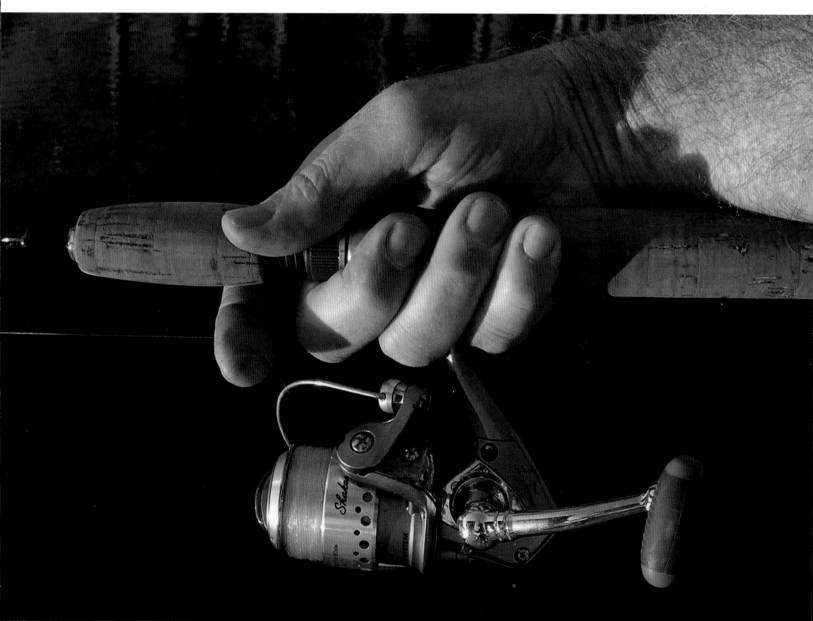

# FISHING RODS

No single fishing rod provides top performance for all types of sportfishing. In fact, many rods are greatly dissimilar, and all are a compromise in attributes, depending on how much of the following they have to do: cast, detect a strike or bite, set the hook, and fight/land fish. Some of these functions require opposite properties for optimal performance, which obviously complicates rod design. Here is a brief review of the major characteristics of the different categories of rods.

## Baitcasting

Baitcasting rod guides mount over the axis of the rod and are placed on top of it, with the reel sitting on top of the handle rather than under it. This arrangement is especially well suited to fighting and controlling a fish, as well as retrieving lures. The rings on baitcasting rod guides are smaller than they are on most other tackle. This is because they don't have to accommodate large spirals of line coming from the reel when casting, the line is fairly close to the rod blank when it leaves the reel, and because the line on baitcasting reels is not prone to twisting and coiling. Guides may have a single or double foot. Double-foot guides are more likely to be used along the entire blank on heavy-action rods or just in the position of the first guide or guides (closest to the reel). Single-foot guides are generally preferred because they improve rod action and decrease weight.

LIGHT, STIFF AND SHARPLY TAPERED BAITCASTING RODS MAKE EXCELLENT CASTING TOOLS.

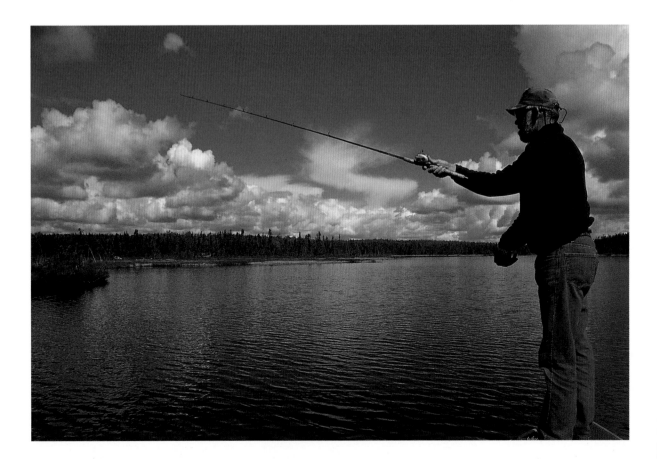

Baitcasting reels mount close to the rod handle in the reel seat, which makes it fairly comfortable to palm the reel and rod. Rod handles are either straight or have a pistol-grip design, the latter are usually found on shorter models. All baitcasting rods that are used for casting have a trigger grip on the underside of the rod, opposite and at the lower end of the reel seat. When holding the rod, this trigger grip rests under either the middle or ring finger. Rods designed for trolling, which have a long handle, usually do not have a trigger grip so they can fit into rod holders. Handle length and overall rod length vary according to application, ranging from five-and-a-half-foot models to nine-footers for steelhead and salmon fishing. Most rods used strictly for casting are six- to seven-and-a-half-feet long.

Baitcasting rods are primarily available in one-piece models, although longer models may have a telescoping butt in which the upper section slides into the lower for storage. There are few travel models, but a few excellent ones exist in two-piece versions.

Action, taper and material construction vary considerably. Baitcasting rods are commonly made of graphite and a mix of graphite and other materials, and many models are specifically tailored to special uses and styles of fishing.

# Big game

Big game rods are used with lever drag reels and are also called offshore rods, tuna rods, billfish rods and deep-sea rods. There is some overlap in this category, with conventional rods used with heavy-duty star drag reels.

Both are generally short, stiff, heavy-action products that are more solidly built than other rod types, and are extremely dependable. The stress and torque put on these products is extraordinary, so components and construction processes are of the highest caliber.

Big game rods were once all six-and-a-half to seven-and-a-half feet long with detachable wooden, aluminum, or fiberglass butts and a long slow-curving tip section. Modern manufacturing technology and changing needs have shortened many big game rods to one-piece products with shorter butts and lighter tips that bend into the foregrip; these rods can put a lot of pressure on a fish for quicker and easier landing, especially for standup fish fighting. Modern big game rods range from five to seven-and-a-half feet in length, with the majority being five-and-a-half to six-and-a-half feet long. Butts are largely aluminum or graphite composite, and all have a gimbal for insertion into a gimbaled rod holder or kidney belt. They have long, beefy handles and heavy-duty reel seats that securely accommodate lever drag reels, and they have a cushioned foregrip large enough for two-

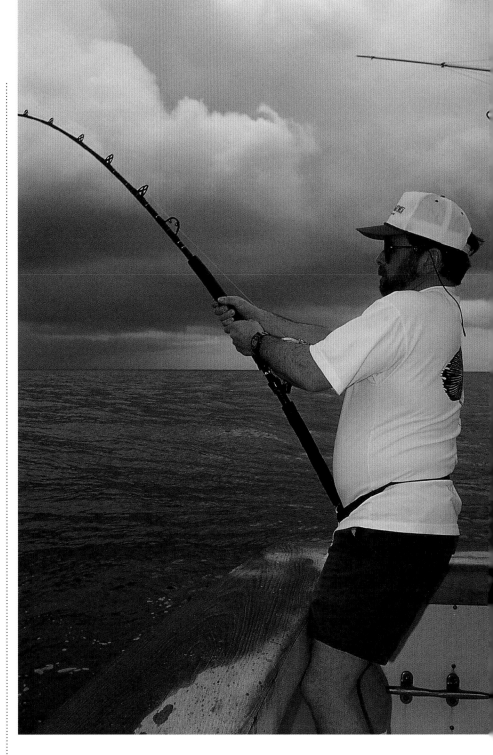

handed use when fighting and lifting heavy-duty fish.

Heavy-duty roller guides are used on most big game rods and all top line class models; some have tip and butt-end (stripper) roller guides. Guides, as well as reels, mount on top of the rod, since these rods are mainly used for fish fighting (as opposed to casting, retrieving or detecting strikes), and they have to withstand the crushing downward force of gamefish on guide ring and frame. Graphite, fiberglass and composites of the two are used in construction. All big game reels are designated according to line strength based upon IGFA record classification; this ranges from six- through 130-pound test, and coordinates with both the reel and line strength that the product was designed to handle.

THIS SHORT, STAND-UP STYLE BIG GAME ROD HAS A LONG FOREGRIP AND A LOWER ROLLER GUIDE.

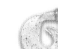

# Conventional

These are rods used with conventional reels, but this is misleading because there is a vast array of rods that fall into this oversimplified categorization. Some products in this array may be called ocean rods, deep-sea rods, boat rods, bay rods, pier rods, trolling rods, bottom-fishing rods, live bait rods, wire line rods, saltwater rods, downrigger rods and so forth. Because they are used with predominantly non-levelwind revolving spool reels, they can all be categorized as "conventional" rods.

All are generally stiff, heavy-action products, with longer models generally used in pier and bridge fishing and downrigger trolling, and shorter models in such boat work as casting, jigging and bottom fishing. Some models are used for particular applications, such as standup fishing for large offshore species.

Conventional rods are generally stout with long, thick, two-handed handles that securely accommodate either level- or free-winding conventional reels, but primarily the latter. Virtually all models have a long, cushioned foregrip large enough for two-handed use for heavy-duty fish fighting and lifting. The butt of many handles has a gimbal for securing it in a gimbaled rod holder or belt.

Heavy-duty, double-foot rod guides are used and are mounted on top of the rod like the reel, which is the system best suited for fighting fish. Some rods feature a full complement of roller guides or tip and butt-end (stripper) roller guides. The rings on those guides that have them are generally small, since there is little casting generally done with such rods (although it is done with some versions).

Lengths and materials vary, although fiberglass and composite construction (graphite and fiberglass) are used with greater frequency in many more conventional rods than in other rod types; few are exclusively made with graphite. Graphite may be used in some reel seats, however, all of which are extremely rugged; some rods also feature trigger grips, although most do not.

# Fly

Fly fishing requires the casting of a heavy and particular type of line to deliver a lightweight fly. Thus, fly rods have a particular and characteristic role. In many fly fishing situations, the reel is primarily a device for storing and retrieving line, so the rod is more important than the reel because it is matched to the weight and design of the line and is essential to delivering the fly. The rod stores and transfers the energy necessary to cast the heavy fly line; its length, taper and action are specifically designed for this activity, meaning that other types of rod cannot properly cast a fly line and, conversely, a fly rod and fly line cannot properly cast a heavy lure or weighted bait.

Fly rods today are labeled on their shaft by the manufacturer as to the weight of line that they are designed for; some can accommodate two line weights. Like fly lines, weights range from one to 15, with five through eight most common. Lengths are normally from seven to ten feet, although there are some shorter models for ultralight fishing and longer two-handed rods up to 17 feet for specialty fishing. Most fly rods are of two-piece configuration, but some long models have more pieces, as do travel models; excellent four-piece travel rods are available as well.

WITH REEL AND GUIDES MOUNTED UNDER THE ROD, SPINNING RODS DO NOT OFFER AS MUCH LEVERAGE AS OTHER GEAR, BUT THEY ALLOW FOR EASY CASTING AND GOOD DISTANCE.

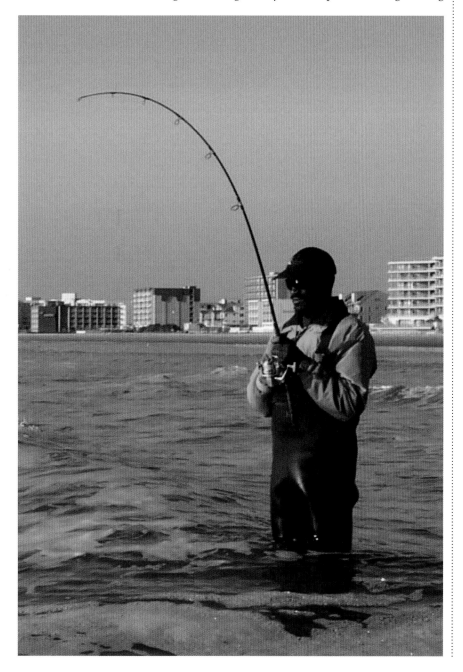

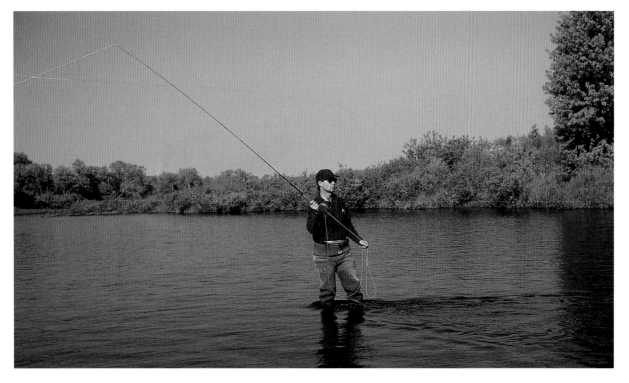

FLY RODS ARE PRIMARILY
CASTING TOOLS MATCHED
TO FAIRLY HEAVY LINES.

Like spinning tackle, a fly reel mounts under the axis of a fly rod so the reel sits under the handle instead of on top of it; this is in part because they are both theoretically geared more to casting than to fish fighting. This does not mean that they do not fight fish well if properly designed, just that casting is generally the greatest attribute of the majority of fly rods; the models designed for big game fishing are designed less for casting and more for subduing fish.

The reel seats of fly rods are positioned at the very end of the rod below the cork grip. There is a butt cap at the end of the rod just below the reel seat, and this sometimes has a fighting or extension butt, which is used for additional leverage and keeps the reel away from the body for easier use when fighting large and strong fish. Most fly rods have a keeper ring, or wire hook keeper, on the shaft just above the grip, which stores the fly hook when the outfit is rigged but not in use.

Most fly rod guides are different from those of other rods, with the exception of the lowest guide, called the stripping guide, which is a low-friction, round-ring model. There may be two or three round guides on some fly rods, and, as with the lower guides on other rod types, they gather the outflowing line and funnel it down to run along the rod. The remaining guides of a fly rod are called snake guides; these light wire guides are nearly friction-free, and aid the passage of the thick fly line during casting and retrieval.

Most fly rods today are made from graphite or a graphite composite; a few are manufactured from fiberglass and fewer still from bamboo. Lighter, more sensitive, and more powerful graphite is far better for picking up line, loading the rod, and propelling it through the air than other materials. Various grades of graphite are available in rods, so there are models that fit all budget ranges.

# Spincasting

These rods are mostly similar to those used in baitcasting, and are fairly uncomplicated. The guides are mainly mounted on top of the rod, and guide rings are generally small, unlike those used with spinning tackle, since lines come straight out of the nose cone of the spincasting reel. The lone exception to this is the hybrid spincasting reel that sports a trigger release; this is mounted under the rod rather than on top of it, and is used with spinning rods.

Spincasting rods have straight and pistol-grip handles, with the latter especially popular. All rods with pistol handles, and some with straight handles, have a trigger grip on the underside of the rod opposite and at the lower end of the reel seat.

Spincasting rods are usually not as stiff as baitcasting rods, having generally lighter action for use with light lines and lures. There are one- and two-piece models, and a few are telescopic. Lengths are shorter than most baitcasting and spinning rods; they range from four-and-a-half feet to six feet, with five- and five-and-a-half footers the norm and some shorter rods available for youngsters. Most rods marketed for spincasting use are made of fiberglass, but a few feature graphite-fiberglass composite construction.

BELOW: HANDLE STYLES
VARY BY ROD TYPE AND
DESIGN; SHOWN ARE FIVE
SPINNING ROD HANDLES
(FROM LEFT), AND TWO
BAITCASTING ROD HANDLES.

# Spinning

The guides of spinning rods mount under the axis of the rod and thus are placed under it, and the reel sits under the handle rather than on top of it. This also occurs with flycasting tackle because these products are theoretically geared more to casting functions than to fish-fighting functions.

The rings on spinning rod guides are also larger than they are with other tackle, to accommodate the large spirals of line that come off the spinning reel spool when casting, and to minimize the effects of coiled or possibly twisted line rapidly funneling through the guides. A single guide foot is standard, meaning that there is just one attachment point for the rod to the blank, which improves rod action. Spinning rod guides also extend a greater distance from the rod shaft than do the guides of other types of rod. This helps to reduce line slap, which is the tendency of line that is cast from a spinning reel to strike the rod shaft, thereby increasing friction and reducing casting distance.

Spinning rod handles are straight, with fixed or adjustable (ring) reel seats, and both one- and two-piece models are common. Handle length and overall rod length vary, ranging from four-foot ultralight models to some surf fishing versions in the 14-foot class.

Action, taper and material construction vary considerably. Spinning rods are commonly made of graphite and a mix of graphite and other materials, and many models are specifically tailored to special uses and styles of fishing.

# Specialty rods

Travel or pack rods are found in baitcasting, spinning or fly versions, and are three- or four-piece products (some also have telescoping butt sections). Ice fishing rods are usually very short, with a soft tip for use around holes in the ice. Flipping rods are long (seven to eight feet), heavy-action rods with telescoping butts that are used for making short casts in close quarters to heavy cover when largemouth bass fishing. Noodle rods are whippy 12- to 14-foot rods with guides that curve around the rod blank; they are primarily used in stream steelhead and salmon fishing for presentation and fish-fighting advantages, and sometimes in trolling. Downrigger rods are eight- to nine-foot, slow-action products that are primarily found in baitcasting versions and take a long, deep bend for use when trolling with downriggers.

Some other rods are made for special applications, and many manufacturers make rods designed for particular species of fish or for use with certain lures or natural baits.

# LINE

Made from different materials in varying strengths, diameters and colors, fishing line is produced in strengths from one to 200 pounds, with six- through 20-pound strengths most popular. Nylon monofilament accounts for the majority of all fishing lines sold, the remainder being primarily braided microfilament, fused microfilament, fluorocarbon line, weighted line, wire line and fly line.

. . . . . . . . . . . . . . . . . . . . . . . . . . . . . . .

## Nylon, fluorocarbon and microfilament lines

Nylon monofilament, often referred to as mono, is a single-strand product made from nylon or nylon alloys; various brands of nylon monofilament line possess the same derivatives, but the way in which they are processed and extruded, and the way in which their molecules are compounded, determine the different characteristics and properties. Fluorocarbon line is a single-strand nylon alloy that looks like conventional nylon monofilament, but is more dense, so it sinks, and has a lower refractive index, which makes it less visible. It has become popular for clear water fishing in recent years. Braided lines consist of intertwined strands of Dacron, gel-spun polyethylene fiber, or aramid fibers; braiding of synthetic microfilament fibers has produced ultra thin, super strong and very sensitive lines. Fused lines are created by fusing the same synthetic fibers, as are braided lines, producing a cheaper, single-strand-like line.

The fishing performance of these lines is based upon the properties that are engineered into them. To some extent, a good line is one with a proper balance of characteristics, primarily being strong, relatively thin, and durable. However, manufacturers can manipulate properties to improve certain performance features, which has resulted in a wider variety of products than ever. Here is a review of some of the most important line characteristics.

### BREAKING STRENGTH

There are two breaking strength designations: test and class. Class lines are predominantly used by saltwater big game tournament anglers, by anglers specifically interested in establishing line-class world records, and by fastidious anglers who want to know exactly what their line strength is. Class lines are guaranteed to break at or under the labeled metric strength in a wet condition. They are more expensive than test lines and are primarily differentiated from test lines in the wet breaking strength feature; other properties should be similar to those of test lines.

Any line that is not labeled as class line is test line. Perhaps 95 percent of all line sold is categorized as test, even if the word "test" is not used on the label. Despite the labeled strength, there is no guarantee as to the amount of force required to break the line in either wet or dry conditions. The labeled strength may not reflect the actual force required to break the line in wet condition. Since there are no guarantees with test lines, they may break at, under or over the labeled strength. An overwhelming number break above the labeled strength, some just a little above and some very far above. Since there is a great deal of difference in the actual breaking strength of various test lines, and since people only know what the label tells them, many anglers fish with line that is much stronger than they think it is. Many are also misled into believing that some lines are stronger than others because they physically feel that way.

To determine the actual fishing strength of a line, you have to soak it in water for a while, then test it. This is because many lines absorb water and are thus weaker

A LAB TECHNICIAN USES HIGH-TECH EQUIPMENT TO TEST THE ACTUAL BREAKING STRENGTH OF LINE.

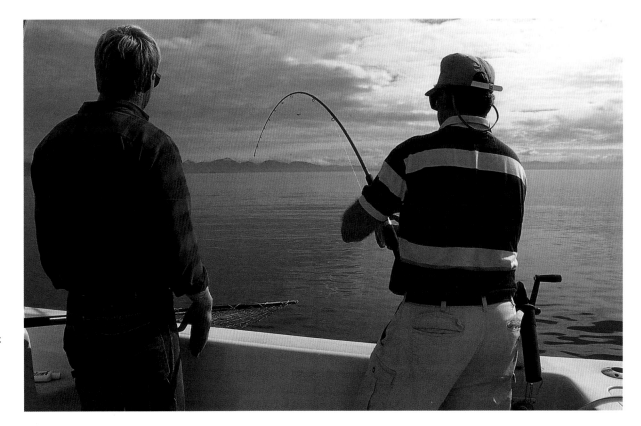

NYLON MONOFILAMENT LINE HAS A CERTAIN AMOUNT OF STRETCH, WHICH PROVIDES SHOCK ABSORPTION, AS DOES THE FLEX OF THE FISHING ROD.

when they are wet. Since few anglers have the machinery to calibrate exact breaking strengths, they are usually in the dark as to the actual strength of a line, although some independent analyses (with widely varying results) have been published.

## DIAMETER

It used to be that the breaking strength of a line was directly related to its diameter. The greater the breaking strength, the larger the diameter. However, nylon monofilament line manufacturers now produce ultra-thin lines that have the same performance characteristics of conventional mono, yet are markedly thinner. Similarly, the newer microfilament lines are exceptional in regard to thin diameter. Therefore, the diameter of a line is no longer necessarily a corollary to its breaking strength.

The diameter of a line has some bearing on the amount of it that will fit on a spool, and is therefore available for fighting strong fish. This is of special concern to light-tackle anglers who need plenty of line on a reel. It is also a factor in achieving distance when casting and in getting lures to work effectively; thinner line has less drag and can be cast further, and it allows lures to dive or sink deeper or faster. Because thin-diameter lines are less visible to fish, they help to draw more strikes, especially in clear water.

To compare products, you have to know the diameter as well as the actual breaking strength. Some manufacturers provide diameter information on their nylon monofilament

products, but not with braided or fused microfilaments. Solid, round, single-strand nylon monofilament provides a uniform diameter and is easy to evaluate, but other products do not provide consistent or necessarily accurate diameter measurements.

## ABRASION RESISTANCE

Abrasion resistance is important in fishing line, but tough to evaluate. Some lines are more abrasion-resistant due to greater diameter, the composition of the line or an applied coating. Determining differences among brands is subjective, and you can only make this judgment through use.

Some lines, particularly premium nylon monofilaments and fluorocarbon, have excellent abrasion resistance. Some are just barely adequate. Dacron has very poor abrasion resistance, which is why it is barely used any longer; microfilament lines have not been very good in this area either. No castable line completely withstands abrasion, but some withstand it better than others. The key is to find a line that resists abrasion adequately while still having other properties important for fishing performance.

## STRETCH

The average amount of stretch in nylon monofilaments was once around 30 percent in a wet state, but has now been reduced in better products from ten to 25 percent. Nylon monofilament line has slightly more stretch in a wet state than in a dry one. Lines with high stretch are great

MACHINES THAT MEASURE ABRASION RESISTANCE ARE OFTEN SEEN AT SPORTS SHOWS, BUT THEY DO NOT MIRROR ACTUAL WET-LINE FISHING CONDITIONS.

for casting, but terrible for hook setting and playing fish because they have too much elasticity.

Lines that have low stretch should increase your ability to detect strikes, aid hooksetting, provide more control in playing a fish, increase sensitivity to feel what a lure or bait is doing, and theoretically help you catch more fish. These have been the most important attributes of fluorocarbon and microfilament lines, which have virtually no stretch.

While you would think that it would be best to fish with a line that had virtually no stretch, such as the different microfilaments, many anglers have tremendous difficulty with these products precisely because they have no stretch and are unforgiving. Anglers set the hook too hard or pull too intensely on a hooked fish and yank the hook out of the fish. Because of low stretch, anglers have to use these products differently than nylon monofilament, and make adjustments (such as decreasing the reel drag and using a more limber rod).

## FLEXIBILITY

A limp, or very flexible, line is advantageous for distance casting, in part because the line comes off the reel spool easily in smaller coils and straightens out quickly. It can be managed on a reel more easily than a stiff line, but lacks sensitivity. Stiff lines tend to spring off the spool in large coils, which flap against the rod guides, decrease distance, and increase the likelihood of developing a tangle.

The flexibility of a line is hard to judge by sight, although in some instances one can feel that a line is very stiff or very limp. Braided lines are limper than nylon monofilaments, which vary a great deal in flexibility. Nylon monofilament line forms a memory when placed in a set position (such as being spooled) for an extended period of time. Nylon lines with less memory are considered limp and are more castable than stiff lines, a factor that is important in light-line angling. Nylon lines with a lot of memory are considered stiff, which contributes to spooling and twist problems and makes casting more difficult.

Castability is also affected by water absorption in lines that absorb water; wet lines usually cast better than dry lines. It is also affected by line diameter; the greater the diameter, the harder it is to cast. With nylon monofilament, the stiffer the line, the less stretch it has but the more difficult it is to cast. Thus, there is a dramatic tradeoff between castability and stretch in nylon monofilament. It is a good idea to wet nylon monofilament line (place the spool in the water) before you start using it on a given day, to help the molecules relax.

Braided and fused microfilaments are different in this respect. They have low stretch, good limpness and high castability, wet or dry.

FLY LINE IS USED TO DELIVER NEARLY WEIGHTLESS OBJECTS, AND SOMETIMES TO HELP PRESENT THEM BELOW THE SURFACE.

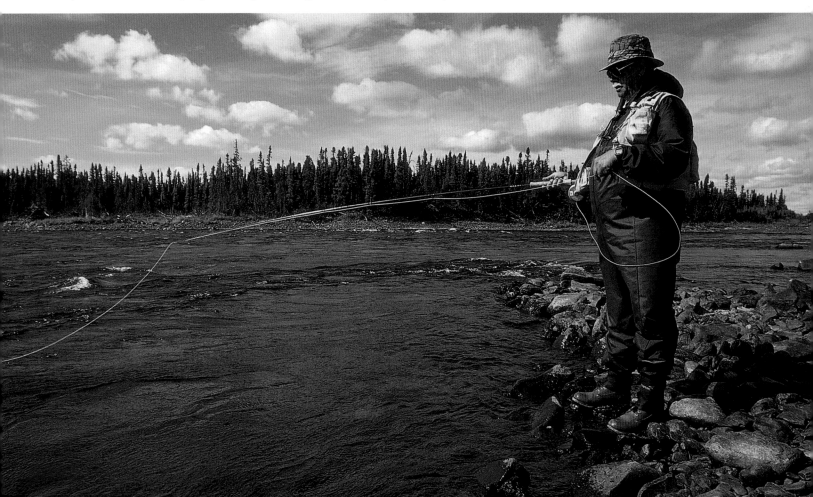

# Fly, Wire and Weighted Lines

Fly, wire and weighted lines are distinctly different in principal usage to most other lines. Weighted and wire lines are trolled rather than cast. Fly line is cast, but it is used to carry nearly weightless objects; other lines that are cast are carried by the weight of the object being cast.

## FLY

Castability is the first and most critical performance characteristic of a fly line, which is a relatively thick product with a core and a coating. The core is a braided synthetic that determines tensile strength and stretch, and influences stiffness. The coating is mainly polyvinyl chloride; it provides most of the weight needed to load the fly rod for casting, and some of the line's flexibility, plus color, shape and density.

Individual fly lines are designed to be stronger than the heaviest tippet that the product will be used with, so their breaking strength ranges from approximately 20 pounds (lightweight, freshwater lines) to over 40 pounds (heavy, saltwater lines).

There are floating, sinking and floating/sinking lines. A floating (F) line is for surface or near-surface fishing. It is the easiest fly line to cast, to pick up off the water and to fish, which is especially important for someone new to this activity. A sinking (S) line is used only for fishing below the surface. Sinking lines are also known as full-sink lines, and are classified according to the speed at which they sink. Floating/Sinking (F/S) lines possess a floating body and a sinking tip section, and are commonly called sink-tip or sinking-tip lines. The length of the sinking tip varies, usually from ten to 30 feet; like full-sinking lines, they vary in sink rate.

The four main line shapes are level, double, weight forward and shooting. A level (L) line is the same weight and diameter throughout, and essentially has no taper to it; it is difficult to both cast and control in the water. A double taper (DT) line has the same taper at both ends and a section of level line in the middle, and is used primarily in short- to medium-range casting. A weight-forward (WF) line is tapered only at the fishing end; it is designed to fish well at short, medium and long distances, and is especially useful for casting large flies, bugs and poppers. A shooting (ST) line, which is also known as a shooting head (SH), is a 30-foot length of tapered fly line, similar to the head of a weight-forward line; it is difficult to cast and mainly used in big water fishing and for long casting.

Fly lines are commonly about 85 to 90 feet long; they may vary in overall length from 75 to 100 feet or more, with the exception of short shooting heads. The portion devoted to the head and the running line varies, but it

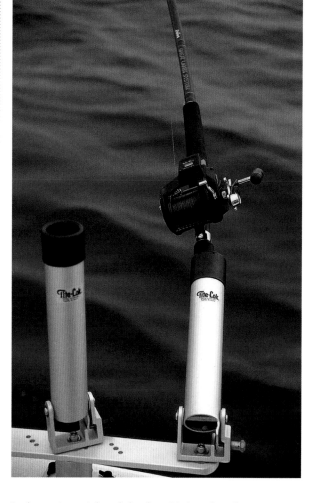

RIGHT: THIS ROD AND REEL, USED FOR DEEP LAKE TROUT TROLLING, IS LOADED WITH WIRE LINE.

is the grain weight of the first 30 feet that determines its classification, according to a standard system in which lines are measured in weights from 60 to over 800 grains and translated into line weight or size, which is inter-related with the rods that are designed to cast such a class of line properly.

Line weights range from one to 15 in designation, the higher numbers being heavier and more difficult for the average person to cast. Line weights from three to eight cover most freshwater needs, and from seven to 12 most saltwater needs. The heaviest lines are used for casting huge flies with muscle rods and handling big game pelagic species, while the lightest lines are used on ultralight rods for minute flies and small-fish angling. Sizes five through eight are most popular nationally, with five or six the most common because of their versatility in freshwater trout fishing.

## WIRE

Used exclusively for trolling and attaining depth, wire lines are primarily made of single or multiple strands of Monel or stainless steel, or multiple strands of copper. Monel is a corrosion-resistant alloy that is more expensive

than stainless steel, more pliant, and less prone to kinking. Multiple-strand wire is easier to handle but poses difficulties when burrs develop; it sinks less readily than single-strand wire, and is used less. Copper wire is pliant and heavier than other wire lines, so it sinks faster; nickel-plated versions are corrosion-resistant.

There is very little stretch to wire line and it is very resistant to abrasion. This makes hookups a little surer and there is less chance of breaking it during a fight with a fish than if you were using other types of line, provided that it doesn't have a kink.

Found in various strengths, but primarily used in 30-, 40-, and 45-pound test, wire line is not as difficult to work with as many people think, but it is certainly not as easy as nylon monofilament or weighted line like lead core and does require some precautions. Wire must be wound on a reel spool under tension, or it will spring off and create a terrible tangle. Tangling, in fact, is possible whenever tension is removed, so when trolling it is imperative that wire be let out carefully and under controlled tension, usually keeping a thumb on the spool as the line is paid out.

**WEIGHTED**

Weighted lines are uncastable core-heavy products that sink and are used for deep trolling. Lead core is the foremost type of weighted line, but similar products have a flexible, non-toxic, lead substitute.

These lines feature a pliable, dense core that is covered by braided nylon or Dacron. Available from 15- to 60-pound test, weighted lines have the density to sink on their own without the addition of external objects, although their bulky diameter offsets some of the sinking ability at trolling speed, usually meaning that to get very deep, great lengths of line have to be trolled or the boat has to be moved very slowly. Weighted lines are much easier to use than wire. They rarely create kinking or jamming problems, and can easily be wound on a reel and set out. They are color-coded to help determine how much is out, although this will not necessarily tell you how deep the lure is.

Weighted lines are available in coated and uncoated versions, the former using some type of plastic. Coating may help abrasion, but generally these lines are not very abrasion resistant. They have less stretch than some similar-strength nylon monofilaments, but they do stretch. They will corrode in saltwater, and have to be taken off the reel spool and rinsed. This in part explains why wire line is universally preferred over weighted line in saltwater.

WHEN LARGE, STRONG FISH GET NEAR THE BOAT, SEVERE PRESSURE TESTS THE LINE AND KNOTS TO THE MAXIMUM.

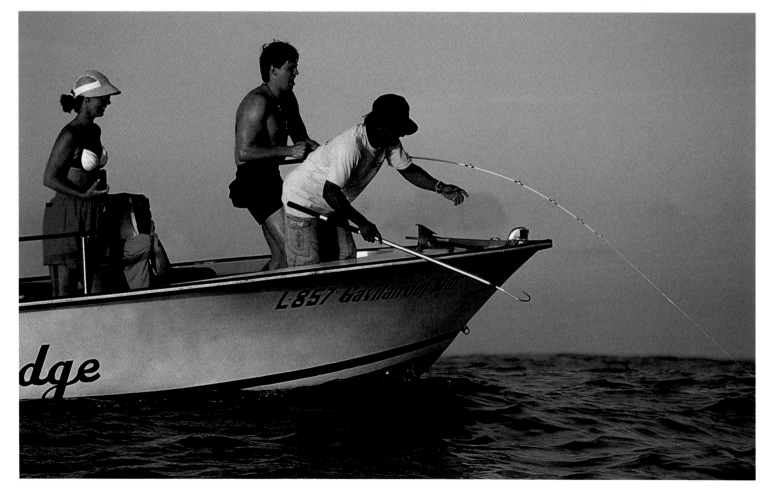

# LURES

Lures are objects used to catch fish and are made from a variety of materials, primarily wood, metal, lead, hard and soft plastic, feather, fur, yarn and combinations of materials. In a sense, all lures represent some form of food, either mimicking them closely, like artificial flies or minnow-style plugs, or being purely suggestive, like jigs, spinners and spoons.

. . . . . . . . . . . . . . . . . . . . . . . . . . . . . . .

Despite representing food, lures are not always attacked by fish that are feeding. However, lures are especially geared toward the feeding behavior of certain kinds of fish—mainly predators that spend a lot of time feeding or hunting prey.

The range of food consumed by these predators is extremely wide, and varies with the species, environment and season. Some fish are more likely to strike lures, and some of those are more likely to strike certain types of lures fished in a particular manner. Thus, the way in which many lures are used is an important component of success. Since there is great variety in lure types, the following is a summary review by category.

A SELECTION OF NYMPHS (LEFT) AND EGG-IMITATING FLIES USED FOR STEELHEAD AND SALMON FISHING.

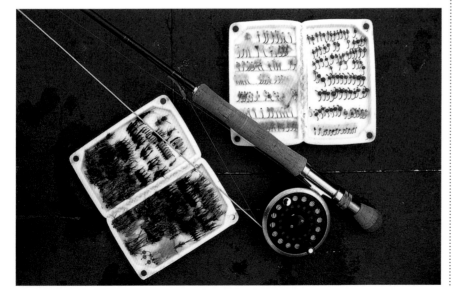

## Flies

Flies are unlike most other lures in that they are extremely lightweight and are presented by virtue of a heavy line carrying them to the water. Many flies closely imitate natural food, especially insects; others are suggestive rather than imitative, serving as attractors.

A wide array of fly types, patterns and size is employed in freshwater and saltwater because of the diverse fish species. Handmade and tied primarily on a single hook from a variety of natural and synthetic materials, flies can generally be categorized as floating or sinking, and are specifically typed as dry flies, wet flies, nymphs, streamers and bugs.

Floating flies are made with buoyant materials and sit on the surface of the water. They include dry flies and bugs and imitate a host of foods, including natural insects, frogs, mice or lemmings, snakes and other creatures. Like natural insects, dry flies are generally allowed to drift on the surface subject to whatever natural current or wind exists, but, to avoid drag, the presentation may require in-air or on-water line mending. Bugs include hard- or solid-bodied poppers and hair-bodied bugs; both are large and usually look nothing like other artificial flies or natural insects. Sinking flies are fished below the surface and are made with materials that absorb water or are more dense than water. They include wet flies, nymphs and streamers, and also imitate many foods. Wet flies represent subsurface forms of aquatic insects or, to a lesser extent, drowned terrestrial insects or small fish; they may be imitative or suggestive and generally drift in the water subject to whatever natural current exists. Nymphs are usually smaller and represent the larval stage of aquatic insects, as well as some non-insect foods; many are more suggestive than imitative, and also drift naturally. Streamers represent baitfish as well as leeches, worms, eels, etc.; they are generally tied on long-shanked hooks, are fairly colorful, and may or may not closely mimic specific prey. Sinking flies are more productive overall because gamefish feed most often below the surface.

## Jigs

Jigs are metal-headed lures with a single hook; their shank is dressed with fur, feathers, rubber, soft plastic, pork rind or other synthetic material and, occasionally, with live or dead natural bait. In some cases these dressings are permanent; in others they are removable and replaceable. The shape of the metal head may be oval, ball, bullet, pancake or angled, and since lead is the most common head material, jigs are often referred to as leadheads.

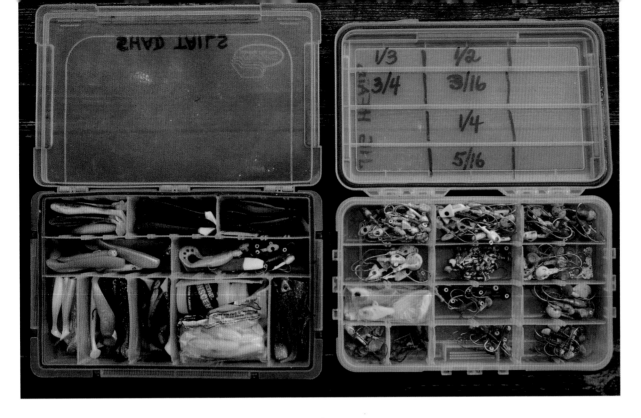

LEFT: VARIOUS SIZE
LEADHEAD JIGS (RIGHT)
AND SOFT PLASTIC BODIES
TO BE ATTACHED TO THE
JIG HOOKS.

Head size primarily determines weight, which is normally between ⅛-ounce and two ounces, but can be several ounces more or as low as ¼₄-ounce.

Jigs cast well, sink quickly and require skillful manipulation. Some type or size of jig is likely to catch nearly any gamefish and many are suitable for diverse species. Although they have a simple appearance, at rest jigs do not closely resemble fish, insects or other aquatic forage, so success with them is directly proportional to your ability to impart action to them, effect a proper retrieval, and detect strikes. Although jigs may be broken down by size to be categorized as panfish jigs, bass and walleye jigs, saltwater jigs, and so forth, the generic categories are: jig and pork/eel combinations, which are popularly used in freshwater bass fishing, and jigs with hair, synthetic or soft plastic bodies, which are available in all sizes and which are used widely in both freshwater and saltwater. Both types are fished differently and have distinct characteristics and applications.

## Plugs

A plug is a relatively buoyant lure with built-in swimming action. Most plugs float at rest, some sink at rest, and others combine floating and sinking characteristics by suspending once they have been retrieved. Plugs come in all sizes, shapes and colors, and in floating/diving, sinking and surface categories. Surface plugs are discussed under surface lures. Floating/diving plugs sit on the surface of the water at rest and dive to various depths when retrieved or trolled. The extent to which they dive usually depends primarily upon the size and shape of their lip, and the location of the line-tie on the nose or lip of the plug. The lip and overall body shape determine swimming action.

Minnow- or baitfish-shaped versions with small lips are the most popular among floating/diving plugs; these are fished very shallow, and may double as surface lures. Other floating/diving plugs of intermediate size are more bulbous or elongated; these are referred to as crankbaits, and are strictly meant for below-surface retrieving or trolling duties. Their running depth may vary from one to 25 feet deep, and are classified as shallow, medium or deep divers. These lures reach greater depths when trolled than when cast, and are usually fished close to the bottom. One exception is a popular trolling lure for salmon known as a cut-plug, which weaves wildly and is mostly used in conjunction with a downrigger. It is a floating/diving lure, that attains very little depth on its own.

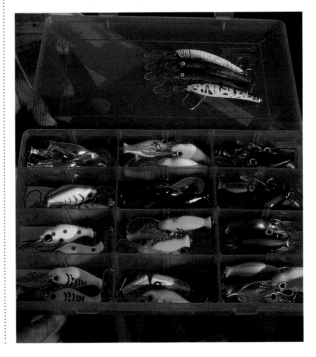

BELOW: DEEP-DIVING PLUGS
USED FOR WALLEYE TROLLING.

Sinking plugs do not float, but are weighted to sink when they enter the water. These are often allowed to sink to a specific depth by counting roughly a foot of depth per second of descent (or whatever rate equals one second), before being retrieved. They are primarily used in freshwater fishing, in metal, plastic and wood-bodied models. Some of these, as well as some floating/diving plugs, have neutral buoyancy; they will not sink or float upward once they have achieved running depth, which makes them appear to maintain a certain depth and be retrieved in a swim-stop motion like a natural baitfish.

Regardless of whether they float at rest or sink, plugs that swim under the surface are characterized as shallow, intermediate or deep divers. Longer and heavier versions are typically used in saltwater and for certain large freshwater species.

A DISPLAY OF OFFSHORE TROLLING PLUGS.

# Saltwater trolling lures

In freshwater fishing, most of the lures used for trolling are also cast, which is why there is no special category of freshwater trolling lures. However, in saltwater fishing there are many lures that are used for trolling that have no casting or jigging application because they are too large, too hard-pulling or too cumbersome for anything other than trolling. These special items are used for roaming vast areas of water, and in some cases with the heavier tackle that is often demanded for really big fish. Saltwater trolling lures include offshore lures, feathers, teasers and tubes.

Also called blue water lures, big-game lures and trolling lures, offshore lures are specialized items meant strictly for such offshore game as billfish, tuna, wahoo and dolphin, usually at speeds that no other lure is capable of handling and under a range of sea conditions. Surface runners create a silvery trail of bubbles, produce a lot of surface commotion and especially appeal to fish that strike from the side, like marlin. Underwater runners generally swim in a straight or near-straight manner, not far under the surface, and appeal especially to fish that strike from beneath, such as tuna or wahoo.

Offshore lures consist mainly of a weighted head and a synthetic tail or skirt. The face of the head has one of these shapes: cone, slanted, flat and concave. Most heads are made of durable hard plastic and the skirts from soft plastic or vinyl; some have soft heads.

Feathers and trolling jigs are weighted trolling lures that can be fished hook-less as single teasers or part of a daisy chain, or they can be run with hooks as lures to themselves. The heads are either of metal or plastic covering lead, and the skirts are made of colorful feathers. Trolling feathers are perhaps the single most popular offshore trolling lure, and are fished for dolphin, various small tuna, wahoo, etc. Trolling jigs are lures with cone-, bullet- or torpedo-head shapes, usually dressed with feather skirts or hooks.

Teasers are hookless lure-like devices designed to be trolled and to create a commotion in the water to attract gamefish to rigged baits or lures that follow the teaser. These are mainly offshore fishing devices used for pelagic species, particularly billfish and, to a lesser extent, tuna. There are many kinds of teasers, and they are made from assorted materials and in varied shapes. A general categorization would include hard or soft conventional single teasers, trolling birds and daisy chains.

Tubes are long, slender, hollow trolling lures made with rubber or plastic tubing. They have a lead head, which may or may not have eyes and two hooks that are attached to a wire leader that runs through the tubing;

one hook is placed midway along the tube body and the other is at the tail. Trolling tube lures range from five to 18 inches long, imitate eels or long sandworms and are top lures for striped bass, bluefish and barracuda.

# Soft lures

Although not a category of lure per se, the catch-all term of "soft lures" refers to soft bodies that exactly or closely represent some type of natural food. They become lures when attached to other objects, especially jig hooks and plain hooks. This includes plastic worms and various small baitfish, eels, leeches, salamanders (often called lizards), frogs, crayfish, hellgrammites and mice. These are used in freshwater and saltwater; in the latter, most soft lures are used as jig bodies.

Soft lures have a feel that is unmatched by hard lures; this sometimes means that they are held by a striking fish for a moment or two longer than a hard lure. Since the strike and rejection of some lures happens in an instant, this extra holding ability may mean a difference in catching a fish or not. The use of scents with some soft bodies may have an added measure of appeal to certain fish. Soft lures are also relatively inexpensive and can be easily replaced.

A subcategory of soft lures is swimbaits, which are somewhat of a crossover lure that are rather bait-like and plug-like in appearance. These feature soft bodies molded around a shaped weight and one or more large hooks, although the body is not replaced once it has been beaten up. Fished in both freshwater and saltwater, these are sometimes jigged and trolled, but are primarily cast and slow-retrieved deep.

# Soft worms

Often called plastic worms, soft worms are artificial worm-like bodies molded from supple synthetic material. Most are made of soft plastic and are commonly called plastic worms, but they may be made from other substances as well and imitate other food, such as a leech, snake, eel or salamander. Soft worms are perhaps the most productive artificial lures for largemouth bass, but they do catch other species as well and are frequently used as components of other lures.

These lures are fairly substantial in size, have a realistic feel and action and move naturally through cover, especially when fished along the bottom. They must be properly manipulated to be effective; how the angler gives these lures action, detects strikes and reacts reflexively to strikes are all major factors in their success. Soft worms may float or sink, and come in all types of tail designs in a whole spectrum of colors and color

combinations or patterns. They are made in small, medium, large and huge sizes. Some are scented, some are oiled and some come pre-rigged. The most important features, in descending order, are softness, buoyancy, size, body and tail shape, color and scent. Rigging methods also vary with soft worms. The weedless

VARIOUS SOFT LURES AND ACCESSORIES IN SALE CONTAINERS.

SOFT WORMS IN ASSORTED COLORS AND SHAPES.

Texas rig, in which the hook point is buried in the worm, is favored where there is cover. The (usually) exposed-hook Carolina rig is favored in non-obstructed areas and in deep water. Other rigging options exist as well.

A variation on the standard soft worm is a specially balanced model called a jerkbait or jerk worm, which has no built-in swimming action and which is fished fairly shallowly beneath the surface in a twitching motion. These lures are not as supple as conventional soft worms and are usually fished just under the surface and in a pull-pause, slow-jerking type of retrieve, which is different to the way in which most other soft lures are worked.

## Spinners

Spinners are metal lures that sport one or more blades that revolve around a central shaft and spin when retrieved. To fish they evidently represent the suggestion of something to eat, since they do not exactly imitate food. Available in a variety of models and sizes, their flashy movement and appearance has made them both effective and very popular, especially in freshwater fishing. Most spinners are cast, and the spinning blade is central to their effectiveness; it is visually appealing when moving, and generates vibrations that can be detected by fish.

There are essentially in-line and weight-forward spinners. The former are most commonly known to anglers, and feature a freely rotating blade (or blades) mounted on a single straight (in-line) shaft. Behind the blades are beads or bodies of lead or metal. Feather, hair or plastic tube skirts may be added to the hook, but many hooks are plain. In-line spinner sizes vary from ⅟₃₂-ounce to several ounces. They may have single, double or treble hooks, blades from ½-inch to several inches long, and assorted types of tail material. Squirrel and bucktail hair are traditionally

FROM TOP TO BOTTOM: SMALL, MEDIUM AND LARGE SPINNERS.

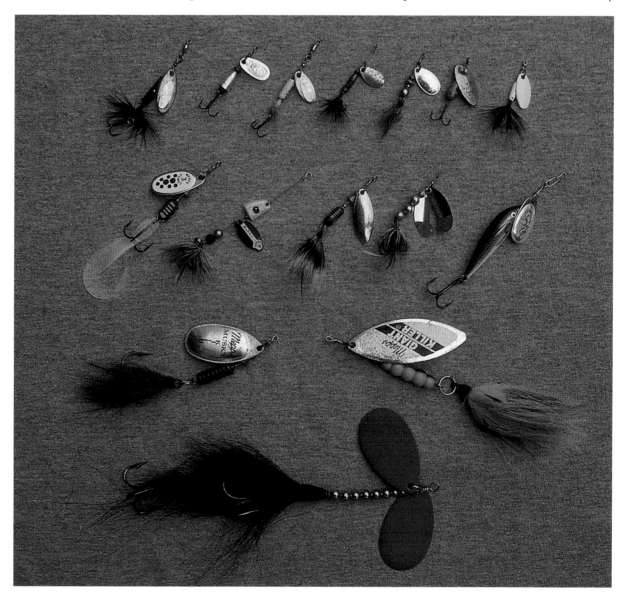

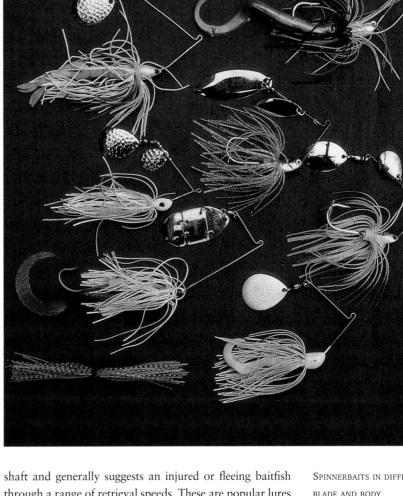

favorite hook coverings, but soft plastic bodies are used on some and a few feature rubber or plastic minnow bodies.

Blade shapes are mainly Colorado, Indiana, French or willowleaf, although there are variations on these and some non-conformist styles as well. The willowleaf, which is the narrowest blade, has less water resistance, enabling it to rotate closest to the shaft and to spin faster. The Colorado is the broadest blade and has the most water resistance, so it rotates furthest from the shaft and spins the slowest. The others are in between these two.

Weight-forward spinners are long-shanked lures with a lead weight molded to the shaft ahead of a spinner blade, which in turn is ahead of a single hook. The hook is primarily supplied bare and impaled with a live worm. Some have a single or treble hook dressed with hair, fur or a soft plastic body. These spinners are used for slow trolling, drifting and casting in freshwater. Simpler versions that feature a long-shanked hook and a single rotating blade with beads along the shaft have long been known as June Bug spinners.

## Spinnerbaits

These lures feature one, two or more spinner blades on an overhead shaft, combined with a lower shaft that has a lead weight and hook covered by a skirt. Primarily cast, spinnerbaits are generally retrieved steadily so that the blades and upper arm run vertically above the bottom part of the lure.

Spinnerbaits are popular bass fishing lures, especially for shallow-water angling, but can also be used in deeper water and for a few other freshwater species. They are relatively easy to fish, and fairly weed- and tangle-free when retrieved around cover and obstructions. Although their appearance is unlike natural forage, their flash and vibration draw strikes.

Spinnerbaits are available in a wide range of sizes, the lighter models being mainly used for panfish and the heaviest ones for northern pike and muskie. Bass-sized spinnerbaits primarily range from ¼- to one-ounce, with ½- and ⅝-ounce models being especially popular. Single- and tandem-blade versions exist, with blades being of Colorado, Indiana or willowleaf design in different colors and impressions.

## Spoons

Spoons are various sinking, wobbling lures primarily made of hard metal and used for casting, trolling and jigging. They are unlike other lure forms in that the blade-like metal body wobbles but does not spin, is not attached to a center

shaft and generally suggests an injured or fleeing baitfish through a range of retrieval speeds. These are popular lures that have international appeal and at some time or another will likely catch nearly any species of fish, although they are more preferable for some species than for others. They are predominantly employed in freshwater and are most useful in clear water due to their visual appeal.

Most spoons are generally slender, with a slight curvature that provides swimming action when retrieved and a flashy appearance. There are two basic, yet vastly different, categories. The first and foremost is casting and trolling spoons, all of which have a curved body; the second is jigging spoons, which generally have a flatter and thicker body and a more focused application.

Casting and trolling spoons include a wide array of lures, some of which are used strictly for trolling, some strictly for casting, and some for both. Those used strictly for casting can be subdivided into weedless and non-weedless models.

SPINNERBAITS IN DIFFERENT BLADE AND BODY CONFIGURATIONS.

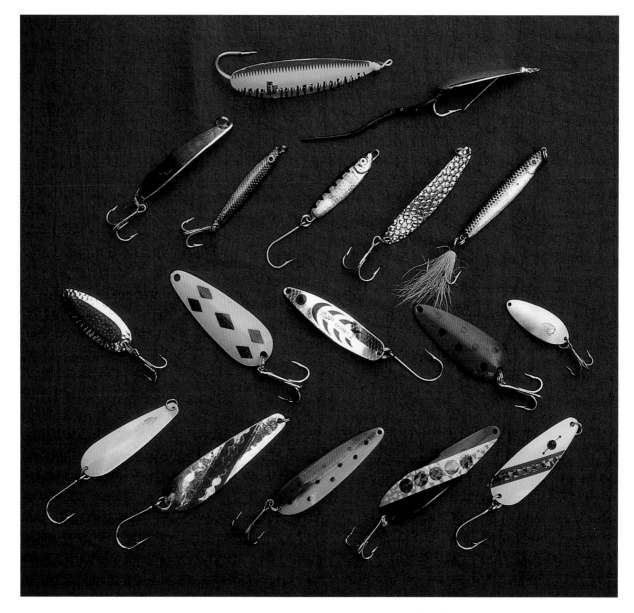

FROM TOP TO BOTTOM:
WEEDLESS, JIGGING, CAST-
ING AND TROLLING SPOONS.

Regardless of application, casting and trolling spoons are made of hard metal, usually brass or steel, and have a curved body (one side is concave). This curvature causes the lure to drag and wobble as it moves through the water. The most important factor in using casting and trolling spoons is to achieve the right retrieve or trolling speed to get the proper action out of a particular spoon. Some spoons swim lazily and sink too deep when worked slowly; or they swim too rapidly and rise too high when worked fast. Weedless spoons are used for fishing in and around thick vegetation. They are generally not 100 percent snag-free, but will usually get through most vegetation with the aid of their incorporated wire hook guard.

Jigging spoons are thick-bodied lures made of hard metal or lead that lack a curved profile. Though somewhat spoon-like in appearance, they do not have a distinctive wobble when retrieved, which makes them suitable for vertical jigging. Their action is essentially one of darting upward and fluttering backward. Most jigging spoons have a flat, compressed, two-sided body; others, especially large saltwater versions, have a three- or four-sided profile that tapers at both ends. The so-called diamond jig of saltwater prominence has four sides, and is wide at the middle and tapered to a point at either end.

## Surface lures

Also known as topwater lures, surface lures are almost exclusively fished by casting and retrieving, and many require proper manipulation if they are to be effective. They appeal to highly aggressive fish and to species that attack from hiding places or gang up on prey, but are not effective with bottom-dwelling species, true deep-water

denizens and fish that do not hunt near the surface in packs.

Anglers find using surface lures highly appealing, since there is the added appeal of watching a fish strike. The keys to successful surface fishing include: knowing when, and when not, to use them; knowing what type to use and how; knowing where to use them; knowing when to switch to other techniques; and being able to put those lures in the position in which they will be most productive.

Any lure worked on the surface or fished both on the surface, as well as within the first one to three feet of the surface, is part of this category; in a broad sense, dry flies and fly fishing bugs and poppers are also surface lures, but are discussed under flies. Types of surface lures include popping and wobbling plugs, floating/diving plugs and darters, propellered lures, stickbaits and specialty surface lures.

Specialty surface lures include a number of soft and hard plastic lures that swim through and over heavy cover in fishing for freshwater bass; most imitate frogs or mice (the latter often called "rats"). Soft lures usually have one hook (sometimes a double hook) that rides up, and the lures are buoyant enough to keep the body of the lure on top of the surface cover. Many use a silicone skirt, or a single or double curly tail for some extra action.

Nearly all poppers and chuggers have a concave, scooped-out mouth, and are both noisemakers and attractors; the actual popping or forward chugging motion is made by jerking the rod up or back, not by reeling line in, to achieve the proper movement. Floating/diving plugs are generally minnow-shaped and have a small lip that helps to bring the lure a short distance beneath the surface when cast-and-retrieved; they are most effective when worked in a deliberately erratic fashion to imitate a crippled baitfish. Propellered surface lures include plugs with propeller-like blades both fore and aft, or just aft, plus buzzbaits, which are sinking spinnerbait-like lures with a revolving blade that gives the lure a noisy, clicking sound when retrieved: both are fished as noisy surface lures. Stickbaits are cigar- or torpedo-shaped lures similar to propellered plugs or surface/diving plugs but without a lip or propeller, and which have a pronounced walking or wide-swimming action; when retrieved they dart, splash, and seem to be lurching in and out of the water.

AN ASSORTMENT OF SURFACE LURES POPULAR FOR FRESHWATER BASS FISHING.

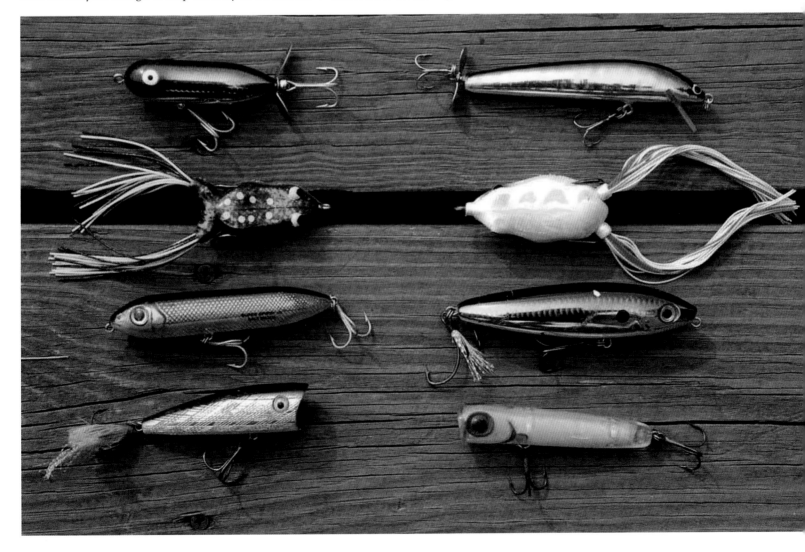

# NATURAL BAIT

**Some form of natural bait is commonly used by both freshwater and saltwater anglers. Bait use is generally skewed toward food that occurs naturally in the water and is normally forage for one or more species of gamefish; occasionally it may include organisms that are rarely part of the diet of fish. Sometimes gamefish feed exclusively on a certain food because it is most abundant, and anglers must use that type of bait in order to be productive (or use a lure that closely represents that food in both size and shape).**

. . . . . . . . . . . . . . . . . . . . . . . . . . . . . . . . . . . . .

Bait has to be presented properly to be effective. It is generally fished in a more passive manner than lures, because the target fish have time to watch it, smell it and perhaps touch it before striking. If it moves in a swift or unnatural manner, it may cause alarm; although a natural bait that appears to be struggling, as many do when hooked, can in itself be attractive to a predator, because it appears more vulnerable and easier to capture. There are some exceptions to this slow-fishing principle, especially in offshore saltwater trolling. Where live natural bait is used, liveliness is vital. Many gamefish, especially in freshwater, are not interested in inactive or dead bait, so when fishing with live bait it is important to keep that bait fresh and vigorous; change it whenever it seems to be losing vitality.

## Freshwater bait

Freshwater natural bait includes worms, minnows, shiners, crayfish, leeches, waterdogs, crickets, grasshoppers, hellgrammites, frogs, salmon and trout eggs, herring, alewives and shad, plus occasionally natural insects, grass shrimp, sunfish (where legal), ciscoes, whitefish and

suckers. Chum made from natural or processed baits is rarely used in freshwater fishing in North America, and even then only by a small number of anglers.

Earthworms and nightcrawlers are one of the foremost freshwater baits, and are used whole or in parts on one or more bait hooks and harnesses, or tipped on jig hooks. Worms are typically fished with or without a weight beneath a float, and are especially favored for panfish, walleye, bullheads, stream trout and river steelhead.

Minnows and shiners are as prominently used in freshwater fishing as worms. Species prominently used for bait include fathead minnow, dace, Arkansas shiner, golden shiner, chub and fathead minnow. Minnows and shiners are primarily fished live with or without a weight, and for a host of large and small fish. Small minnows are used for crappies, bass, walleye, trout and in ice fishing. Large shiners are used in Florida for largemouth bass, and other large baitfish (including suckers) are employed for pike, muskie and lake trout. Small minnows and shiners are sometimes impaled through the lips to adorn the hook of a jig or jig-spinner combination.

Among the herring species, alewives are fished alive for trout in lakes; gizzard and threadfin shad are fished alive or as dead or cut bait for stripers; and herring are used alive or dead for stripers and various catfish, as well as whole or cut for chinook and coho salmon.

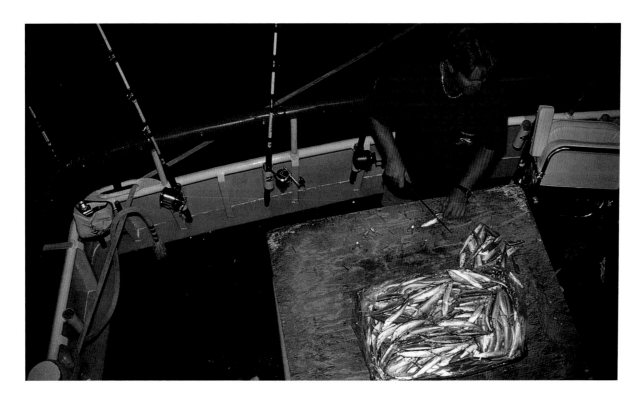

BALAO BEING CUT UP FOR
PARTY BOAT FISHING.

Crayfish are used in both hardshell and softshell versions, with the latter preferred but only occasionally available. Hooked through the tail with a long-shanked hook, whole live crayfish are primarily used for smallmouth bass; tails and pieces of tail are used for other fish, especially steelhead.

Cured and preserved salmon and trout eggs are popularly used in river drift fishing, especially for rainbow trout and steelhead. These are fished singly with small hooks, or as a cluster either unwrapped or in a nylon mesh sack.

## Saltwater bait

Natural baits are very common in saltwater fishing for a wide range of fish, and are used live, dead and as chum. A lot of chumming is done in saltwater, especially for tuna, shark, reef and flats species, both by small private boat anglers and party and charter boat anglers. The same species that are used as live bait, as well as smaller fish that are ground up (like menhaden), are used as chum, and also as cut or strip bait that is placed amidst the chum.

Nearly any small live fish can be used as bait for some type of saltwater gamefish. Depending on the locale and availability, such species as pinfish, blue runner, anchovy, menhaden, grunts, sardines, pilchards, mackerel and herring are favored. These fish are usually hooked through the lips or upper back, sometimes with a double-hook setup or through the eyes (soft-fleshed fish).

As in freshwater, worms are among the most prominent natural bait. This includes sandworms, clamworms and bloodworms, used whole or in parts on one or more hooks. Worms are trailed behind a spinner rig for stillfishing, trolling or drifting for a variety of small inshore fish, especially blackfish and flounder.

Live shrimp are a popular bait for various coastal gamefish; they are hooked through the top of the head for free swimming, or threaded on a bait hook or jig head. Live blue crabs are also used, in smaller sizes for the likes of tarpon and permit, and in larger sizes for snapper, grouper, redfish and other species; they are hooked through the tip of the shell, often with their claws removed. Abundant in many tidal areas, fiddler crabs are used for snappers, groupers and sheepshead. Live eels are extremely popular on the East Coast for inshore drift fishing, surf fishing and jigging/casting. A very hardy bait, they are fished on jigs as well as lip-hooked on a bottom rig, and are a good live offering for striped bass.

An assortment of natural baits is also used in offshore trolling for billfish, tuna, dolphin, wahoo and king mackerel. Squid, balao, mullet, mackerel, and bonito are the main baits, usually fished whole, but sometimes in strips. Many of these baits are purchased frozen, then thawed in water, rigged with wire on stainless-steel hooks, and fished behind wire leaders. Other natural baits used for various saltwater gamefish include sand fleas, which are used by surf and pier anglers for pompano; cut herring baits, which are used for salmon mooching in the Pacific Northwest or for bottom fishing; octopus chunks, which are used for drift fishing or stillfishing; and such dead baits as clams, mussels and snails.

# TERMINAL TACKLE

**The term "terminal tackle" refers to all of the individual and collective equipment used at the end of a fishing line. That can include bait rigs and leaders and the like, but for the most part it means such basic items as hooks, sinkers or weights, snaps, swivels and floats.**

. . . . . . . . . . . . . . . . . . . . . . . . . . . . . . . . . . . .

## Hooks

Fishhooks exist in a dazzling array of patterns and sizes. Single hooks (one main point) are most common; they are favored with most types of bait, used on all but a few artificial flies, and are attached to many types of lures. Double hooks (two main points) are the least common hook; they are mainly used in tying artificial flies, some are employed in bait fishing, and some are attached to weedless lures. Treble hooks (three main points) are widely used on many lures; they are almost never used with flies, but are occasionally fished with bait.

The eye of the hook, which is where line is tied, comes in many shapes, depending on application. The most common of these is the ring, or ball, eye. Eyes may be straight in line with the hook, turned up or turned down; turned-up eyes are preferred on short-shanked, heavily dressed flies; turned-down eyes are preferred by some people for their line of hook penetration.

Hook shanks are straight, bent, curved, humped and otherwise configured, while hook points come in a number of versions; many hooks are chemically sharpened and extremely sharp when fresh.

The majority of hooks have barbs. The purpose of a barb is to hold the hook in the fish, although the ability to do this is greatly over-rated. Hooks without barbs are termed "barbless;" these facilitate hook removal and are required in some waters to minimize injury to released fish. A pattern is the name by which a style of hook is known. This is a function of its bend, which is the curved section between the point and the shank, and a key element in the strength of the hook. Most hooks have a gradual bend, which resists pressure more than a symmetrically round design.

Regardless of pattern, hooks are designated according to size, which is specified in whole numbers at the smaller end of the spectrum and as "aught" fractions as they get larger. The smallest hooks, depending on manufacturer, are No. 32, 30 or 28; the largest hooks range from 14/0 up to 19/0.

## Sinkers

Sinkers are metal fishing weights used to sink a lure or bait. There are many different shapes, sizes and applications for both freshwater and saltwater fishing.

Most sinkers used in North America are made from lead. Bans exist in a few places in North America on lead weights of a certain size, which has led to the use of non-toxic metals, especially brass, but also steel, tin and tungsten. These materials differ. Tin, which is softer than other non-lead metals, is mainly used for removable split shot. Steel, which is expensive but the most durable and noisiest metal, is used in sliding and fixed sinkers. Brass is

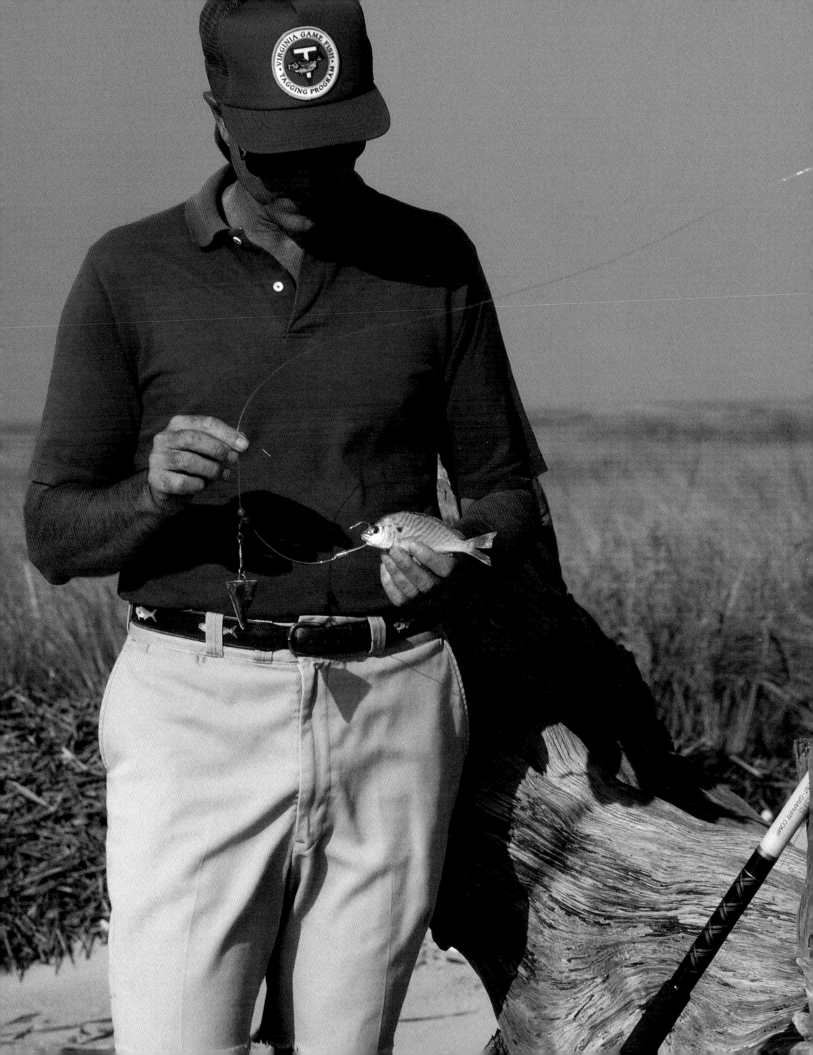

AN ASSORTMENT OF
HOOKS AND EGG SINKERS
FOR BOTTOM FISHING.

harder and noisier than lead but less so than steel; brass contains some lead, however, so it may be less commonly used in the future.

There are both fixed and free-sliding sinkers. Fixed versions attach directly to a fishing line or leader by being pinched, twisted or tied; they move whenever the bait or lure moves, and also when a fish takes the bait or lure. Free-sliding, or slip, sinkers ride along the line; they are used primarily with bait and allow the line to move when a fish takes the bait without moving the sinker, which provides less resistance than a fixed sinker and may be preferable for shy or light-biting fish.

Fixed sinkers include split shot, which are small pinch-on spheres and are the most prominent fixed sinker; rubber-core sinkers; and clinch-on versions. Fixed sinkers used in trolling include the torpedo, bead chain, keel and planing models. Sliding or slip sinkers include ball, egg or barrel, cone or bullet, and walking versions. Bottom-fishing sinkers include pyramid, bank, bell and split shot. Choice depends on fishing conditions, including the species you seek, the depth to be fished, and such factors as current and wave action.

## Snaps

These thin-metal connectors join fishing line and a lure and may be used to facilitate lure changing or to enhance the action of some lures. They vary in strength and design.

The safety snap model, which has a sharp bend and does not really lock, is one of the poorest snaps, but is cheap and common. A similar two-piece snap is the interlock or lock-snap model, which is only slightly better because the tag end rests in a guarded channel and tucks around the edge for more holding power. Both of these are subject to failure after repeated opening and closing.

One-piece, all-wire snaps, in which the tempered wire wraps around itself, are better than the aforementioned items. The common duolock model has a double-end opening that allows attachment to two items with closed eye rings; it is often used with spoons and plugs and is favored because of its rounded bend. Another popular and strong model is the cross-lock, which has double ends that meet on the same plane and abut each other; the bend is less rounded, however, so it does not maximize action for some lures. Other types that are especially popular in saltwater include the coastlock snap, which has a single-opening end that is especially strong and common on many big-game swivels; the tournament snap, which is similar to but stronger than the coastlock; the heavy-duty corkscrew snap; and the McMahon snap, a dual-grip model.

## Swivels

These freely turning metal connectors prevent twist in fishing line that is caused by the action of a lure, bait or sinker. Swivels are used by themselves to connect two lines

or a line and one or more leaders. They are also used in conjunction with a snap; this combined entity is known as a snap-swivel. Swivels should not be attached directly to a hook.

Swivels used without a snap are either slide bearing or ball bearing. Most slide-bearing swivels are of the two-way barrel, chain or three-way dropper variety. The bearing surface of these swivels may become deformed under severe stress, which makes them bind so they no longer spin, negating their effectiveness.

Brass-barrel swivels are by far the most commonly used swivels, especially among freshwater anglers, but these (and other) slide-bearing swivels are not nearly as functional as ball-bearing swivels, which are more expensive but better and more reliable. The rings of the best-quality ball-bearing swivels rotate freely due to highly polished, stainless-steel ball bearings and tapered design.

A snap swivel is strictly intended for attaching an artificial lure directly to a line or a leader to an artificial lure. Preventing twist is its primary purpose, and providing a convenient means of quick attachment and detachment is the secondary purpose. It is only used with some spoons, and with spinners (especially when trolling or when retrieving these lures in current); it is unnecessary with other lures. Snap swivels are distinct from snaps in function, even though they may be used together. Swivels used with a snap are always barrel-shaped, with closed-eye rings at both ends; snaps may be of various designs.

# Floats

Although most anglers in North America use the term "bobber," the proper name for the entire category of objects that sit on the surface, attach to the fishing line, and are meant to indicate the subsurface bite or strike of a fish, is "float." Floats are the most prominent bite or strike indicators. They are primarily made of balsa wood or hollow plastic, though some are made of cork.

Modern float designs, rigging, fishing tactics and control techniques are part of a highly effective fishing system for diligent anglers, and for many species of fish in freshwater lakes and rivers. There are many float designs, with the better models helping anglers to present a hooked bait as naturally as the fish would expect it to behave.

A float is a major factor in making an unalarming presentation. In places where fish are not very astute, or when fishing for aggressive species, a highly buoyant float (such as the round plastic model) may be used with success often enough to overlook its deficiencies. However, such buoyancy acts as a drag on hooked bait and is a dead giveaway to light-biting fish. So it is better to fish with a float that is designed to avoid alerting fish and is still sensitive enough to alert the angler to a bite.

Correct float selection is dependent upon knowing the depth of the water where you are fishing. In a boat, this is often accomplished by using sonar; without sonar, and when fishing from the shore, it is necessary to use some type of weight attached to the line to plumb the depth. Determining depth in this manner is known as "plumbing." This activity can also help to determine the composition of the bottom where you are fishing (mud, gravel, weeds, etc.), where stumps or other snags are located, and changes in depth so the angler can create a mental picture of the area and visualize where the fish might be.

A major factor in proper float usage is balancing it properly. This balancing is also known as "shotting," since small split shot, or a jig or combination of both, are

AN ASSORTMENT OF MEDIUM- TO HEAVY-DUTY SNAPS, THREE-WAY SWIVELS, SNAP SWIVELS, BARREL SWIVELS, AND REPLACEMENT O RINGS.

added in just the right amount and place so that only a minimum amount of the float tip is above the surface and visible to the angler depending on the circumstances. It is always best to have the least possible weight to get the float in a balanced position.

Mini floats from one inch to two-and-a-half inches long are perfect for pole fishing in stillwater (slow-flowing water) from six inches to four feet deep. They are unlikely to scare fish because of their smaller shape and lesser splash. Balsa mini floats can be fished with from one to four BB-size shot.

A simple crow or porcupine quill float, or a balsa-bodied float on a thin dowel stem (called a shy bite by some and about seven inches long in several sizes), is good for pole fishing in stillwater from four to 18 feet. These are extremely sensitive and deadly for all panfish, catfish and small carp, and are more stable in the wind because they have longer stems.

Both of these floats are attached to the line and held in place at each end by a silicone sleeve, which allows you to change floats instantly if necessary. Each time you change the float, it has to be balanced either by adding or subtracting split shot.

When fishing at a distance in flowing water with a rod and reel, you have to control a float by connecting the fishing line on the top and bottom of the float. In flowing water you must also set the correct float speed by balancing it properly with shot. The type of float used varies with the flow speed. Fixed floats may be bulb-like in medium flows

or more buoyant in fast and turbulent water. These and other fixed floats stay on the line at a pre-selected position, and are usually held in place by silicone sleeves at both the top and bottom of the float. Slip floats slide on the line, and a float stop and bead are used to allow the floats to move along the line to a given point. There are two eyes on slip floats, top and bottom, and the fishing line runs through these, with the stop controlling the depth setting. Small-bodied slip floats are used with small- to medium-sized baits; larger and more buoyant models are used with big baits and for catching big fish.

Floats used solely in stillwater with a rod and reel (called "wagglers" in Europe) are used for fishing at any distance and at any depth, and may be slip or fixed models. Bulbous at the bottom and long-stemmed at the top, they cast very well, and are connected to the line only at the bottom.

Small, low-profiled, balsa wagglers are used for casting to shallow water along the bank or up to 30 yards away, while larger models are used in windy conditions and for longer casts. Deep fishing, or combating wind, requires long peacock quills, some with and some without a balsa body. These floats may be up to 13 inches long.

As a general guide for balancing, fixed wagglers should have at least 60 percent of the total lead shot positioned to lock the float in place, with the rest of it being drop shot (lower and closer to the hook or jig head). For slip wagglers, start with a bulk pattern, and for a rest shot place two smaller shot four feet from the bulk shot, which helps to minimize tangles.

POPPING CORKS AND PEGGED FOAM FLOATS FOR INSHORE SALTWATER FISHING.

# ACCESSORIES

**There are numerous accessories used by anglers, especially those who fish from a boat. Some of the more prominent items are detailed here.**

. . . . . . . . . . . . . . . . . . . . . . . . . . . . .

## Lure and tackle storage

With anglers being highly mobile, a number of ways have evolved to transport and store fishing tackle, especially lures and flies, accessories, and small terminal items like hooks, sinkers and various rigs. Storage options have greatly expanded today and the following options are available to anglers.

### TRADITIONAL TACKLE BOXES

The traditional means of storage is the tackle box, now almost entirely made from plastic instead of metal, and sporting pivoting, compartmented trays. Tackle boxes are manufactured in trunk, hip roof and drawer configurations, plus double-sided tray models.

A trunk box has one or more trays that pivot up and back together to reveal a large open well at the bottom of the box; these are now rare, due in part to lack of durability in the support brackets. Hip-roof boxes have two sets of trays that open out to face each other, with a well at the bottom; they are more prevalent than the trunk box, but are becoming less common. The drawer box is the most popular style and has trays that slide out rather than pivot on a bracket; this usually has more compartments for storage than either the trunk or hip-roof designs, and may allow for bulk storage in bottom or top wells.

Double-sided plastic, tray-style tackle boxes with see-through lids are also fairly common. Some have an over/under tray arrangement in which two latches open to reveal a lower storage well; only the upper tray has a see-through lid. Other versions are accessed from the top and bottom via separate latches. These boxes have see-through lids on both sides, which have a tendency to be scratched and cracked or broken more than the over/under model. Both styles have movable compartments and hold a lot of gear.

The type of box to use largely depends on the amount and size of objects that you need to store. Most anglers outgrow their initial small or intermediate-size boxes and purchase more or larger ones as they accumulate tackle and/or expand their fishing interests. Many people who do a lot of angling and/or who fish for various species keep several boxes or storage systems, often organized by lure types or tackle-by-species.

Some boxes are geared toward specific types of storage needs, such as big lures, and possess features (a rack to hold spinnerbaits, for example) that accommodate this.

A LEVERED, MULTI-TRAY STYLE, HARD PLASTIC TACKLE BOX.

Compartments are usually plastic-proof, which means that soft lures will not disintegrate in them due to chemical reaction.

The better tackle boxes are watertight, with channeling that prevents water from entering the interior, and have strong latches that allow snug closure. Some are designed to prevent accidental spillage (even tipping) in case the latch is left open and the box picked up. A good-quality, hinge-pin arrangement in the back will last a long time, and a good handle is mandatory. Large handles aid carrying and exchanging, but if they stick out too much from the box they may get in the way; a recessed handle is desirable when boxes are going to be stacked or objects placed on top of them.

## UTILITY BOXES/SOFT CARRIERS

Utility boxes are colored or opaque, see-through boxes of various sizes stored in soft-sided carriers. These lightweight utility boxes are handle-less, one-level, polypropylene trays, usually with movable compartments, having varying exterior and depth dimensions. Anglers may purchase

a good quantity of these, store items by category or application needs, and mix and match boxes in carriers as their situations require.

Called bags and satchels by some, soft carriers exist in all types of configurations to accommodate these boxes. Better models are made of waterproof, ripstop nylon, and some have a waterproof bottom; others are water-resistant. These have zippered access, with front or top tray loading, and most have a shoulder strap as well as a top handle. The amount of lures and terminal gear that can be stored in some models is particularly impressive, especially those that have side compartments for small trays and pouches or holders for tools and spools and other miscellaneous items.

## FISHING VESTS

Fishing vests are multi-pocketed articles of clothing that store readily accessible tackle and are used primarily by mobile wading anglers, especially stream and river fly anglers and people who walk to distant waters. They are generally sleeveless garments worn over the shoulders and around the chest; their numerous pockets are commonly filled by tackle junkies to overflow.

Standard-length fishing vests extend to the waist, while short-length models cover just the chest. Commonly called a shorty, a chest-high vest facilitates wading in deep water with chest-high waders without soaking the vest and its contents.

The most common items stowed in fishing vests are small utility boxes with flies or lures. Better vests have many deep-bellowed pockets to accommodate these. Some are sized to accommodate larger boxes, such as those used for streamer flies or lures, while others, both on the exterior and interior of the vest, accommodate other styles. Many pockets are designed to hold specific objects, such as a penlight, stream thermometer, hook sharpener, sunglasses, sunscreen, fly floatant, leader-dispensing spools and so forth. Back pockets accommodate a light rain jacket and possibly a camera or extra reel or reel spool, and interior pockets are intended for keys, wallet, map and the like. The material for better vests is quick-drying, rip-stop nylon, and some have stretchable mesh shoulder construction to help spread the weight load, a comfortable rib-net collar, and non-corroding zippers. Good features on many vests are exterior loops, D-rings, tubes for retractable tool holders, and Velcro loops for temporary rod holding.

## OTHER STORAGE DEVICES

Other means of carrying gear for wading and mobile anglers include a wide array of rigid chest boxes, soft chest packs and soft fanny packs. None of these can store the full range of items like a vest , but they are lightweight and may be useful for short outings if you put the right things inside.

Rigid metal or plastic chest boxes have shoulder and chest straps, and are worn conveniently in front of the angler. They are readily accessible, but susceptible to breakage when traveling. Soft chest packs, which are available in a range of models from simple one-pocket items (more like a small pouch) to multi-compartmented products that are nearly a mini-vest, are also convenient. Many of these feature mesh or see-through material so you can view a pocket's contents without opening it. Soft fanny packs range from single-pocket models to versions that can hold a few small fly boxes and several accessories.

# Gaffs and nets

The primary tools that assist anglers in landing fish that they cannot, or do not want to, land by hand are a landing net and a gaff.

A gaff is basically a sharp hook attached to a pole, stick or handle. There are hand, stick and flying versions. A hand gaff is short-handled, and is primarily used from small boats for lip-gaffing fish that are to be released unharmed. A stick gaff is longer, having a large hook attached to a stick or pole, and is used for small- to intermediate-size fish up to about 150 pounds; the length of the stick may vary from two to six feet, and the shaft may be wood, aluminum, stainless steel or fiberglass. A flying gaff is a device with a large hook attached to a long pole (up to eight feet) and connected to a rope that is tied to the boat; when the hook enters the fish it separates from

A POTPOURRI OF LANDING NETS.

the pole and remains tethered to the rope. Flying gaffs are used for large fish, mainly those over 150 pounds.

The hook on a gaff is stainless steel and the gap, or distance from the point of the hook to the shaft, varies from two to 16 inches, depending on the fish. Some large boats used for offshore fishing carry several gaffs with different hook sizes and handle lengths because of the different sizes of fish they encounter.

Hand gaffs are usually used to capture fish that are to be released; the fish are lipped in the lower or upper jaw and are held long enough to be unhooked, then are released with the gaff being slipped out of the mouth. Stick and flying gaffs are mostly used for fish that are to be kept, with the point of the hook being driven into the side or belly of the fish.

Landing nets are mesh bags mounted on a wooden, metal or graphite frame attached to one or more handles. They are used to capture individual hooked fish, which is what distinguishes them from a seine or a commercial fishing net. Landing nets are commonly used in freshwater but less frequently used in saltwater.

Nets made out of cotton mesh were once the norm, but are now less common. They retain moisture, deteriorate quickly if not dried, and are easily cut or torn. Since cotton is a soft material it doesn't damage fish very much, but the knotted mesh and the beads necessary to weight the net can scrape or scuff the scales, fins, or mucous of a fish. Knotted nylon nets, though more durable than cotton, are stiffer and more abrasive, and not a good choice for fish to be released.

Both cotton and nylon nets are particularly likely to grab a hook. Because they are made of braided strands, it can be annoyingly hard to get buried hooks out. Though cheaper, knotted nets are inferior to knotless nets, which are now available in rubber or rubber-coated mesh, and greatly minimize the incidence of hooks grabbing in the net, and of fish being harmed by hook-catching or by contact with the net itself.

Some knotless and rubber-coated nets feature a flat bottom, rather than a rounded one. This lets a fish be supported by its full length and weight, assuming that the fish is not longer than the bottom of the net.

A net should be suited to the kind of angling being done and the fish anticipated. Nets used by wading anglers for trout and similarly small fish have a short handle and small hoop diameter (12 to 14 inches); nets used by anglers in boats have longer handles and larger hoops. The further you have to reach to land a fish, the longer and sturdier the handle needed; strong, reinforced handles are necessary for heavy fish. Pier and bridge anglers use a large, handle-less net that is lowered and raised on a rope. A few nets merge a scale into the handle in order to weigh a fish that has been netted.

The larger the fish you're likely to encounter, the bigger the hoop and the deeper the bag necessary. Many people have nets that are adequate for routine-size fish, but inadequate for landing a monster. When fishing from small boats, you should have a net that is at least four feet long from forward net edge to handle butt, with a wide rim and a deep net bag. A net with a longer handle is better for landing big fish in big water and from boats with high freeboard (because you cannot reach the water level so easily). Most nets feature aluminum handles and frames, and mesh bags are rubber, polyethylene, nylon or cotton (which tends to rot). A net should be rinsed after use to increase its longevity.

Linear mesh bags with a pair of wooden side handles are used by fisheries technicians and some anglers to support fish without handling. These are called cradles, and are cumbersome for a lone angler to use. With help, however, they are very good for landing long fish that are to be released, especially toothy species like pike and muskie.

# Waders

While wet wading can be done in warm weather, anglers who fish in cold water (anything below the mid-60s feels cold), in places that are murky, and where there might be creatures that you would rather not have contact with, need to wear some type of waders. These waterproof garments keep you dry and in some cases warm, and the corresponding footwear helps to provide good footing.

Ideally, waders should be completely waterproof, warm in cold water, cool in hot weather, durable, lightweight, supple, rip-proof, compact when folded up, breathable so they are not damp inside when worn, and low in cost. Some waders are a good marriage of these ideals, but none can do them all, which means that anglers may own two or three different types of waders.

### CHEST AND HIP WADERS

One of the reasons they have different types is because there are two overall different styles: chest and hip. Similar to pants, chest waders cover a good portion of the body from the legs to the upper chest. They have shoulder straps or suspenders, and often a waist-level belt, and are simply meant to help you wade deep. A bit bulky, chest waders provide some warmth but are tough for distance walking or climbing. A modified version, the waist-high wader, is designed for anglers who get in and out of boats frequently to fish in cold water where the air temperature is warm. Hip waders are short and fitted to each leg, with the material of each leg extending up to the hips and held up by a strap that loops onto the wearer's belt. They are often

synonymously referred to as hip boots, but are technically slightly different; hip boots cover the same area, but are made from heavier material. Hip waders are used in relatively shallow water, are easy to put on and take off, provide easier walking and are cool in warm weather.

Waders that have integral boot bottoms are known as boot-foot models. The boot, which is usually heavy-soled, is part of the legs and permanently attached to an upper section. These are good for people who do a minimal amount of walking in waders. Waders that require separate boots are called stocking-foot models. The wader is separate from the boot and features an integral stocking-style foot section that is worn inside a pair of wading boots or shoes. These are mostly found on chest waders, they provide good ankle support, and are good if you have to do a lot of climbing.

## MATERIALS

Waders are made out of old materials like canvas and rubber, and modern materials like nylon, PVC, and neoprene, and may feature multi-ply construction.

Rubber waders are economical and are best for their sturdy boots, some of which have tennis-shoe-type inserts. They do not last very long, however, and are heavy. Rubber hip waders, because they are walked in much more, are preferred over rubber chest waders. Canvas waders are lighter, though weak in the boot area, while waders with rubber-canvas construction try to bridge the best and worst of both materials.

Nylon is the material for most ultralight waders, which exist in stocking-foot style. These are not insulated and offer no real warmth, but are comfortable in warm weather, easily packed and fairly economical. Some stocking-foot waders are made from PVC, which is cheaper (but less durable) than nylon.

Neoprene stocking-foot and boot-foot chest waders are very popular, though more expensive than waders made of the previously mentioned materials. Bending, casting and walking is good in neoprene waders because of the soft and supple nature of the material. Being somewhat form-fitting, they also help reduce water drag. An ability to keep anglers warm is probably the most important feature of neoprene. The primary drawback is that it does not disperse inner heat outward, meaning that it makes you wet or damp. They are also very uncomfortable in warm weather. The newest, and most expensive, waders are so-called breathable models, which have sandwiched material construction, are heavier than ultralights, much lighter than neoprenes, and disperse body heat outward to prevent inner moisture. It is possible to walk and fish all day in these waders with little condensation in your clothes. They are not form-fitting like neoprenes, which can make them

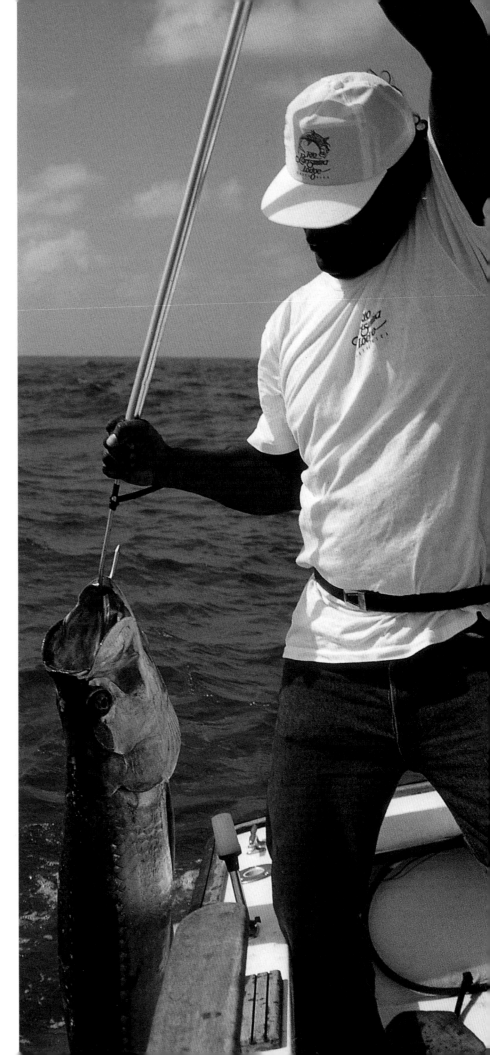

a bit baggy, but this means you can wear warm garments underneath. Most are stocking-foot models.

Some top-quality waders feature a zip-down front for easier entry and exit, and some men's waders have a zippered fly. There are also waders specifically designed for women, with special considerations for different body types and foot and ankle shapes.

### BOOTS AND SOLES

Wading boots are worn with stocking-foot waders; these are rugged and are usually made of high-quality synthetic material or leather, and provide good support for walking and protection from falls and below-ankle collisions. Calf-high, tight-fitting wading shoes are used without waders by some anglers to keep gravel and sediment out, and to offer foot protection. Many have hard, ridged soles, although felt soles are better for stream usage; dark versions are fine in most freshwater situations, but light colors are preferred in saltwater and in situations where a lot of time is spent in the sun.

The type of sole on boot-foot waders, wading boots and wading shoes depends on where you fish, but is always geared toward providing non-slip footing. Hard, rubber-bottomed soles are best for soft bottoms and gravel. Soft felt or feltlike soles are good for boulders and slick rocks, but are banned in many places to prevent the spread of invasive species. Flat, compressible, soft rubber soles are good on slippery stream bottoms and are more durable than felt. Metal gripping cleats, or creepers, which are either permanent attachments or strap-on metal studs, provide the most stable walking on boulders, slick rocks, jetties and ice, but are cumbersome to walk in and must be taken off in some situations.

## Float tubes and kick boats

The umbrella term "float tubes" includes items also known as belly boats, personal inflatables and U-tubes. These personal watercraft are personally propelled, mostly

THIS ANGLER IS WEARING CHEST-HIGH, BREATHABLE WADERS WITH WADING SHOES.

inflatable, and are used to access ponds, small lakes, protected sections of bigger waters, secluded waters, and small-to-moderate streams and rivers. Many can be stowed in a small car or a closet, and can be packed into a remote location. They are quiet, relatively unobtrusive, and economical compared with most conventional boat options.

Many anglers float in or on a tube, wearing chest waders and a pair of swim fins. The waders are usually neoprene, but lighter materials work in warm waters at appropriate seasons; breathables and ultralights are good options. The float tube is propelled backward by leg power, which theoretically frees the angler's hands for casting and allows for constant positioning adjustments.

Many inflatables have an open end entry, with the closed end squared or pointed. Most of these have a generalized U-shape, but some have a wedge or V-shape for cutting through the wind and waves better. U-shaped versions have separate arm and back bladders, which raise the level of the angler. Older models are oval-shaped with no open end; it is harder to get in and out of these tubes.

The lower you sit the less visibility you have and the harder it is to cast with certain tackle, so sitting higher is desirable if it does not adversely affect stability. The tubes or bladders are inflated by a foot pump or compressor. Better float tubes have a high back support, adjustable seat, an apron or lightweight basket for catching line or laying objects while rigging, and watertight zippered pockets for gear storage.

Pontoon-style float tubes are intended to be more maneuverable than inflatable tubes, and raise the angler to a higher, or sometimes adjustable, position. Primarily called kick boats, the majority feature two inflatable pontoons, pointed at the ends, bridged by a frame with a seat. Some feature non-inflatable, molded, hard-plastic pontoons. Some models are designed primarily for foot kicking, but many have oars, making them row tubes.

Kick boats take a while to assemble, weigh a lot more than inflatables, and cost more, but they are versatile, easy to maneuver, and faster. Oars make them very maneuverable and easy to control. They also have room to store gear, and keep more of the user's body out of the water.

A good pair of swim fins is important when using float tubes and some kick boats. You must move backward in fins to get anywhere, and they are tough to walk in. Fins

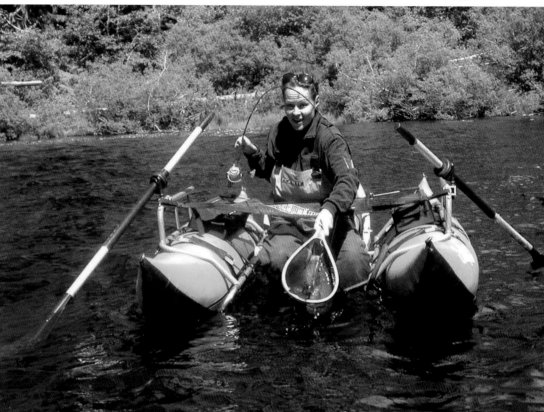

for these devices are shorter than those used for swimming and diving, and should have more rigidity.

# Personal Flotation Devices (PFDs)

Many anglers do not pay much attention to this type of accessory, yet it can become the most important thing they own if a life-threatening situation develops on the water.

Commonly referred to as a PFD, a personal flotation device is meant to float a person in the water and to help hold their head above water so they can breathe. They are primarily used by people in boats, but they may also be worn by anglers who wade in swift water, by anglers who fish out of float tubes and kick boats, and by young and old people who are on a dock, pier or other location where it is possible that they might fall into the water.

Federal and state laws require that every vessel has a U.S. Coast Guard-approved personal flotation device of correct size for each person on board. It is not required that they be worn in some places, but they should be available if required. Regulations vary between states, provinces and countries, and may depend on what agency has jurisdiction over a particular body of water; in some locations, children under a certain age, as well non-swimmers, must wear a PFD.

A PONTOON KICK BOAT IS VERSATILE AND EASILY ROWED ON BOTH STILL AND FLOWING WATERS.

Few anglers wear a PFD in their boat, or they wear one only in adverse conditions or when operating a boat at high speed. People who are good swimmers, who are in stable boats, who fish in shallow water, who fish in warm water, and those out on fair-weather days in moderate or calm water conditions are usually in no danger by not wearing their PFD all the time. However, accidents happen; novice anglers and novice boaters typically underestimate the consequence of changing wind and wave conditions or current, and fail to realize that they can be vulnerable, especially in a small boat, even on a day that looks harmless or in a location with warm or placid water. Falling out of a boat is one of the leading causes of boating-related fatalities. Falling into the water without a PFD increases the chance of drowning, especially if the water is cold and/or a person is injured. In cold weather, and when boating on cold water, it is smart to wear a PFD all the time because the degree of danger is heightened due to the quick onset of hypothermia.

Of course, it does little good to have a PFD in the boat, but not to wear it, or at least not have it immediately available when you need it. Research says that 80 percent of boating-related drowning victims were found not to have been wearing PFDs.

There are five categories of PFD, classified from the lowest level, Type I, to the highest level, Type V. Type III PFDs should be carried by most boating anglers. They are the most comfortable PFD, although not comfortable enough for all-day wearing, and are available in many different styles for different activities. Vest-style Type III PFDs are frequently referred to as life vests and life preservers, while coat styles are referred to as life jackets.

Type III PFDs will not turn an unconscious person face up, but they do make it easy for a conscious wearer to place themselves in a face-up position. They are intended for calm and moderate near-shore waters where there is a chance of a quick rescue. Some Type III PFDs provide warmth for a bit of hypothermia protection, and some are available also as fishing vests. Some versions have collars that help keep a wearer's head up.

The main reason why people do not wear PFDs is that they are not comfortable enough, especially when worn over a moderate amount of clothing. Make sure that your own PFD fits you properly, with or without heavy clothes. To get some confidence in it, you should try it out in a pool; if you could be in the water a long time, you need enough buoyancy to keep your head out of the water. Make sure that it does not ride up on your body, which makes swimming difficult; you might need to swim a considerable distance in a PFD as well.

The U.S. Coast Guard approved some manual- and automatic-inflating PFDs. Top-quality, inflatable PFDs have become more popular because they are light, suspender-like devices that are very comfortable to wear even over bulky clothing, and they don't inhibit arm movement for casting or normal fishing activities. Approved inflatable PFDs, though expensive, could be a good choice for freshwater anglers who use small boats, people who use canoes, kayaks, inflatable boats and float tubes, and also those who wade in cold rivers.

# Electric motors

For many anglers who fish from boats, an electric motor is one of the most important accessories invented. This item takes the place of oars and paddles, but is quieter

A TYPE III VEST-STYLE PFD IS THE COMMON CHOICE FOR MANY ANGLERS.

and often can be operated without interfering with fishing activities. More significantly, an electric motor is used to maneuver and position a boat for casting in order to fish more effectively.

Called a "trolling motor" by many people, an electric motor can be used in trolling, but is primarily used for positioning while casting. Electric motors are most prevalent in freshwater fishing, especially by people who fish for bass and walleye; saltwater usage has increased as manufacturers have improved corrosion resistance.

Electric motors are powered by from one to three 12-volt batteries and differ in the amount of power, or thrust, that they are capable of delivering at maximum operation. The heavier the boat and boat load, the more thrust is needed for proper maneuvering, especially when there is wind or current to deal with.

There are bow- and transom-mount models. Permanently mounted bow models are used on most fiberglass and many aluminum boats in freshwater, with the bracket support installed on the bow port to put a little weight on that side and counterbalance the console and driver weight on the starboard side. Removable transom models are used on small boats such as rowboats and jonboats.

Bow mounts are preferred by many freshwater anglers, especially those who cast to cover, since boats move with greater ease when pulled rather than pushed and you can see where you are headed and know when to avoid objects. However, bow mounting is not possible or suitable on some types of boat without a lot of adaptation. A few fishing guides and tournament anglers put bow- and transom-mount motors on their boats, using either or both when conditions warrant.

Transom-mount electric motors are manually operated by hand, while bow-mount models come in manual or remote operation models. Manually operated bow motors can be tough to use when the water is rough and the boat is rocking and bouncing. For this reason, many people use some type of extender, attached to the handle or shaft, to make it easier to reach and operate the bow motor.

Remote-operation units come in several versions. Some are maneuvered via a foot-control pedal that is fixed to the bow deck; this allows an angler complete hands-free operation because their foot is working the pedal

AN INFLATABLE PFD LIKE THIS IS COMFORTABLE FOR SUSTAINED WEARING.

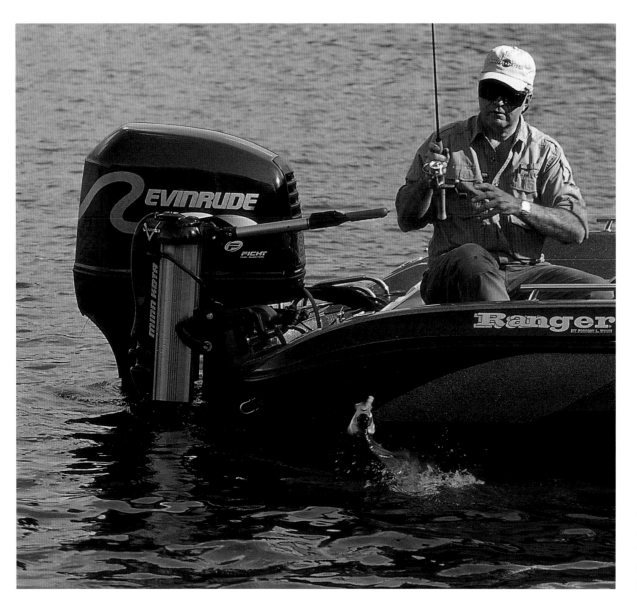

to control direction and speed. Cable and foot-pedal breakage, however, lead to the development of other versions, including models that are operated remotely by a touch pad attached to a long flexible power cord; the touch pad can be operated by hand or foot.

A few of the latest freshwater and saltwater electric motors are completely remote controlled, being operated by a wireless hand-touch pad, which eliminates the hindrance of wires and cables but still requires the operator to take a hand off a fishing reel to make speed or other adjustments. The most sophisticated of such bow-mounted electric motors feature the latter method of operation, and are also equipped with auto pilot and GPS-enabled spot-location functions. In other words, it will take you along a specific course, and is also capable of returning to, or holding your boat on, a learned location. Some models also interface with bow-mounted sonar so that you can automatically maneuver to or along a specific

location, depth, or contour as noted on the sonar.

On bow-mount motors, the deck mounting bracket also houses the release/take-up system, which must operate smoothly for getting the lower unit into and out of the water with minimum effort; some motors have an auto stow/deploy feature in which the motor is automatically raised or lowered.

Shaft length is a factor in choosing a motor, and needs to be done with a specific boat in mind. Large boats, and boats that will be used in rough water conditions, require a long-shaft motor so the prop will grab properly and, in the case of manual models, the control handle is at an accessible height; there are accessory devices that attach to the upper shaft and extend upward to make manual control easier. Batteries are the lifeblood of the electric motor. Frequent use of an electric motor battery means that the battery constantly goes through the process of being charged (often overcharged), is then drained at varying levels

OPPOSITE PAGE: A
BOW-MOUNTED, FOOT-
CONTROLLED, ELECTRIC
MOTOR PERMITS PRECISE,
CONSTANT MANEUVERING
FOR CASTING.

of discharge, and is often neglected before or during charging again, and having all of this happen over a wide range of time and temperatures. Obviously they have to take a lot of punishment.

Electric motors are best powered by deep-cycle batteries, which have special plates that allow them to be regularly drawn down and recharged; standard batteries are not meant to do this and do not have nearly the life of deep-cycle batteries when used for electric motor operation. There are maintenance-free, gel cell models, as well as liquid acid models; many people now opt for the former. Deep-cycle batteries for electric motors are rated by size or amp-hours as well as by voltage. Make sure to get the right voltage for your motor's needs.

The best AC charger for a deep-cycle battery is not the old standard type that reverts to a trickle when full charge is reached, because constant current can cause damage. A charger should be capable of not exceeding safe voltage levels for either gel or liquid acid batteries, and should automatically shut off when the charging cycle is complete. Modern chargers have the ability to charge single or multiple batteries safely, and these are usually at least 20-amp, heavy-duty models.

DECK-MOUNTED SONAR, WITH A TRANSDUCER ON THE ELECTRIC MOTOR BELOW, IS STANDARD ON BASS BOATS.

# Sonar

The word "sonar" is an acronym for sound navigation and ranging equipment, and was applied by the military in the First and Second World Wars. Sonar used for sportfishing purposes is also called a depthfinder, depth sounder, fish locator, fishfinder and echo sounder. In sportfishing, its purpose is to determine depth, help find fish, locate submerged habitat that attracts fish, aid boat use and help anglers to become accurately acquainted with the beneath-the-surface environment of any body of water in significantly less time than without it.

Transmitting depth information is the predominant function. This is used consistently as an aid to determining where and how to fish, allowing more precise, and thus more effective, presentation of lures or bait than might be possible if the depth, bottom contours and underwater habitat were unknown and constantly changing.

Sonar units primarily include a display and a transducer, which are connected by a coaxial cable to each other. The display unit indicates the information that the transducer has provided by issuing extremely swift signals through the water.

How it does this depends on several factors, especially the unit's operating frequency. Operating frequency may be low, such as 50 or 83 kilohertz (kHz), or high, such as 200 kHz. There are other frequencies used as well by some units; and many now have dual-frequency capability, meaning that you can switch from low to high or vice versa, or that the unit can search using both frequencies.

Low frequency is best for very deep water (beyond 300 feet), and provides less definition, while high frequency is meant for shallower use, where it has good definition and resolution. Most anglers, especially in freshwater, use 200 kHz units, or dual-frequency units that are primarily set for the higher frequency mode. Some dual-frequency models can display simultaneous information from both frequencies on the same screen or in a split-screen presentation, enabling you to display and compare information.

The signal echoes that are returned to sonar instruments are presented via a liquid crystal display (LCD), cathode ray tube (CRT) or light-emitting diodes (LEDs). The first two provide picture-like representations on small rectangular screens, while the latter appears as a flashing light on a circular calibrated dial. A few manufacturers offer LCD screens that mimic the readouts of circular LED dial displays. Most sonar units used by anglers are of the LCD variety.

Transducers come in various sizes, mounts and frequencies, and send out pulses directly below the boat

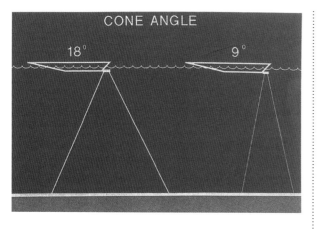

CONE ANGLE

18°        9°

in a three-dimensional, cone-shaped wave. Cone angles range from narrow to extremely wide. The diameter of these cones influences how much detail is seen.

There is no universally accepted "standard" method for measuring and rating cone angles. One manufacturer's eight-degree transducer may be the equivalent of another's16-degree model, for example. Generally speaking, high-frequency (more than 100 kHz) transducers come in "wide" and "narrow" cone-angle versions. As a rule of thumb, you can quickly find the diameter of a transducer's coverage at any depth by dividing that depth by seven for a narrow cone or by three for a wide cone. A narrow cone angle has about two-foot diameter at a depth of 15 feet; it has about a four-foot diameter at a depth of 30 feet. A wide cone angle has a five-foot diameter in 15 feet of water

and ten-foot in 30. Most low-frequency transducers have a cone angle of about 45 degrees, which covers a diameter about equal to the depth. Its diameter is about 15 feet at a depth of 15 feet and a diameter of about 30 feet at a depth of 30 feet.

The narrowest cone angles are most useful in extremely deep water, such as 150 feet or more. The widest cones enable you to see a lot more of what is beneath you, and are especially useful for downrigger trolling and fishing directly below the boat; they work best at slow boat speeds. The medium-range cones are less specialized, have all-around functionality, and are best used in less than 100 feet of water. The only drawback to the super-wide cone angle is that it takes in so much information that people are often fooled into thinking that the fish it has located are directly below the boat when they may be well off to the side. Some sonar features dual transducers or single transducer housings with dual cone-angle capability, allowing the user to switch back and forth.

Many sonars only view what is below the boat, but some do so with down-scan technology that provides photolike views of what is below, especially on the bottom. Units so equipped allow splitting the display screen to see both this view and a normal representation of what is below side-by-side.

Some sonars have transducers capable of looking to the side as an adjunct to viewing directly below, either via

LEFT: THE CONE ANGLE OF A SONAR'S TRANSDUCER GREATLY AFFECTS THE AMOUNT OF AREA COVERED.

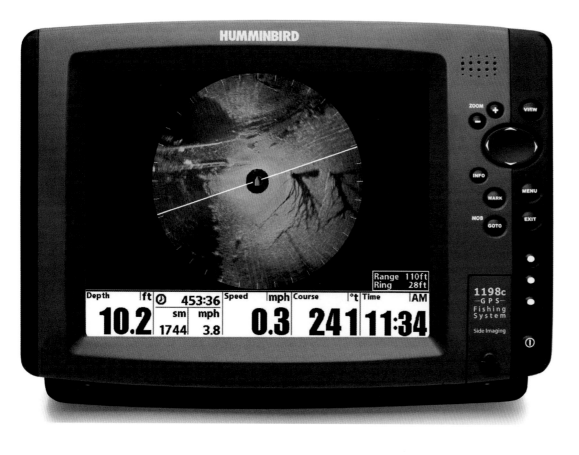

THIS IMAGE FROM A HUMMINBIRD SONAR UNIT WITH 360-DEGREE SIDE SCANNING REVEALS CHANGES IN TERRAIN AS WELL AS OBJECTS AS THEY APPEAR AROUND THE BOAT.

a rotating transducer or a fixed-mount side-viewing transducer. Called side scan or structure scan, these produce photolike views of fish and objects at varied distances away from the boat (though not at great distances).

One of the latest side-scanning units has a transducer that accomplishes 360-degree viewing, allowing you to see fully around the boat to a distance of 150 feet. This can also be used in split-screen mode to provide a conventional down view alongside a 360-degree view.

Sonar evolved from flashers to paper chart recorders to LCDs and video sonar using cathode ray tubes. Chart recorders were once the premium sonar and the equipment that provided the best underwater detail; both these and flashers are practically obsolete—although some veteran sonar users still prefer flasher-only units, especially for ice fishing.

Most sportfishing sonar today features a liquid crystal display, and many people now use the terms sonar and LCD virtually synonymously. The better LCD sonar units give good detail and the displays are much easier to see than they were years ago. In the past sonar displays were uniformly monochrome (black and white). Color sonar units are now widely produced, and equally as good in resolution and detail as monochrome units, though more expensive.

Depending on the unit and optional accessories, modern sonar units typically also provide boat speed, distance traveled, and water temperature information. Some can be integrated into other electronics, especially global positioning systems and navigational charts and maps, as well as displaying engine information and much more data. Units combined with GPS are especially popular, with users often showing navigational information alongside sonar views in split-screen or multi-screen mode.

Sonar is available in portable, as well as permanent, mount versions. Portable models work on almost any boat, but are primarily used on small craft. The transducer is generally attached to a bracket and clamped to the gunwale or transom, or to a suction cup placed on the transom.

Fixed, bow-mounted sonar is particularly helpful for freshwater anglers who spend much of their angling time in the bow of a boat, casting and running the electric motor to maneuver along likely fishing areas. Ideally, the transducer for this unit should be located on the bottom of the bow-mounted electric motor to give readings directly below the front of the boat.

Fixed, console-mounted sonar is used by many boaters, sometimes as their only type of sonar, sometimes in conjunction with a bow-mounted unit. When it is the only sonar aboard, an accessory swivel bracket allows it to be turned as necessary so it can be seen from anywhere in the boat. The transducer for console-mounted sonar (as well as for sonar located near the stern on a tiller-steered boat) is located on the transom, or, in a few cases, mounted in the sump or integrated into the hull during construction.

# Electronic navigation devices

Many boating anglers, particularly those who fish large lakes, rivers and the ocean, use some type of electronic navigational aid for general navigation, boating safety and as an aid to actual fishing activities, especially when angling in wide-open waters for nomadic schools of fish or pelagic species, and when fishing specific bottom structures.

The most prominent device for this today is a Global Positioning System (GPS), which is a unit that sends signals to, and receives them from, a constellation of orbiting satellites. In operation, the user's position is instantly known, the degree of accuracy is very high, the system is rarely affected by weather or localized signal interference, and it can be used at all hours wherever there is an open view of the sky. Most boating anglers use fixed-mount GPS units with a self-contained antenna; some use small, battery-operated, handheld units with a self-contained antenna.

A GPS receiver calculates its distance from a satellite by measuring

TO GET A TOTAL PICTURE OF WHAT'S BELOW AND AROUND THE BOAT, AS DEPICTED WITH THIS LOWRANCE HDS7 UNIT, YOU CAN SIMULTANEOUSLY HAVE A STANDARD DIRECTLY-BELOW-THE-BOAT VIEW (UPPER LEFT), A PHOTOLIKE BELOW-THE-BOAT VIEW (TOP RIGHT), AND A SIDE-SCAN TO THE LEFT AND RIGHT VIEW (BOTTOM).

the time it takes for the satellite's signal to reach it. The receiver determines its two-dimensional position (latitude and longitude) by measuring its distance from three satellites. It finds its three-dimensional position (latitude, longitude and altitude) by measuring its distance from a fourth satellite as well. The receiver knows the positions of the satellites overhead and automatically uses those that provide the best geometry for accuracy. Obviously, for good results, the receiver needs to view at least three or four satellites at once. The better models have twelve channels for tracking more than four satellites at a time, as some come into view while others go out of view.

GPS receivers do not have a compass or any other mechanical, direction-finding device built into them; they rely entirely on position fixes derived from satellite signals. Normally, they find your position about once every second and they calculate speed, direction of travel and distance by comparing where you are one second with where you are the next. You must be moving for GPS to determine your speed and direction of travel; you cannot stand still and use the unit like a magnetic compass. It will work at slow trolling speeds, but the faster you travel the easier and more accurately a receiver can track speed and direction. A receiver's level of performance depends more on its number of parallel channels, and the software used to manage them, than just its physical size. Most newer receivers have 12 channels; when the unit is switched

on, these channels find a position in seconds unless the receiver is blocked from the transmitting satellites. They have enough channels to lock onto all of the satellites in view and can switch instantly back and forth as necessary if signals are blocked.

Handheld portables are pocket-sized receivers (powered by AA batteries) that are used by anglers in canoes, inflatables, rental boats and other craft without electrical systems, or when temporarily fishing from someone else's boat. They are also perfect for hike-in fishing on remote waters. While they are a good compromise for anglers who use GPS for a variety of outdoor activities that require portability, they are not the best choice for a permanent mounting in your boat. It can be more difficult to see their smaller screens and press their smaller keys while bouncing across the water than when using a full-sized, permanently mounted model. Battery consumption and replacement can become an issue with these as well.

Permanently mounted units are larger than handhelds and have bigger, easier-to-see displays. These units are powered by the boat's electrical system. The head is generally designed to be mounted on a gimbal bracket, but some can also be flush-mounted on a flat panel surface, although the latter will have a relatively narrow viewing angle.

GPS receivers are commonly available in combination with sonar units and as plug-in options for chart plotters, radars and other electronics. Combination units are

usually less expensive than having two separate models, and can help to ease console crowding on boats where space is at a premium.

Sonar/GPS combinations are probably the most common. Anglers can show either sonar or GPS readings on the whole screen, or split the screen to show sonar displays on one side and GPS information on the other. While this saves space and money, it also has its disadvantages. If the sonar breaks, the GPS has to go with it to the service facility because it is in the same case. You may also find yourself in a serious fishing situation that requires precise navigation and maximum sonar detail, and wishing that each function could be shown full-screen at the same time. Some professional guides, tournament competitors, charter boat captains and big-water skippers use two sonar/GPS combo units in their quest for maximum redundancy. They use one as a sonar and the other as a GPS, and have an automatic double backup in case of trouble.

Many anglers find navigating with digital, on-screen charts/maps easier than finding their way with the usual GPS features: latitude and longitude numbers, virtual highway graphics, or track plotters. Accessories that feature map- or chart-like detail in electronic cartographic form are called chart plotters or mapping units, and the usage of fixed-mount versions in marine environments is often referred to as electronic charting, although many people simply refer to this as mapping. Chart plotting

and mapping units are available as stand-alone devices, but may be incorporated into other products, including radar and sonar instruments. Stand-alone versions may be interfaced with these other devices, as well as others, including autopilots.

Until recently, electronic charting or mapping devices featured highly detailed information for a given area that was contained on cartridges that plugged into the body of the unit. You bought and inserted different cartridges for different sections of the country or different bodies of water. While some such units are still available, they have been superceded by more sophisticated mapping units with far greater detail and huge internal memory capabilities.

Most navigational devices today have 20 or more megabytes of memory, and contain enormous amounts of information and detail without needing to insert cartridges to highlight different areas. Moreover, this internal data can be amended or updated via linkage with home computers and the Internet. Straight out of the box, some of these devices include charts for all U.S. coastal areas, including Hawaii, Alaska, and the Great Lakes, plus thousands of inland bodies of water. You may never take your boat beyond a 50-mile area of your own coast, but you could navigate through most of North America if you wanted to.

Onscreen, the land-based, or topographic, information displayed by these charting units looks much like a road map, while the hydrographic information displayed looks

like a navigational chart and displays detailed information on harbors, marinas, ship channels, and navigational aids, and perhaps also assorted services, lodging, attractions, etc., much like automobile navigational instruments, which have evolved from, and are now parallel in development with marine navigational instruments.

Today, navigational devices have a huge amount of memory and contain enormous amounts of information and detail without needing to insert cartridges to highlight different areas. The use of cartridges, where applicable, further expands memory and information greatly. Moreover, this data can be amended or updated via linkage with home computers, smartphones, and the Internet. Better chart or map units provide a new set of more detailed information when you zoom in, which means that the more detailed zoom view has come from a different, and larger scale, chart. Increased detail is often important for boating and fishing purposes.

Navigation-only units and combined sonar/navigation units are evolving at almost a breakneck pace, with technology driving an avalanche of advancements. For example, some navigational units can display thousands of lake maps (different from federally issued navigational charts) that also feature bottom contours and identify known and previously identified (on paper maps) species-specific fishing locations. Some work on a user-created mapping/charting basis and/or with crowd-sourced information sharing. And there are smartphone apps that allow wireless communication with some chartplotters to update and transmit boating and chart information.

There are also navigational devices that allow you to create your own precise digital contour maps while on the water, which could be useful and very informative if you fish places that aren't charted, like private lakes and ponds, or which are not otherwise well detailed, like inshore flats, or locations that are susceptible to changing conditions, like estuaries and marshes where storms change the landscape and create new channels and sandbars. Stay tuned, as this arena of boating-related fishing is advancing rapidly.

# Planers

Planers are devices that help to get a lure or bait away from the angler by taking it deep, taking it off to the side, or in some cases taking it both deep and away. The two general categories include planer boards and diving planers.

### PLANER BOARDS

Used exclusively in trolling, and primarily for trout, salmon and walleye fishing, planer boards enhance flatline trolling presentations by taking lures out to the side of a

OPPOSITE PAGE: A PROGRAMMABLE ELECTRIC DOWNRIGGER LIKE THIS HAS MANY FEATURES USEFUL TO FREQUENT ANGLERS.

moving boat. This allows lures to pass near fish that may have been spooked by the boat (and moved off to the side) or that are in areas where you cannot, or do not want to, take a boat.

Planer boards include sideplaners and in-line planers. A sideplaner is a large plastic, or wooden, surface-swimming board that works somewhat like a downrigger on the surface. A non-fishing line or cable tethers the board to the boat so that it runs at varied distances off to the side (there are port and starboard models that sport two or three runners). One or more fishing lines attach to the tow line via release clips; you can use light to heavy spinning or baitcasting tackle, and fight a fish unencumbered when it strikes your lure and the release frees the fishing line. Most sideplaners are about 30 inches long with double runners, but some homemade models used in rough water are up to 48 inches long.

An advantage to trolling with a sideplaner is that if you have multiple lines on one side of the boat and the outermost release pops, you can slide the inner lines out, then put the released line back out as the inside line. This is done without having to retrieve fishing lines or the board. If you want to replace one lure without bringing the board and other lures in, you can pick up your fishing rod, reel up the stack, pop the fishing line out of the release, reel in the lure to be changed, reposition the other lines and releases on the

tow rope, and set the new lure out in the inside position. An in-line planer is smaller but similar to a sideplaner in principle. However, it attaches directly to the fishing line. In use, a lure is set out the desired distance, then the fishing line is run through a snap at the rear of the in-line board and also into a release clip at the towing point. The in-line planer is set out at whatever distance off the side of the boat you desire. When a fish strikes, the line pulls out of the release and the board slides down the line, being stopped ahead of a hooked fish by a barrel swivel, bead, and leader. Due to heavy towing strains, a stout baitcasting rod and fairly strong line are necessary for in-line planer fishing.

How far you set a planer board out to the side of the boat depends on how close to shore you want to be, how far apart you want to spread your lures, how much room you have to fish, and how much boat traffic there is. Eighty to 100 feet out is standard for sideplaners when boat traffic is moderate; they can be run out as much as 200 feet if you have a high anchor point in your boat for the tow line. In-line boards are run 30 to 100 feet out.

With planer boards you can troll whatever lures are appropriate for the conditions, and you can use hard-pulling lures (like deep divers) by adjusting tension on the release clip. It is important, however, to know how deep lures run at the length of line you have them set behind the planer, and having the tension on the release set properly. The tension must be tight enough to withstand the force of the lure or the weight being trolled, but not so tight that it is hard to pull out on a strike.

Lures can be set any distance behind a planer board that seems feasible. You do need ample line on your reel, however, because the fishing line extends first to the release clip on the planer board, then to the lure, and could go out further if a strong fish takes line off the reel.

## DIVING PLANERS

Diving planers also attach to the main fishing line a few feet ahead of the lure, and are used to bring that lure down to a certain level. The design of the planer and the forward motion of the boat make it dive. When a fish strikes, it trips a release that causes the diver to flatten and offer minimal water resistance as the fish is played.

There are nondirectional diving planers, which only run straight down, and directional diving planers, which run straight down or down and off to the left or right. Directional divers are more versatile and more popular since they provide off-to-the-side deep presentation opportunities. Both types may also serve as attractors due to their size, color and/or swimming motion.

Spoons and cut plugs are especially favored lures to use with diving planers. Minnow plugs and dodger-fly or

NON-DIRECTIONAL DIVING PLANERS (TOP AND LEFT) AND A DIRECTIONAL DIVER (RIGHT).

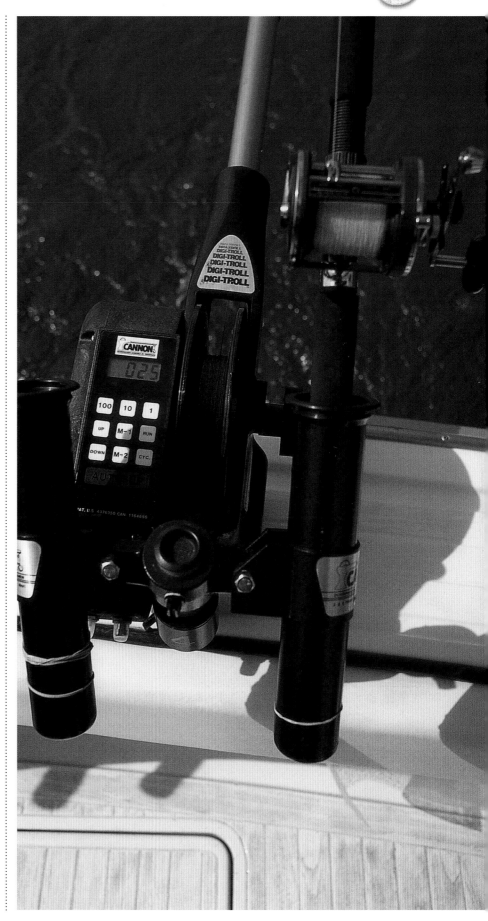

dodger-squid combinations are also employed, but seldom diving plugs, unless they are very shallow-runners and can withstand sometimes-erratic planer action. Since lures are set only a short distance behind downriggers, they are very responsive to boat movement.

Lures are set a short distance behind diving planers, because of the difficulty of netting a fish that is five or so feet behind a diving planer; three to five feet is a common setback length. Leader strength should be as strong or stronger than the main fishing line, preferably 17 to 20 pounds if big fish are likely to be encountered, and perhaps 25 to 30 if a dodger is trolled.

To determine how deep a diver will run, consult the chart supplied by the manufacturer, and set out a precise length of line to get down to the desired fishing level. Many diving planers have an adjustable tension screw release, which has to be set right for the strength of line used and the depth being fished. If you want to retrieve one and the release will not trip, it is hard work bringing it in. A few models can be reset without retrieving the planer.

Long, stout rods are necessary for diving planer use. Nine- to ten-footers are used on big boats, and seven- to eight-footers on smaller ones. Because diving planers pull so hard, a good rod holder is necessary, preferably an adjustable one that can take a lot of handle torque and that is easy to get the rod out of.

# Downriggers

Mainly used for trolling in freshwater, a downrigger is a tool for controlling the depth presentation of a lure, bait or fly. It is primarily used for catching trout and salmon in big lakes, but can be used for other species as well as in saltwater.

A fairly simple device, a downrigger features a reel filled with cable that is extended via a boom to reach over the side of the boat. A heavy lead weight attaches to the end of the downrigger cable, and a line-release mechanism is located on or near the weight or at any other place along the cable. A lure, attached to fishing line, is placed in the water and set at any desired distance behind the weight, then secured in the release. The downrigger weight is lowered to the exact depth you want to fish. When a fish strikes the lure, the fishing line pops out of the release and the fish is played on the fishing line, unencumbered by a heavy weight or strong cable.

There are manual and electric downriggers. Many small-boat owners use less-costly manual downriggers. Small manual models clamp onto the transom or gunwale, or fit into the oarlock; larger ones can be mounted permanently on a base. Manual downriggers are always

MANUAL DOWNRIGGERS AT THE STERN OF THE BOAT HELPED ACCOUNT FOR THESE SALMON.

hand-cranked to bring the weight up; some older manual models are cranked down, too, though on most you release clutch tension to lower the weight.

With electric downriggers, which are preferred by busy trollers with large boats, the weight is automatically raised and lowered. They are generally made for permanent and sturdy mounting locations. Electrics are considerably more expensive than manual downriggers and require power hookups, often through an auxiliary battery.

Downriggers have a line counter to indicate the length of cable used and the relative depth of the weight. Ten- to 12-pound weights are the norm; these help to keep the cable directly below the boat, or as close to it as possible, for precise depth determination. This is especially important if you are using a wide-angle sonar transducer (which allows you to see the weights on the sonar screen), if there is current, when trolling at a fast speed, and in water over 50 feet deep.

A round ball with a stabilizing fin on the back is the most popular shape of weight. Fish or torpedo shapes are fairly popular, while some anglers prefer a "pancake" model with a slender head and a broad fin. Some weights have a thick rubber or vinyl coating, which helps to protect the boat when they hit the side or are dropped on the gunwale or deck. Weights are available in various colors;

fish are often attracted to the trolled downrigger weight, possibly because of the color, but most likely because of the vibration.

Line releases are essential to using downriggers. They can be attached to the weight, to the downrigger cable at the weight, and to the cable at any location above the weight. Fishing line is clamped into a release under variable pressure. Some feature a trigger that pops open and which can be set to release under greater or lesser tension. Some feature spring-loaded jaws capped with rubber pads; how far into the pads you set the fishing line determines the tension. Easily adjustable tension settings are important in line releases, and setting the right tension is critical for catching fish. Most fish that take a lure trolled behind a downrigger weight impale themselves with the hook(s) of that lure when they strike it and pull the fishing line out of the release. A release set too loosely will provide little resistance to help set the hook; if set too tight, a small fish may strike the lure and not pop the line out of the release, causing the fish to be dragged for some distance. Also, a tight release often cannot be freed by the angler from the boat in order to change lures.

There is a proper middle ground that varies, depending upon the strength of the fishing line used and the type of lure trolled. When using light line, you have to set release

tension fairly light so the line is not broken if a big fish strikes the lure. When using lures that are heavy or that create a lot of resistance when pulled through the water, such as large deep-diving plugs or a dodger, the release tension must be set high enough so that the fishing line stays in the release and does not pop out without a fish striking, especially in rough water.

## Attractors

Attractors are trolling accessories meant to get the attention of fish, especially in mid- to deep water. They are employed near the end of a fishing line and ahead of a trailing lure or bait. Two types that are especially prominent in freshwater are cowbells and dodgers/flashers.

Cowbells feature multiple in-line blades and simulate a group of baitfish. The blades are spaced at intervals over a short-to-medium length of braided-wire line. Some

models feature a rudder at the head, to which the fishing line is attached, and all feature a swivel to prevent line twist. A short leader (six to 24 inches) and lure is attached to the end of the rig.

Usually a spoon or streamer fly is attached to cowbells, but sometimes a shallow-swimming plug or strip of bait is used. Blade shapes includes willowleaf, Colorado and Indiana, with lengths from one-and-a-half to five inches. They are predominantly silver, but may be painted or adorned with colored tape.

Cowbells are used mainly for deep trolling, particularly for lake trout. They are used occasionally with downriggers, but mostly on wire or lead-core line, or on lines weighted with a heavy sinker.

Dodgers and flashers are thin metal objects, oblong and rounded at the ends, usually two to three inches wide and five to ten inches long. Dodgers sway from side to side and do not rotate unless run too fast; flashers rotate, but do not sway. Both sport swivels at each end, come in various sizes and colors, and can be altered in appearance with the application of prism tape. Dodgers are more widely trolled than flashers.

Cut plugs, spoons, flies and imitation squid are fished behind dodgers and flashers. Flies and squid are the most popular trailing lures, and are set 12 to 18 inches behind the attractor. Cut plugs and spoons are set 18 to 30 inches back.

Dodgers and flashers do not have any built-in weight, so they are usually fished behind a downrigger, but they are also used in conjunction with diving planers and heavy sinkers. The distance from the planer or sinker to the attractor is two to six feet; a short lead improves its action.

## Anchors

There should be some type of anchor in every boat, at least for use in an emergency if not while actually positioning a boat for fishing. People who stillfish and those who drift are among the primary users of anchors, although anglers who tend to cast in specific areas may use one to temporarily maintain position until that location can be thoroughly fished.

In recent years, an electric transom-mounted anchor that deploys a hydraulically activated pole into the bottom in water up to 10 or 12 feet deep has become popular among large-boat bass anglers and some inshore saltwater anglers. Though expensive, this anchoring device is convenient because it automatically deploys and stows, is quiet, and allows for precise anchoring. Most anglers, however, use some type of weighted device to anchor manually, especially in rough or deeper water.

LEFT: A DISPLAY OF COLORFUL FLASHERS.

especially in sections of water with riffles, rapids or shoals. Large homemade anchors, such as blocks and iron chunks, are not efficient, and are also back-breakers to retrieve.

The mushroom anchor is cheap, usually made of lead, and sometimes with a vinyl or plastic coating. It is solid, fairly small, stows easily and is popular among small boaters in freshwater, where it is mainly used in ideal conditions and for soft bottoms. It primarily holds due to its weight (usually eight to ten pounds) rather than its intrinsic grabbing ability.

The Danforth anchor, also called a fluke, has good holding power and is very popular. It folds flat for relatively easy storage, and is lightweight (three to ten pounds). It features two long, flat, and pointed flukes that dig into the bottom as upward pressure is applied on the line. It is especially effective in mud, sand and clay. In rocky terrain the flukes may skip over the bottom instead of digging in, and they tend to pick up debris when retrieved. They may also be hard to use in extremely soft bottoms with a lot of grass. Some newer aluminum versions feature an adjustable shank, which can be changed to suit different bottoms. Most have a trip feature for releasing the anchor.

Navy anchors combine moveable flukes with a lot of weight. They are made of lead, sometimes coated with vinyl, and feature bulb and pivoting weight design. Navy anchors hold especially well in soft bottoms, and are fairly popular, especially in freshwater, but they have a poor holding-power-to-weight ratio. They are found in five- to 20-pound sizes. The plow anchor has a broadhead-like blade and a design that rights the anchor and causes the blade to furrow into the bottom, eventually burying itself if the bottom is soft enough. This is good over diverse bottoms, especially where there is sand and moderate grass. Some versions have a pivoting shank, which reduces the tendency of the anchor to pull out when there is a sharp change in the angle of pull. These large anchors range from 15-pounders for 25-foot boats up to 60-pounders.

A metal, gang-hook type of anchor that sports four to six upward sweeping claws is called a grapnel. It has no value on soft bottoms, but is excellent on rocky bottoms, as the claws catch objects readily. Grapnels can get badly hooked onto the bottom and can be impossible to retrieve unless a trip line is attached to the bottom so it can be overturned. They are slightly bulky for storage and the hooks have a way of snagging things as well as rubbing against the boat. Another type of anchor used by some anglers is the so-called river anchor, which is lead, usually vinyl coated, with three wide-cupped blades. Models weigh from ten to 30 pounds and are best on rocky bottoms and where the current varies. Other anchor types that may be used in rivers are mushroom, twin-fluked, Navy models, and improvised versions previously mentioned.

The weight and/or the design of the anchor usually determines its holding power, but a heavy anchor is not necessarily a requirement to hold a big boat; bottom conditions, water conditions, anchor type, how the anchor was set, the amount of anchor line out and other matters play a role in effective anchoring.

Small boaters may use cement blocks, cement- or sand-filled cans and jugs, sash weights, pieces of iron, truck tire chains and other makeshift and economical dead weights as anchors. Most of these are only suitable for small-to medium-sized boats, generally under 20 feet in length, and in fairly calm water. They may not hold sufficiently in heavy waves or in current, and generally have little ability to grab the bottom and dig in, although they may hold if they snag behind a big object, like a rock. Many river anglers use an improvised anchor, especially chain, primarily as a weight to slow their downstream movement,

# CASTING

Casting is one of the most important and common aspects of fishing. Although it is possible to fish for some species without casting (such as by trolling, drifting and vertical jigging), this action is required for many types of angling, particularly in presenting, and being able to retrieve, lures. Good casting skills are often important to angling success, especially in achieving accuracy and sometimes in achieving distance. the act of casting is one that many anglers enjoy unto itself, preferring forms of fishing that require casting to those that do not.

. . . . . . . . . . . . . . . . . . . . . . . . . . . . . . . . . . .

THE GREATEST PORTION of all casting activity involves the use of a light, or virtually weightless, line carried by a weighted object. This is done with spincasting, spinning and baitcasting tackle, and occasionally with conventional tackle. Flycasting, however, involves a completely different principle, since the fly line is weighted and carries a nearly weightless object.

Mastering any type of casting involves practice and good technique. Good casters are especially able to make suitable casting presentations under adverse circumstances, such as when the wind is blowing, when the boat is turning, when the current changes their position, when there are many obstructions, when fishing in tight quarters and so on. They also know that proficiency is necessary all of the time, since the first cast made to a targeted location is often the most critical one.

DEPICTED IS THE PROPER WAY TO HOLD SPINCASTING (1), SPINNING (2), BAITCASTING (3), AND FLYCASTING TACKLE PRIOR TO CASTING. WHEN YOU MAKE A CAST, BOTH SPINCASTING AND BAITCASTING REELS SHOULD BE ROTATED (IN THIS EXAMPLE ROTATED TO THE LEFT) SO THAT THE HANDLES FACE YOU.

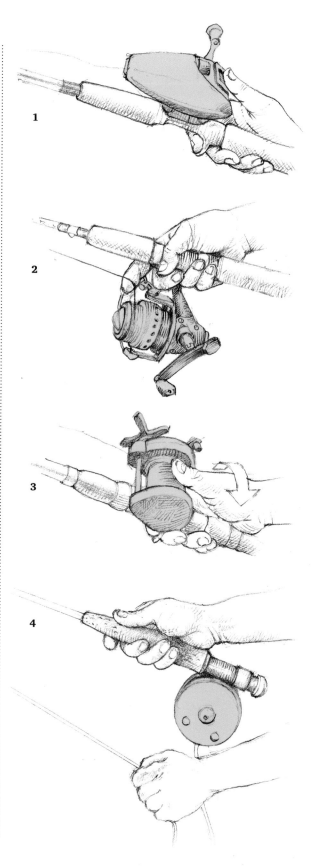

1

2

3

4

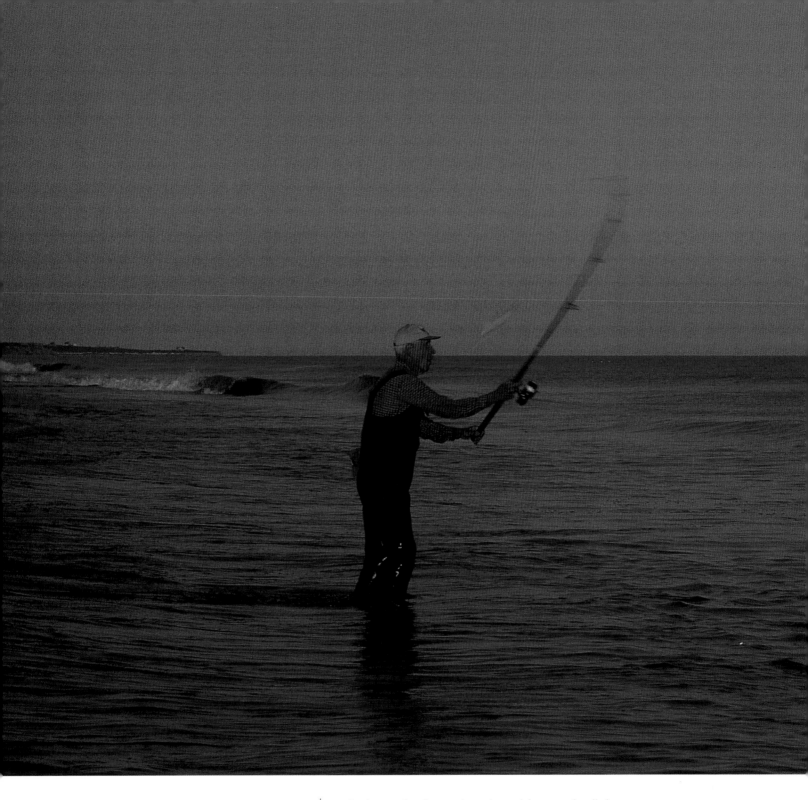

# Casts with spinning, spincasting and baitcasting tackle

### OVERHEAD CAST

Also known as the straight-ahead cast, the overhead cast is the most basic and common casting method with all of these tackle types. The rod tip is raised vertically and the line is projected directly in front of the caster, whose eyes pick up the flight of the line and the cast object immediately.

In the overhead cast, the wrist and forearm do all the work, using the top section of the rod for thrust. The cast begins with the rod low and pointed at the target. Bring the rod up crisply to a point slightly beyond the vertical position, where flex in the rod tip will carry it back; then, without hesitating, start the forward motion sharply, releasing the lure halfway between the rod's vertical and horizontal positions. The entire casting action should be a smooth, flowing motion rather than simply hauling back and heaving. With stiff, fast-action rods, there is likely to be little or no flex in the rod tip; these rods load easily, and casts can be very quick and snappy.

USING TWO HANDS ON HIS SPINNING TACKLE, AN ANGLER LAUNCHES A PLUG INTO THE SURF.

Although the overhead cast is often made with one hand, many people prefer to use both hands to attain greater distance and accuracy. This is especially true with longer and heavier spinning and baitcasting rod-and-reel combinations, with rods that have long handles and when casting big, heavy lures. Two-handed casts are made by placing the secondary hand on the lower part of the rod handle and using both forearms and wrists to execute the proper motions.

## SIDE CAST

Although executed horizontally, the side (or sidearm) cast requires virtually the same motion as the overhead cast. It begins with the rod low and pointed slightly outward. Use the wrist and forearm to flex the top section of the rod back and then forward, releasing the line just before the rod tip is pointed at its target; follow through with the forward motion after releasing the line to bring the rod in front of

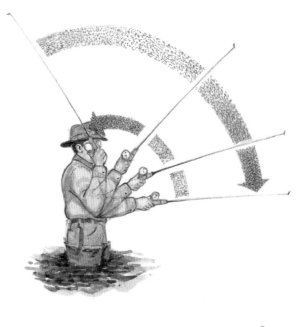

you. Timing is critical. You have to release the line at the proper moment, which varies with lure weight and rod action. The side cast is a little more difficult than the overhead cast and requires some practice, as does achieving accuracy, which is affected by the fact that the line, lure and rod are not immediately aligned with the caster's eye and the lure is not as quickly picked up as it heads toward its target, although it does have a much lower trajectory than the overhead cast.

The side cast can be modified so that it is also a side lob cast by starting with the rod tip pointed low toward the water and raising it up on the forward motion; this raises the trajectory and produces a soft landing.

Side casts are desirable or necessary when overhead casting is prevented by overhead objects. They are also good in windy conditions, since keeping the line and lure low to the water minimizes drifting off course. It is hard to achieve significant distance with side casts, and you have to be mindful of the location of companions when making them.

## UNDERHAND CAST

To make an underhand cast, hold the rod waist-high, angled halfway between the vertical and horizontal positions and pointed at the target. Flex the rod up, then down, then up again to gain momentum for the lure; on the second upward flex, the line is released. There is very little arm movement in this cast, but plenty of wrist action.

The underhand cast is made while standing and is basically for very short distances and in tight quarters. It is easy to follow the lure with this cast because it is right in front of you, unlike when making a side cast. Many rods are too stiff to permit this cast, and they have to be short enough so that when standing in a boat, you have enough distance to the water to make the required motion.

## FLIPPING

Flipping is a controlled, short-casting technique used in close quarters to present a moderately heavy jig or plastic worm in a short, quiet, accurate manner. It is mainly done by bass anglers standing up in a boat using a long (seven-and-a-half-foot) rod and baitcasting reel, but you can flip in some other circumstances.

To flip, let out an amount of line about equal to the length of the rod. Strip line off the reel until your free hand and rod hand are fully extended away from each other. Hold the rod at about a 45-degree angle and pull on the line with your left hand to get the bait moving backward. Drop the rod tip, then start bringing it up to move the lure toward its target. You should be able to speed the lure forward with a slight flexing of the wrist. Let the extra line in your left hand slide out through the rod guides while moving the hand forward.

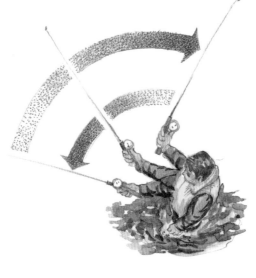

BEGIN THE **OVERHEAD CASTING** MOTION (TOP) BY AIMING YOUR ROD AT THE TARGET; BRING THE ROD BACK TOWARD YOU CRISPLY, AND SLIGHTLY BEYOND A VERTICAL POSITION, BEFORE SWIFTLY COMING FORWARD AND RELEASING THE LINE. THE **SIDEARM CAST** (BOTTOM) IS ACCOMPLISHED IN A SIMILAR MANNER IN A HORIZONTAL FASHION.

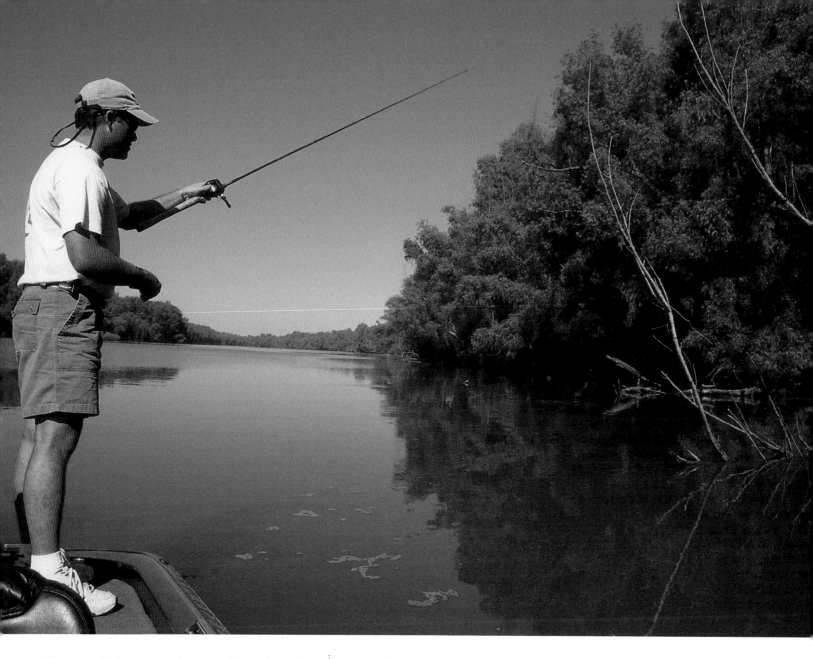

To move the lure to another spot, lower the rod tip and point it toward the lure, grab the line between the reel and first guide with your free hand, and strip it back while lifting up on your rod. Swing the lure out and back and send it forward again to the next object.

**PITCHING**

This low-trajectory cast is made from a distance to present a lure under low-hanging cover and objects. It is mostly made with a two-handed casting motion using a baitcasting outfit. To make a two-handed pitch cast with a baitcasting outfit, put the reel in freespool and let out enough line so that the lure drops down even with your reel. Hold the lure carefully in your free hand and pull on the line to bring your rod tip down so it has a slight bend. Bring the rod up as you let go of the lure and take your thumb off the reel spool at the same time. If you do it right, the lure will speed toward its target on a low trajectory.

Do not overload the rod, which can lead to a backlash on the reel spool. The rod must have a fast enough tip to send the lure to its target with just one smooth movement. The key to making good pitch casts is lifting your rod arm at the exact instant you release the casting weight

# Casts with flycasting tackle

Some mastery of proper technique is important in flycasting, which is why there are schools for learning how to cast with fly tackle and hardly any schools for learning how to cast with other types of equipment. This activity is not inherently difficult, but in order to make repeatedly good presentations, to counter wind conditions, and to make casts beyond short distances, you have to develop coordinated wrist and forearm movement. Brute strength is not necessary to flycast well, nor is a lot of wrist action—which results in quick, whippy rod movements. Unlike casting most other types of tackle, flycasting requires the use of both hands, one for rod control and the other for line control.

THIS BASS ANGLER HAS JUST SHORT-PITCHED A JIG TO A NEARBY TREE.

FLYCASTING HAS BOTH BACK AND FORWARD CASTING MOTIONS THAT ARE INTERTWINED. THE BACK STARTS WITH A SMOOTH LIFT, THE ROD STOPS ABRUPTLY BEFORE REACHING A VERTICAL POSITION, AND THE ROD TIP DRIFTS BACK TO ALLOW THE FLY LINE TO UNFURL. WHEN THE LINE STRAIGHTENS, ACCELERATE THE ROD FORWARD. STOP IT ROUGHLY AT THE POSITION SHOWN, THEN FOLLOW-THROUGH BY LOWERING THE ROD TIP TO A NEAR HORIZONTAL POSITION TO ACHIEVE A GENTLE DROP OF THE LINE, LEADER AND FLY.

OPPOSITE PAGE: THE DOUBLE HAUL REQUIRES A BIT OF WELL-TIMED ASSISTANCE FROM THE NON-ROD HAND. ON THE BACK CAST, USE THE NON-ROD HAND TO GRAB THE LINE (1) AND THEN TO SHARPLY PULL DOWN ON THE FLY LINE (2) AS YOU SIMULTANEOUSLY RAISE THE ROD; CONTINUE PULLING THE LINE FORWARD (3) AS THE ROD MOVES BACKWARD. ALLOW THE LINE HAND TO DRIFT UP AND BACK (4) AS THE LINE STRAIGHTENS OUT ON THE BACK CAST, THEN PULL DOWN ON THE FLY LINE (5) AS YOU ACCELERATE THE ROD FORWARD. CONTINUE PULLING ON THE LINE (6) AS THE ROD MOVES FORWARD, THEN MOVE YOUR NON-ROD HAND FORWARD WITH THE OUTGOING LINE AND RELEASE IT (7), WHICH ALLOWS EXTRA LINE TO SHOOT OUT THE ROD GUIDES TO GAIN DISTANCE.

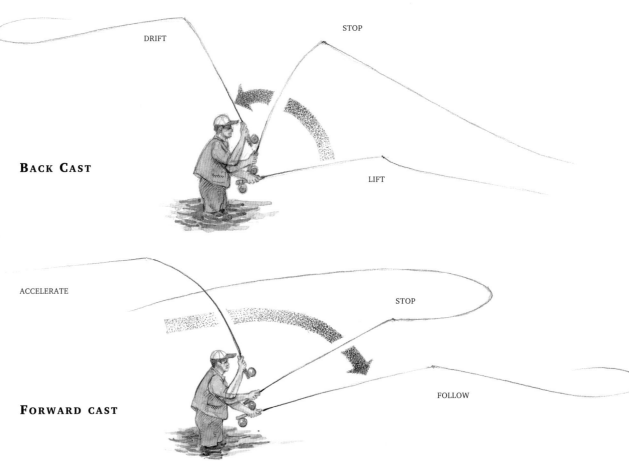

BACK CAST

FORWARD CAST

The two primary casts are the overhead and the roll. Another casting action, though not technically a cast, is called hauling, which is a maneuver used in overhead casting to accelerate the line.

**OVERHEAD CAST**

The overhead cast has both forward and backward movements, the latter of which is dependent on picking up the fly line and leader off the water properly.

To illustrate the basic overhead cast, we will use an angler who is facing, and casting to, the right. Beginning with the fly line (preferably a floating line to start) and leader fully extended straight out in front of you and the rod in an approximate three o'clock position, hold the line in your non-casting hand, raise the rod decisively to the 12 o'clock position, and flick your wrist sharply, allowing the rod to go no further than an 11 o'clock position. This action brings the fly line and leader off the water and sends it into the air behind you. Pause for an instant to let the line straighten out, and, just as it does, bring the rod forward to the one o'clock position; a tight loop should unfurl. As the line straightens, follow through by lowering the rod tip. The forward casting movement is akin to that of hammering a nail into the wall, and it takes the right timing to load the rod properly to provide optimum forward impetus.

Note that the overhead cast starts by raising the rod, which moves the line in front of you to pick it up and start it into the air, so it is important to get this initial act right. Raise the rod with moderate speed and deliberate motion; neither slow nor fast motions load the rod properly. Start casting with short lengths of fly line out, and gradually work up to longer lengths.

Although the technique described here accounts for one back-and-forth motion, flycasting is seldom a series of one-shot casts. It is often necessary to move the line and fly through the air in a series of continuous motions to get enough line out to place the fly correctly. This is called false casting, and means making two, three or sometimes four backward-and-forward casting motions without allowing line or fly to touch the water before laying the line and fly down.

Keep arm movements to a minimum, and rely on wrist and forearm action to perfect a motion that is more akin to hammering a nail than to tossing a ball. Do not lift your elbow up high or raise your arm so that the rod hand winds up over your head. If your casting arm moves a lot, control will suffer.

Note that there are situations (in close quarters and wind) when the best way to get a fly to a target is to turn your body directly away from it, cast in the opposite

direction, and use what would ordinarily be the back cast to lay the fly down.

## HAULING

Hauling is a means of accelerating the line to load the rod, and is used to help pick the line off the water for the back cast or to shoot out a greater length of it in the forward cast. Doing either one of these alone is a single haul, and doing both in the same casting sequence is known as a double haul. When double hauling, the angler uses the non-rod hand to give some speed both to the pickup and forward momentum of the fly line. This technique takes practice to master.

Assuming that you cast with the right hand and hold the fly line in your left, you would accomplish this as follows: hold the line firmly in your left hand ahead of and close to the reel, and, at the same instant that you raise the rod to lift line off the water for an overhead cast, pull sharply on the line in your left hand, bringing it down toward your left hip. As the line rises into the air on the back cast, raise your left hand and release some of the line to extend the backward length of the fly line in the air; as the line straightens out behind you, grab the line near the reel with your left hand and, at the same time as your right

hand begins to power the rod forward, pull sharply down on the line in your left hand. As the rod comes forward, release the line in your hand to shoot it through the guides and extend the casting distance.

To get greater amounts of line out, which is called "shooting," strip about ten to 12 feet off the reel and send it shooting through the rod guides by properly hauling it.

WITH A LITTLE INSTRUCTION AND DRY-LAND PRACTICE, BEGINNING FLYCASTERS CAN QUICKLY LEARN PROPER TECHNIQUE.

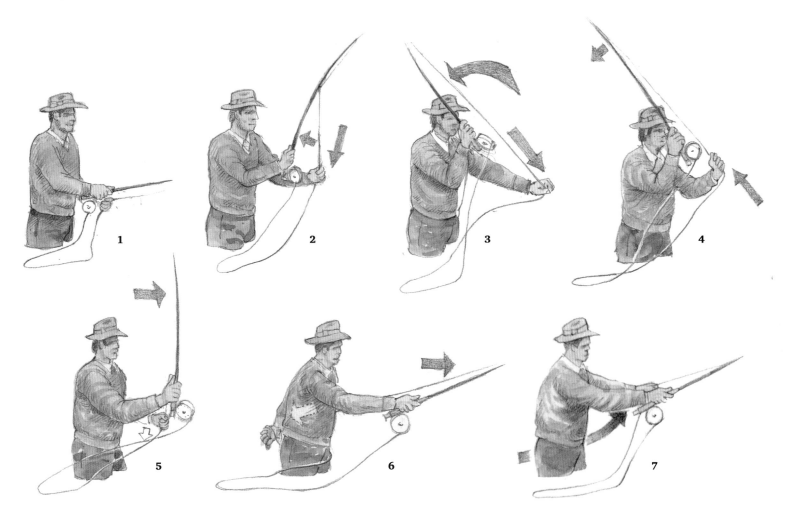

1

2

3

4

5

6

7

WHEN TRYING TO GET YOUR
FLY TO DRIFT NATURALLY TO
FISH HOLDING DOWNSTREAM
OF A ROCK, THE FLY LINE
HAS TO CONTEND WITH SLOW
AND FAST CURRENTS, THE
LATTER CAUSING THE LINE TO
MOVE AND THE FLY TO DRAG
UNNATURALLY. TO COMBAT
THIS, AS YOU CAST YOUR FLY
IN THE PROPER LOCATION
TO DRIFT, MEND THE LINE
BY THROWING AN IN-AIR
CURVE IN IT; THIS DEPOSITS
MOST OF THE BELLY OF THE
FLY LINE UP INTO THE FAST
CURRENT. WITH THE LINE ON
THE WATER, YOU CAN ALSO
LIFT UP A PORTION AND MEND
IT BY FLIPPING THE LINE
UPSTREAM TO COMPENSATE
FOR ITS FASTER
DOWNSTREAM FLOW.

## ROLL CAST

This cast is intended for short-distance presentations (20 to 30 feet) and for laying out line to pick it up for a standard overhead cast. It is easiest with floating and slow-sinking lines, and with sink-tip lines that are not too deep.

To make a roll cast, raise the rod tip up steadily but not too quickly until it is just past a vertical position (generally when the rod gets past your ear) and at a point where there is a curved bow of line extending from the rod tip behind you, then bring the rod sharply forward and downward in a nail-hammering motion. The last action brings the line rolling toward you with leader and fly following, then rolls it over and lays it all out straightaway. When you bring the rod up to execute this cast, cant it slightly outward; the line coming from the rod tip must be to the outside of the tip, not between the tip and your body.

## SLACK-LINE CASTS

In-air maneuvers that throw slack in the fly line during the cast are called slack-line casts. These are a form of mending to affect a proper drift once the line lies on the water.

A curve cast, which can be made when fishing upstream or downstream, forms a curve in the line as it settles on the surface. Do this by dropping the rod tip from a vertical position to one side and then returning it to the vertical position while the forward cast is in progress and before it lands.

A reach cast, which is made when facing upstream, is done by reaching upstream with the rod while the line is in the air and then laying the line on the water.

An S-cast is one in which the angler slightly overpowers the cast and stops the line so that the fly halts in mid-air and bounces a bit backward, then lets the line fall to the surface, laying a series of S-like curves in the line on the water. A pile cast, which is used for short drifts in quick or pocket water, is done by casting high above the target spot and stopping the cast abruptly; this dumps the line on the water, which piles it up closer to the fly for a short drag-free float.

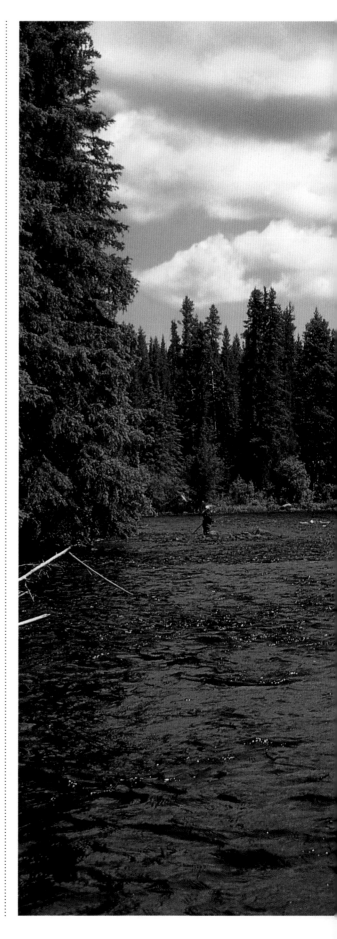

# RETRIEVING

**Manipulating lures through the water with rod and reel is one of the most enjoyable aspects of angling, and also one that often requires some level of skill and experience. Retrieving is all about controlling depth, action and speed, yet this varies considerably with the many categories and sub-categories of lures.**

A CHIEVING PROPER DEPTH is perhaps the most important factor in retrieving lures, since you have to get to the fish's level or to the level at which the fish will strike. Doing so is a function of the design of many lures and the way in which they are used. Action is also a design function, but only to the extent to which the lure is properly fished; achieving proper action is necessary for any lure to have maximum attractiveness, and that is often dependent on how the angler manipulates the lure.

Speed is often the most overlooked factor in lure retrieval; this is influenced by the diameter of line being used, the type of lure, current and the retrieve ratio of the reel. Many anglers have a tendency to retrieve lures too fast,

which is often their own fault rather than that of the lure or tackle used.

Plugs are especially prone to being fished fast. To be effective with diving plugs, for example, you must know how deep they run. Diving abilities depend on the lure's design, the diameter of line used with it (thinner line helps achieve greater depth), and the speed of retrieve. Contrary to popular belief, it is not necessary to crank the reel handle as fast as possible to achieve maximum depth with diving plugs. A moderate pace of retrieve gets the lure as deep as it will go.

When using diving plugs, it is usually best to keep them rooting along the bottom, over objects and along impediments. This is a straightforward matter with most floating/diving crankbaits. With sinking divers, let them settle to the bottom or count them down to a particular level and make your retrieve at a rate that is slow enough to keep the plug on or as close to the bottom as possible. Plugs that float, and models that suspend, are very effective when worked in a pull-pause manner. Minnow-like plugs can be fished on a straight retrieve, allowing them to run a foot or two beneath the surface, but are often better retrieved in a series of short, jerk-pause movements, running them forward half a foot with each motion.

Nowhere is retrieval more important or obvious than with lures fished on the surface. Among surface plugs, poppers are generally best worked slowly. The actual popping or forward chugging motion is made by jerking your rod up, or back, not by reeling line in. Keeping the rod low and pointed toward the lure helps reduce slack to work the lure properly. With wobbling surface plugs, the common retrieval method is a straight, continuous motion.

It is a worthwhile technique, however, to make the lure stop and go at times, or to give it a pull-pause motion, particularly as it swims next to an object.

Propellered plugs are retrieved in a jiggling-jerking-pausing motion that is erratic and representative of a struggling or crippled baitfish. Point the rod down, utilize the rod tip to impart action effectively and make your wrists do the work. Buzzbaits, which are propellered versions of spinnerbaits, must be retrieved in a steady, moderate manner, usually near heavy cover, though sometimes they can be momentarily paused for added effect.

Walking surface plugs, also called stickbaits, have to be manipulated skillfully to catch fish. The principal retrieve, called "walking the dog," causes the lure to step from side to side. To accomplish it, begin with the rod tip pointed toward the water. This permits a desirable angle of pull, and allows the head of the lure to lurch in and out of the water most effectively. The all-important lure action is achieved through an adroit combination of rod-tip

FOR MANY SPECIES OF FISH IT IS IMPORTANT TO RETRIEVE YOUR LURE ON, OR FAIRLY CLOSE TO, THE BOTTOM; IF YOU CANNOT MAINTAIN CONTACT, YOU MAY NEED A DIFFERENT LURE, SOME WEIGHT ON YOUR LINE, OR DIFFERENT TECHNIQUES.

WHEN YOU USE A DEEP-DIVING PLUG, USE ONE THAT GETS DOWN TO THE PROPER BOTTOM LEVEL, FISH IT SLOWLY TO KEEP IT IN CONTACT WITH THE BOTTOM (ARROWS), AND OCCASIONALLY MAKE IT STOP AND GO.

twitching and reel-handle turning. Make a continuous series of short rod-tip jerks while simultaneously advancing your reel handle perhaps half a turn with each jerk to take up slack. Slowing the pace widens the lure's path of travel; speeding it up narrows it.

You can modify this by "half-stepping," which makes the lure move repeatedly to one side instead of from side to side. To do this, jerk the rod tip to bring the lure in the desired direction. Then barely nudge the rod tip, which causes the lure to turn its head just slightly outward without advancing. Now jerk the rod tip as before and the lure will dart back in the same direction in which it last headed. Repeat this to make the plug continue to head inward. Minnow-like floating plugs are used as surface lures by keeping the rod tip low and gently jerking them back toward you a few inches, reeling in an appropriate amount of line to minimize slack with each rod movement. A rod with a fairly soft tip helps, and the time between jerking motions depends on the species and their state of aggressiveness.

Lures that sink are fished in a very different manner than those that float. Spinners, for example, are almost constantly being retrieved once they are cast. In moving water, you generally cast a spinner upstream at a quartering angle (ten o'clock viewed from right, two o'clock viewed from left). The lure is tumbled by the swift water and also reeled forward at the same time. Fish spinners as slowly as you can under the circumstances; you should be able to feel the blade revolve with a sensitive rod. The depth of retrieve can be altered by raising or lowering the rod, or by changing the speed of retrieval.

In streams, it is important to get a spinner working the moment it hits the water. Hesitation often means hung spinners, particularly when casting across-stream in a fast flow. In lakes, spinners can be cast parallel to the bank and allowed to sink to the bottom, then retrieved just slowly enough to rotate the blade and keep the lure swimming over the bottom.

Similarly, spinnerbaits, which are primarily used in shallow water where there is a good deal of cover, are often retrieved close enough to the surface so that you can see the lure through the water on the retrieve. Here, it is necessary to begin retrieving a spinnerbait the moment it hits the water. Occasionally, spinnerbaits are retrieved out of sight along the bottom, or fished very deep by fluttering them down dropoffs and ledges in a series of short hops or in a jigging-like motion; these actions are imparted by stopping a steady retrieve and lightly pumping the rod, somewhat like jigging.

Retrieving spoons is even more straightforward than spinners and spinnerbaits, since the action is derived from their size and contoured shape. Although spoons are primarily retrieved shallow, they can be fished at varied levels by letting them sink via the countdown method (count at a cadence of one second per foot) and then reeled steadily with an occasional twitch to alter the action momentarily. The heavier the spoon, the deeper it sinks during retrieval. The most important factor in retrieving spoons is to use a speed that produces the best wobbling action.

Swimbaits are also a lure that succeed with a straightforward retrieve most of the time, and which are versatile for shallow, mid-depth, and deep use, although a heavier lure is necessary for deep water and where current is present. A slow, steady retrieve with an occasional twitch is generally best, including one that allows the lure to run along the bottom, occasionally kicking up some mud or sand. Very slow bottom movement may work in freshwater for bass, but a steadier retrieve is usually required in saltwater.

Soft worms, or plastic worms, have to be retrieved properly to be effective. There are a number of rigs and fishing methods to use with soft worms, but the most common technique is fishing along the bottom with a Texas rig, using a slip sinker just ahead of the hook eye. To retrieve this, begin with the butt of the rod and your arms close

WHEN RETRIEVING SOME LURES, LIKE PLASTIC WORMS OR JIGS, HOLD THE ROD TIP HIGH TO FEEL THE LURE AND TO DETECT A STRIKE.

to your body, and with the rod held perpendicular to you and parallel to the water. Raise the rod from this position (say nine o'clock) upward, extending it between a 45- and 60-degree angle, which means moving it from nine o'clock to 10.30 or 11. As you raise the rod, the worm lifts up off the bottom and swims forward, falling to a new position. Make this motion slowly, so that the worm does not hop too far off the bottom, yet swims slowly. When your rod reaches that upward position, drop it back to its original position while at the same time retrieving slack line.

Keep motions slow. When you encounter some resistance, try gently coaxing the worm along; if this fails, hop the worm with short twitches of the rod tip. The worm should usually be on the bottom, or right near it, although it is occasionally beneficial not to hug the bottom exactly, but to swim the worm slowly just off the bottom or above submerged cover.

Although worms are greatly different than flies, retrieving flies is also a fairly precise activity, since many flies are not so much retrieved as presented and drifted in a lifelike manner.

In still waters, a dry fly is usually cast to a rising fish or to a likely fish lair, where it may be allowed to rest momentarily or be slowly skimmed across the surface by stripping line in short segments. In moving water, a

dry fly is cast directly upstream or up and across stream and allowed to float with the current, while slack line is gradually taken up during the float.

Wet flies and nymphs, which are primarily used in current, are fished below the surface and often near or close to the bottom. They are primarily cast up and across current, sometimes more up than across in order to get the fly deep. Nymphs are fished on a tight line, often using a strike indicator on the leader butt or the end of the fly line to detect strikes. They are mostly fished on a free drift without drag, but are sometimes jerked a bit.

Because they are meant to represent small fish, streamer flies are retrieved in short darting or jerking movements, usually caused by stripping fly line in with your free hand. In current they are cast up and across stream directly across stream and downstream, and stripped while they drift. Elsewhere they are allowed to sink, and are then retrieved in foot-long strips, fine twitching movements or short pulls.

Poppers and swimming bugs are fished with a pull-pause, line-stripping motion or the twitch of a fly rod tip. More vigorous strips produce loud noises, while slight twitches produce light popping sounds. Sometimes it is worthwhile to fish these flies in a quick darting manner.

# JIGGING

**There are various sizes and styles of single-hooked, leadhead jigs and single- or treble- hooked metal jigging spoons. As a group they cut across a wide swath of species. Many cast well and sink quickly, and are useful in both freshwater and saltwater, whether cold or warm. However, success with these lures requires skillful manipulation, as they have little or no inherent action on their own. Success is directly proportional to your ability to impart action to the lure, to effect a proper style of retrieval and to be able to detect strikes.**

· · · · · · · · · · · · · · · · · · · · · · · · · · · · ·

ESTABLISHING CONTACT with your lure, getting and keeping it where the fish are, and using the right rod to feel a strike, are keys to jigging. The greatest concern is often how deep you need to fish, and how effectively you do that. Jigs excel at being on, or close, to the bottom, which is where the majority of jig-caught fish are found. They are also productive for covering the area in between in vertical presentations.

## Bottom jigging

It sounds obvious, but one of the keys to jigging on the bottom is getting a jig to the bottom, and keeping it there. The simplest way to get a jig to reach the bottom is to let the lure fall freely until the line goes slack on the surface of the water and no more comes off the spool.

If the water is calm and the boat is still, you can readily detect when you are on the bottom. If it is somewhat windy or if current is present, watch the departing line carefully to detect the tell-tale slack and to differentiate between line that is leaving the spool because the lure has not reached the bottom and line that is being pulled off by a drifting lure or boat. In a boat with sonar, you will know the depth below,

which helps you to determine when the lure should hit the bottom, especially in deep water.

It is easier to get a jig to the bottom and keep it on the bottom with light line (thinner diameter) than with heavy line, although lighter line is not always practical. It is also easier with a heavy jig, but using a heavy jig may not be best for the species or conditions. So you often need the right combination of line strength (or diameter) and jig weight.

Choosing the right weight jig is very important. Ideally you should use a lure that gets to the bottom and stays there under normal conditions, but which is not too large to be imposing to fish. Most anglers who fail to reach the bottom not only do not use the right retrieval technique or compensate for wind or current, but also use too light a jig for getting down to the bottom under the conditions. Maintaining contact with the bottom is very important.

Once you have cast your jig out a reasonable distance and it has settled to the bottom, retrieve it toward you in short hops over the bottom as long as the terrain and length of line out permit. If you are in a boat and drifting, the jig will eventually start sweeping upward and away from you and the bottom as you drift, unless it is very

VERTICAL JIGGING, WHICH IS REPRESENTED BY THE ANGLER IN THE BACK OF THIS BOAT, PRIMARILY ENTAILS WORKING THE JIG DIRECTLY BELOW YOUR POSITION; WHEN **BOTTOM JIGGING**, YOU GENERALLY CAST TOWARD SHORE, ALLOW THE JIG TO SETTLE TO THE BOTTOM, THEN WORK IT ALONG THE BOTTOM.

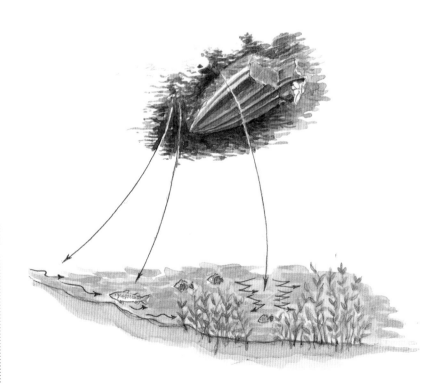

heavy, so you need to pay out more line occasionally until the angle of your line has changed significantly, then reel in and drop the jig back down again.

Although the method described is standard bottom-jigging procedure, it is sometimes necessary to swim a jig by pumping it slowly and reeling so that the jig never actually hops along the bottom. Other times it may be necessary to drag it slowly. When retrieving a jig along a moderately sloped bottom, try slowly pulling the lure a little bit off the bottom, then letting it settle down while keeping in contact with it; take up the slack and repeat. When retrieving a jig on a sharply sloping bottom, like down a ledge, slowly pull the lure over the structure until it begins to fall; let it settle, then repeat. Do not hop the jig up quickly here, as it will fall away from the bottom and will likely miss a good deal of the important terrain.

With certain jigs, like grubs, it is sometimes a good technique to make them jump quickly off the bottom rather than make short hops. You can also swim a jig on the edges of cover by reeling it slowly across the bottom and giving it occasional darting movements with manipulation of your rod tip. The majority of strikes while jigging come as the bait falls back down, so be alert for a strike and keep a good feel and an eye on your line to detect this.

When fishing a jig in current, cast upstream or up-and-across stream, engage the line-pickup system as soon as the lure splashes down, reel up slack and try to keep the line taut by letting the jig drift or by reeling in slack to achieve a natural drift. In quickly moving water, keep slack out and the rod tip up to maintain contact with the lure as it bounces along. In deep, swift current, swim the jig a bit by pumping the rod tip.

# Vertical jigging

Jigging vertically, either in the water column or just over the bottom, is done with both leadhead jigs and metal or lead jigging spoons. Maintaining contact with and over the bottom is not an issue, though you might fish just above the bottom or start at the bottom and jig your way upward. Sometimes it is necessary to get to a particular depth and regularly jig at that spot.

When you know the exact depth to fish, you can let the desired length of line out and commence jigging the lure up and down in the same spot, using a slow lift-and-drop motion, never reeling in any line and only paying line out if you begin to drift. To know how much line you are letting out, reel the jig up to the rod tip, stick the rod tip on the surface, let go of the jig and raise your rod tip up to eye level, then stop the fall of the jig. If eye level is six feet above the surface, your jig will now be six feet deep. Lower the

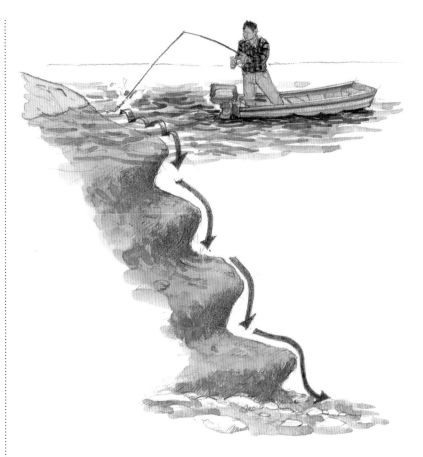

rod tip to the surface and do this again. Now you have let out 12 feet of line. Continue until the desired length is out. When using a levelwind reel with a freely revolving line guide, you can measure the amount of line that is let out with each side-to-side movement of the line guide, then multiply this by the number of times the guide travels back and forth. If the reel does not have such a guide, strip line off the spool in 12- to 18-inch increments until the desired length is out.

For some vertical jigging, you may need to let your lure fall to the bottom, then jig it up toward the surface a foot or two at a time. Bring the lure off the bottom and reel in the slack, then jig it there three or four times before retrieving another few feet of line and jigging the lure again. Repeat this until the lure is near the surface. The only problem here is that you do not usually know exactly how deep a fish is when you do catch one, and you cannot just strip out the appropriate length of line and be at the proper level.

In some respects the technique of drop-shotting, which features a lure suspended in the water above a weight, is a lot like jigging. The weight takes the lure (a hooked worm, grub, or other soft plastic body) to the level you want to fish, and it rests on the bottom while the lure is suspended above, activated by the occasional slight movement of your rod tip. This rig can also be used while drifting, and also while ever-so-slowly using an electric motor to shift position.

IF YOU ARE JIGGING ALONG A STEEP SHORE OR DOWN A CLIFF OR LEDGE, YOU SHOULD ALLOW THE JIG TO GET DEEP AND ALSO MAKE IT MOVE IN SHORT, SLOW HOPS SO THAT IT DOES NOT LEAP OUT AND AWAY FROM GOOD COVER.

OPPOSITE PAGE: THESE WALLEYE ANGLERS ARE SLOW-HOPPING JIGS ALONG THE BOTTOM BY REPEATEDLY RAISING AND LOWERING THE ROD IN SHORT INCREMENTS, RE-TRIEVING A BIT OF LINE WITH EACH SUCCESSIVE MOTION.

# Strike detection

While many fish strike a jig suddenly and with enough force that you react instantly by setting the hook, most fish strike a jig when it is falling, which is a moment when there is often a slight amount of slack in the line. Detecting a strike in this instance can sometimes be difficult. If you fail to detect such a strike quickly enough, the fish may reject the lure or you will be too late to set the hook properly. You can help keep slack out of the line when a jig falls by lightly tight-lining it backward. Slightly lower your rod tip as the jig falls; when you feel a strike, set the hook quickly and forcefully, reeling rapidly at the same time.

Having the right rod is important in detecting strikes and setting the hook, especially when you use light jigs. A well-tapered rod with a fast tip is preferable for most jigging; keep the rod tip angled slightly upward when jigging. A low-stretch line can also be helpful in detecting strikes, especially when fishing very deep and with heavy lures; it is also an aid to steering large fish quickly away from bottom objects.

Strike detection while jigging is more difficult in windy conditions, which move your boat around, and when fishing in and around weeds, due to brushing objects that feel like light strikes constantly.

TWO ANGLERS FISH IN DEEPER WATER BY JIGGING VERTICALLY BENEATH THEM.

# TROLLING

**While casting and jigging are fishing activities that require anglers to make a presentation physically, hold the fishing rod in their hands and retrieve or manipulate the lure, trolling is distinctly different because it involves presenting a lure or bait behind a power-driven boat, often with the rod placed in a holder, and maneuvering the boat to manipulate the lure or bait. This is true of both freshwater and saltwater trolling, and in pursuit of a wide range of species.**

. . . . . . . . . . . . . . . . . . . . . . . . . . . . . .

MOST TROLLING IS DONE in open waters where there are few or no obstructions, and for fish that are deep and/or wander a lot. Although trolling may appear to be an easy or laid-back manner of fishing, you cannot regularly have success simply by dragging any lure or bait an indeterminate distance behind a boat at an unknown depth, in an unplanned fashion. You must know exactly where your offerings are and how they are acting, and you must make a calculated, determined effort to entice a fish. That means being able to do a lot of things well, including setting lines/lures/baits, interpreting sonar signals, knowing when to change offerings or locations, knowing the proper speed at which to troll and understanding how to manipulate a boat to effect an attractive presentation.

## General methods

Trolling can generally be broken down into about six methods, which are summarized here.

Fishing an object on an unweighted line is known as flatlining, and is the most common method for relatively shallow fishing. Depth depends on the weight or diving ability of the object being trolled, which is a factor of boat speed, line size, current, trolling-line length, and so forth. It is important to evaluate the depth that trolled lures or bait actually attain. Although most flatlining is done at slow

AN ANGLER PREPARES TO PLACE A DIVING PLANER INTO ACTION.

to moderate speeds, especially in freshwater, high-speed surface flatlining is practiced in some situations, primarily in saltwater for billfish, with offshore lures being trolled quickly on top of the water or through the surface foam.

Fishing an object on a line that is weighted with some type of sinker—like a drail, split shot, keel, bell, bead chain or other type—helps to get a lure or bait deeper than it could be presented with a line that is not so weighted. The importance of knowing the actual depth being fished is the same as with unweighted lines.

Fishing an object behind a lead core or wire line is a means of using a heavy non-casting line to achieve depth with the lure or bait being trolled. The depth is dependent on the amount of line trolled. This technique can allow for precise depth positioning, but it does have

some drawbacks. Both lead core and wire lines are bulky, which takes something away from the fight of a fish. In addition, wire has to be used on stout tackle and is subject to kinking, crimping and spooling difficulties.

Fishing with a diving planer is a means of getting lures deep without weights or other attachments. A stout rod and heavy line is necessary with diving planers, and the planers sometimes get in the way of landing fish, but since the planer trips when a fish is hooked, you do not have to fight both the planer and a fish.

Fishing an object behind a releasable cannonball sinker is a deep-trolling system in which a large round sinker gets the line down deep and drops to the bottom when a fish strikes. You lose a lot of weights, need stout tackle, and often do not know the depth at which you

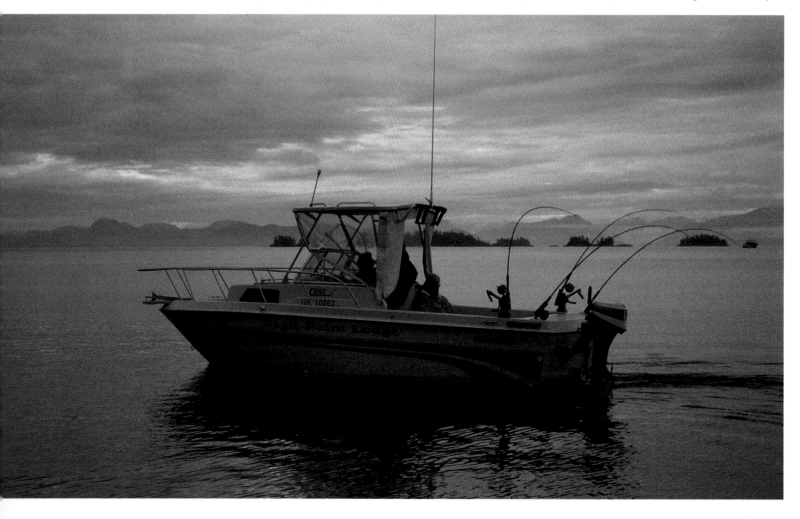

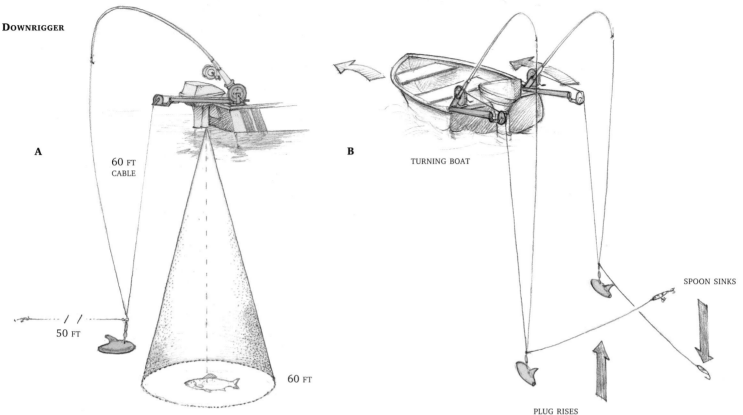

**DOWNRIGGER**

A

60 FT
CABLE

50 FT

60 FT

B

TURNING BOAT

SPOON SINKS

PLUG RISES

---

are fishing when you are off the bottom with this system.

Fishing an object behind a downrigger is very popular because of the precise depth control it affords; you can set your lure or bait any distance desired behind the weight, and you fight the fish unencumbered by a heavy line, weight or other device. This method affords the most controlled-depth presentation possible, plus the use of lighter and more sporting tackle.

# Speed and presentation issues

Speed plays a vital role in trolling. The key factor is having the speed that gets the right action out of your lures or bait, and which is also correct for the habits of the fish being sought. Many variables affect trolling speed, including current, waves, wind velocity and direction, type and weight of boat, power of the engine, type of lure, and so forth. A good example of variables is the difference in boat speed when heading into the wind or current versus when moving with the wind or current. You will obviously go faster with the wind than against it, assuming you never reposition the throttle. The same is true of current. Add varying wave heights, and there is a lot of difference. These factors affect the way your lure works and may explain why, on a particular day, you catch fish trolling in one direction and not in the other, which happens fairly often.

Always remember that boat speed must be compatible with the lures and bait fished. Trolling lures, in particular, are designed to be fished within a certain range of speeds; there is a particular speed at which each lure exhibits its maximum action. Bait must be trolled at such a speed that it appears realistic. It is often the case that certain lures and baits cannot be fished with others simultaneously, since they require different speeds to be effective.

To get the most out of trolled lures, check the swimming action of every lure before it is put into the water; focus on the speeds that work well for the lures in your boat, perhaps compiling your own lure speed chart; and take time to run all of your different lures in the water beside the boat to determine their ideal speed and to observe what range they will tolerate.

Be aware of ways in which you can manipulate the boat to affect lure speed. Many fish are caught when boaters speed up or slow down and when they make turns. On a turn, the lure on the outside of the turn speeds up and the lure on the inside slows down, unless the turn is very long and gradual. Such changes in lure behavior often trigger strikes, and may indicate that your prior speed was incorrect for the successful lure or that you needed a change in speed to trigger a strike from a curious fish. Frequent alterations in speed, either by decreasing or advancing the throttle or by turning, is a valuable tactic as long as you know if your lures will work properly at the different speeds. Do not overlook the habits of the fish you are trolling for, because the right speed for a given lure may still be

As is depicted in Illustration A, boat speed and current can cause the downrigger cable to sway back, meaning that the lure you are trolling will probably not be at the level of the fish, even when the cable length is equal to the distance of the fish below the boat. The affect of a turn is shown in Illustration B; turns briefly cause floating/diving plugs to rise and non-floating lures (like a spoon) to sink.

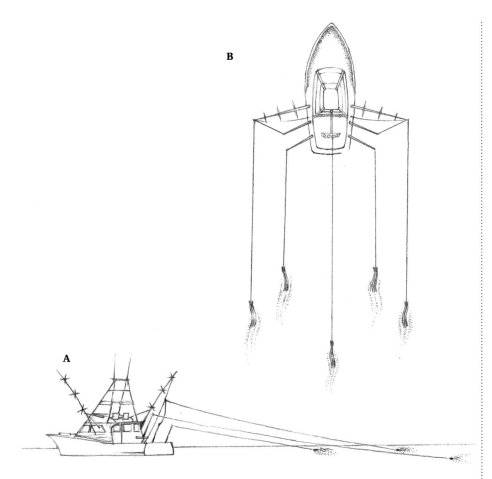

B

A

AN OVERHEAD VIEW (A)
OF A COMMON OFFSHORE
TROLLING SPREAD SHOWS
HOW LINE LENGTHS SHOULD
BE STAGGERED. WHEN
TROLLING FOR TUNA AND
BILLFISH, THE LURES OR
BAITS GENERALLY MAKE
A COMMOTION ON
THE SURFACE (B).

RIGHT: DEVICES LIKE
THIS OLDER MODEL
INSTRUMENT, PLACED
ON THE DOWNRIGGER
CABLE ABOVE THE WEIGHT,
RELAY DEEP TEMPERATURE
AND TROLLING SPEED
INFORMATION.

the sound of your engine, and watch the action of your lures. Watch other anglers; get alongside a boat that has recently caught a fish and duplicate its speed, then check your tachometer.

Note that in some places—especially in portions of the Great Lakes—there are deep underwater currents that can affect lure or bait action unbeknown to anglers observing the action of their lures in the water at the boat. Below-surface or deep-water currents affect the speed and action of trolling lures. You can troll all day, change colors frequently, have no success whatsoever, and have no idea why. If you are flatlining under such circumstances, you may be able to detect the influence of current by watching your lines and rod tips, but most of the time this will not be an indicator. You can determine the presence of strong current by watching a downrigger cable (which tends to sway back more than usual), but even then you will not know how it is influencing your lures.

There are electronic speed indicators that relay the speed of your lure or downrigger via sensors that attach to the downrigger cable above the weight and transmit that speed to a readout. They can also indicate temperature at the depth of the sensor and at the water surface. The latter is sometimes most valuable, as trolling in the right deep temperature zone is important for catching some fish, notably freshwater trout and salmon.

the wrong speed for the fish you are seeking. So it is a good idea to experiment with different lures and different trolling speeds.

It can help a good deal in catching fish if you can measure the speed at which your boat moves. This helps you to determine the exact speed that is effective for certain lures as well as for producing fish, rather than always guessing or estimating.

You need some reference point to determine boat speed. Engine revs, which are indicated on a tachometer, are not a perfect gauge of boat speed, but, in the absence of other references, they can be used to estimate speed when conditions are relatively calm.

Precise speed indication can be obtained by using relatively sophisticated electronic instruments that employ paddlewheels on the boat transom; the paddles spin as the boat moves and relay speed on a digital display. These units may read differently from each other, but they can be calibrated. Another electronic device for calculating boat speed—and one with exceptional accuracy—is a GPS navigational device, which calculates distance moved over time and should be used in the fastest update mode.

In the absence of a speed-indicating device, become a rod-tip watcher when you flatline: listen carefully to

# DRIFTING

**Drifting can appear to be a fairly haphazard way of fishing, something very lazy and easy. However, it is a necessity in some situations to drift with bait or lures, rather than to be moving under electric or outboard motor power; an example is when the fish appear to be spooked by motor noise. But to be really effective you must not be haphazard, or totally lazy.**

. . . . . . . . . . . . . . . . . . . . . . . . . . . . . .

T HE ESSENTIAL ELEMENTS of successfully drift fishing over a specific location are being aware of how deep you are fishing, where you are headed and what you are using. Proper boat positioning is especially critical. For a variety of reasons, every drifting boat has a tendency to move off a straight line even though it would seem that wind direction dictates a certain path as long as you start at the right spot. To determine how your boat drifts, observe it in a controlled situation with the

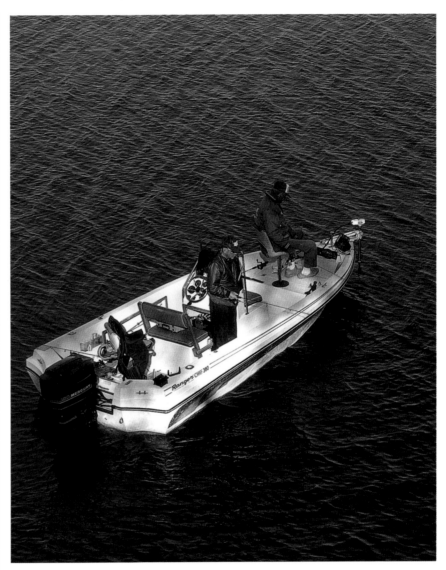

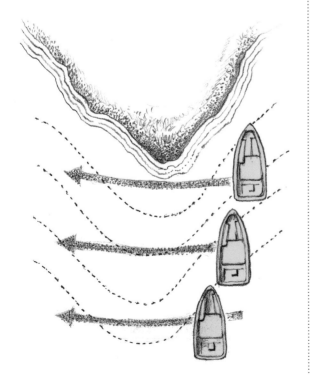

outboard motor in the water and aligned straight with the keel. To counter the tendency to move off a straight line, turn the motor in the direction that the boat wants to head, which acts as a rudder and keeps it in a proper attitude with the wind.

In order to drift properly over a particular stretch of water, you have to plan the approach correctly, taking wind and current into consideration. It is best if the boat is broadside to the wind, but this is not possible with some boats, although a sea anchor helps with smaller craft. Be sure to note where you start a drift and have success, as you should return and re-drift over productive stretches, as well as drift to the sides to cover all parts of a particular

ANGLERS DRIFT AND FISH VERTICALLY FOR WHITE BASS, USING THE ELECTRIC MOTOR AS NEEDED TO HELP MAINTAIN POSITION.

LEFT: DEPICTED HERE IS HOW A BOAT MIGHT POSITION ITSELF TO USE THE WIND TO DRIFT ACROSS A POINT.

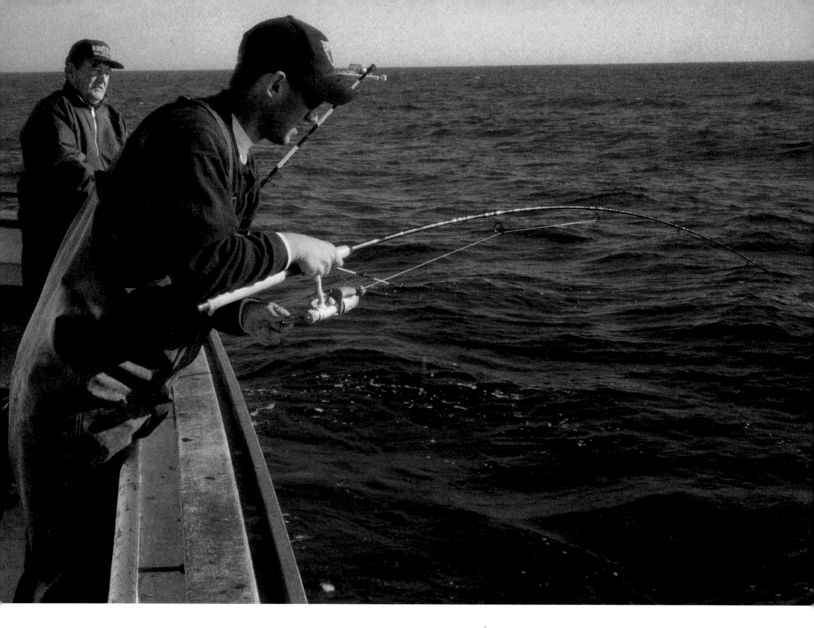

area. The longer you drift, and the more the wind shifts, the harder it will be—especially in open-water environs—to return to the proper place or to achieve the desirable drift. In saltwater, drift fishing is affected not only by wind, but also tides. Because of tide, many places in bays, in canals, along coastal areas, or in the open ocean can be completely devoid of fish or activity at one stage of the tide, yet provide sterling action hours later. Here, study each place you plan to fish, and determine how different wind and tide conditions affect the area. Studying charts will help you know the bottom conformation.

When making a long drift, fish are usually caught sporadically rather than in one tight spot, but that may depend upon the species. Repeat this drift and focus on adjacent waters for similar drifts. If you are in freshwater and have an electric motor, use it sparingly to help keep you in the right position, or to slow the drift speed. One of the benefits of drifting, especially in shallow water and near shore, is that you are not creating noise with either an electric or gasoline motor, so use either for positioning sparingly.

In rivers, boaters use electric motors, outboard motors or oars to effect downstream boat movement at a pace much slower than the speed of the current, allowing them to cast lures and baits and work them better or longer (or present them more often) in likely places. This is especially effective for salmon, steelhead, trout, bass and walleyes.

# Bait and lures

When drift fishing with bait, pay attention to both the type of bait rig that you use and to the weight or sinker. Bank, dipsey, pencil lead and split-shot sinkers are commonly used in bait drifting. While split shot are often used for suspending bait at specific depths, the others are essentially used for keeping contact with the bottom, are good in deep water, and cast well. Split shot are preferred for light tackle. Dipsey sinkers are also used with light to medium tackle, and where bait is suspended off the bottom above the sinker.

A very popular freshwater bait-fishing rig, used for drifting as well as for trolling, and which is especially useful on perch, walleyes and bass, is a spinner rig, which features a small spinner ahead of a worm, with a fixed sinker or sliding sinker above it. Another popular, bottom-drifting

bait rig features a three-way swivel with one lead going to a sinker and the other to a bait hook. Bass anglers will find that a Carolina rig is a very good worm rig for bottom drifting. You need the right-sized weight to keep the worm down, of course, which will depend on wind and depth.

In saltwater, drifting is largely done with bait and with jigs. Various bait, for example, is used for flounder, sea bass, porgies, blackfish, striped bass and weakfish. In canals, drifting a sinker close to the bottom often results in snagging debris, especially in the rocky bottom areas, so it is better to use a float rig that keeps the hooked bait just off the bottom yet within range of feeding fish.

Some species avoid swift tidal flow, and may stack up in deep holes within bays and inlets. As the tide slows, usually an hour before, during and after the change, they fan out searching for food. Live bait is good for these fish, and is often very effective when drifting. With live bait, drift along with the current, paying out 40 to 50 feet of line. When the current is running fast, you may have to add a rubber-core sinker to the line to take the bait down, but as the tide slackens no weight is needed. Fish the reel in freespool, and as a fish picks up the bait, let it move off, ensuring that the bait is well within the fish's mouth.

The key to successful deep jigging in salt water is being intimately familiar with the bottom conformation. This can be accomplished by carefully studying charts of the area, and then using sonar to view the reef, wreck or ridge to determine where these features exist, and where the fish are holding. Then it is a matter of determining the direction of drift. If wind is lacking, you will be moved by the tidal flow; if wind is present, it may overpower you and move you against the current.

Once you have made this determination, move to the high bottom spot and drop a marker buoy, which allows you to bracket the area, moving farther away from the marker on each succeeding drift. The buoy also alerts you to avoid drifting from deep water into the peaks of the reef, which often results in getting snagged or makes it easier for some hooked fish to dive into the coral and break off. Drifting and chumming on a broad expanse of offshore water may also bring great rewards. With modern electronics, it is possible to cruise known haunts of pelagic species. Once a favorable temperature break is located, you will often see schools of squid, mackerel, herring and other types of forage. This can be exploited by shutting the motor, drifting and establishing a chum line to attract the targeted species. Jig, fish with live bait, or drift dead bait or strips in the chum.

While you are drifting along, if you stream a bait out 100 feet or more, the current will push it toward the surface, which may require adding a rubber-core sinker to the leader to keep the hooked bait drifting along at the

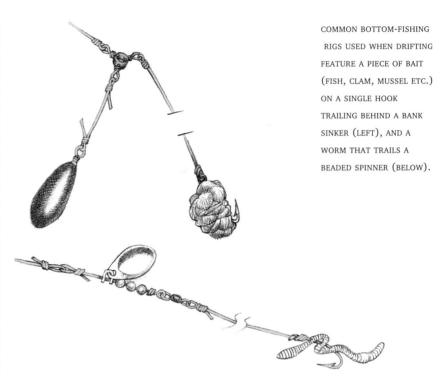

COMMON BOTTOM-FISHING RIGS USED WHEN DRIFTING FEATURE A PIECE OF BAIT (FISH, CLAM, MUSSEL ETC.) ON A SINGLE HOOK TRAILING BEHIND A BANK SINKER (LEFT), AND A WORM THAT TRAILS A BEADED SPINNER (BELOW).

same depth as the chum. Conversely, when there is minimal current or wind, an inflated balloon, cork or styrofoam float may be added to the line to suspend the bait at the desired level. Otherwise it might sink directly to the bottom, while the light, partially suspended, chum particles drift off at intermediate levels.

Some anglers who cast lures use a wind-aided drift to their advantage in combination with occasional electric motor use to help maintain a desired position. Although different lures can be cast for different species while drifting, a jig is generally the best lure to use, either with a soft-plastic attachment or a strip of live or dead bait.

Make sure that if you cast while drifting, you cast ahead of the boat to cover the area you are approaching, not the area that has already past. However, a fast wind-aided drift does not allow for proper retrieval of some lures that are cast downwind and retrieved upwind. When jigging, it is best to fish on the upwind side of the boat, letting the lures cover ground at the same pace as the boat. It is hard to fish jigs that drift underneath the boat, as they would when fished on the downwind side of the boat. This is especially necessary in deep water.

If the wind is pushing you at such a clip that you cannot maintain contact with the bottom, you may need to use a heavier weight, or periodically reel in and lower the jig right beside the boat until it hits the bottom. Another option is to cast it to the side and slightly ahead of the boat, which gives the lure (or bait) the opportunity to get down to the bottom by the time the boat is directly overhead, increasing the effective time that it stays in the likely area before swinging upward and having to be retrieved.

FOLLOWING PAGES: BRITISH COLUMBIA ANGLERS DRIFT FOR SALMON USING WEIGHTED CUT BAIT THAT SPINS IN THE DEEP CURRENT; THIS TECHNIQUE IS CALLED "MOOCHING."

# LOCATING FISH

It can fairly be said that you cannot expect to catch fish if you do not locate fish. Locating them involves visual observation, intensive searching, understanding fish habits and preferred habitats, and more.

. . . . . . . . . . . . . . . . . . . . . . . . . .

## Spotting fish or fish activity

Visual observation of fish themselves is one way to locate them, and the one most people prefer. In a stream, for example, trout may reveal their presence by rising to the surface to capture insects. In a lake, a school of bass chasing shad may force their prey to the surface, and the resulting commotion allows anglers to pinpoint a group of fish and

perhaps intercept them. In saltwater, the frenzied activity of a distant group of birds may indicate a school of bluefish that is ripping into bait. On a grassy flat at low tide, the exposed tail of a bonefish or redfish, which is scrounging the bottom for food, makes it obvious to stalking anglers. In these situations and in many others, the problem of locating fish is solved by the activities of the quarry and the observances of the angler.

However, most of the time when fishing in either fresh water or saltwater, you do not readily locate fish by observing them, and have to search for them without actually spotting them. To a large extent, that means knowing what places they prefer for food, comfort or temperature reasons.

# Tributaries and temperature

A lot of variables influence the location of fish. The extent to which they inhabit specific places, or prefer certain habitats, varies with the species and may be influenced by seasons, spawning, water conditions and other factors.

In a general sense, you locate fish by evaluating the place that you are fishing, watching water conditions to determine where fish may be and how to present lures or bait to them. This is referred to in a general way as "reading water," and is done in all types of environments, especially in freshwater. It is sometimes easier in rivers than in still waters (ponds, lakes and reservoirs) because many elements are more obvious. For example, in current, any kind of sizable obstruction (boulder, bridge footing, pier, etc.) creates a slack pocket where fish can lie without exerting much effort and watch for food; these are readily located. Still waters, especially, pose problems for many anglers, particularly in places that they do not know well, and for the obvious reason that the surface usually gives no indication of what is below.

Lakes, ponds, impoundments, bays, oceans and other bodies of water are all quite different, so the type and size of body of water plays a role in what you do and how you do it. The species available and/or desired is another consideration; obviously, the more you know about fish behavior and habitat, the better. Gamefish are usually found in certain places for specific reasons, and the better you understand the relationship between their depth, cover, temperature, food needs, and so forth, the better you are able to put the pieces of the underwater puzzle together. Often, electronic equipment—especially sonar— is employed to help with this, if not actually to locate fish then to determine depth and identify objects.

In big lakes and river systems, tributaries play a critical role in gamefish behavior. This is especially true in the spring, when many predator and prey species enter tributaries to spawn, or come into the near-shore areas influenced by tributaries because of the presence of food and more comfortable conditions. In the spring, they bear the rain and snow-melt runoff that helps open up the lake, then the warm water that ultimately raises the temperature of the cold main lake. A warm rain is a blessing for a big body of water that is influenced by a major tributary, because it will stimulate activity, feeding and possibly spawning.

Water temperature on the surface or well below it is a key to the behavior of some gamefish. In the Great Lakes, for example, early-season fishing primarily occurs in fairly shallow water close to shore. Trout and salmon seek warm water there, as do the alewife and smelt that they feed on. Sometimes it is important to find and fish the warmest water along the shore.

Elsewhere, however, the upper layer of water may be warmed up a bit on a mild sunny spring day. This might cause fish to be caught very shallow. This is especially true for bass, for example, which will eventually make nests in warm shallow water, or for trout or salmon, which will be attracted to pockets of warm water or vertical separations of different-temperature water away from immediate tributary areas. This may be in the vicinity of a warmwater discharge, or it may simply be the phenomenon of water movement and mixing. Nonetheless, surface-temperature variants can be important to recognize.

Temperature remains a factor after spring for many fish species. Water stratification sends cold- and coolwater fish to deeper freshwater locales in the summer, meaning that when you fish open-water areas, you have to know the

SOME COMMON ELEMENTS OF A RIVER ARE LOCATED IN THIS COMPRESSED REPRESENTATION.

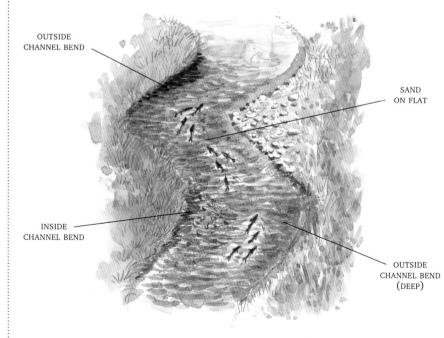

OUTSIDE CHANNEL BEND

SAND ON FLAT

INSIDE CHANNEL BEND

OUTSIDE CHANNEL BEND (DEEP)

IN THE EARLY SEASON, A
TRIBUTARY USUALLY BRINGS
WARM WATER, WHICH IS
ATTRACTIVE TO BAIT AND
PREDATORS; BROWN TROUT
AND STEELHEAD MIGHT BE
CAUGHT IN THIS GREAT
LAKES SETTING.

shore, so they place different demands upon the angler. Draw upon your knowledge of a species when deciding where to go and what to do.

Also, think in terms of edges. Like most animals, fish are attracted to some type of edge, be it structure or temperature. A prominent edge lair might be a shoal or reef; an underwater mound or island, sand bars and gravel bars are similar. These locations may be rocky or boulder-strewn, or they may be sandy with moderate weed growth, but they attract small baitfish, which in turn attract predators. Often, there is deep water on one side.

The deep-water/shallow-water interface near islands can be similarly thought of as an edge, incidentally, as can a sharply sloping shoreline. These are places at which bait naturally migrates by, and logically present feeding opportunities. Bait and gamefish also migrate by points, and some fish leave deep-water haunts to visit points temporarily to feed, so these are edge-like places, especially in big lakes, that offer frequent opportunities for predators to ambush prey.

preferred temperature of the species you seek, attempt to find out the depth at which this temperature is found, and try to relate this to prominent areas that would attract your quarry (such as long, sloping underwater points, submerged creek channels, sharp dropoffs, and so forth).

Big waters are slow to warm up in the spring, and slow to cool off in the fall. This can mean that small bodies of water may be better to fish in the earliest part of the season, till the larger waters warm up, and that big waters may sustain good fishing for a longer period of time in the fall.

## Habits, objects and edges

Grass, weedbeds and other forms of vegetation may also be important fishing areas of big lakes for certain species, so you may need to locate this type of cover. Bays, coves, islands and shoals are usually good places to start the search for vegetation, which is as likely to be submerged in moderate-depth water as it is visible and close to shore.

There is no doubt that knowledge of fish habits and habitat requirements through the seasons is one of your greatest allies when solving the mysteries of where to fish and what to look for in a big body of water. In freshwater, for instance, if lake trout are your quarry, you should be looking for rocky shoals, reefs and islands near deep water, as lakers are prone to come in from deeper water to such areas, feed, then leave. Open-water salmon do not orient much to underwater features, so when they are not close to shore in spring or fall, you have to fish specific deep-water temperature zones and aggressively search for them and for baitfish. Stripers, too, are often nomadic and follow schools of bait, but in many impoundments, the tops of submerged timber, old river channels and other identifiable underwater terrain give them a place to find food. Largemouth bass and pike orient strongly toward various forms of cover, usually near

RIGHT: THE OUTER
BENDS (DARKER WATER
HERE) OF A STREAM HAVE
DEEPER WATER, WHICH IS
WHERE TO LOOK FOR
TROUT AND SALMON.

# Current and tide

Current is also a factor in locating fish. Look for a spot where strong current brings bait washing by, or which retards the movement of weak, crippled or wounded fish. Back eddies, slicks, tidal rips and current edges are more good spots. In rivers, a promising place is where a secondary tributary meets a major flow, especially in summer when the secondary tributary may dump cooler and more oxygenated water into the main flow.

In flowing water, it is the deeper places that often hold fish and which are sought by anglers. Slow-moving water is a sign of depth. Water is deepest where the current comes against the bank; years of this have gouged the bank and bottom, resulting in deeper water. Shallow water is found on the inside of a bend. In many places the bank is much steeper on the outside of a bend than on the inside, and this is another clue to the location of the deeper and shallower portions. When current strikes an object it may cause less turbulence in front of, or behind,

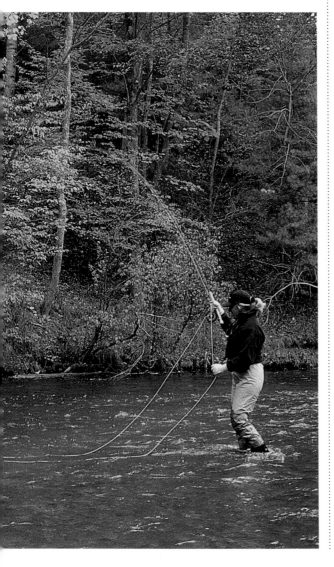

that object. This may be a place where fish locate because they do not have to work as hard to resist the flow, and also because it may be a good place to find food. Boulders are the most common object in currents, but small islands or shoals also exist, and in high water, stumps and fallen trees are also objects that can attract fish.

In saltwater, tides and current have a major impact not only on where fish may be found, but on whether they

are likely to be feeding. Many saltwater fish, particularly species inhabiting inshore areas, bays, and brackish water, are more active when the tide is moving than they are when it is slack. The effect of tide can be more pronounced in certain places than others, and underwater structures or differing bottoms may present good feeding opportunities when a tide is falling, rather than when it is rising. Tides act much like a river current in many places, especially in bays and estuary areas.

Ocean currents are more pronounced in offshore waters, and fishing where main warm water currents exist is important for pelagic species, although there are eddy-like pockets of ocean currents that can be found and which also hold such species as tuna, billfish and dolphin.

Tide changes affect much of the inshore, near-shore, estuary and marsh environment. Jetties that might be good to fish just before and after a high tide are probably not worth fishing at the other end of the tide range. Some flats, mangrove islands, marshlands and the like will be dry or nearly so on a low tide. And yet, in some instances, such as stalking feeding bonefish, the low water is best because it makes the fish easier to spot. So the places that you fish in high water and low water may be greatly different. And this difference is even more profound during a high or new moon.

SWIFT CURRENT CAUSES TURMOIL AND DISORIENTATION FOR SMALL FISH, MAKING SUCH A PLACE A GOOD ONE TO FIND PREDATORS; HERE, MANY BOATS ARE FISHING FOR COHO SALMON.

# HOOKSETTING

WHEN THE ROD TIP IS
POINTED DOWN AND THE
BUTT IS CLOSE TO THE
STOMACH OR CHEST,
YOU ARE IN THE MOST
DESIRABLE POSITION TO
REACT WELL TO A STRIKE.

**Sometimes fish hook themselves when they take your offering, but you cannot rely on that happening. Often an angler must react to a strike by forcefully setting the hook.**

I F YOU HAVE ANY QUESTION as to whether it takes more than a jerk to set the hook, try this simple test, which says a lot about hooksetting effectiveness: Tie a barrel swivel to the line on any fishing rod and have a friend stand 40 feet away from you holding the swivel clenched between his thumb and forefinger. Raise the rod slowly and apply all the pressure you can to try to pull that swivel out of

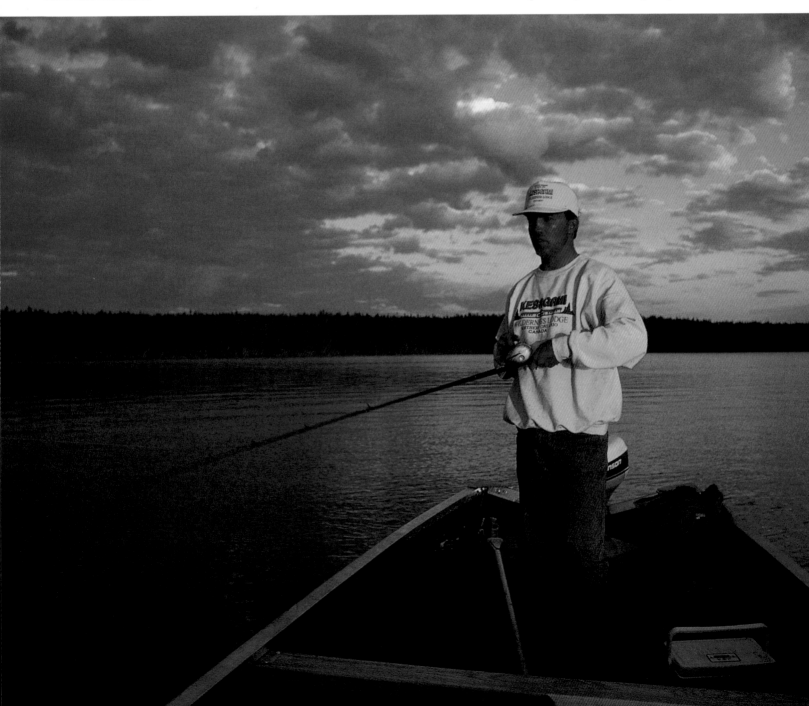

his hand. If you do not jerk back violently, you cannot pull it out. The lesson: Pulling back on the rod with steady pressure after you detect a strike is not how to set the hook. The irony is that many people intuitively realize this and think they take definitive action when they set the hook, yet often do not stick a fish well enough to land it.

The amount of force that you can generate in hooksetting is affected by numerous factors, especially the action of the rod, the distance of line between you and the fish, the amount of stretch in the line, drag placed on the line in the water, and whether a fish is heading away from or coming toward you. Even when you prevail over these matters, there are other influencing factors, such as where in a fish's mouth your hook point makes contact, the style and sharpness of hook, and what you do immediately after you set the hook.

## Rod position

Effective hooksetting largely involves timing and hook-point penetration. The timing element is partly down to reflexes and partly being prepared for what is about to happen before it happens. Generally, for example, it is helpful to keep your rod tip down when retrieving. With the tip down, you are in the best position to respond quickly to a strike, even if, as often happens, you are distracted when the strike occurs. If there is little or no slack in the line you can make a forceful sweep up or back when you set the hook, and then be in immediate control of a fish to begin playing it. When working some lures, however, it is necessary to keep the rod tip up to work the lure properly and to detect a strike readily. In such a case, when setting the hook you can compensate for a high rod position by bowing the rod slightly toward the fish while reeling up slack; this enables you to get a full, powerful backward sweep and be in the proper position for the fight.

## How it's done

When a fish strikes, set the hook by bringing your rod back and up sharply while holding the reel handle and reeling the instant you feel the fish. Where possible, you should be reeling and striking all in one motion, keeping the pressure on constantly and not yielding unless the fish is strong enough to pull line off the drag.

Keep in mind that hooksetting is not a whole-body maneuver, but an exercise of wrists and arms. Also, the position of the rod when you set the hook and as you complete hooksetting is important. The butt should be jammed into the stomach or mid-chest area to bring the

full arc and power of the rod into play, without having hands or arms flay wildly over your head. In order to counter line stretch, it is important to reel hard and fast the moment you set the hook.

The hooksetting procedure does not necessarily end once you have set the hook. Sometimes it is desirable to set it rapidly two or three times in succession. This might be advisable when using a thick-bodied plastic worm, since the hook point has to pierce the worm, and the plastic (which gets bunched on the hook shank during hooksetting), can affect penetration.

Followthrough is usually important, and sometimes critical, to the process as well. The line must remain tight after hooksetting. People who bring their rod tip back behind their head or raise their arms up high often put some slack momentarily into the line when they bring the rod back down in front of them. Not having to do this is the advantage of keeping the rod in front of you, and also of reeling continuously until the fish is firmly hooked and offering some resistance. Once you have the fish firmly hooked you can change the angle of pull as conditions warrant, which usually means applying sideways pressure rather than upward pressure.

## Distance and line stretch

Anglers who use nylon monofilament line are more effective at setting the hook at short and intermediate distances than they are at long distances due to line stretch. It is harder to counter the effect of stretch when you have a long line. You can generate more force and be more efficient at short distances, and are less efficient at long distances. The importance of this varies among types of line. Some nylon monofilament lines have up to 30 percent stretch when wet, and are obviously more problematic at hooksetting as distance increases. By comparison, a low-stretch line (braided Dacron, microfilament or nylon), if it had other desirable fishing qualities, is theoretically better for hooksetting over all distances.

## Hooksetting when trolling

In most trolling, especially in freshwater, the fish already has the lure when you pull the rod out of its holder. Should you set the hook then? It depends on the situation and fish. Yes, if the quarry is large and hard-mouthed. No, if you are using very light line or the quarry is soft-mouthed, where you run the risk of pulling the lure out. In either case, you will still have to concentrate on keeping pressure on the fish and not making a mistake when playing it. In big-

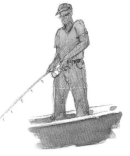

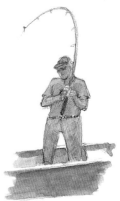

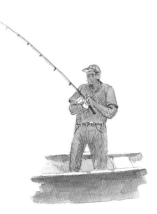

TO SET THE HOOK PROPERLY, START WITH THE ROD POINTED LOW (TOP); WHEN YOU SET THE HOOK, KEEP THE ROD BUTT IN YOUR STOMACH WITH THE TIP UP HIGH (MIDDLE), THEN CONTINUE TO PLAY THE FISH WITH THE BUTT HELD AT LOWER CHEST LEVEL, WHERE YOU HAVE POWER AND CONTROL.

game fishing and offshore trolling, heavy-duty reels are adjusted with greater drag for setting the hook (called a "strike drag"), which is relaxed to a lighter tension once the fish is on. The heavier drag allows a lot more force to be applied and counters the effect of stretch.

# Hooksetting when fly fishing

Most of the time when fly fishing, especially when using light-wire hooks on small flies and thin tippets, you just need to crimp the fly line to the rod butt with your fingers, snap the rod tip up and keep the line taut to set the hook. It may help—especially in removing slack or in bringing more force to bear—to strip line out with your non-rod-holding hand at the same instant that you raise the rod tip up. The bonier the mouth of the fish, the larger the hook and the heavier the tippet or shock leader, the more you need to "reef" it to the fish, either by strip-striking or, when a strong fish is running away, pinching the line to the rod butt, turning the reel handle and quickly raising the rod.

## IMPEDIMENTS TO GOOD HOOKSETTING

- Limber or soft rods, which detract from your ability to drive the hook home, especially if hooks are small or buried in soft plastic (like a worm) or natural bait.

- A loose drag setting, which causes line to slip off the reel.

- A belly or bow in the line, which causes friction and makes it harder to generate direct rod-to-fish force.

- An obstruction that impedes the line (such as a brush or an aquatic plant), which directs hooksetting more at the impediment than the fish.

- A dull hook, since most fish are lost because the hook slips or is thrown when the fish jumps, often because the hook did not penetrate well enough to hold the fish. A super sharp hook penetrates easier and increases your chances of landing a fish.

- Not paying attention when you get a strike, which often causes you to overreact or react improperly because you are caught unaware.

- Holding your rod in such a manner that it is in a poor position to react quickly.

WHEN YOU ARE FIGHTING A FISH, KEEP
THE ROD IN THE POSITION DEMONSTRATED
BY THIS ANGLER AND BE SURE NOT TO
LET THE FISH HAVE ANY SLACK LINE.

# PLAYING AND LANDING FISH

Most anglers have no trouble playing and landing the majority of their fish, which are relatively small or easily overcome on the tackle they use. It takes more skill and finesse, however, to deal with big fish, and with tough fish caught on light tackle.

## Playing fish

Sometimes the point is not simply to capture a fish that you have hooked, but also to play it quickly in order to release it unharmed, to land it before other predators attack it, and to be able to steer it away from objects that might cut the line. Many fish are lost as a result of the way in which the angler plays the fish. Within the capabilities of your tackle, you should take the fight to a fish rather than

YOU MUST KEEP THE PRESSURE ON WHEN FIGHTING A STRONG FISH; ALLOW THE DRAG TO DO ITS JOB AND RECOVER LINE AT EVERY OPPORTUNITY.

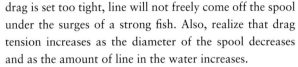

THIS ANGLER HAS LOWERED HIS ROD TO A SIDEWAYS POSITION TO CHANGE THE ANGLE OF PULL ON A LARGE FISH.

sitting back and being casual. It helps if you have confidence in doing this, and know what your tackle can do.

Large fish are often lost because of line breakage as a result of inferior quality line, damaged line or bad knots. An improper reel drag setting is also a culprit; when the

**BELOW**: IF YOU HOLD THE ROD TOO HIGH WHEN PLAYING A FISH CLOSE TO THE BOAT (1), YOU CANNOT CONTROL IT EFFECTIVELY. WHERE NECESSARY TO KEEP THE FISH CLEAR OF THE BOAT (2), REEL DOWN, STICK THE ROD TIP IN THE WATER, AND DIRECT THE LINE AWAY FROM PROBLEMS. CHANGING THE ANGLE OF PULL (3) IS A GOOD TACTIC WHEN PLAYING STUBBORN FISH; CHANGE FROM OVERHEAD TO SIDE PRESSURE TO MOVE THE FISH, THEN SWITCH BACK TO OPPOSITE-SIDE PRESSURE AS NECESSARY.

drag is set too tight, line will not freely come off the spool under the surges of a strong fish. Also, realize that drag tension increases as the diameter of the spool decreases and as the amount of line in the water increases.

Rod position is especially important to play strong fish properly. From the moment you set the hook, your rod butt should be jammed into your stomach or mid-chest area to utilize the full arc and power of the rod. Keep the tip up throughout a normal fight and constantly maintain pressure on the fish. Avoid slack line.

Whenever a fish is deep, not budging or swimming strongly to one side, pump the rod by lowering the tip and simultaneously reeling in line, then pressure the fish as you bring the rod back up. Once the rod is up, lower it and reel; continue doing this. Some fish and some tackle require constant short pumping motions, often called "short stroking;" this is more common when using standup tackle for tuna and billfish.

When a fish is fairly close to you and still energetic, continue to keep the rod tip high or fully taut when held to the side, and be prepared to direct the fish. If it rushes toward you, reel as fast as you can to take up all slack. If the fish runs under the boat, stick the rod tip well into the water to keep the line away from objects (especially motors). Where possible, go toward the bow or stern to follow or control the fish better. If your drag is set properly, you need not try to out-muscle a fish; use finesse to get it close enough for landing.

There are times when it helps to change the angle of pull on a strong and stubborn fish, perhaps to help steer it in a particular direction or to make it fight a little differently. Side pressure is how you do this. Bring your rod down, hold it parallel to the water, and turn your body partially or entirely sideways to the fish. You can pump the fish while in this position, and should switch sides as necessary when the fish moves far enough in any direction. Here are a few other pointers:

**1**

**2**

**3**

- Use the boat to chase after a fish that is taking too much line;
- Bow toward a leaping fish (salmon, sailfish, tarpon) when using flycasting gear; this slackens line tension so the jumping fish does not land on the line and pull the fly hook free;
- If a fish is hooked poorly, you can stop it from jumping by putting your rod tip in the water and keeping a tight line;
- When a strong fish surges away while close to the boat, temporarily point the rod right at the fish, which eliminates rod pressure and means only reel drag is in force;
- Guide the fish toward the person who will land it and try to get its head or snout out of the water or partially so;
- Never reel the fish right to the rod tip, but to a point where the line is equal to the length of your rod or slightly less;
- Anticipate a landing miscue and be prepared for a fish to bolt away at the last moment; keep line free from tangling, and put the reel in freespool in case the fish suddenly gets free, which often keeps you hooked up.

# Landing fish

Bringing a fish into your control or possession, even temporarily, is the crux of landing, and it is accomplished by hand-holding, netting or gaffing. Unfortunately, many good-sized fish are lost close to the boat because of the actions of the angler or the person attempting to land the fish, so it is important to take proper measures to land fish, both for the sake of capturing them as well as for maintaining individual safety.

When you are ready to land a fish, you have presumably made the decision whether to keep or release it, since this has a lot to do with how you land it and handle it afterward. If you are not keeping it, then consider unhooking the fish in the water to minimize injury to the fish. You can do this by holding the line with one hand or gripping the fish around the lower jaw with a jaw-gripping tool, and using a pair of pliers, a hook-gripper or a hook puller to get the hook out, then letting the fish go immediately. In this manner, the fish is never, or minimally, touched and least likely to be injured.

## HAND-LANDING

You have to be careful when you land a fish by hand. If a fish is going to be released, handling should be reduced to a minimum to avoid causing damage to internal organs, increasing the possibility of infection by removing the protective coating, or injuring it externally. If the fish will be

kept, then handling does not have to be as careful, the major concern then being to avoid personal injury.

If you are going to release fish, you never hold them by the eye sockets, and should avoid handling them under the lower edge of the gills, which can be fatal. Some fish can safely be grabbed by the inside lower gill cover, and under the upper gill cover near the back by placing the thumb under the upper edge of the gill cover and the tip of the middle finger under the edge of the opposite gill cover.

Some fish, which lack teeth on the jaws, can be hand-grabbed with bare hands by the lower jaw, which fairly immobilizes them for unhooking. Jaw-holding tools exist for lip-landing toothy fish, and some types of gloves, especially tough-coated, sure-grip versions, are useful for

THIS SMALL RAINBOW TROUT CAN BE GRASPED SAFELY FOR UNHOOKING AND RELEASE IF THE HAND IS WET FIRST AND THE FISH IS NOT SQUEEZED HARD.

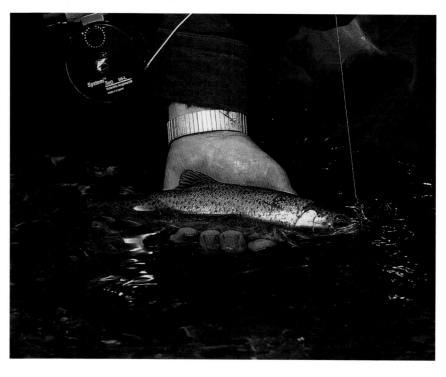

lip-landing. You can also land billfish species by their bill (carefully) and some large freshwater and saltwater fish by the rigid caudal peduncle area of their tail.

## NETTING

Because there is a possibility of damaging fish that are netted when a multi-hooked lure is used, you should not net some fish, especially if they are to be released. The hooks grab the net webbing, and the fish pull violently against the impaled hooks. The decision to release has to be made before you bring the fish into the net.

Most nets today are made of synthetic materials, some of which are fairly coarse and heavily knotted. The best nets for landing fish that you must, or want to, release are those with knotless webbing, which minimizes bodily scrapes, and with rubber-coated mesh, which inhibits

hook points from catching in them. Some also have long flat bag bottoms that a fish can lay in lengthwise.

When you net a fish, wait until it is within reach and headed for you. If possible, wait until a fish's head is on the surface or just breaking to the surface, since it has less mobility then. Do not net a fish from behind: the best position is from the front. Do not touch the fish with the rim of the net until it is well into the net, and resist taking a stab at a fish that may be technically within reach of an extended net, but not in the best position for capture.

A major netting problem is snagging a multihooked lure on the mesh or webbing of the net bag. This is one of the surest ways to lose fish, particularly heavy specimens that cannot be readily hoisted into the boat or scooped up in the now-tangled net.

## GAFFING

Gaffs are primarily used in saltwater and mainly for fish that will be kept. Some states prohibit the use of gaffs for certain species, or restrict the type of gaff that can be used or the body part in which a fish can be gaffed, so you must check local regulations before using a gaff. Fish to be released can be gaffed in the lower jaw with a hand gaff, preferably by driving the point through the inside of the mouth and out of the lower jaw (rather than coming from outside to inside). This is done when the fish is thoroughly played out.

If you plan to keep a fish, the location where you gaff it is not critical, but gaffing is often done in the upper back muscle of the fish's midsection. This may damage some meat but it is a good secure spot. Gaffing a fish in the belly may lead to a violent reaction on the part of the fish that could cause it to shake free, pry the gaff out of your hand, or break the gaff. It also contributes to a heavily bleeding fish that makes a mess in the boat or in a fish box.

To gaff properly you must get the point of the gaff in the water beneath the fish and then strike upward sharply. Being too excited or careless can cause problems. When gaffers flail wildly they often miss the fish, strike it in a spot that makes control and lifting difficult or, worse, strike and break the angler's line. Poking the fish with the gaff instead of ramming it home is likely to make the fish act wild, perhaps causing it to surge enough to break free.

NETTING A BIG LARGE-MOUTH BASS.

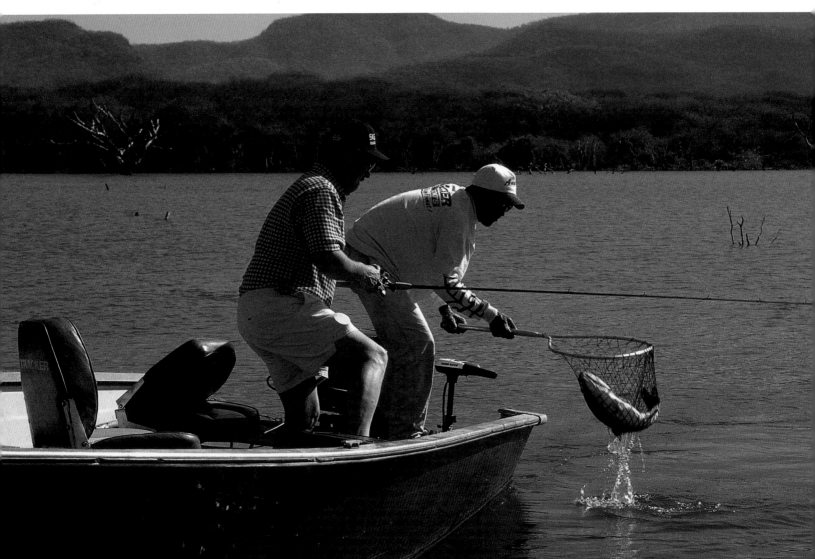

# RELEASING FISH

**The act of releasing a fish that you have caught is based on the presumption that the fish will be unharmed and able to survive being hooked, played, landed, handled, unhooked, revived and released. Every one of these elements can be a factor in the two most important issues that affect a fish's ability to survive: injury and stress. Before delving into those key factors, consider the following basic elements as a guideline for how to release fish properly.**

. . . . . . . . . . . . . . . . . . . . . . . . . . . . . .

Most aspects of these commandments are pretty obvious. A few things that enter into the equation, however, require a little more explanation.

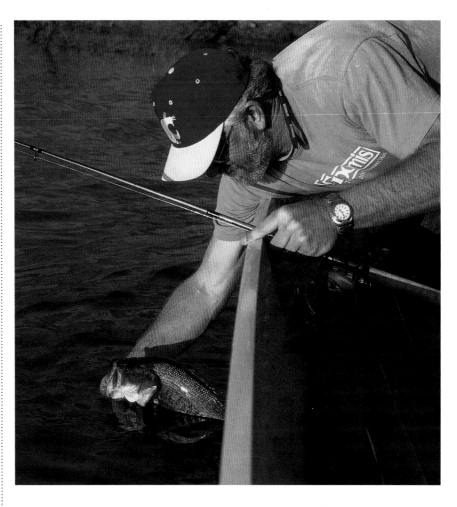

BASS ARE HARDY ENOUGH (AND LACK TEETH) TO BE HELD BY THE LOWER JAW FOR UNHOOKING, AND CAN BE RELEASED THAT WAY.

## THE 12 COMMANDMENTS FOR RELEASING FISH

1. Do not freespool a fish that has struck live or dead bait, or lures that might be taken deep. Set the hook quickly to keep bait or lures from being swallowed.
2. Use a circle hook with bait whenever possible.
3. Play and land the fish quickly.
4. Do not confine fish that will be released.
5. Minimize handling; keep the fish in the water whenever possible.
6. If you must hold the fish, do so firmly but gently; use a wet hand, glove, or towel. Snap a photo quickly.
7. Do not let the fish flop around.
8. Keep fingers and objects out of the gills and eyes.
9. Use long-nose pliers or another tool for extracting hooks.
10. If a fish is hooked in the esophagus or stomach, cut the line.
11. Revive a tired fish by holding it upright and moving it forward or from side to side.
12. Return the fish to the water gently and headfirst.

## Make it quick

Extended battles with large or strong fish promote lactic acid buildup. Some fish are so stressed after being landed and/or handled for release, and their lactic acid level is so high, that they have a greatly increased need for oxygen, making them harder to revive and requiring more recovery time before they can swim off on their own. Therefore, it is advantageous to land a fish quickly, unless it has been hooked in very deep water. Playing the fish until it is exhausted, or "belly up", may lead to lactic acid poisoning and death. This eventuality may be prevented not only by playing a fish quickly, but also by unhooking it carefully and releasing it as quickly as possible.

Large fish tend to have more difficulty with stress, and in some studies they have experienced a higher mortality rate than smaller fish. In freshwater, most fish are landed in

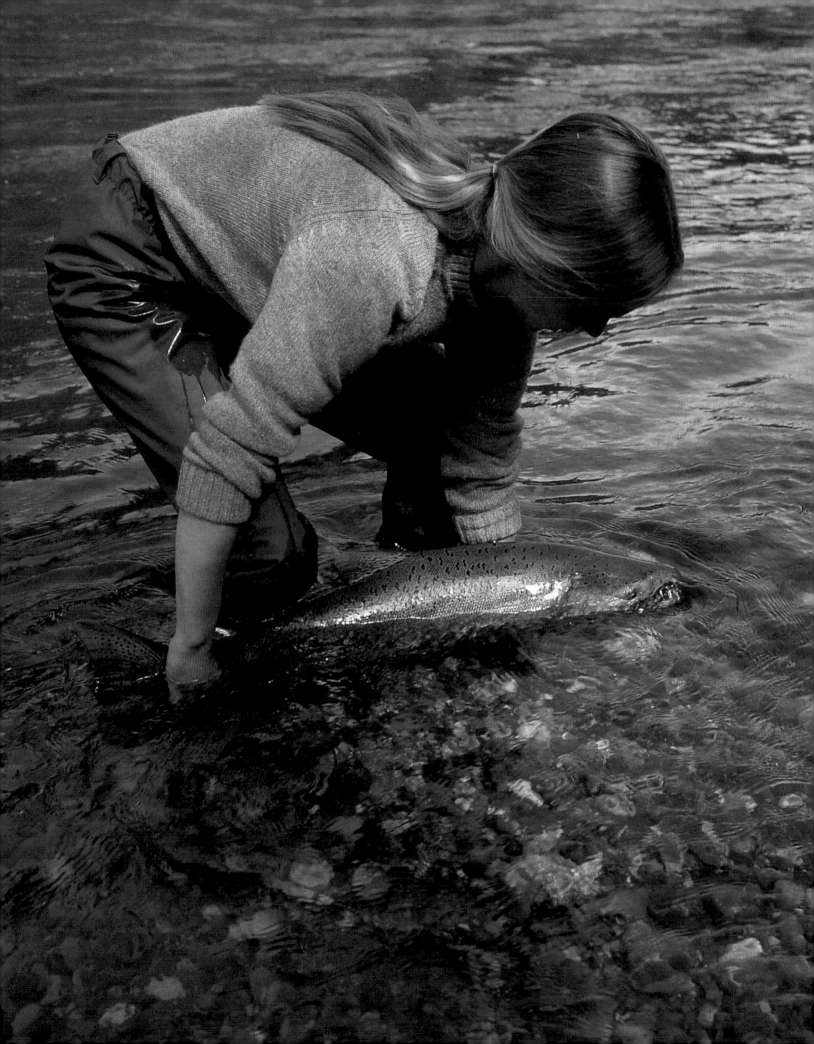

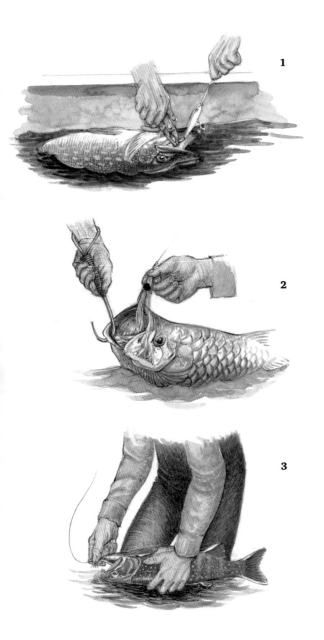

longer and result in a stubborn fish that will not give up and cannot be resuscitated after capture. Fish of identical sizes can be played to identical times with different outcomes; one may be played aggressively by an experienced angler using light tackle and be successfully released; while the other fish may be played by an inexperienced angler using heavier tackle and be incapable of revival. If you take the fight to the fish, no matter what the tackle, you often can convince the fish to give up. This gray area is evidently a psychological one, but it is an aspect of playing large and tough fish that many anglers give little thought to.

## Wetter is better

Published guidelines for releasing fish, prepared and supplied to the public by fisheries agencies and cooperating organizations, overwhelmingly recommend wetting your hand, or using a wet glove or towel or cloth, before grabbing a fish that must be handled. The purpose of this is to prevent removal of a fish's protective mucous-like coating, which is especially important in freshwater and in warm-water environments.

But how many people actually do this? My observation is that much less than a minority of people do it. Wading anglers have a leg up on others in wetting their hand before touching a fish, probably because they are in or close to the water. But boaters, who have to lean over and reach into the water to get their hands wet, seem to find this inconvenient. Bass anglers, who have the most to gain from catch-and-release because bass are so intensely pursued, are, on average, pretty poor about this. Despite the fact that they are going to release their catch, they are most likely to swing a bass into the boat, then grab it with a dry hand, sometimes after it bounces on the deck.

They, and everyone else whose hands only get wet after they have touched the fish, can do better. If you cannot release the fish while it is in the water and without touching it, then you can make the effort to wet your hands before holding it.

## Revive fish forward, not backward

Fish that are stressed experience lactic acid buildup and essentially need to be calm and receive oxygen. When reviving a fish, it helps if you can get oxygen to it by moving it forward to force water into its mouth and over the gills. Most instruction on this subject advises moving the fish back and forth in the water.

SOME FISH CAN BE READILY RELEASED BY KEEPING THEM IN THE WATER AND USING A PAIR OF PLIERS TO FREE THE HOOK (1); SOME LARGE FISH CAN BE LIP-GAFFED (2), ALTHOUGH THIS IS OFTEN A TWO-PERSON OPERATION; SMALL, FRISKY FISH CAN BE TURNED UPSIDE DOWN (3) BRIEFLY WHILE YOU UNHOOK THEM.

LEFT HAND PAGE: THIS CHINOOK SALMON IS BEING SUPPORTED WITH TWO HANDS AND FACED UPSTREAM UNTIL IT CAN RECOVER ENOUGH ENERGY TO SWIM OFF ON ITS OWN.

a relatively short period of time, either because of the skill of the angler or the type of equipment employed, or because most freshwater fish are relatively small and are able to recover from stress fairly quickly if they are not otherwise injured or mistreated.

How long is too long for large or strong fish? There is no guaranteed timetable, and there is no good way to measure this. If complete exhaustion meant certain death for a fish, then it would mean death for every animal that exercises itself to exhaustion, including long-distance runners and racehorses. Obviously, exhaustion cannot equate entirely with death. Some large and strong fish that are played to exhaustion can be revived and set free. Some cannot.

Indeed, the way that a fish is played may be the critical element. Playing a fish aggressively is more likely to result in breaking its spirit and saving its life. A tug-of-war can last

A fish takes water into its mouth and forces it over the gills and out of the external opening to take oxygen into the blood. It does not do this by swimming backward or by facing downstream. If you held a fish downstream long enough in a strong current, it would die. Could a wading angler stir up sediment and induce suffocation from backward movement? Maybe. Could a person move the fish backward so quickly and abruptly as to do it harm? Maybe.

Only moving forward is admittedly harder with fish that cannot be held by the mouth by hand. However, it is usually possible with the right gripping tool. Mouth-gripped fish can be led forward in a circular or figure-eight pattern, especially if they are not big, but other fish, and large individuals, are harder to do this with. Boat anglers can aid some fish by moving the boat slowly forward under outboard or electric-motor power, but such fish have to be supported near the head. You cannot hold a fish by the tail alone and move the boat forward because the fish gets turned sideways or backward.

If you cannot move a fish forward, and to avoid moving it forward and backward, you should cradle it with two hands, one holding the caudal peduncle (the stem before the tail fin) and the other supporting the area close to the pectoral fins. Hold it upright and keep it steady, perhaps moving it sideways if possible, until the fish recovers and can swim off on its own.

## Plunge a deep fish

Fish that are taken from deep water, especially lake trout and salmon, may be harder to release than those taken from shallower water. In addition to playing them slowly to allow natural depressurization, you can aid their return to deep water by giving them a good sendoff. When the fish is ready to be released, hold it in the water at the surface with the head in the water, moving it forward or from side to side until it is fully recovered. There are two options for releasing it. For fish that are large and too heavy to hold well, give the tail a quick squeeze to stimulate a vigorous dive. For fish that are not so large and hard to hold, give it a vigorous shove or push headfirst and straight toward the bottom for a solid head-start back down to the pressures and temperature from which it was taken.

GET FISH BACK INTO THE WATER AS QUICKLY AS POSSIBLE; RELEASE THEM HEAD-FIRST AND UPRIGHT, AS IS BEING DONE WITH THIS BONEFISH.

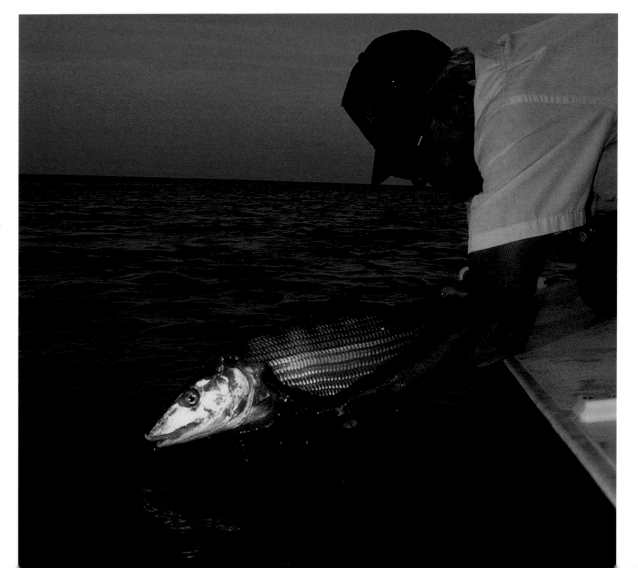

# KNOTS & KNOT TYING

**Knots are critical to fishing success, as you will find out when you encounter really strong fish and tough angling conditions. If you do not tie a knot right, that knot could be the weakest component of your fishing tackle. Conversely, tying a knot that retains the maximum breaking strength of the line means that you have no weak component.**

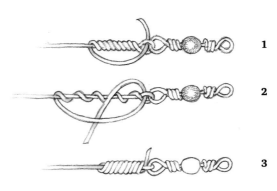

IMPROVED CLINCH KNOT.

SOME TYPES OF LINE seem to accommodate particular knots better than others. Knot failures in nylon monofilament lines, for example, usually result from improper tying. Knot failures in braided and fused microfilament lines are usually due to using the wrong type of knot. Some fundamental facts about knot tying include these: practice at home, not on the water, and with different line strengths; make neat wraps and be uniform each time you tie; snug knots up tightly with even, steady pressure, and moisten the line first; be careful not to nick the line when you trim the knot; hand-check the knot after you have tightened it; and test your knots occasionally with a scale to see if they are delivering top performance.

It is helpful to know several different knots, and to realize that just because a knot is easy to tie does not mean that it is best in every circumstance. Bulky knots, for example, aren't useful on a small hook or will not pass through rod guides well. If you know a number of knots, you can adapt to changing circumstances. The following is a sample of a few excellent, widely used fishing knots.

## Terminal knots

Terminal knots are used to tie a line directly to a lure or hook.

### IMPROVED CLINCH KNOT

Probably the most popular terminal connection, especially in freshwater and with nylon monofilament line, this knot is best used for lines under 20-pound test. It can give 90 to 100 percent strength when properly tied, but only 75 to 85 percent if poorly tied.

To tie, pass the line through the eye of the hook, then make five turns around the standing part of the line and thread the end through the loop ahead of the eye (1). Bring the end back through the newly created large loop (2). Moisten the knot with saliva and note that the coils are spiraled properly and not overlapping one another. Pull firmly to tighten up (3). Test knot with moderate tension and clip off the loose end.

Depending on the type and diameter of line being used, six spirals may be best for line through 12-pound test, and five for 14- to 17-pound test.

### PALOMAR KNOT

This small-profile knot is easy to tie well consistently. It is especially good with slick (smooth-finish) lines and microfilament lines if two or three turns are made around the hook eye, and is also popular for tying leader tippets to flies. Tied properly, it yields 90 to 100 percent strength. When tying this knot to large, multihooked plugs, make a long loop to allow the big lure to pass through it.

To tie it, double about six inches of line and pass the loop through the eye of the hook or the eye of the lure (1). Tie an overhand knot in the doubled line (2) and pass the loop over the entire hook or lure (3). Moisten the knot, pull on both ends, tighten and clip the tag end (4).

PALOMAR KNOT.

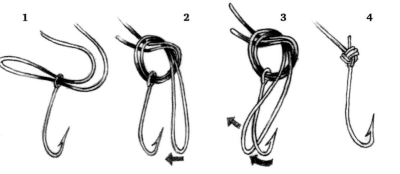

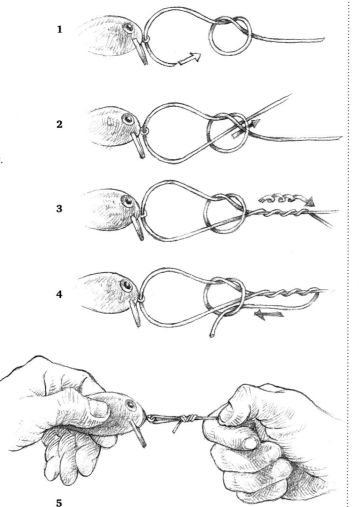

NON-SLIP LOOP KNOT.

**1**

**2**

**3**

**4**

**5**

## NON-SLIP LOOP KNOT

A loop knot helps you get more action out of a lure or fly and is often preferable to using a snap. One that does not slip is best. Primarily used with nylon monofilament, the non-slip loop knot has good strength, and is not as difficult to tie as it seems.

To tie it, make an overhand knot in the line, leaving about six inches at the tag end, then pass the tag end through the hook eye (1) and then back through the overhand knot (2) the same way that it came out. The size of the overhand knot determines the size of the loop; for most situations, keep it small.

Hold the overhand knot softly with one hand and pull on the tag end of the line to bring the overhand knot down toward the eye. Wrap the tag end around the standing line (3) the proper number of times (seven wraps for conventional-diameter line under ten pounds, five for ten- to 14-pound line, four for 15- to 40-pound line, three for 50- to 60-pound line, and two for heavier line). Bring the tag end back through the loop of the overhand knot (4) the same way that it exited. Moisten, pull on the tag end

to form the final knot, then pull from both ends to snug up completely (5) .

# Line-to-line knots

Line-to-line knots join two lines of similar or dissimilar diameter, including fishing line to a leader or tippet.

## LINE-TO-LINE UNI

This is an excellent knot for joining two lines and perhaps the easiest line-to-line connection to make. It is best for joining lines up to 20-pound test of similar diameter, but can also work on those of different, but not hugely disparate, diameter by decreasing the number of wraps on the stronger line. It can also be used to join a nylon monofilament line with a microfilament line.

To join two light lines of fairly similar diameter, overlap each at least ten inches. Hold these in the middle of the overlap with your left hand and make a circle with the line extended to the right (1). Bring the tag end around the double length six times (2), pulling snugly after the last turn (3). Repeat the process in reverse direction on the other side (4 and 5). Moisten the line and knots and pull the two sections away from each other (6) to draw the knot up; then pull it firmly and clip both loose ends (7). Use five wraps for ten- to 17-pound line, four wraps for heavier line.

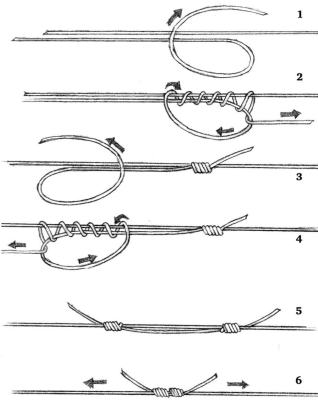

**1**

**2**

**3**

**4**

**5**

**6**

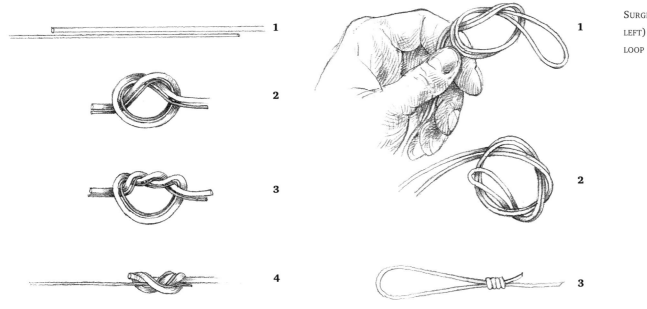

SURGEON'S KNOT (FAR LEFT) AND SURGEON'S LOOP KNOT (LEFT).

## SURGEON'S KNOT AND SURGEON'S LOOP

The surgeon's knot is simple to tie and good for connecting a tippet and fly leader, especially when using a shock tippet. To tie it, bring the tippet and leader lines parallel to each other and overlap about six inches (1). Make a loose overhand knot, bringing the tippet completely through the loop (2). Bring both lines through the loop a second time, keeping the strands together (3). Hold both lines at both ends and pull the knot tight (4). Trim closely as this is a slightly bulky knot, and any protrusion could catch in the rod guides.

The surgeon's loop knot is common and easy to tie, and is used to put a loop in the end of a line; the loop is then connected to other lines. Primarily used in fly fishing for loop-to-loop leaders, it is slightly bulky and can snare rod guides. To tie it, double the end of a line and make an overhand knot at the point where the line is doubled (1). Leave the loop open and pass the end of the double line through it a second time (2). Hold the single standing line and adjust the loop size, then pull on the loop to tighten it and clip excess (3).

## COMMON NAIL OR TUBE KNOT

Known primarily as a nail knot, but also a tube knot, this is meant for joining lines of dissimilar diameter, and has long been a preferred method of connecting the butt end of a leader to a fly line, as well as reel backing to a fly line. It is formed with the use of a smooth instrument like a nail, small tube, piece of straw, straightened paper clip or sewing needle. This is a nicely compressed knot that moves through rods guides well and does not pull out.

To tie it using a tube (a short piece of rigid plastic from the tube used in a ball-point pen is great), lay tube, butt end of leader and tip end of fly line alongside each other with fly line headed left and leader headed right. Pinch all three in the middle with your right thumb and index finger and allow eight to ten inches of leader overlap. With your left

TUBE/NAIL KNOT.

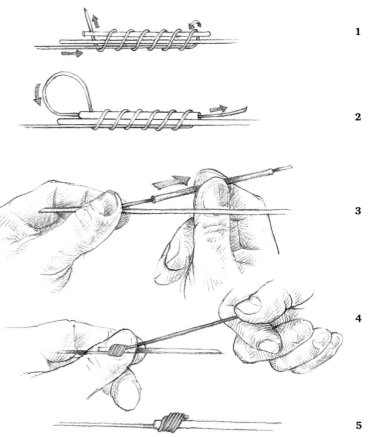

hand, wrap the leader snugly five or six times around the fly line, leader and tube, working from right to left (1), lining the wraps up against each other and pinching the entire assemblage in your right fingers. Pass the butt end of leader through the tube from left to right (2). Pull both ends of the leader tight and remove the tube (3). Tighten both ends of leader again (4) and simultaneously pull on the leader and fly line tightly before clipping off ends (5).

To tie this using a nail, place a nail between the two lines and follow the same instructions as for a tube with the following exceptions: make the wraps less snug and run the tag end of the leader down alongside the nail. Using a small-diameter tube is actually easier.

# Double-line knot

SPIDER HITCH KNOT.

Double-line knots are used for creating strong, double-line leaders using the actual fishing line. The two main knots here are the bimini twist and the spider hitch, the former being quite complicated and primarily used in offshore fishing activities. Both hold the full 100 percent breaking strength of the main line.

## SPIDER HITCH KNOT

This is much easier to tie than the bimini twist, especially with cold hands. It is very useful in lighter-strength line, and is overlooked as a leader for light-tackle fishing.

To tie it, make a loop of whatever length of line you want to use as a leader, and hold the ends between thumb and index finger at the first joint of the thumb (1). Make a small loop in the line, tuck it between the fingers, and extend it directly in front of the thumb (2). Wrap the doubled line around the thumb and small loop five times working toward the tip of the thumb, then pass the double line through the small loop (3), making the five wraps unwind off the thumb using a steady draw (4). Pull firmly on all ends to snug up the knot (5).

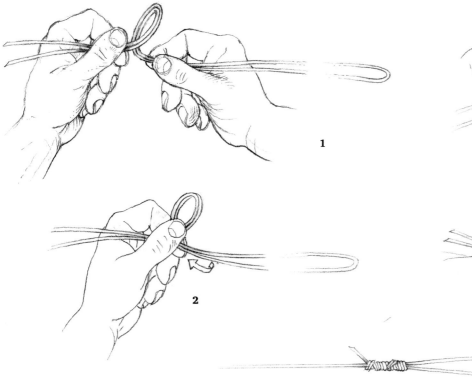

# SETTING DRAG TENSION

**The feature of a reel known as the "drag," is basically an adjustable friction clutch. Itallows line to slip outward from a reel spool when a strong fish cannot be readily hauled in and swims the other way. Without this, the line may break or the hook may straighten or rip out. It essentially allows an angler to wear down and land a fish whose overall weight and strength outmatch the breaking strength of the line.**

A LTHOUGH PEOPLE WHO CATCH small fish rarely use the drag on their reel, this feature is very important, especially when using light line, when playing large and strong fish and when fish make strong and sudden surges while being landed.

## How it works

The drag mechanism allows line to slip outward by turning or revolving the spool. The spools of spinning and spincasting reels are stationary when the line is cast and when it is retrieved; the spool moves back and forth (up and down) when line is retrieved, but it does not turn. However, when there is sufficient force to activate the drag, the spool turns in a clockwise rotation, which allows line to come off under tension, the amount of which is determined by pressure applied to internal drag washers.

The spool of a reel revolves when the line is cast and when it is retrieved; tension is also applied to drag washers which affect the spool's movement, but in a different way. When spool friction exceeds the tension on the line, the reel handle turns the main gear and the spool and allows line to be recovered. When tension on the line exceeds friction on the spool, the spool revolves against handle pressure and line can be pulled off the spool.

PROPER DRAG TENSION IS NEVER MORE IMPORTANT THAN WHEN USING HEAVY TACKLE FOR BIG SALTWATER FISH.

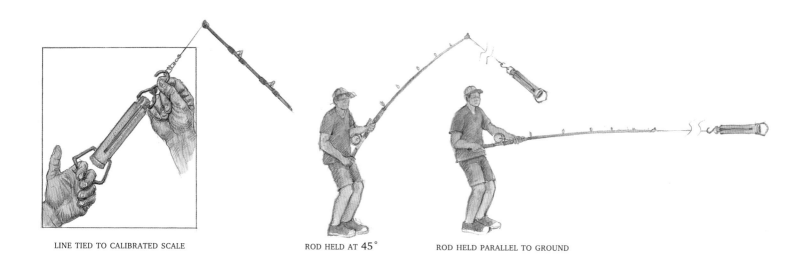

LINE TIED TO CALIBRATED SCALE        ROD HELD AT 45°        ROD HELD PARALLEL TO GROUND

To accurately measure drag tension, use a top-quality spring scale (inset) with an easily read gauge. When you measure with the rod at a high angle, remember that this position can produce greater drag tension due to rod guide friction; when you measure with the rod pointed directly at the scales, you have the least amount of drag tension.

# How to set it

Drag tension is increased or decreased by turning a knob or wheel. It should not be adjusted during a fight—unless it has been improperly set to start with—because it is impossible for most anglers to know by quick feel if too little or too much tension has been applied, likely hindering efforts to land the fish. The big if is whether the drag is set properly to start.

Most people set the drag via the "feels good" method—pull a little line off the reel, fiddle with the drag adjustment, and pull a little more until it feels "about right." The most precise way to set drag tension is to use a calibrated scale and measure it. The drag should be adjusted to the point where it slips at between 30 and 50 percent of the wet breaking strength of the line. That would be three to five pounds of tension for a ten-pound line. Most people are better off in the 30 to 35 percent range

There are two methods to measure this, both using a line that is run through the rod guides and tied to a calibrated scale (a good spring scale will do). One way is to hold the rod parallel to the ground and pointed directly at the scale(A), pulling on the scale so that there is no tension on the rod; adjust drag tension until it takes 30 percent of the line's breaking strength to make the drag slip. This is the least amount of pressure you can apply when fighting a fish, assuming that when a big fish steams off you point the rod directly at it until it stops running, then raise the rod up again to fight it.

In the other method(B), hold the rod at a 45- to 60-degree angle like you were fighting a fish, and use the scale to pull on the line so that tension is applied to the rod as it would be in many fishing situations. Adjust drag tension until it takes 30 percent of the line's breaking strength to make the drag slip. The former method is preferred by many good anglers because they know that

judicious supplemental tension can always be applied by placing the palm or fingers on the spool.

Once you set drag tension in either manner, you'll readily appreciate the difficulty of getting a precise setting by the "feels good" method, and, more importantly, by changing tension in the midst of battle. If you unintentionally up the ante to 70 percent of breaking strength, for example, you are flirting with disaster. If you do not think so, deliberately set the tension at 70 percent, walk off about 30 feet and try pulling on the line attached to a scale.

# Bigger issues

How well the drag operates when it is needed most is the real issue, and that encompasses these considerations:

Variation: does it retain its original setting or does it stray from this? Straying is bad.

Maximum drag force: can the drag be set to where it does not slip at all (lockdown), should that be necessary? This is useful, but not critical, to many situations.

Range of adjustment: how many revolutions can you turn the control mechanism on the reel? Ideally you should be able to get up to that 30 percent number with just a short adjustment, then have a lot of adjustment from 30 to 50 percent, then ramp up very quickly to full lockdown.

Drag washer size: are they large enough for the severe tests? The most efficient drag washers are those with a large inside diameter as well as a large outside diameter to cope best with heat dissipation. An aluminum spool also helps dissipate heat better than a graphite spool. This is where rear drag reels falter; design constraints restrict them to small washers, which do not dissipate heat and are inconsistent under severe stress.

# HOOK SHARPENING

**New processes have made hooks sharper than ever, especially those on lures. This is especially true of treble hooks and smaller and finer diameter wire hooks. Nevertheless, hooks can lose their sharpness quickly, and even become quite dull through use, especially from impacts. Impacts occur in the tackle box, after catching fish, being grabbed by pliers for unhooking, contacting objects in the water and in other ways.**

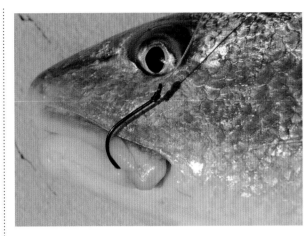

A SHARP BAIT HOOK, OR HOOK ON A LURE, EQUALS MORE FISH LANDED.

IT IS OFTEN THE CASE, especially when fishing with lures, that fish get impaled barely in their mouth, and are lucky to be caught. Dull hooks make the job of sticking a fish tougher, so there are very practical fish-in-the-boat reasons for making sure that you check the sharpness of your hooks from time to time, and buff them up whenever necessary. You will especially benefit from this when you encounter especially large fish, and when angling with light line and light rods.

Most fish hooks have many rough spots, even though it is hard to see these with your eye. If you could view hooks under a powerful microscope, however, you would be surprised at what the surface of the point and barb looks like. This is especially true of previously used hooks that have been in a tackle box for a while. Some will also have a bent point or burrs on the barb, both of which cost fish because the affected hooks will not penetrate properly. Sharpening smooths out rough spots and makes it easier to get the point and barb deep enough in the fish to keep it on your line.

To improve the sharpness of a hook, you have to grind the point and barb over a sharpening stone or file. The best way to sharpen bigger, hardened, thick-bodied hooks—including those made of cadmium and stainless steel and hooks that are forged (flattened around the bend on both sides)—is with a file, which only cuts on the forward stroke. Start by sharpening the barb and the inside cutting edges that lead toward the point, and at the same angle as the factory-made cutting edge (if it has one). Sharpen both

sides, then do the immediate point area, filing repeatedly toward the point on both sides. It is a good idea to put a mini-cutting edge on the very tip of the point opposite the barb, to facilitate penetration.

For smaller hooks—like those used on most inland waters and nearly all freshwater fish—use a medium-grit honing stone with some type of channel in it. If all you have got is a file, use it to the best of your ability. The key is not what shape the sharpening device is or what it cost, but that it is abrasive and that you use it to put a triangulated shape on the hook. Honing stones (generally in the form of a stick) should be sized to the hook being sharpened, as large models do not adequately reach all parts of a smaller hook. Sharpening stones sharpen on both the forward and backward strokes. They should be used in the same manner as a file, first grinding on the inside of the point, then on the left and right sides and the very tip. If you use the channel or groove in a sharpening stone, be sure to rotate the hook so that all parts of the point are affected. Be careful not to prick or hook yourself with the point by holding the stone and hook firmly, and make smooth, deliberate motions. Always test a sharpened hook to see if it is good enough. Take a hook, rest the point on your thumbnail, and lightly drag the point across the nail. When sharp enough, the hook will catch on the nail; if not, it will slide across.

Be careful not to oversharpen a hook, which is more likely with light wire versions. If the tapered wedge of the point becomes too short, which it can through excessive sharpening, it may not penetrate as well. If it is ground too thin, it may be susceptible to bending or breaking.

**BELOW:** WITH A FILE, TRIANGULATE HOOK SHARPENING BY FILING ACROSS THE INSIDE OR TOP CUTTING EDGE (1) AND ALONG BOTH SIDES OF THE HOOK POINT (2). THEN FOCUS ON THE TIP (3) TO CREATE A MINI-TRIANGULAR POINT (4). THE FINAL RESULT IS A HOOK WITH A SHARP BARB, INSIDE CUTTING EDGE, SIDES AND POINT TIP (5).

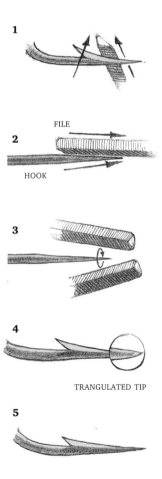

1

FILE

2

HOOK

3

4

TRANGULATED TIP

5

# LIGHT-TACKLE FISHING

**Having some fun, experiencing a challenge, giving the fish a little more opportunity, and honing your skills are the enticing elements of the light-tackle fishing game. Oddly enough, light-tackle anglers sometimes hook more fish than non-light tackle anglers because the lighter line used can lead to more strikes. But the real deal is fun.**

On average, most anglers catch small fish using medium to heavy gear. They can make mistakes—like not tying a perfect fishing knot, or having an inconsistent reel drag, or engaging in a tug of war—and most often still land the fish. A light-tackle angler does not have that latitude.

Going light is not the same for all species of fish. Using two-pound test line would be light tackle for bluegills but ultradumb for muskies, which grow much larger, inhabit bad places, have hard toothy maws, and which are difficult to hook and land even with standard tackle. So if there was a definition of light tackle, it would have to incorporate the words "within reason."

There is no glory or sportsmanship to fishing with the lightest possible tackle and having a good fish break off with hardware in its mouth. And there is no glory or sportsmanship to stressing a fish so much that it may not recuperate when released because the tackle was too light or the angler too inexperienced to land it in appropriate time. If you are going light, know the limitations of your tackle, yourself and the situation, and know how to revive a tired fish properly for release.

## Rods and reel drag

Most people think primarily of line and line strength where light tackle is concerned, and while that is a major component, do not overlook the relationship between line and rod and reel. Rods used for light-tackle fishing tend to be a bit limber to provide more of a cushion for the lightness of the line. They can be short for small fish like stream trout or panfish, but a longer rod is a distinct advantage for landing big fish. Long rods (seven to nine feet is the norm, but ten- to 14-footers are used by some anglers) give you more leverage to pressure a fish, putting less strain on your arms and wrists, and they are very helpful when a hooked fish is near the boat, so you can steer it around obstacles.

Reel drag and line capacity are major issues in the light-tackle pursuit of large or strong species. For salmon, steelhead, trout and stripers, which are capable of making hearty runs, you need plenty of line and an unhesitating

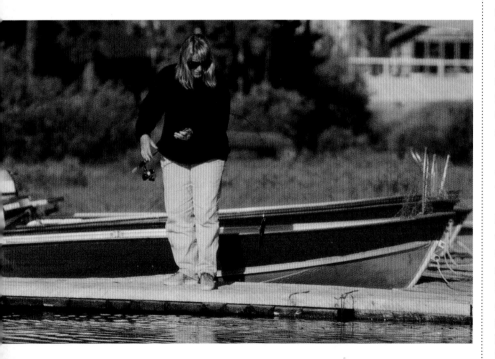

NO MATTER WHAT SIZE FISH YOU CATCH ON LIGHT TACKLE, IT IS VERY ENJOYABLE.

LIGHT-TACKLE FISHING FUN is a bow in the rod. It is the scrap put up by a fish that only weighs half a pound. It is the experience of having to take extra steps to keep a moderate-size fish from getting into cover and breaking off. It is taking more than a few seconds to land a one-pound fish. It is using brains over brawn. It is being a more complete angler.

drag, which is obviously set loose. For fish that can be strong but do not make long runs, line capacity is not a major consideration, but drag is, especially if it is called into play suddenly and briefly.

# Playing and landing fish

When there is little boat traffic or few anglers nearby, it is not hard to play a big fish in open water because there is nothing for it to snag your line on. The deck can be cleared and the boat maneuvered to your advantage. If the drag is set properly, the fish can take plenty of line and do its stuff. But if there are obstructions beneath the surface, or if you hook a big fish unexpectedly in a place where there are plenty of snags, then you have to be aggressive and take the fight to the fish as quickly and as well as you can.

If you use good equipment, including a quality line with a knot that retains full strength and a rod with backbone, you can pressure a fish with light tackle. Whether you are in a boat in open water or on a riverbank, you will probably be unable to land a really big fish by playing tug-of-war. You will have to pump and reel whenever possible to gain on the fish, but you will almost certainly have to move in some way to change position to work the fish more effectively. You may have to walk the bank or wade downstream after a big-river fish, because you will not have the muscle to coerce him back upstream. You may have to get below the fish or at least get into a section of river that has less current. You may need to move the boat to change the angle of pull on a fish.

In either case, you will often have to change the rod angle from vertical to horizontal right or horizontal left. When the fish runs, let the tackle do its job. When the fish stops running or seems to be resting, you must work on it and work on it. When the fish gets near you, be ready for sudden movements and do not try to overpower it unless it seems thoroughly exhausted. When it lunges, let it go, and point the rod directly at the fish to minimize drag. A lot of big fish hooked on light tackle are lost near the boat due to sudden surges or the hook pulling out.

Unless a fish happens to be solidly hooked in a bony part of its mouth (which you usually do not know until after you have landed it), the longer you have it on, the more chance there is for the hook point to enlarge the hole where it sticks the fish; eventually a large hole may cause the hook to pull free. With light tackle, there is no doubt that you can spend an hour on a really large fish, but if you know how to play a fish properly and use drag, wind, current and boat position to your advantage, you need not spend most of the day fighting Goliath.

TYING PROPER KNOTS AND USING GOOD LINE ARE IMPORTANT COMPONENTS OF LIGHT-TACKLE FISHING.

# PLACES

# CANADA

It can reasonably be argued that Canada has, per capita and per square acre, the best sportfishing of any country on Earth. Given Canada's relatively low population, large land area and tremendous amount of water, it is hard to make a case for any other country. Certainly Brazil, in South America, rivals Canada for total water resources, but those are largely in massive river systems threaded through the rain forest,  and not an extraordinary patchwork of rivers and lakes all over the country.

. . . . . . . . . . . . . . . . . . . . . . . . . . . . . . . . . . . . . . . . . . . . . . . . . . . . . . . . . . . . . .

ACCESSING A REMOTE WILDERNESS LAKE BY FLOATPLANE IS ONE OF THE GREAT CALLING CARDS FOR CANADIAN FISHING.

BECAUSE IT HAS SO much water, Canada is blessed with excellent sportfishing. It draws most of its non-resident anglers from the U.S., and is viewed by many as a quintessential place to visit for a secluded experience in a pristine wilderness. Access to the most remote areas, which are roadless, is not easy to afford or accomplish in limited time, however, and the open-water seasons are fairly short for most of the country.

Canada's abundant sportfishing opportunities range from the rivers and lakes of the stark northern-Arctic tundra to the thickly forested, southern-boundary wilderness lakes and the vast, deep waters of the Great Lakes that border the U.S. They range from western, fjord-like, Pacific Coast bays replete with whales and grizzly bears to eastern tidal maritime island streams. In between are countless bush lakes.

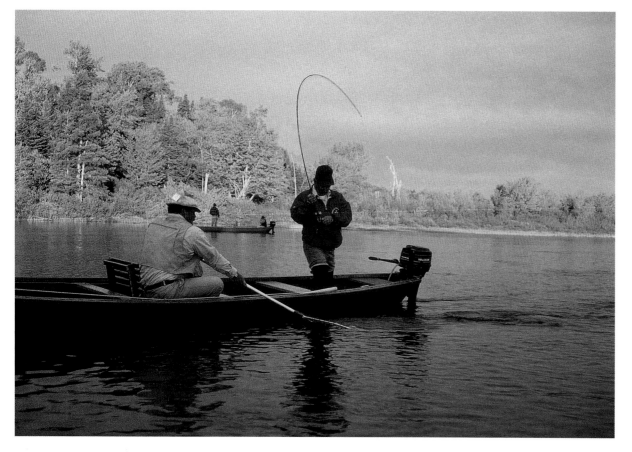

The majority of sportfishing in Canada occurs in freshwater. This is partially because of geography—since most of the land is far from a coast—and partially because there are more abundant and diverse fish inland, partly due to cold coastal waters.

There are plenty of guides, charter boats and services for anglers in Canada, especially in the more well-known and publicized areas. Most lodges and camps have guides, and charter boats exist on major inland waters and on the coasts. Lodges, camps and other facilities dedicated to serving anglers are plentiful and widely advertised.

With so much to offer, Canada can seem overwhelming to a prospective angler from outside the country. The best thing is to focus on a particular region or a particular species, and then decide what place(s) to visit in order to catch either many of that species or large specimens (at some places, it is possible to do both).

Although some places are not as productive as in the past, many of Canada's waters still provide good fishing. However, drive-in access to some has resulted in extraordinary fishing pressure. The building of more logging roads has meant improved access to places few could previously reach in the summer, and these have been hit hard.

Overfishing is one of the reasons why travelers who are able and willing to fish without the convenience of having their own boat are prepared to journey to fly-in locations, whether main lodge or outpost, to be assured of a high-quality Canadian experience. At such places there is a growing emphasis on: catch and release (except small fish for lunch), including trophy specimens; using barbless or debarbed hooks; using single-hooked lures; and prohibiting fishing with bait so as to minimize injuries to fish.

# PIKE, LAKERS AND WALLEYE

Lake trout, northern pike and walleye are the top freshwater species, and are most widely distributed and available across the interior provinces and territories. Pike and lake trout are especially favored by nonresident anglers, who cannot do as well in their home states or countries for these species. Americans, for example, cannot find consistently fast pike action in most of the U.S. and trophy specimens are increasingly rare. In the U.S., a 15-pound pike or lake trout is a large specimen, and not a common one, with the exception of some areas of the Great Lakes. In Canada, such fish are very common, especially in more remote waters.

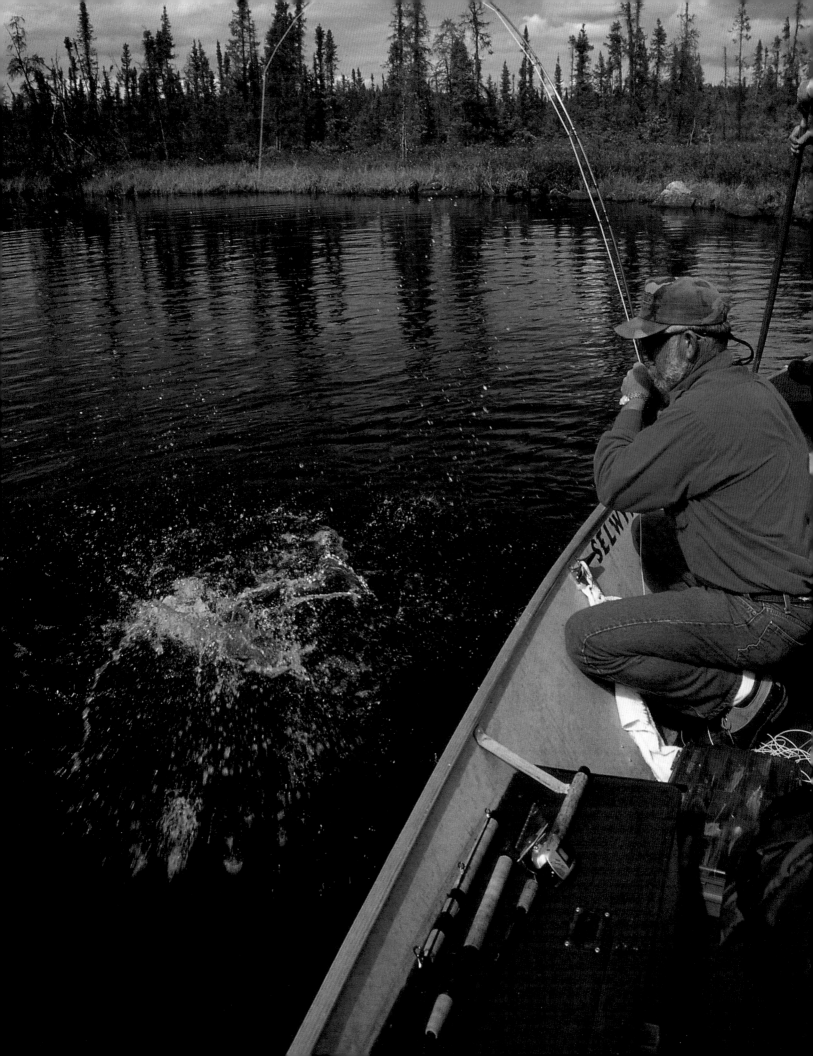

Nearly all of Canada has pike fishing, the exceptions being the Maritime provinces and British Columbia, and these fish are exceptionally plentiful in some waters. Lots of pike-catching action is not hard to encounter, and in some of the more conservation-oriented waters you can catch and release your largest pike ever.

Bigger pike generally come from the remote northern lakes in the heartland provinces of Manitoba, Saskatchewan, Ontario and, to a lesser degree, northern Quebec. Some big pike are also caught in the southerly reaches of the Northwest and Nunavut Territories. Twenty pounds is a magic trophy mark, but a pike over 18 pounds is generally considered a "trophy" according to the angling award programs that exist in several provinces. Although specimens over 30 pounds are caught annually, it is a fact that pike over 25 pounds are rare, and many fish get over-estimated by happy anglers, since most of the large fish are released voluntarily or by edict.

While there is good pike action in some of the bigger rivers and lakes within big river systems, the majority of the best fishing is in lakes, especially big lakes and places that are not readily accessible from roads. The larger fish are usually found in big lakes as well.

Fishing for Canadian pike is almost always a casting proposition, in large part because little pike angling is done in big, open-water areas. Most anglers focus on weedy back bays, meandering marshes, and protected backwater nooks and crannies. Additionally, and especially in the far north, anglers visually see a lot of pike while fishing for them. They are spotted cruising the shallows or chasing a lure. And because the fish are pretty voracious, you sometimes get to see a cavernous mouth open and inhale your lure. It is an active game.

The prime pike-fishing period is early in the season, especially if you are interested in catching lots of fish. When northern lakes melt, the shallow bays and backwaters are the first to open and warm up, and pike cluster in these places, sometimes resting in water barely deep enough to cover their backs. You can do a lot of sight casting then. Weeds are sparse at best and the water is ultra clear. You can also catch large fish, but since pike spawn in late winter or early spring, pike in early season are not as hefty as they will be later, and the real monsters seem to be elusive. On good pike lakes, there is usually no bad time to fish for this species. Later in the season, when the weeds are thick, most pike will be off the shoreline and in the weeds, and sight-fishing opportunities are greatly reduced, making them less visible but not less available. Pike feed well then, and have better girth.

Lake trout are fairly abundant in many parts of Canada. With more emphasis on conservation of these old and slow-growing fish, and many of the best lakes being subject to catch-and-release guidelines, the future for the lake trout in Canada looks good.

The better lake trout angling is usually found in the upper third of the southern provinces, as well as throughout the Northwest and Nunavut Territories. Northern Manitoba and northern Saskatchewan provide some of the best opportunities for big fish, but the eastern and central tundra waters, as well as Victoria Island, are also notable.

In the far north, rivers offer exciting lake trout fishing by casting, but they seldom produce big fish; in fact, a fish over 15 pounds from a river is very large, although very big fish may prowl the turbulent inlet when the water temperature and forage conditions are right. In lakes, these trout are often structure oriented and migrate to reefs, shoals and islands to feed; they also cruise the shorelines. In lakes that warm up and create a thermocline, lakers will go to cool water below the thermocline in large, open-water bowls. This is where their primary food—ciscoes and other lake trout—is found.

A lot of Canadian lake trout fishing is done in the upper 30 feet of water, which is different from fishing for these trout in the U.S., where they are usually very deep. This is mostly true of cold northern waters, and lake trout here are very scrappy, more so than fish caught from the great depths. More than one person fishing in a top lake has hooked and played a huge, tenacious and drag-pulling laker for an hour or more.

In the far north the water stays cold all season, so you can catch lake trout there in the upper strata throughout the open-water period (which is basically just summer). In places that warm up in the summer and where the surface water reaches the 60s, the trout always go deep. Some of the heaviest fish are caught late in the season when the fewest anglers are out. Few far-north lodges stay open late in August or into September because of hostile weather and airplane delays, but those who do so cater for knowledgeable, hearty anglers searching for trophy fish.

The busiest time for most lake trout lodges is the first few weeks of the season; camps are usually full. Most bookings are made eight to 12 months in advance, prior to knowing what the winter will bring. A severe winter and/or a long cold spring will delay ice-out, and possibly limit the places where you can fish if you are scheduled at a lodge on the first or second week; but many anglers take that chance. As with its lake trout fishing, Canada's walleye angling amply covers both large fish and plenty of action. These fish range northward, but are most abundant in the southern half, or less, of the country. Big and small lakes and rivers—both plentiful in southern Canada—provide ample angling opportunity. Quebec, Ontario, Manitoba and Saskatchewan lead the field, particularly the mid- to southern regions of those provinces.

OPPOSITE PAGE:
BATTLING AN EXPLOSIVE PIKE ON SASKATCHEWAN'S SELWYN LAKE.

One of the nice things about Canadian walleye fishing is that you do not necessarily have to go to remote waters to have really good angling. Seldom are the biggest fish found in remote places. A six-pounder, which is a good-sized walleye, is pretty rare in most northern waters. The biggest fish may be closer to the border; such places as Lake of the Woods, Rainy Lake, the Detroit River, Lake

Erie, the St. Lawrence River and the Bay of Quinte on northeastern Lake Ontario produce eight- to ten-pound or larger walleyes and good overall numbers of fish.

From late spring through summer and into fall, walleyes are primarily located on rock reefs, sandbars, points, weed edges and the like. In big lakes, some walleyes suspend in open water where there are schools of baitfish; this is especially the case in the Great Lakes.

Perhaps more so than other Canadian fish, walleyes draw many visiting anglers who drive and fish on their own (unguided), either piloting a boat by themselves at a resort, or towing their own (and usually well-equipped) boat to the designated site. The entire gamut of walleye tackle and techniques is employed, with fishing ranging from difficult in hard-fished waters to cast-after-cast easy in some remote, fly-in lakes. The latter usually also offer good pike fishing, so good combo angling is available.

The season for walleye begins in spring in Canada, and the opening date draws a rush of people; that date varies by province and by district within provinces. Walleyes have usually spawned by the time that the opener occurs, and sometimes the fish are still scattered and migrating to summer haunts.

# SALMON, CHARR AND TROUT

Salmon and charr are Canada's other most heralded fish, with salmon especially so since they are more accessible. But to find them you have to go to the four corners of the country. Salmon and charr are intensely popular in coastal regions, but the anadromous coldwater species native to those areas are not available to the vast majority of Canadians without incurring substantial travel; this is even more so for charr than for salmon.

Atlantic salmon are considered to be the premier Canadian sportfish, with a rich history and tradition. Unfortunately, they have been under tremendous pressures due to various factors, especially excessive commercial harvest in the North Atlantic, and their numbers are much less than they were decades ago. Naturally occurring sea-run Atlantic salmon are found in maritime Quebec, Newfoundland, New Brunswick and Nova Scotia—all of which have well-known and storied rivers. New Brunswick and the Gaspe Peninsula of Quebec have the best Atlantic salmon presently, but here and elsewhere the fish are subject to seasonal conditions and ocean events that cause fluctuations in the numbers and size of fish returning each year.

Angling for Canada's Atlantic salmon is almost entirely restricted to fly fishing, although landlocked populations exist (in Labrador and Quebec) and these can be pursued by various methods, including casting spoons with spinning tackle and trolling with various tackle types. For non-resident anglers, sea-run Atlantic salmon fishing is largely a guided affair, with angling taking place on specific sections, or beats, of rivers, the season being mainly from June through September.

Overharvesting has had some impact on naturally occurring stocks of Pacific salmon (coho, chinook, sockeye and chum) off British Columbia, but a greater impact has occurred through environmental changes, especially the damming of rivers, and water-quality issues, some due to extensive logging. However, these fish—as well as sea-run rainbow trout (steelhead)—are caught in rivers and coastal tidewaters, and the chinook and coho may range to large sizes, with the larger individuals usually caught in tide water at the mouths of major rivers.

Fishing for coho and chinook is both a saltwater and freshwater proposition—the latter occurring in rivers as spawning-run fish make their migration, and the former occurring along the coast for fish that have yet to enter their natal tributary. The timing of major runs is different, and occasionally the runs can be adversely affected by commercial activities. British Columbia has 27,000 km of coastline and over 1,500 spawning rivers, so there's a lot of opportunity here, although the vast majority of resident and non-resident salmon anglers fish in saltwater for the brightest, hardest-fighting—and best-tasting fish—so fresh, they still carry sea lice. Anglers primarily mooch (a form of slow-trolling with cut-herring baits) or troll bait and lures with downriggers.

Although the Pacific Northwest salmon fishery is the most historically significant, it should be noted that some of the most prolific fishing for chinook and coho salmon in Canada occurs on its interior border with the U.S. in the Great Lakes, where lakes Michigan, Erie and Ontario, in particular, produce good numbers and sizes of salmon, as well as steelhead and brown trout. These fish have been introduced by Canadian and American wildlife agencies, and are largely sustained through annual stocking, but provide ample opportunity throughout the year. Being close to major population concentrations (salmon and steelhead can be caught in view of Toronto skyscrapers) makes these fish more accessible to a greater number of Canadians, even if they are not native to that region. Thus, a visitor to Toronto with a yen for fishing could find action in streams or Lake Ontario for these species.

Salmon, steelhead and some trout (brown trout and lake trout) are caught near the shore in the Great Lakes in spring and late summer, and in deeper offshore water later in midsummer. They are also caught in tributaries in late summer and early fall. Steelhead are caught throughout the winter in tributaries.

In northernmost Canada, fresh from the Arctic Ocean, naturally occurring sea-run Arctic charr are perhaps the

CASTING FOR SALMON ON THE MARGAREE RIVER IN NOVA SCOTIA.

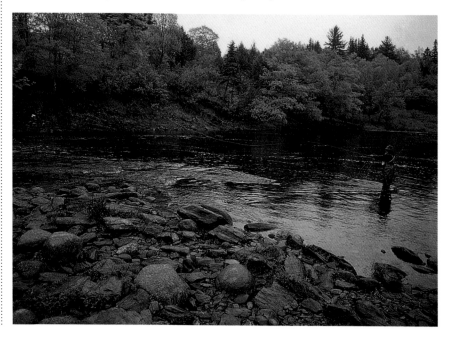

**ABOVE:** A STEELHEAD ANGLER FISHES THE
DEAN RIVER IN BRITISH COLUMBIA.
**BELOW:** A BIG LAKE TROUT
FROM FERGUSON
LAKE

most exotic major Canadian sportfish. This species has been caught by relatively few anglers. It is available only for a limited midsummer period, and the waters in which it is found are accessed almost entirely by fly-in air service. Arctic charr occur in many isolated interior lakes and most of the coastal rivers and streams which rise from lakes that can support spawning. The majority of charr are caught in rivers; however, the larger specimens are primarily caught in the lower reaches closer to the salt. The major Arctic charr rivers flow into the Arctic Ocean and Hudson's Bay. Some are also found along the Quebec and Labrador coasts. Charr do not run great distances inland like Pacific salmon. Usually only the small specimens are found in the lakes. The sea-run charr that are caught early in the season are very bright fish, looking like a steelhead or fresh-run salmon in coloration, but they develop remarkable colors. Later-run charr

can possess beautiful shades of red and orange, plus spots. Non-spawning fish, especially the sea-run form, tend to be silver. The largest known Arctic charr taken by anglers have come from the Tree River in Nunavut Territory. The Tree River stock, and related runs from the Coppermine and others rivers, have consistently produced big fish. Chantrey Inlet in Nunavut also produces big charr, although it has a very small window of opportunity at the time of ice-out. More reliable are various rivers on Victoria Island, which have produced assorted line-class world records over the years. Although there are plenty of charr in the various rivers of Baffin Island, these waters have not been known for large specimens, and fish over 15 pounds have not been common there.

Various trout are available across Canada. These include rainbow and cutthroat trout in British Columbia, brown trout in Alberta and brook trout in the eastern provinces. British Columbia has a tremendous fishery for native rainbows and cutthroats in inland waters, with lots of places—some at high altitudes—having excellent populations. Some coastal rivers have good runs of steelhead, which are a sea-run form of rainbow, as well.

The single best place in North America for large brookies is Labrador, although some large fish occasionally come from northern Quebec and northern Ontario waters. Brook trout, actually a charr and native to the continent, are favored by many eastern river and stream anglers, and sea-run brookies (or salters) are found in some of the maritime rivers. While many of the rivers and lakes of Labrador (and Newfoundland) contain brook trout, trophy-class specimens tend to come from central Labrador, particularly the Minipi watershed and the English River.

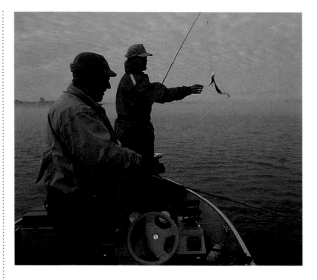

*FALL FISHING FOR MUSKIES ON THE OTTAWA RIVER IN ONTARIO.*

# Other Species

Other species in Canada that have some following include bass, muskie, grayling and halibut; fishing through the ice in winter is very popular.

Both largemouth and smallmouth bass are found in Canada, with smallmouths more abundant and providing good-to-excellent fishing in southern Ontario, southern Quebec, New Brunswick and Nova Scotia. One or both species are very prominent in large and small inland lakes across this region, and smallmouths are very prevalent in such large waters as Lake of the Woods, Georgian Bay, Lake Erie, eastern Lake Ontario and the St. Lawrence River. Muskies are present in southern Ontario and Quebec, with especially large fish in Lake Huron/Georgian Bay and tributary waters, in the Ottawa River, and in the

*AN ANGLER CASTS FOR GRAYLING AT HUNT FALLS, DOWNSTREAM FROM SCOTT LAKE, IN SASKATCHEWAN.*

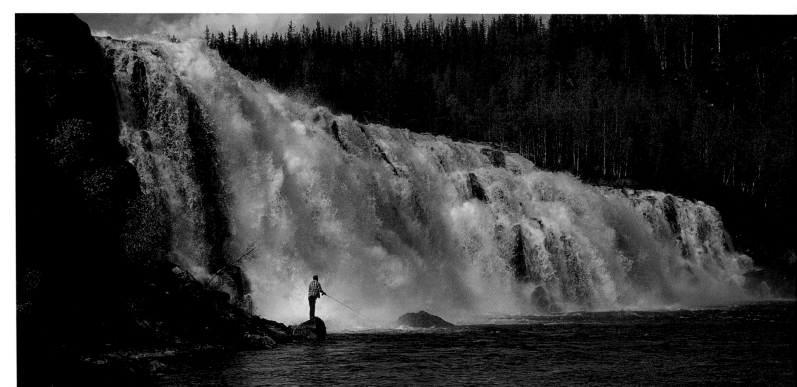

St. Lawrence River in both Ontario and Quebec. Lake of the Woods in southern Ontario is probably the most prolific muskie water in Canada, if not all of North America, and is the best place to seek a fish of 35 pounds or better.

Although grayling are widely present in northern rivers and streams, they are generally unavailable without making a fly-in trip. Few anglers make northern expeditions exclusively for these fish, which average one-and-a-half pounds, but they are popularly sought on light spinning and fly gear as an adjunct to other fishing activities in the north. Halibut are just the opposite of grayling in almost every respect. They are caught off the northern British Columbia coast, primarily as a diversion to salmon, albeit in large sizes and with very stout tackle.

Sportfishing in Canada is most popularly pursued from early spring through fall, especially by non-residents; however, ice fishing is very popular, and some locations have a solid, four-month-long season. Yellow perch, whitefish and lake trout are the major interests. Huge Lake Simcoe in Ontario bills itself as the "Ice Fishing Capital of the World," and attracts up to 5,000 anglers per weekend in the height of the season. Because of its proximity to Toronto, this area does have outfitters geared to taking out people who otherwise do not have the equipment or knowledge.

# Regulations

In Canada, regulations restrict sportfishing by season, usually to protect spawning fish or fragile populations; these apply to most species of freshwater fish. For the most part, regulations regarding seasons, methods of fishing, catch limits and licensing are determined by provincial and territorial governments. There is no national or federal sportfishing license in Canada, although each of the 14 provinces and territories requires a license issued by their government, which is only valid in waters within that jurisdiction, and none of them require you to take a test or examination to obtain a sportfishing license. Whether resident or non-resident, any person can purchase a fishing license, although the non-resident fee is higher. Licenses can usually be purchased for varying time periods (a full year, a week or three days); they are most commonly acquired at stores selling fishing tackle, but can also be obtained at some government offices, marinas, lodges, or camps.

Various provinces and territories are likely to have region-wide or water-specific regulations pertaining to the manner of fishing. Manitoba, for example, mandates barbless hook use in all of its waters. These and other issues are addressed in a brochure or booklet that is provided with the purchase of a fishing license, or can be found at the website for the state agency that regulates freshwater and/or saltwater fishing.

# UNITED STATES

Many non-Americans fail to appreciate that the U.S. is such a large country, and one not only with a lot of water resources, but also one in which there is exceptional public access to water and thus to sportfishing. It is fortunate to have water throughout most of its landmass, and to abut portions of two oceans with powerful currents and favorable temperature. The result is an incomparable variety of esteemed freshwater and saltwater gamefish.

. . . . . . . . . . . . . . . . . . . . . . . . . . . . . . . . . . . . . . . . . . . . . . . . . . . . . . . . . . . . . . .

THE U.S.'S ABUNDANT OPPORTUNITIES range from the pine-studded wilderness lakes of northern Minnesota to the mangrove-flooded backwaters of the Everglades, from fishing under the Golden Gate Bridge in San Francisco to alongside the Chesapeake Bay Bridge in Virginia, and from wading Rocky Mountain coldwater streams to using jonboats in Florida's reclaimed sea-level, phosphate pits. These opportunities provide many great,

almost-great, and just-plain-good angling, especially to those with moderate skills. With very few exceptions this is publicly accessible; some excellent American waters —particularly in Alaska—are difficult, and relatively expensive, to reach because of their remoteness.

Unlike in many countries, a great deal of angling in America is done from boats; more than 16 million recreational boats are in use by Americans, and more than

**OPPOSITE PAGE:** ANGLING FOR SMALLMOUTH BASS AND WALLEYE AT QUEBEC'S LAC BEAUCHENE.
**BELOW:** SMALLMOUTH BASS ANGLERS PLY THE ALLEGHENY RIVER IN PENNSYLVANIA.

12 million of these are large enough to be powered and/or to require state registration. A lot of recreational boat owners trailer their boats, and many of these are anglers for whom the ability to be mobile and to sample different places is very important.

In many of the more popular fishing areas in the U.S., there are plenty of guides, charter boats and services catering for anglers. In freshwater, major lakes, rivers and areas with abundant opportunities have many guides (with and without boats) and charter boats are plentiful on the larger inland waters and along all coastal areas. All of the major coastal ports have fleets of party boats—which can accommodate a large number of anglers—for bottom fishing, and charter boats for both inshore and offshore trips. Smaller guide boats, usually taking no more than three anglers and primarily used for near-shore, estuary and flats fishing activities, are available as well, and are especially numerous in southern regions. Lodges, camps and other facilities dedicated to serving anglers are plentiful, and are widely advertised.

Sportfishing is most popular in the U.S. from early spring through fall. Far fewer people fish during the cold-weather months, although ice fishing is very popular in the more northerly regions, and the most southerly areas (especially Southern California, South Texas and Florida) provide the most comfortable winter fishing due to a normally mild winter climate.

While fishing in the U.S. is good to excellent by most standards, it is not as good as it was in the middle of the 20th century, or even as recently as the 1970s. Pollution, habitat destruction and alteration and commercial fishing are the major culprits. In saltwater, increasingly sophisticated and numerous commercial efforts have led to the overharvest of many food fish as well as forage fish, and directly or indirectly impacted on gamefish species; this has been particularly evident with marlin, swordfish, tuna, salmon, cod and haddock, but also with many other species, including redfish and striped bass—both of which rebounded after reaching near-catastrophic population lows and after being subject to long-term harvest moratoriums. Recreational angling has played a role in diminished populations or fishing success, too, if not as a result of overharvest then as a result of intense pressure. This is especially so in freshwater. Fisheries management efforts have sometimes helped, and sometimes hindered, the situation. Efforts to propagate some species have resulted in great stocking, transplanting and fish restoration efforts—among them trout and salmon introduction into the Great Lakes (which is one of the greatest fisheries success stories of all time), striped bass introduction to freshwater, and management of bass to bring huge-growing Florida strain largemouths to various

states. However, the widespread introduction of carp is recognized as a mistake, and these fish are greatly ignored or denigrated, although they are widespread, numerous and harmful to many habitats.

While many species of fish, and those in certain waters, are retained by anglers for consumption (especially panfish, catfish, walleye, chinook and coho salmon, and stocked trout in freshwater, plus dolphin, yellowtail, bluefish, flounder, snappers, groupers and other species in salt water), the past 20 years have seen an evolution in attitude and a much greater inclination to release fish voluntarily. Catch-and-release fishing is not only common, it is accepted for some species in certain areas, no matter what the size. This notwithstanding, fishing pressure is intense on many popular bodies of water, especially seasonally (like the opening of the season, in early spring, during the spawning run), and crowding is possible at some. However, because of the many waters that exist in America, and a tendency for people to flock to certain places and species, it is possible to find under-utilized fisheries populations and locations that can be enjoyed in solitude.

# FRESHWATER

Two-thirds of the people who fish in the U.S. do so in freshwater, in part due to geography: most states are located far from marine environments. Largemouth bass are the most popular freshwater species.

A highly adaptable fish, largemouth bass are widely available in large and small bodies of water alike, including lakes, reservoirs, ponds, rivers and streams, as well as some low-saline tidewater environments. They are found in 49 out of 50 states, the lone exception being Alaska. The states of Texas, Florida and California are especially noted for bass, in part because they have in the recent past produced, or currently produce, the larger specimens. However, many states—especially in the central and eastern portions of the U.S.—have excellent largemouth bass populations and a good mix of sizes.

Almost all sportfishing for bass is done by casting with lures, the vast majority of it being from boats. The wide array of habitats and cover preferences of this species, as well as its predatory ambush nature, lends itself to virtually all types of lures and diverse presentations.

Smallmouth bass inhabit cooler and rockier environs than largemouths, are less widely distributed, and. on average, smaller in size. They predominantly occur from the southerly regions of Canada to the middle of the U.S., but are lacking in warmer environments. The premier smallmouth fisheries exist in a belt from southwestern Ontario and Minnesota

eastward to New Brunswick and Maine, although some rivers and impoundments in the central U.S., including Tennessee and Alabama, are notable for big specimens.

A similar overall range exists for walleye, a species highly coveted for its flesh and one that attracts legions of anglers with the beginning of the open-water season each spring. However, walleye have expanded westward to develop significant fisheries in some waters, including the Columbia River. The major fisheries for walleyes now exist in the largest lakes and river systems, which tend to produce the bigger fish and abundant numbers. Unlike bass, little directed casting is done for walleyes, and the major emphasis is on trolling, jigging and natural bait presentations.

Northern pike have a good following, but are less widely available than the foregoing species, and muskellunge attract a small but ardent coterie of anglers who devote a lot of effort to what are generally modest catch results. Other than Atlantic salmon, muskie are the least widely available major freshwater gamefish in the U.S., and are considered difficult to catch with consistency; as with bass, the majority today are released by anglers. Muskies are most prominent in and around the states bordering the Great Lakes, and particularly so in Minnesota and Wisconsin. Pike overlap muskies in many of the same waters and do not grow as large on average, but are much more numerous and susceptible to a variety of lures. Truly large pike, though, are not common in the U.S.

Crappies, bluegill, sunfish, yellow perch and white bass—as well as assorted catfish and bullhead species—collectively

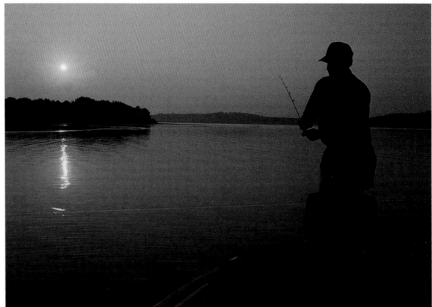

rank second to bass in total angling interest, and provide a lot of satisfaction (as well as good eating) to many anglers. However, they do not have the glamor or get the publicity that is typical for other species. Yet these fish are generally abundant, widely available and accessible to people of all skill levels and abilities. Spinning and spincasting tackle are almost exclusively used for panfish, with a great emphasis on angling with small natural baits and jigs.

All of the species previously mentioned are largely self-sustaining in their respective environments, although

EARLY MORNING BASS FISHING AT LAKE EUFAULA, ALABAMA.

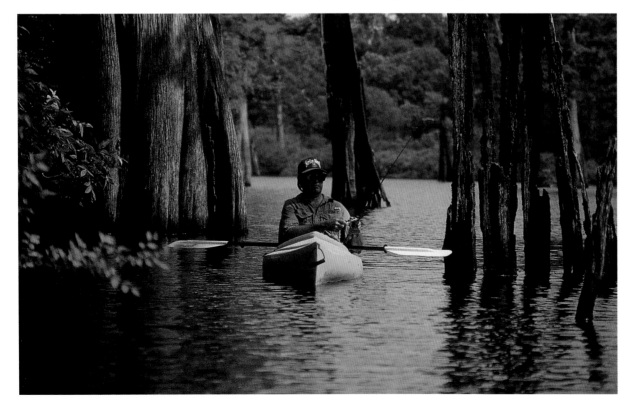

KAYAK BASS FISHING IN A BACKWATER BAYOU ON THE ARKANSAS RIVER IN ARKANSAS.

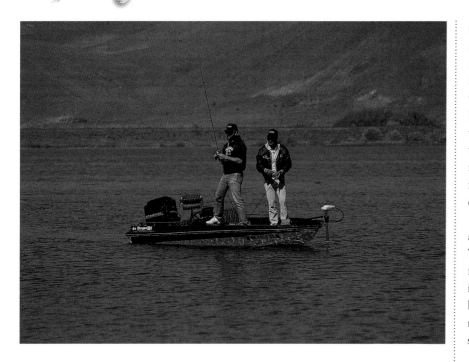

especially in the Midwest and Northeast. These fish are seldom found in large sizes. They are actually charr, and their family relatives, lake trout, do grow large; they exclusively inhabit the cold waters of northern lakes, especially those that are large and deep. Lake trout are primarily caught by trolling with medium- to medium-heavy tackle, shallow when the water is cold early in the season, then deep as it warms. The Great Lakes offer the best opportunities for numbers and size of lake trout in the U.S., though good fishing can be had in smaller inland waters in a few states, especially in New York and New England.

Rainbow and brown trout are more tolerant of warmer and less pristine waters than both brook and lake trout. They are also more widespread and thus are encountered far more often. Both are primarily river and stream inhabitants, although this varies; brown trout can grow to huge sizes in some lakes. Small specimens resulting from regular stockings inhabit waters where these fish cannot sustain themselves.

Excellent rainbow trout and/or brown trout fishing (and in some places cutthroat trout) exists in the highlands of various regions. This includes northern California, the Rocky Mountain states, the Ozarks of Arkansas and Missouri, the Catskill and Adirondack Mountains of New York, and the southern Appalachian Mountains, but very good fishing also exists in Michigan, Pennsylvania, Washington, Idaho, Vermont and elsewhere. Big rainbow

there is some supplemental or introductory stocking by government agencies.

Trout are very popular in the U.S. and are widely available. There is a lot of variety in trout species as well as habitat.

Brook trout, which are native to North America, are favored by many small-stream and high-pond anglers,

(or steelhead) and brown trout also exist in some waters scattered around the continent, most notably in the Great Lakes, where they are caught by trolling in spring and summer, and bank or wade fishing in tributaries from fall through winter, and in some rivers in the Ozarks.

Salmon are very popular in the regions where they occur, but, as anadromous coldwater species, are not available to the vast majority of Americans without incurring substantial travel. They are restricted geographically to naturally occurring Pacific stocks, with the greatest populations existing in Alaska, and virtually no viable fishing in New England for Atlantic salmon, although there are fishable rivers across the border in New Brunswick.

With the exception of Pacific salmon (coho, chinook, sockeye and chum salmon) in Alaska, native North American salmon have been under tremendous pressures due to environmental changes, especially the damming of rivers and water-quality issues, and to excessive commercial harvest in the oceans. However, thriving fisheries for transplanted salmon in the Great Lakes have provided exceptional angling in both lakes and major tributaries; this is sustained by extraordinary levels of stocking, and is not subject to commercial fishing pressures. The most reliable fishing for Pacific salmon exists in the Great Lakes and in Alaska; landlocked Atlantic salmon, which exist in New England and the Great Lakes, are the only real version of that species caught in the U.S.

# SALTWATER

Saltwater fishing in the U.S. varies considerably along all three coasts, as well as in the Caribbean, which is not technically in North America but is still popular with many U.S. anglers.

In the Atlantic, anadromous species, such as shad and striped bass, are major spring attractions in large coastal rivers; striped bass are one of the most important coastal species from the Carolinas to Maine. Numbers of striped bass were severely depressed as recently as the mid-1980s due to commercial fishing and water pollution, but stiff commercial harvest controls and improved water quality have allowed their numbers to rebound dramatically. They

ON MICHIGAN'S PERE MARQUETTE RIVER, A GUIDE WAITS FOR HIS ANGLER TO WEAR DOWN A BIG SALMON.

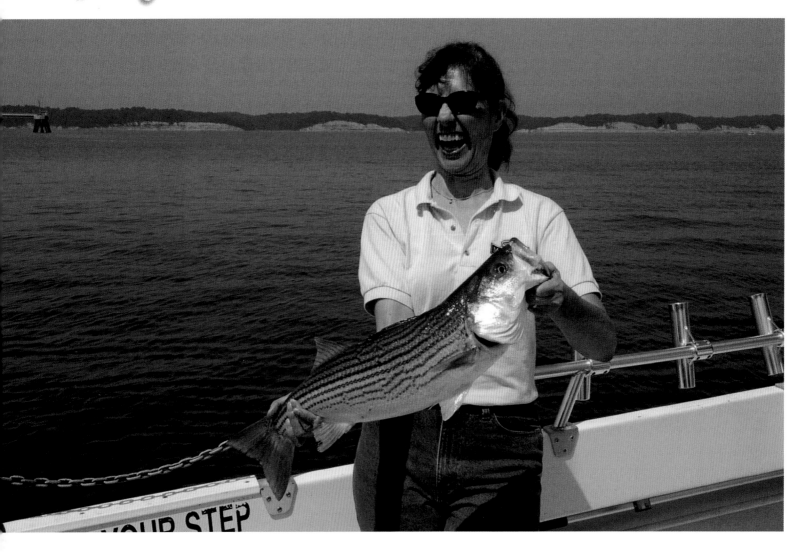

A STRIPED BASS
FROM CHESAPEAKE
BAY NEAR SOLOMON'S
ISLAND, MARYLAND.

OPPOSITE MAIN PICTURE:
SURF FISHING AT DUSK
NEAR MONTAUK POINT,
NEW YORK.

OPPOSITE INSET:
LATE-DAY TARPON
FISHING IN THE
FLORIDA KEYS
NEAR ISLAMORADA.

are caught on various tackle, with both bait and lures, and with most fish released due to regulations.

Stripers, although naturally a saltwater species, have been widely transplanted into freshwater rivers and lakes, and huge landlocked populations of these fish occur in many impoundments throughout the middle and southern regions of the U.S.; few are naturally self-sustaining. In many locations, hybrid striped bass—the result of cross-breeding a pure-strain striped bass with a pure-strain white bass—are stocked by state fisheries managers and provide a fast-growing and aggressive sportfish.

Bluefish, spotted seatrout, flounder, and assorted bottom fish (especially tautog, sea bass, and croakers) are also major species in the same inshore region as striped bass and, to some extent, also drum; most are suitable for lighter tackle presentations. The upper East Coast also offers offshore opportunities for big game species, including marlin, tuna, dolphin and shark, although this is a more specialized, expensive and heavier-tackle endeavor. Blue marlin are caught off New York, New Jersey and North Carolina, although not in great numbers, with white marlin

taken off Maryland. Bluefin tuna are sometimes caught in these regions, especially most recently in winters off North Carolina, but yellowfins are more likely to be taken.

Further south the emphasis is more on a different mix of species, as the warmer climate leads to more tropical conditions, and the coastal sweep of the warm Gulf Stream comes closer to the shoreline. This is why sailfish and dolphin are caught not far from the South Florida coast, as well as king mackerel and other species. Some marlin and yellowfin tuna are likely, but these fish, and other pelagic species, are more prominent in the deep blue water off various Bahamian islands.

Inshore, however, attention turns to drum (redfish), seatrout, snook, tarpon and bonefish, as well as the occasional permit. Shallow-water fishing for redfish and seatrout from the Carolinas to Florida and all along the Gulf of Mexico is very popular, with wade-fishing and boat-fishing both enjoyed, sometimes by stalking fish along tidal grass flats. Snook are the least abundant of these species; they are mainly found in the brackish backwaters of the Sunshine State, and are highly susceptible to severe

cold spells. Tarpon are very abundant and one of the premier light-tackle fish, both on the flats and in passes and inlets—eagerly pursued and almost universally released after capture.

Bonefish are also a glamor species and are hotly pursued by anglers fishing from flat skiffs. In Florida waters, bonefish can run to large sizes, but are more solitary and skittish, while in some parts of the Bahamas they are more abundant in schools, and often not quite as wary as elsewhere. They, too, are virtually all released alive.

On the West Coast, coho and chinook salmon have long been the premier catch in the Pacific Northwest. However, these fisheries have been troubled, although there are still opportunities, sometimes limited, along the coast and in the streams of Washington, Oregon, and Northern California. Alaska has excellent inland salmon fishing, and good coastal fishing for salmon and halibut.

California is a hotbed for saltwater fishing, and its opportunities range from salmon in northerly coastal rivers, to offshore pelagic species and to the ever-popular yellowtail, albacore and a great diversity of surf and bottom-dwelling species. In Southern California, assorted rockfish, lingcod and other species are always popular and available, while the occurrence of warm, bait-laden currents is necessary to produce good catches of bonito, barracuda, yellowtail, albacore and tuna. Long-range fishing trips—some lasting up to several weeks—explore distant waters, especially off Mexico, with albacore and yellowfin tuna the primary pursuits.

With a considerably different topography, the West Coast does not have the shallow flats fishing characteristic of the southeastern U.S., and thus none of the same inshore species; however, there are plenty of challenging opportunities for light-tackle users.

It is easy to forget that Hawaii is part of the American fishing scene, too, since it is so distant from the mainland

and not technically in North America. However, Hawaii is in a league of its own for saltwater angling, with the main emphasis on pelagic species, especially yellowfin tuna and blue marlin, and is certainly one of the hotspots in American saltwater fishing.

# Regulations

For the most part, regulations regarding seasons, methods of fishing, catch limits and licensing are determined by state governments. There is no national or federal sportfishing license in the U.S., although each of the 50 American states requires a license issued by its government to fish in freshwater. In some states, that same license also applies to saltwater fishing in the marine waters of that state; in others a separate license is required for saltwater fishing; and in a few there is no license requirement for saltwater fishing. A fishing license issued by a state is only valid in waters within that state, and in some instances shared boundary waters. No state requires a test or examination to obtain a sportfishing license. Any person, whether resident or nonresident, can purchase a fishing license; licenses are valid for varying time periods (year, week, three days, or per day). They are most commonly acquired at stores selling fishing tackle, but can also be obtained at some government

offices, marinas, or lodges, and are becoming increasingly available by telephone purchase via a credit card.

A state fishing license is valid for both public and private waters within a state. The vast majority of waters are publicly accessible, but a license does not grant permission to cross private property to reach or leave the water. In waters that are privately owned, or which are inaccessible because all of the land around them is in private ownership, permission must be received to fish. There is no private licensing arrangement as exists in Europe, although an access fee may be charged by the owners of private land or waters who run a commercial business (such as a private marina or boat dock where people launch a boat, or a pay-to-fish facility).

Regulations exist that restrict sportfishing by season, usually to protect spawning fish or fragile populations. During a limited time frame, the season will be "closed" for a particular species. This applies especially to trout and salmon species; but also to bass, walleye, pike, and muskie, especially in northern states. There may also be regulations regarding the manner of fishing; examples include a waterway where only barbless hooks are permitted, or where the use of live or dead bait is prohibited. These and other issues are addressed in a brochure or booklet that is provided with the purchase of a fishing license, or can be found at the website for the state agency that regulates freshwater and/or saltwater fishing.

# MEXICO

Hot bass fishing lakes, striped marlin off Cabo San Lucas, Pacific sailfish off the western mainland, Atlantic sailfish at Cancun and Cozumel, and tarpon, permit and bonefish along many areas of the Yucatan coast—these are among the top angling attractions in Mexico. These very different activities have drawn anglers from afar, especially from the U.S., and California in particular, for a long time.

. . . . . . . . . . . . . . . . . . . . . . . . . . . . . . . . . .

FRESHWATER FISHING IN MEXICO is a different phenomenon than elsewhere in North America. Mexico does not have the abundant inland opportunity or diversity that is characteristic of most U.S. states and all Canadian provinces. Thus, its freshwater fishing pales in comparison to its saltwater opportunities; however, there are many people who equate this country with fantastic largemouth bass angling.

# FRESHWATER

There are relatively few sizable rivers and almost no large natural lakes in this arid country. The largest lakes are artificial, having been formed by dams that were primarily constructed for irrigation and/or hydropower. There are perhaps 50 of these waters in various parts of the country, and many in the northwestern region in the foothills of the Sierra Madre Occidentals. Many of these lakes are usually full of brush and trees; some are literally flooded forests, where catching large strong fish can be a challenge.

Very few Mexicans fish for sport in freshwater, as most fishing here is for subsistence or commercial purposes, using handlines or nets. This has been a serious problem in some lakes, causing depleted fisheries or at least lowered numbers of large fish. Some of this is concurrent with, or a byproduct of, food fishing for tilapia.

SUNRISE BASS FISHING
AT LAKE AGUAMILPA.

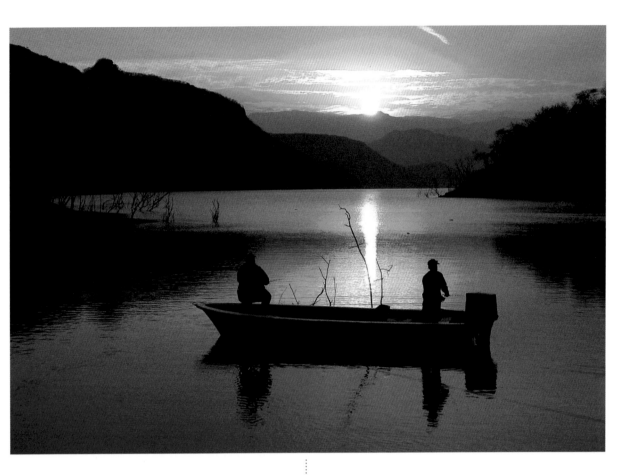

OPPOSITE PAGE (TOP):
MOUNTAIN IMPOUNDMENTS,
LIKE EL SALTO LAKE HERE,
PROVIDE GREAT SCENERY
AND LOTS OF BASS COVER.

A GUIDE SHOWS OFF A LAKE
HUITES BASS IN FRONT OF
THE REMAINS OF A CHURCH,
WHICH WILL BE FLOODED
DURING HIGH WATER.

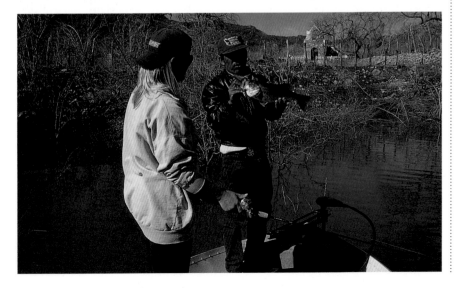

The only freshwater fish that draws non-resident anglers is black bass, negra lobina. A few other species are present, and occasionally sought, such as crappie and bluegill in Lake Novillo in the state of Sonora, but largemouth bass are the main draw.

The major attention for bass anglers over the years has been on impoundments, primarily on newer ones as they first became accessible, and, in a few instances, on older ones. Larger impoundments and lakes with bass include, but are not limited to: Lakes Angostura, Novillo, Macuzari and Oviachic in Sonora; Dominguez, Hidalgo, Baccarac, Mateos, Ocaroni, El Salto, Comedero, Huites, and Picachos in Sinaloa; Aguamilpa in Nayarit; Palmito and Tortuga in Durango; Chapala in Jalisco; Pátzcuaro in Michoacán; Malpaso and Angostura in Chiapas; Miguel Alemán in Oaxaca; several small lakes near the city of Tampico; Guerrero, Españole and Azúcar in Tamaulipas; Cochillo in Nuevo León; Don Martín in Coahuila; Boquilla and Granacia in Chihuahua; and Falcon and Amistad on the Texas border.

Some of these have been extremely well publicized over the years, and fishing in most has had its ups and downs. Lake Guerrero, for example, was the first Mexican lake to become popular, initially being known for producing awesome catches of fish, then later for huge fish. Lake Huites was highly touted in the mid-1990s, and produced terrific numbers of bass in the eight-pound class, but water-level fluctuations hurt it for a while. Lake Mateos was an early star that also went through hard times and has recently rebounded. A very popular bass lake in Mexico has been El Salto, a 24,000-acre impoundment about one hour north of Mazatlan, which has produced good numbers of bass as well as a lot of fish over ten pounds and up to 14, with a few larger bass having been caught. Ironically, this lake was not well thought of in the mid-1990s, but Florida-strain largemouths have made a big difference.

Largemouth bass have been stocked in various parts of Mexico at least since the 1930s, and have been transplanted and introduced widely here. Northern-strain largemouths were evidently the only known bass in Mexican waters until the late 1970s, when pure-strain Florida largemouth bass were stocked in Lake Guerrero, where they eventually grew large enough to attract a lot of attention. Since then, some other lakes have been stocked with Florida bass in the states of Sinaloa and Sonora. Baccarac, Comedero, Salto, Huites, Picachos and Oviachic are some of the impoundments that have these fish in addition to Guerrero, and all have produced big fish.

**LEFT:** THE AUTHOR HOLDS A TROPHY LARGEMOUTH FROM EL SALTO LAKE.

**FAR LEFT:** THE DELUXE ANGLERS LODGE AT EL SALTO LAKE INN, WHICH IS NESTLED IN THE SIERRA MADRES, 90 MINUTES FROM MAZATLÁN.

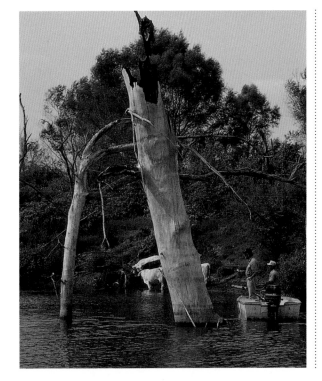

A BIG BASS IS LANDED
AT LAKE GUERRERO.

Some very big largemouth bass (from pure Florida stockings) have been caught, including a confirmed 17-pounder from Guerrero. It has been rumored that bigger fish were caught, including some 18-pounders from Guerrero and a 19-pounder from Baccarac, but these reports have been clouded with suspicion and speculation about netting. Two 18-pounders were said to have been caught by commercial fishermen in Comedero in 1997, and it is likely that bass of this size or larger have been caught by netters in Mexico. A 16-pounder was caught by an angler in Lake El Salto in 2000, besting a 15-pounder caught there the year before. Since some Florida bass have grown to over ten pounds in just three-and-a-half years, it has been speculated that more recently created western Mexico lakes, which have ample forage and which are not netted, have the potential to grow a bass exceeding the long-standing 22lb 4oz world record.

There has been a succession of boom-and-bust bass lakes in Mexico, however. The boom is usually due to the typical pattern that envelops new lakes with good forage and bass populations—quick-growing bass that are aggressive

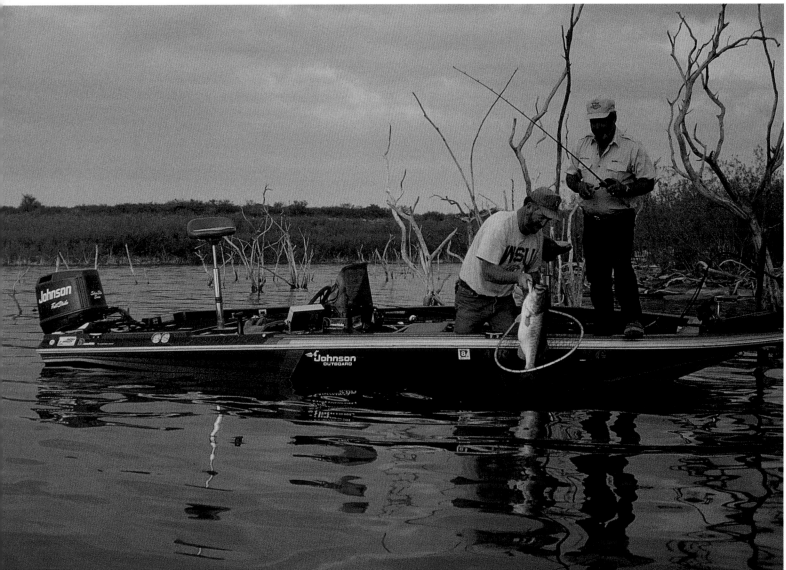

and uneducated, and which are feisty fish owing in part to a fat torso. This results in high numbers of fish per boat or angler on a daily basis.

The mantra of camp owners and operators in Mexico has historically been one of numbers; 100 bass (or more) a day has been the calling card for legions of anglers who could not experience such fishing on their home waters in their wildest dreams. The bust has followed within a few years (sometimes as few as two or three) when either the average size or number of fish has dropped. This has often been blamed on local netting (or spearfishing), which has certainly been part of the problem.

Drought and fluctuating water levels are two of the biggest problems with Mexican lakes. Lowland impoundments are prone to drought and may be very low for many years. Some have gone dry and had to be restocked when they were refilled. The water level in mountain lakes here can also vary dramatically, which does not do good things for either the fishery or for fishing action.

Shallow fishing and surface action are possible in Mexican lakes that are full, or which have experienced stable conditions for a long period. But in the mountain lakes, bass have a tendency to stay deep more, perhaps due to the nature of the often-falling water, and they become harder to catch when they stay deep.

The preferred time for largemouth bass fishing in Mexico is before and during the spawn. Spawning time varies with altitude and location. Bass in the mountain lakes normally spawn between mid-March and early April; those in the flatland lakes spawn in January. Some lakes that are just an hour-and-a-half away from each other have a spawn that is months apart. October and November can be good months as well, and sometimes provide the best fishing, although this may vary from year to year due to other conditions. Many camps are closed between May and September because the hot summer period is not very desirable. In short, January to March are preferred by many visiting anglers because of weather and fishing conditions at home.

# SALTWATER

Although many of Mexico's saltwater opportunities are explored through established sportfishing operations, some areas of both coasts remain to be thoroughly investigated for angling potential due to minimal access. Opportunities for self-guided exploration exist for adventurous traveling anglers, especially for those who speak Spanish. With so much to cover over so large a geographic area, the following information is broken down by major coastal

areas, with the exception of the area along the Gulf of Mexico, which has the least notable saltwater fishing.

THE MAZATLÁN SPORT FISHING FLEET PREPARES FOR A DAY OFFSHORE AT THE EL CID MARINA.

## BAJA PENINSULA

With the Sea of Cortez on its east and the Pacific Ocean on its west, the 760-mile-long Baja Peninsula is almost surrounded by water, which presents tremendous fishing opportunities along both coasts. Most of the best action is from boats, but there is some excellent shore fishing on the Pacific side.

The more well-developed towns have fishing fleets and cater for traveling anglers, especially those interested in blue-water species. The adventurous and exploring angler with plenty of time has a lot of opportunity, but will take a long time traveling unpaved roads to learn all the better spots and to catch all the more prominent and desirable species.

There is excellent offshore fishing from San Quintin south to Guerrero Negro, with good numbers of bluefin, yellowfin and bigeye tuna being caught during summer and fall, as well as dorado (dolphin) and yellowtail. Not many private sport boats ply these distant waters, so most access is via long-range boats from San Diego.

Farther south at Magdalena Bay, there are several offshore banks that attract schools of gamefish and provide excellent tuna and wahoo action. At certain times in the fall, large numbers of striped marlin and big sailfish are available.

Offshore anglers who fish north of Cabo San Lucas head to the Goldengate Banks for marlin, dorado, yellowfin tuna, black seabass, grouper and pargo. South of here by 20 miles or so, is the Jaime Banks, just above Cabo; striped marlin fishing here during winter and early spring months can be fabulous.

Cabo San Lucas, the southernmost tip of Baja, is world famous for billfish. Large numbers of striped marlin invade the waters near Cabo from about the beginning of the year into early spring. At that time, nearby Jaime and Goldengate Banks host large numbers of striped marlin in the 90- to 150-pound range.

Here, marlin feed on extensive schools of mackerel that forage near the banks. Striped marlin are receptive to trolled marlin lures, and are especially fond of live bait. Live mackerel are the most commonly used bait, but small green jacks are also popular. Large yellowfin tuna, some of which exceed 200 pounds, also cruise these banks at this time of year. Some Cabo anglers target big tuna, and are rewarded with good numbers of 200- to 275-pound yellowfins. As summer arrives, fishing for the larger blue and black marlin gets better, peaking in the fall. The larger marlin are hooked on large trolling jigs and plugs and large live baits. Fishing for wahoo, dorado, roosterfish and school yellowfin can be very good inshore.

The fishing northeast of Cabo San Lucas toward the Sea of Cortez around the town of San José del Cabo is also very good, with anglers working the nearby Gordo Banks for all the major billfish, and also enjoying some good reef fishing for grouper and pargo. Spring and summer sees good numbers of wahoo on the Gordo Banks.

The area known as the East Cape, which roughly means the waters northeast of Cabo San Lucas from Punta Frailles to the southern end of Cerralvo Island near La Paz, is popular with anglers, boasting several fishing resorts and a well-equipped fishing fleet. Striped, blue and black marlin are caught here during spring and summer, and there are also swordfish, yellowfin tuna, dorado, wahoo and sailfish to be had. Closer to shore, roosterfish, jack crevalle and ladyfish are found along the beaches and on the edges of rock formations. At nearby reefs, leopard grouper, pargo, triggerfish, African pompano and a few amberjack are available.

From here on up the coast, there are assorted opportunities for yellowtail at offshore reefs and islands, as well as large grouper and large pargo, plus billfish offshore, though mainly more to the south than the north. Loreto is a favorite spot, and is conveniently located near a large airport. North of Loreto the major species become bonito, sierra mackerel, grouper, cabrilla, yellowtail and such near-shore species as corbina, yellowfin croaker, shortfin corvina, white seabass and orangemouth corvina.

## PACIFIC MAINLAND

The entire western mainland coastline has diverse pelagic, bottom and inshore species, including Pacific sailfish, striped marlin, Pacific blue marlin, black marlin, dolphin, yellowfin tuna, roosterfish, cubera snapper and corvina among many others, pursued from big charter boats, little skiffs, long wooden pangas or surf and shore.

Here, sailfish are caught within a few miles of shore. Blue marlin are caught a few miles further out, and typically weigh in the 150- to 300-pound range, although larger fish have been caught. Billfish are present year-round, but the best chance of scoring is in the winter months.

Dorado are perhaps the foremost quarry, and are especially abundant from summer through fall in the northern reaches of the Cortez, though generally moving southward as the season progresses. In the fall, smaller school fish wander into shallower water and provide light-tackle opportunities. Roosterfish are very popular, and many line-class world records for this species have been set in the Sea of Cortez. Cubera snapper and assorted bottom fish, including massive grouper and sea bass, are abundant all along the coast in rocky locales.

The major accessible locales for sportfishing along the western mainland are, from the north: Kino Bay, Guaymas, Topolobampo, Mazatlán, Puerto Vallarta, Ixtapa/Zihuatanejo and Acapulco. Some of these, especially Mazatlán and Acapulco, are major tourist sites with large sportfishing charter fleets, and they tend to attract the angler who wants to spend one day of a general vacation fishing offshore for dorado or sailfish, but they do not usually attract the tourist whose visitation purpose is strictly sportfishing.

The northern section of this coast is still within the confines of the Sea of Cortez, and harbors much of the same fishing as is found on the Baja Peninsula. Kino Bay is close to various islands that offer diverse opportunities; Tiburon is especially notable here. Topolobampo, which is near Los Mochis, is both north and south of a bay- and inlet-studded coast, with an abundance of explorable inshore water.

In Guaymas—which is easily reached by highway from Nogales, Arizona—sailfish, plus all three species of marlin, and yellowfin tuna, wahoo and dolphin are caught offshore from San Carlos Bay. The existence of greater numbers of billfish and tuna depends on the presence of warmer currents, so summer through fall is usually the best period. There is also good reef fishing here within a few miles of the bay. At the southern end of the Cortez, Mazatlán has scores of well-equipped charter boats, and although some light-tackle inshore fishing is possible, the focus is primarily offshore. This area may produce sailfish year-round; the prime period, however, is from June through September, which is also a good period for large

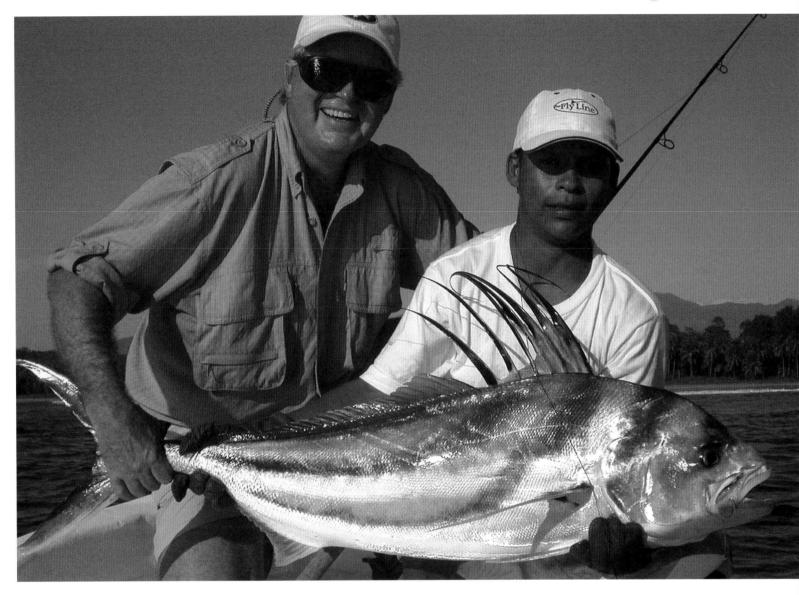

dorado. Blue marlin and black marlin can be caught from May through December, while striped marlin are present from December through May.

Further south and close to deep water, Puerto Vallarta has much the same species as Mazatlán. Sailfish here are mainly a May-through-December proposition; tuna are caught from September through March; wahoo are present from September through December; and marlin are available from August through December.

The adjacent villages of Ixtapa and Zihuatanejo, which are north of Acapulco, offer good sailfish action. The local bounty includes yellowfin tuna, blue marlin, black marlin, dolphin, jack crevalle, skipjacks, roosterfish and Sierra mackerel. December through April is the primary period for offshore fishing, but billfishing can be spotty, since there is no shelf nearby to concentrate fish, and trolling efforts are geared to hooking up with migrants.

Much the same can be said of the coast from south of Acapulco to the border with Guatemala. A close look at a map will reveal a lot of shoreline here without nearby roads and without significant access, yet with various small villages, so there is clearly much to be explored. An example of this is at Huatulco, a small village east of Puerto Angel and west of Salina Cruz in the state of Oaxaca. Situated on the edge of the Gulf of Tehuantepec, and not far from the Middle America Trench, with associated dropoffs and several seamounts, Huatulco is nicely positioned to receive warm northerly-flowing current, and this brings with it a bounty of bait as well as lots of sailfish, plus marlin, yellowfin tuna and dolphin.

## YUCATAN PENINSULA

Despite the excellent fishing of the Baja Peninsula, the Yucatan Peninsula can arguably be called Mexico's leading angling region, with some of the finest inshore and offshore angling in the world.

ZIHUATANEJO PRODUCED THIS LARGE ROOSTERFISH, WHICH WAS CAUGHT ON A SURFACE LURE.

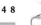

The offshore fishing at the tip of the Yucatan Peninsula is focused on the islands of Cancun and Isla Mujeres, which are adjacent to the Yucatan Channel separating Cuba and Mexico and the location of strong northward-flowing currents that channel bait and pelagic fish species along the tip of the Yucatan Coast.

The sailfish population here is extraordinary, and the best days see multiple hookups. There are also white and blue marlin available. Whites are plentiful at times and they, too, can be the cause of multiple strikes or hookups. White and blue marlin are caught around the 100-fathom curve off Cancun and Isla Mujeres, which is just a few miles offshore. There is no real shelf or quick drop off Isla Mujeres and Cancun, but there is an upwelling of sorts out in the 100-fathom water where current sweeps by.

It is the presence of prodigious schools of bait, especially in the spring and early summer, that makes the waters off the northern tip of the Yucatan such an attractive area. Trolling methods commonly involve looking for balled bait, and dorado, bonito and other fish are sometimes annoyingly plentiful. Opportunities for light-tackle fishing, using spinning rods and eight- to 20-pound line, and fly tackle are good. The best period for billfish and dorado is spring. Inshore there are plenty of bonefish, plus tarpon, snook and permit. None of these fish runs to giant sizes here, but they are readily available. Some of this takes place less than an hour's drive from Cancun. Twenty miles north at Isla Blanca lagoon are extensive flats as well as numerous coves, bays and mangrove islands.

A JACK CREVALLE CAUGHT IN THE SURF NEAR IXTAPA.

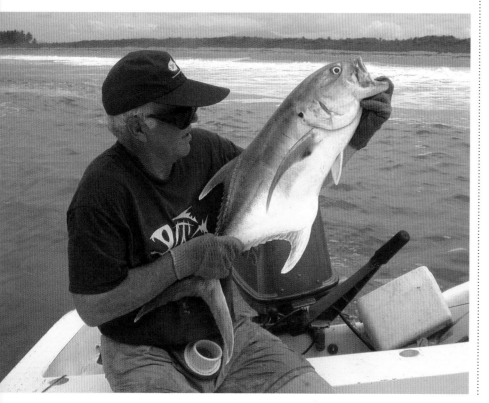

Further south at Cozumel, Atlantic sailfish are the premier quarry, and are found more abundantly here than in most other locales worldwide. Sailfish begin their migration off this island around the full-moon period in March, although they show up in numbers in February and the peak time is from March into June.

Cozumel is a great place for people who want a one-day venture to catch their first sailfish. It is also a great place to catch sails on fly, light spinning and baitcasting tackle. Additionally, this is an excellent place for a realistic chance of getting a multiple hookup, a grand billfish slam (white and blue marlin plus sailfish in a single day), or a super grand slam (the other three billfish plus swordfish). The offshore fishery has held up well for years here, sometimes raising double-digit numbers of fish.

Trolling at Cozumel predominantly takes place in the 12 miles of deep water that separates the island and the mainland, often close to the Yucatan near Playa del Carmen in ten to 60 fathoms of water. Sailfish migrate northward with the strong current, coming from the open waters of the Caribbean and working their way up the coast past Cozumel, passing the head of the peninsula at Isla Mujeres and Cancun, before moving into the Gulf of Mexico. White marlin are also encountered along the mainland shoals and edges, sometimes caught in the same locales as sailfish. Blue marlin, however, are more likely to be caught further offshore and over deeper water. This occurs in the channel, which has some irregular bottom structure.

Flats get less attention in Cozumel, and the area has not been publicized for this. Although bonefish are abundant along the Yucatan flats on the mainland, they are not so plentiful at Cozumel because the island has little shallow water. There are some bonefish and permit to be caught, however, and while it may not be world-class fishing, it is good enough to offer a very pleasant day, especially if you do not savvy big-water fishing or you experience a heavy blow that keeps big boats off the water, or you just want to take a spinning or fly rod in tow and poke around. This exists in and near small lagoons at both ends of the island.

The reefs around Cozumel, incidentally, are rated as among the world's finest for diving. Palancar Reef, which surrounds Cozumel, is one of the world's largest coral reefs. The edges of the reef yield some big groupers, red snapper and other bottom fish, plus the occasional dolphin and kingfish.

Excellent light tackle flats fishing exists along southeastern Quintana Roo. The shoreline drops off sharply just south of Cancun and does not offer flats fishing, but south of Tulum, which is the most visited of all Mayan archaeological sites, the region in and around the Sian Ka'an Biosphere Reserve (a 1.3-million-acre region with tangled mangrove swamps, vast tropical forests and

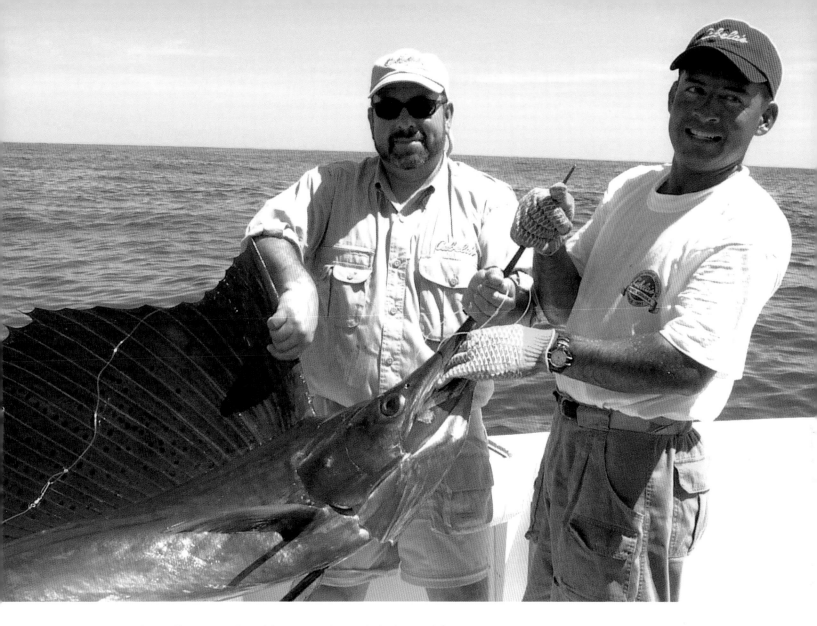

isolated swampy beaches), offers tarpon, bonefish, permit, snook, and assorted other species. Netting is prohibited in the Reserve, and there is a minimal number of local inhabitants, so the fish are undisturbed and plentiful. Boca Paila, Ascension Bay and Espiritu Santo Bay are the main fishing areas, with facilities available at each location.

The fish here are not generally large, although some huge permit have been caught, including 40- to 50-pounders on fly tackle. However, catching the grand-slam species (tarpon, bonefish and permit) or super grand slam (plus snook) in a day is very realistic, especially at Ascension and Espiritu Santo bays, and these may be the foremost places in the world for achieving such an accomplishment.

Bonefish and permit are the primary catch, and both are often found in large schools on the flats. Tarpon mostly exist in mangrove backwaters, and range from small sizes up to 70 and 80 pounds. Snook here are up to 20 or 25 pounds as well, but are generally less numerous than the other species. Big barracuda, plus sharks and jacks, are also available. Some flats fishing is done by wading, but most of the flats are soft and muddy and

preclude this, making poling and casting from boats the standard procedure.

Boca Paila is about two hours by auto from Cancun, and is protected from prevailing winds. Boasting plenty of easily reached flats, Boca Paila has the motherlode of small bonefish and is renowned for lots of permit. Tarpon, snook and barracuda, plus various reef species, are also here. Much the same can be said for vast Ascension Bay as well, 25 miles south of Boca Paila and with a cornucopia of mangrove islands, channels, flats and creeks. Other fish encountered here include jack crevalle, cubera snapper and large barracuda. Large permit are on the flats at Ascension Bay, as well as large schools of one- to five-pound bonefish. There are tarpon in the mangrove areas and also in some landlocked lagoons accessible via a rugged dirt road. Espiritu Santo Bay is about 15 miles south of Ascension Bay, and is less known and visited. Loads of flats and mangrove lagoons exist in this large area, too, and a barrier reef parallels the shoreline and crosses in front of the mouth of the bay. Huge permit and ample schools of bonefish are also found on flats here, with small tarpon near mangrove shores, between the reef and shoreline, and in lagoons.

A PACIFIC SAILFISH BROUGHT TO THE BOAT IN THE SEA OF CORTEZ.

# INDEX

*Numbers in italics refer to photographs
or illustrations*

Abrasion resistance 128, *128*
Abu-Garcia Abumatic spincasting reel *114*
Abu-Garcia Eon baitcasting reel *99*
Abu-Garcia Suverän spinning reel *121*
Acapulco 246, 247
Adirondack Mountains 236
Africa 78
Aguamilpa, Lake 242
Alabama *40*, 235, *235*
Alaska 11, 15, 64, 72, 233, 234, 237, 239
Albacore 10, *10*, 84, 239
Albacore, false *see* little tunny
Albacore, true 10
Alberta 231
Alewives 11, 18, 33, 45, *55*, 69, 80, 88, 90,
    140, 199
Allison tuna *see* yellowfin tuna
Almaco jack 52
Amberjack 52–3, *53*, 246
American shad 12–13, *12*, *13*
Amistad, Lake 242
Anchors 167–8, *168*
Anchovy 10, 11, 20, 23, 49, 85, 141
Angostura, Lake 242
Annapolis River *12*
Appalachian Mountains 236
Arctic Charr 14–5, *14*, 54
Arctic grayling 16, *16*
Arctic Ocean 229, 230
Arizona 246
Arkansas *91*, *235*, 236
Arkansas River *235*
Artificial flies 132, *132*
Ascencion Bay 249
Atlantic barracuda 20
Atlantic bonito 11, *11*
Atlantic halibut 50, *51*
Atlantic mackerel 61
Atlantic Ocean 10, 11, 12, 23, 25, 50, 51,

61, 70, 73, 77, 79, 85, 86, 229, 237
Atlantic sailfish 241
Atlantic salmon 17, *17*, 18, 19, 31, 229,
    235, 237
Attractors 167
Australia 78
Azúcar, Lake 242

Baccarac, Lake 242, 243, 244
Baffin Island 231
Bahamas 20, 67, 77, 85, 238
Baitcasting gears 96, 99, 100, *100*
Baitcasting reels 96, *96*, *97*, *98*, *99*, 100
Baitcasting rods 122–3, *122*, *126*
Baitcasting spools 96–8, *97*
Baitcasting tackle 96–100, *96*, *97*, *99*, 172,
    *172*, 174, 175
Baja California 86, 87
Baja Peninsula 23, 245–6
Balao 49, 61, 141, *141*
Bank 194
Bar jack 52
Barracuda 20, *20*, 239, 249
Barracuda, Atlantic 20
Barracuda, Pacific 20
Barramundi 78
Bass 56–59, *56*, *57*, *58*, *59*, 137, 140, *175*,
    193, *193*, 199, 209, 211, 231, 235, *235*,
    240, *240*, 241, 242, *242*
Bass, black 242
Bass, Largemouth 46, 56–59, *56*, *57*, *58*,
    *118*, 135, 200, *208*, 231, 234, 241, 242,
    243, *243*, 244, *244*, 245
Bass, sea 195
Bass, smallmouth 46, 56–59, *59*, 231, *233*,
    234, *236*
Bass, striped 70, 90, *195*, 234, 237–8, *238*,
    239
Bass, white 79, 235, 238

Batteries, motor boats 158
Beauchene, Lac *59*, *233*
Beaverkill River *33*
Belly boats 153
Bermuda 86, 87
Big game lures 134
Big game reel gears 103
Big game rods 123, *123*
Big game tackle 100–101, *100*, *101*, 103,
    *103*, 104
Big Pine Key 76
Bigeye tuna 84, 86, 245
Billfish 21–4, 100, 134, 141, *192*, 201, 207,
    246, 248
Bimini twist knots 216
Black bass 242
Black bullhead 38
Black crappie 46
Black drum 70
Black marlin 246, 247
Black rockfish 72
Black seabass 245
Blackfin tuna 84, 86
Blackfish 195
Blacktip shark 75, 76
Blackwater River *68*
Blue catfish *38*, 39, 40, 41
Blue marlin 21, 22, 23, 24, 238, 246, 247,
    248
Blue rockfish 72
Blue runner 52, 61, 141
Blue shark 75, *75*
Bluefin tuna 84, 85, *85*, 238, 245
Bluefish 10, 25–6, *26*, 199, 234, 238
Bluegill 27–8, *27*, *28*, 46, 92, 220, 235, 242
Boat drift 194, *194*
Bobbers 146
Boca Paila 249
Bocaccio 72

Bonefish 29–30, *29*, *30*, 199, *212*, 238, 239, 241, 248, 249, *249*
Bonito 10, *10*, 11, 23, *53*, 84, 239, 246, 248
Bonito, Atlantic 11, *11*
Bonito, Pacific 11
Bonnethead shark 75, *76*
Boquilla, Lake 242
Bottom jigging 185, *185*, 187
Bottom-fishing rigs 194, 195, *195*
Bow-mounted motor boats 155, 157, *157*
Braided Dacron line 127, 203
Braided microfilament 127, 128, 129
Breaking strength 127, *127*, 128,
British Columbia 45, *51*, 68, *195*, 227, 229, *230*, 231, 232
Brook trout 31–34, *31*, *32*, *33*, 54, *112*, 236
Brown bullhead 38
Brown shark 75
Brown trout 31–34, *32*, *33*, *34*, 69, *200*, 229, 231, 236, 237
Bugs 132
Bullhead, black 38
Bullhead, brown 38
Bullhead, yellow 38
Bullheads 38, 40, 41
Bunker 25, 71, 74, 79, 81

Cabo 245, 246
Cabo San Lucas 23, 241, 245, 246
Cabrilla 246
Cains River *19*
Calcasieu *73*
California 10, 11, 20, 23, 53, 57, *58*, 72, *72*, 86, 234, 239
California halibut 50, 51
California yellowtail 53
Cambridge Island *14*
Canada 15, 64, 89, 223–32, *224*, *225*, *226*, *227*, *228*, *229*, *230*, *231*, *232*
Canadian Maritimes 85, 227
Cancu 241
Cancun 247, 248
Cannonball sinker 190
Caribbean 11, 22, 52, 67, 87, 237
Carolina rig 135, 195
Carp 35–7, *35*, *36*, *37*, 234
Casting spoons 137, *138*
Casting with baitcasting reels 96–9, *99*
Catfish 38–41, *40*, *41*, 114, 140, 234, 235

Catfish, blue *38*, 39, 40, 41
Catfish, channel *38*, 39, 40, 41
Catfish, flathead *38*, 39, *39*, 40, 41
Catfish, white 38, 39, 40, 41
Catskill Mountains 236
Cayuga Lake *17*
Cerralvo Island 246
Chain pickerel 42–3, *43*, 62, 64
Channel bass *see* Redfish
Channel catfish *38*, 39, 40, 41
Chantrey Inlet 231
Chapala, Lake 242
Charr 31, 54, 229–30, 236
Charr, Arctic 54
Charr, Landlocked 14, 15
Charr, sea-run 14, 15
Chart plotting 161, 162, 163
Chesapeake Bay 52, 79
Chesapeake Bay Bridge 233
Chesapeake Bay Bridge-Tunnel *238*
Chest boxes 149
Chest waders 153
Chiapas 242
Chihuahua 242
Chinook salmon 44–5, *44*, 140, *140*, *211*, 229, 234, 237, 239
Chuggers 139
Chum 10, 25, 30, 36, 49, 52, 61, 76, 77, 81, 86, 93, 140, 141, 195
Chum salmon 229, 237
Ciguatera 20
Ciscoes *55*, 140
Class line 127
Clinch knots, improved 213, *213*
Coahuila 242
Cochillo, Lake 242
Cod 107, 234
Coho salmon 44–5, *45*, 140, *140*, *201*, 229, 234, 237, 239
Colorado spinner blade 136, 137
Columbia River 235, *236*
Comedero, Lake 242, 243, 244
Conventional reel gears 107, 108
Conventional reels 104, *104*, 107, *107*, 108, *108*
Conventional rods 124, *124*
Conventional tackle 172, *172*
Copper rockfish 72
Coppermine River *14*
Corbina 246
Cortez, Sea of 245, 246

Corvina 246
Corvina, orangemouth 246
Corvina, shortfin 246
Cowbells 167
Cozumel 241, 248
Crab 67, 29, 30, 51, 52, 67, *67*, 71, 73, 77, 78, 80, 82, 83, 141
Crappie 46–7, *46*, *47*, 92, 140, 235, 242
Crappie, black 46
Crappie, white 46
Crayfish 28, 40, 42, 57, *58*, 69, 89, 90, 93, 140, 141
Crickets 40, 47, 140
Croaker 70, 73
Croaker, yellowfin 246
Cuba 247
Cubera snapper 246, 249
Current 201, *201*
Curve cast 178
Cut-plugs 165
Cutthroat trout 231, *236*

Dace 140
Dacron 128, 131
Daiwa Emblem Z-Surf spinning reel *120*
Daiwa Millionaire baitcasting reel *99*
Danforth anchor 168
Dean River *230*
Delaware 74
Delaware Bay 79
Deluxe Anglers Lodge *243*
Deluxe Fishing Lodge *228*
Detroit River 228
Diameter, Line 128
Dipsey 194
Diving planers 163, 164–5, *164*, 189, 190
Diving plugs 25, 40, 49, 54, 63, 65, 69, 87, 89, 91, 165, 181, *181*, *191*
Dodgers 167
Dolphin 48–9, *48*, *49*, 134, 141, 201, 234, 238, 247
Dominguez, Lake 242
Don Martín, Lake 242
Dorado 245, 246, 248
Double taper fly line 130
Double-hauling *176*, 177
Double-line knots 216
Downrigger rods 126
Downrigger trolling 190, 191, *191*, *192*
Downriggers *164*, 165–7
Drag setting 100–101

Drag system, spinning reels 120–21, *121*
Drag tension 101, 217, *217*, 218, *218*
Drawer tackle box 147
Drift bait 194
Drum 70, 73, 238
Drum, black 70
Dry flies 132
Durango 242
Dusky shark 75

Eels 11, 25, 74, 80, 81, 85
El Cid Marina *245*
El Salto lake 242, *242*, 243, 244
El Salto Lake Inn *243*
Electric downrigger *164*, 165
Electric motorboats 155, 157–8, *157*
Electronic navigation devices 160–63, *161*,
   *162*
English River *31*, 231
Erie, Lake 228, 229, 231, *233*
Españole, Lake 242
Espiritu Santo Bay 249
Eufaula, Lake *235*
Everglades 233

Falcon, Lake 242
False albacore *see* little tunny
False casting 176
Feathers 20, 22, 23, 49, 61, 83, 86, 132, 134
Fenwick F series fly reel *113*
Ferguson lake *230*
Files 219, *219*
Fish habits 200
Fishing vests 148
Flashers 167, *167*
Flathead catfish *38*, *39*, *39*, 40, 41
Flatlining 189–90, *190*, 192
Flexibility, Line 129
Flies 132, 182, 184
Flies, dry 132
Flies, floating 132
Flies, sinking 132
Flies, wet 132
Flipping 174–5
Flipping rods 126
Float tubes 153, *153*
Floating flies 132
Floating fly line 130
Floating plug 91, 181, 182, *191*
Floating/diving plugs 133–4, 139
Floating/sinking fly line 130

Floats *145*, 146
Florida 12, 20, 23, *23*, 27, 29, 52, 57, *58*,
   *67*, 70, 73, 74, *76*, 77, *77*, 78, 82, *83*, 86
Florida 233, 234, 238, *238*, 329
Florida Keys *49*
Florida pompano 52–3
Flounder 50–51, *50*, 107, 195, 234, 238
Flounder, Gulf 50
Flounder, southern 50
Flounder, starry 50
Flounder, summer 50, 51
Flounder, windowpane 50
Flounder, winter 50
Fluorocarbon line 127, 129
Fly line 127, *129*, 130
Fly reel drag *110*, 111, 112, 113, *113*
Fly reels 109–113, *109*, *110*, *111*, *112*,
   *113*, 117
Fly rods 124–5, *125*
Flycasting 175–8, *176*, *177*, *178*
Flying fish 48, 49
French spinner blade 136
Freshwater bait 140–41, *140*
Friction washer 103
Frogs 40, 42, 140
Fur lures 132
Fused microfilament 127, 128, 129

Gaffing 208
Gaffs 149–50, *150*
Gaspe Peninsula 229
Gears, baitcasting reels 96, 99, 100, *100*
Gears, Big game reels 103
Gears, conventional reels 107, 108
Gears, Lever drag reels 103
Gears, spincasting reels 115
Gears, spinning reels 118
Georgia 73, *81*
Georgian Bay 231
Global Positioning System receivers 160,
   161, *161*, 162, *162*, 163, 192
Golden Gate Bridge 233
Goldengate Banks 245, 246
Gordo Banks 246
Granacia, Lake 242
Grasshoppers 40, 47, 140
Gray snapper 77
Gray trout *see* Weakfish
Grayling 231, *231*, 232
Great Lakes 18, 44, 45, 55, 63, 64, 69, 89,
   107, 192, 199, 224, 225, 228, 229, 234,

235, 236, 237
Green jacks 246
Grilse 18, *19*
Grouper 107, 234, 245
Grouper, Leopard 246
Grunt 141
Guatemala 247
Guaymas 246
Guerrero Negro 245
Guerrero, Lake *57*, 242, 243, *244*
Gulf flounder 50
Gulf of Mexico 11, 22, 50, 70, 73, 74, 77,
   82, 86, 245
Gulf of Tehuantepec 247
Gulf Stream 86, 238
Gulfport *240*

Habitats 200
Haddock 234
Hadley Bay *14*
Halibut 50–51, *51*, 231, 232, 239
Halibut, Atlantic 50, 51
Halibut, California 50, 51
Halibut, Pacific 50, 51, *51*
Hand-landing fish 207
Hard plastic lures 132
Hauling *176*, 177
Hawaii 22, 52, 239–40,
Hellgrammites 50, 57, 89, 140
Herring 12, 22, 23, 24, 25, 40, 45, 51, 61,
   72, 80, 85, 87, 140, *140*, 141, 195
Hickory shad 12
Hidalgo, Lake 242
Hip roof tackle box 147
Hooks 142, *142*
Hooksetting 202–4, *203*
Horse-eye jack 52
Huatalco 247, *247*
Hudson Bay 63
Hudson River 79
Huites, Lake 242, *242*, 243, *243*
Hunt Falls *16*, 231
Huron, Lake 231
Hybrid striped bass 238
Hybrid striper 79, *81*, 90

Ice fishing rods 126
Idaho 237
Improved clinch knots 213, *213*
Improvised anchors 168, *168*
Indiana spinner blade 136, 137

Inflatables 153, *153*
In-line planers *162*, 163
Isla Blanca 248
Isla Mujeres 247, 248
Islamorada *23, 29, 238*
Ixtapa/Zihuatanejo 246, 247

Jack crevalle *52*, 246, 247, 249
Jacks 20, 22, 52–3, 61, 67, 249
Jacks, green 246
Jaime Banks 245, 246
Jalisco 242
Jigging spoons 138, *138*
Jigs 132, 133, *133*, 134
Johnson Maxxum Pro spincasting reel *115*

Kasmere lake *228*
Kesagami lake *89*
Key West 77
Kick boats 153
Killifish 74
King mackerel *60*, 61, 87, 141, 238
King salmon *see* Chinook salmon
Kino Bay 246
Knots 213–6, *213, 214, 215, 216, 221, 221*

La Paz 246
Labrador *31*, 229, 230, 231
Ladyfish 246
Lake trout 54–5, *54, 55*, 140, 212, 225,
    227, 229, 230, 232, 236
Landing fish 207–8, *208*, 221
Landing nets 149–50, *149*
Landlocked salmon 17, *17*, 18, 19
Large-arbor fly reel *110*, 113
Largemouth bass 46, 56–59, *56, 57, 58,
    118*, 135, 200, *208*, 231, 234, 241, 242,
    243, *243*, 244, *244*, 245
Lead lures 132
Leadheads 133
Leeches 40, *57*, 69, 88, 89, 140
Left-retrieve baitcasting reels *99*, 107
Left-retrieve big game reels 103
Left-retrieve conventional reels 107
Left-retrieve fly reels 113
Left-retrieve lever drag reels 103
Left-retrieve spincasting reels 114
Lemon shark 75, 76
Leopard grouper 246
Leopard shark 75
Level fly line 130

Lever drag reel gears 103
Lever drag reels 100–101, *100, 101, 103*, 104
Light tackle 220–21, *220, 221*
Line diameter 128
Line flexibility 129
Line recovery 108
Line releases 166
Line stretch 128–9, *128*, 203
Line, braided Dacron 127
Line, breaking strength 127, *127*, 128
Line, double taper fly 130
Line, floating fly 130
Line, floating/sinking fly 130
Line, fluorocarbon 127, 129
Line, fly 127, *129*, 130
Line, Level fly 130
Line, shooting fly 130
Line, sinking fly 130
Line, weighted 127, 130, 131
Line, weight-forward 130
Line, wire 127, 130–31, *130*
Line-to-line knots 214–6
Line-to-line uni 214, *214*
Lingcod 239
Little tunny 10, 84
Long Island *74*
Loreto 246
Los Mochis 246
Louisiana *73*
Lures 165, 180, 181, *181*
Lures, big game 134

Mackerel 11, 22, 23, 24, 25, 60–61, *60*,
    76, 71, 84, 85, 86, 87, 141, 195, 246
Mackerel, Atlantic 61
Mackerel, king *60*, 61, 87, 141, 238
Mackerel, Sierra 246, 247
Mackerel, Spanish 61
Macuzari, Lake 242
Magdalena Bay 245
Maine 234, 237
Mako shark 75, 76
Malpaso, Lake 242
Mangrove snapper *see* gray snapper
Manitoba *54*, 227, *228*
Manual downrigger 165, 166, *166*
Marathon *67*
Margaree River *229*
Marina Del Rey *72*
Marion, Lake *39*
Marlin 117, 234, 238, 245, 247

Marlin, black 246, 247
Marlin, blue 21, 22, 23, *24*, 238, 246, 247,
    248
Marlin, striped 21, 22, 23, 241, 245, 246
Marlin, white 21, 22, 23, 248
Maryland 23, 238
Massachusetts 74
Mateos, Lake 242
Mazaltan *78*, 242, *243, 244*, 246
Mead, Lake *36, 81*
Menhaden 11, *24*, 25, 26, 61, 71, 73, 74,
    76, 80, 141
Metal lures 132
Mexico 10, 11, 20, 23, 53, *57, 57*, 72, 78,
    *78*, 85, *87*, 239, *240*, 241–9
Michigan *44*, 236, *237*
Michigan, Lake 229
Michoacán 242
Microfilament, braided 127, 128, 129
Microfilament, fused 127, 128, 129
Midwest 89
Miguel Alemán, Lake 242
Minipi watershed 231
Minnesota 233, 234, 235
Minnows 28, 42, 43, 46, 47, 51, *57*, 61,
    73, 80, 88, 89, 90, 91, 93, 140
Minnow-style (like) plugs 11, 20, 34, 63,
    67, 93, 182
Miramichi Lake *225*
Miramichi River *13, 18*
Mississippi River 39, 63
Missouri *90*, 236
Monofilament, nylon 127, 128, *128*, 129
Montauk *75, 80*, 86
Montauk Point *238*
Mooching *195*
Mullet 20, 22, 23, 40, 49, 53, 61, 71, 73,
    74, 78, 83, 85, 86, 87, 141
Mushroom anchor 168
Muskegon River *44*
Muskellunge 42, 62–3, *62, 63*, 64
Muskie 140, 150, 220, 231, *231*, 232, 235,
    240

Nail knots 215–6, *215*
National Marine Fisheries Service 85
Navy anchor 168
Nayarit 242
Needlefish 20, 22
Netting fish 207–8, *208*
Nevada *36, 81*

New Brunswick *13*, 17, *18*, *19*, *225*, 229, 231, 234
New England 10, 11, 236, 237
New Jersey 11, *11*, 238
New York 17, *33*, *55*, 64, 74, *74*, *75*, *80*, 86, 236, 238, *238*
Newfoundland 229, 231
Nightcrawlers 89, 140
Nile perch 78
Niño, El 10
Nogales 246
Non-slip loop knots 214, *214*
Noodle rods 126
North Carolina 23, 74, 85, 86, 238
Northern pike 42, 62, 225, 235
Northern seatrout *see* Weakfish
Northwest Territories *14*, 227
Nova Scotia *12*, 229, *229*, 231
Novillo, Lake 242
Nueltin Lake *54*, *228*
Nunavut Territories *14*, 227, 231
Nylon monofilament line 127, 128, *128*, 129, 203, 213
Nymphs 132, *132*, 184, *236*

Oahe, Lake *35*
Oaxaca 242, 247
Ocaroni, Lake 242
Octopus 22, 51, 141
Ontario *62*, *89*, 227, 231, *231*, 232, 234
Ontario, Lake *55*, 228, 229, 231
Orangemouth corvina 246
Oregon *236*, 239
Ottawa River *62*, 231, *231*
Overhead cast 173–4, *173*, *174*, 176–7, *176*
Oviachic, Lake 242, 243
Ozark Mountains 236, 237

Pacific barracuda 20
Pacific bonito 11
Pacific halibut 50, 51, *51*
Pacific Ocean 22, 23, 44, 50, 51, 53, 72, 85, 224, 229, 237, 245
Pacific sailfish 241
Pacific salmon 68, 229, 230, 237
Pack rods 126
Palancar Reef 248
Palmito, Lake 242
Palomar knots 213, *213*

Palometa 52
Panfish 234
Pargo 245, 246
Pátzcuaro, Lake 242
Pencil lead 194
Penn International 70 lever drag reel *103*
Penn Senator 114 conventional reel *107*
Pennsylvania *233*, 236
Perch 89, 92, 194
Perch, Nile 78
Perch, yellow 92,–3 *92*, *93*, 232, 235
Pere Marquette River *237*
Permit 52, 67, *67*, 238, 241, 248, 249
Personal flotation devices 154–5, *154*, *155*
Personal inflatables 153
Pickerel 89
Pike 140, 150, 200, 225, 227, *227*, 240
Pike, northern 42, 62, 64–6, *64*, *65*, *66*, 225, 235
Pile cast 178
Pinfish 60, 71, 83, 141
Pitching 175, *175*
Planer boards *162*, 163–4
Planers *162*, 163–5
Plastic worms 135, 182, 184, *184*
Playing fish 205–6, *205*, *206*, 209, 211, 221
Plow anchor 168, *168*
Plugs 11, 15, 19, 20, 25, 26, 28, 33, 34, 40, 45, 47, 49, 53, 55, 61, 63, 65, 66, 69, 71, 74, 78, 80, 81, 83, 86, 87, 88, *88*, 89, 91, 93, 132, 133, *133*, *180*, 181, *181*
Plugs, floating/diving 133–4, 139
Plugs, sinking 133
Pollack 51
Pompano 141, 246
Poppers 28, 53, 71, 74, 78, 139, 181, *182*, 184
Porbeagle shark 75
Porgies 195
Prince of Wales Island *51*
Propellered plugs 181
Puerto Angel 247
Puerto Vallarta 246, 247
Pumpkinseed 27
Punta Frailles 246

Quebec 17, *59*, 227, 229, 230, 231, 232, *233*
Quillback rockfish 72

Quintana Roo 248
Quinte, Bay of 228
Rainbow runner 52
Rainbow trout 141, 207, 231, 236, 237
Rainy lake 228
Reach cast 178
Red drum *see* Redfish
Red snapper 77
Redfish 70–71, *70*, *71*, 74, 199, 234, *240*
Releasing fish *207*, *209*, 211–12, *211*
Retrieving with baitcasting reels 99–100
Revillagigedo Islands 86
Right-retrieve baitcasting reels *97*, *99*, *107*
Right-retrieve big game reels *103*
Right-retrieve conventional reels *107*
Right-retrieve fly reels *113*
Right-retrieve lever drag reels *103*
Right-retrieve spincasting reels *114*
Rockfish 72, *72*, 239
Rockfish, black 72
Rockfish, blue 72
Rockfish, copper 72
Rockfish, quillback 72
Rockfish, vermilion 72, *72*
Rockfish, Yelloweye 72
Rocky Mountains 64, 233, 236
Rod handles *126*
Rods, baitcasting 122–3, *122*, *126*
Rods, big game 123, *123*
Rods, conventional 124, *124*
Rods, downrigger 126
Rods, flipping 126
Rods, fly 124–5, *125*
Rods, ice fishing 126
Rods, noodle 126
Rods, pack 126
Rods, specialty 126
Rods, spincasting 125
Rods, spinning 126, *126*
Rods, travel 126
Roll cast 178
Roosterfish 52, 246, 247

Sablefish 51
Sailfish 21, *21*, 22, *22*, 117, 207, 238, 245, 246, 247, *247*, 248, *248*
Sailfish, Atlantic 241
Sailfish, Pacific 241
St. Lawrence River 228, 231, 232
Salina Cruz 247

Salmon 17–19, *17*, *18*, *19*, 69, *132*, 133, 141, 163, *195*, 199, 200, *200*, 207, 212, 220, 229, *229*, 234, 237, *237*, 240
Salmon eggs 33, 45, 69, 140, 141
Salmon, Atlantic 17, *17*, 18, 19, 229, 235, 237
Salmon, chinook 44–5, *44*, *211*, 229, 234, 237, 239
Salmon, chum 229, 237
Salmon, coho 44–5, *45*, 140, *140*, *201*, 229, 234, 237, 239
Salmon, Landlocked 17, *17*, 18, 19
Salmon, Pacific 44, 68, 229, 230, 237
Salmon, sockeye 229, 237
Saltwater trolling lures 134, *134*
San Diego 86, 245
San Francisco 233
San José del Cabo 246
San Quintin 245
Sand fleas *52*, 141
Sand lance 51, 72
Sandbar shark 75
Sanddab 50
Sardines 11, 23, 86, 141
Saskatchewan *16*, *65*, *66*, 227, *227*, *231*
Sauger 89
Saugeye 89
S-cast 178
Scott Lake *65*, *231*
Sea bass 195
Seabass, black 245
Seabass, white 246
Sea-run salmon 18, *19*
Seatrout 32, 73–4, *73*
Seatrout, spotted 73, *73*, 238
Selwyn Lake *66*, 227
Shad 12, 237, 239
Shad, bait 40, 43, 46, *57*, 80, 81, 90, 91, 93, 140
Shark 75–6, *75*, *76*, 100, 141, 238, 249
Shark, blacktip 75, *76*
Shark, blue 75, *75*
Shark, bonnethead 75,*76*
Shark, brown 75
Shark, dusky 75
Shark, Lemon 75, *76*
Shark, Leopard 75
Shark, mako 75, *76*
Shark, porbeagle 75
Shark, sandbar 75
Shark, sharpnose 75

Shark, thresher 75, *76*
Shark, tiger 75
Sharpening stones 219, *219*
Sharpnose shark 75
Shellcracker 27
Shimano Curado baitcasting reel *100*
Shimano Symetre spinning reel *120*
Shimano Tiagra 130 lever drag reel *103*
Shimano TLD Star conventional reel *108*
Shiners 40, 43, *57*, *58*, 63, 140
Shooting 177
Shooting fly line 130
Shortfin corvina 246
Shrimp 11, 29, 30, 40, 51, *52*, 61, 67, 71, 72, 73, 74, 77, 78, 82, 83, 141
Sian Ki'an Biosphere Reserve 248, 249
Side cast 174, *174*
Sideplaners 163–4
Sierra mackerel 246, 247
Sierra Madre Occidentals 241, *243*
Silver salmon *see* Coho salmon
Silversides 11, 73, 74, 80, 90
Simcoe, Lake 232
Sinaloa 242, 243
Sinkers 142, *142*, 144
Sinking divers 181
Sinking flies 132
Sinking fly line 130
Sinking plugs 133
Skipjack 247
Skipjack tuna 84
Slack-line casting 178
Slow-hopping jigs *187*
Small-arbor fly reel *110*
Smallmouth bass 46, 56–59, *59*, 231, *233*, 234, *236*
Smelt 18, 19, 20, 40, *45*, 54, *55*, 69, 80, 88, 90, 199
Snapper 77, *77*, 234
Snapper, cubera 246, 249
Snapper, gray 77
Snapper, red 77
Snapper, yellowtail 77, *77*
Snaps 144, *144*
Snap-swivels *144*, 146
Snook 78, *78*, 238, 248, 249
Sockeye salmon 229, 237
Soft carriers 148, *148*
Soft lures 135, *135*
Soft plastic lures 132
Soft worms 135–6, *135*, 182

Sonar 158–60, *158*, *159*, 166, 185
Sonar/GPS combinations 161, 162
Sonora 242, 243
South Carolina *39*
South Dakota *35*
Southern flounder 50
Spanish mackerel 61
Specialty rods 126
Speck *see* Sea trout
Speckled trout *see* brook trout
Spider hitch knots 216, *216*
Spincasting reels 114–6, *114*, *115*, *116*, 117, 217
Spincasting rods 125–6
Spincasting tackle 172, *172*, 174, 235
Spinner rig 194
Spinnerbaits 28, 43, 47, *58*, *59*, 65, 137, *137*, 182
Spinners 15, 16, 28, 33, 43, *55*, 63, 65, 66, 69, 88, 89, 91, 93, 132, 136–7, *136*, 182
Spinning reels 117–8, *117*, *118*, 120–21, *120*, *121*, 217
Spinning rods 126, *126*
Spinning tackle 172, *172*, *173*, 235
Splake 54
Split shot 194
Spoons 13, 15, 16, 19, 20, 22, 23, 25, 33, 34, 43, 45, 49, *52*, 53, 55, *58*, 61, 69, 74 80, 81, 83, 86, 87, 89, 91, 93, 132, 137–8, 165, 182, *191*
Spotted sea trout 73, *73*, 238
Spotting fish 198–9, *198*
Spring salmon *see* Chinook salmon
Spring scale 218, *218*
Squid 10, 11, 20, 2, 23, 24, 25, 44, 48, 49, 51, 52, 53, 61, 72, 73, 74, 77, 80, 85, 86, 87, 141, 195
Star drag 100, 107, *107*, 114, *114*
Starry flounder 50
Steelhead 68–9, *69*, *132*, 141, *200*, 220, 229, 230, *230*, 231, 237
Stickbait 91, 181
Stockton Lake *90*
Streamers 10, 13, 15, 33, 43, *55*, *58*, 81, 83, 132, 182, *182*, 184
Strength classification, conventional reels, 107
Stretch, Line 128–9, *128*
Strike detection 187–8
Striped bass 70, 79–81, *80*, *81*, 90, 195, 234, 237–8, *238*, 239

Striped marlin 21, 22, 23 241, 245, 246
Stripers 140, 200, 220
Suckers 40, 54, 63, 64, 140
Summer flounder 50, 51
Sunfish 27, 46, 90, 140, 235
Sunshine bass *see* Hybrid striper
Surface lures 138–9, *139*
Surface plugs 20, 63, 74, 83, 181
Surgeon's knots 215, *215*
Surgeon's loop knots 215, *215*
Swimbaits 135
Swim fins 153
Swivels 144–6, *144*
Swordfish 21, 24, 234, 246, 248

Tackle boxes 147–8, *147, 148*
Tampico 242
Tarpon 82–3, *82, 83*, 107, *150*, 207, 238–9, *238*, 241, 248, 249
Teasers 134
Tejon lake *58*
Temperature 199, 200, *200*
Tennessee 235
Terminal knots 213–4
Test line 127
Texas 52, 57, *70*, 73, 234, *240*, 242
Texas rig 135
Thresher shark 75, 76
Tiburon 246
Tide 201
Tiger muskellunge 62
Tiger shark 75
Topolobampo 246
Toronto 229, 232
Tortugo, Lake 242
Transom-mounted motor boats 155, 157, *157*
Travel rods 126
Tray-style tackle box 147, *147*
Treble hooks 219, *219*
Tree River 231
Tributaries 199, 200, *200*
Trolling motor boats 155
Trolling spoons 137, *138*
Trout 74, *130*, 150, 163, 198, 199, *200*,

220, 234, 236, 240
Trout eggs 69, 140, 141
Trout, brook 31–34, *31, 32, 33*, 54, *112*, 236
Trout, brown 31–34, *32, 33, 34*, 69, *200*, 229, 231, 236, 237
Trout, cutthroat 231, *236*
Trout, Lake 54–5, *54, 55*, 140, 212, 225, 227, 229, *230*, 232, 236
Trout, rainbow 68–9, *68*, 141, *207*, 231, 236, 237
Trout, sea 32
True albacore 10
Trunk tackle box 147
Tube knots 215–6, *215*
Tubes 134–5
Tulum 248
Tuna 10, 61, 84–6, *86*, 100, 134, 141, *192*, 201, 234, 238, 245, 247
Tuna, bigeye 84, 86, 245
Tuna, blackfin 84, 86
Tuna, bluefin 84, 85, *85*, 238, 245
Tuna, skipjack 84
Tuna, yellowfin 84, *84*, 86, 238, 239, 240, 245, 246, 247
Tunny, Little 84

Underhand cast 174
Utility boxes 148, *148*
U-tubes 153

Vermilion rockfish 72, *72*
Vermont 237
Vertical jigging *185*, 187, *188*
Victoria Island 227, 231
Virginia 233, *238*

Waders 150, 152, *152*
Wading boots 152–3
Wagglers 146
Wahoo 87, *87*, 107, 134, 141, 245, 246, 247
Walker's Cay *20*
Walking surface plugs 181, 182, *182*
Walleye 42, 88–9, *88, 89*, 92, *133*, 140,

*162*, 163, *187*, 194, 225, 228, 234, 235, 240
Washington 10, *69*, 237, 239
Waterdogs 89, 140
Weakfish 73–4, 195, 238
Weedless spoons 138, *138*
Weighted line 127, 130, 131
Weight-forward fly line 130
Wet flies 132, 184
White bass 79, 90–91, *90, 91*, 235, 238
White catfish 39, 40, 41
White crappie 46,
White marlin 21, 22, 23, 117, 248
White River *91*
White seabass 246
Whitefish *54*, 64, 140, 232
Whiterock bass *see* Hybrid striper
Willowleaf spinner blade 137
Windowpane flounder 50
Winter flounder 50
Wire line 127, 130–31, *130*
Wisconsin 235
Wood lures 132
Woods, Lake of the 228, 231
Worms 25, 28, 29, 33, 36, 40, 42, 47, *58*, 65, 69, 72, 73, 74, 77, 80, 88, 93, 140, 141, 184, 194

Yampa River *236*
Yarn lures 132
Yellow bullhead 38
Yellow jack 52
Yellow perch 92–3, *92, 93*, 232, 235
Yelloweye rockfish 72
Yellowfin croaker 246
Yellowfin tuna 84, *84*, 86, 238, 239, 245, 246, 247
Yellowtail 52–3, 234, 239, 245
Yellowtail snapper 77, *77*
Yellowtail, California 53
Yucatan 241
Yucatan Channel 247
Yucatan Peninsula 247–9

Zebco 114